MICHELANGELO

V. THE FINAL PERIOD

THE FINAL PERIOD

LAST JUDGMENT

FRESCOES OF THE PAULINE CHAPEL

LAST PIETÀS

By CHARLES DE TOLNAY

PRINCETON UNIVERSITY PRESS · PRINCETON

MCMLXXI

To R. B. de T.

FOREWORD

THE five volumes of this series, written between 1940 and 1959 and published between 1943 and 1960, are reissued here without modification except for the replacement of a number of photographs.

Addenda and corrigenda for these five volumes will appear as an appendix in the sixth volume, now in preparation, on Michelangelo as architect.

The author wishes to express his special thanks to Princeton University Press and to its Director, Mr. Herbert S. Bailey, Jr., for the decision to reissue this work, which has been long unavailable.

CHARLES DE TOLNAY

Firenze
Casa Buonarroti
October 1968

PRELIMINARY REMARKS AND
ACKNOWLEDGMENTS

AFTER the manuscript of this book was finished, I had the privilege, thanks to the special permission of the author, to read the not yet published, excellent thesis of Ruth Feldhusen, *Ikonologische Studien zu Michelangelo's Jüngstem Gericht*, Hamburg, 1953. Because it came to my attention so late, I am not able to say all that I would like to say about it here. I consider it especially gratifying that Dr. Feldhusen agrees with the substance of my earlier article on the Last Judgment (*Art Quarterly*, 1940), the method of which she characterized as follows: "This interpretation [of the Last Judgment] received its essential impulses from the objective and formal structure of the work itself, and infers from this structure the mythical sources of the whole and of its parts. . . ." It is precisely this method which I used again in this volume, while incorporating the results of my previously published studies.

This volume was, like the previous ones, realized by the generous assistance of the Bollingen and the John Simon Guggenheim Foundations, to which I am especially indebted. I wish to express here my gratitude to the late Dr. Frank Aydelotte, to Dr. John D. Barrett, Dr. Abraham Flexner, and Dr. Henry A. Moe for their unfailing encouragement.

My thanks are due, moreover, to the keepers of the collections of the Vatican, the Rijksmuseum in Amsterdam, the Musée Bonnat in Bayonne, the Casa Buonarroti and the Uffizi in Florence, the Teyler Museum in Haarlem, the Ashmolean Museum in Oxford, the British Museum in London, The Bibliothèque Nationale and the Louvre in Paris, the Albertina in Vienna and the Royal Library of Windsor Castle. I would like also to thank the private owners of Michelangelo drawings, who have greatly facilitated my studies.

A number of friends have given patient and untiring help in the English wording, among whom I should mention, first of all, Mills F. Edgerton, Jr., John R. Russell, and Jeanne Day who carried most of the burden. I express to all of them again and also to Mary Ann Farley-Tully and Barbara Esser my deep gratitude.

For supplying photographs I thank the late Costantino Baroni, Emilio Lavagnino, Filippo Magi, Giovanni Poggi, Ugo Procacci, Filippo Rossi, János Scholz, and Count Antoine Seilern.

Last but not least, sincere thanks are due to the staff of the Princeton University Press, particularly to Miss Harriet Anderson, Fine Arts Editor, and Mr. Herbert S. Bailey, Jr., Director, for carefully carrying through the publication, as well as to Mr. Harold Hugo, of the Meriden Gravure Company, for his conscientious supervision of the collotypes.

Although the text, the critical notes, and the catalogue of drawings complement each other, each part also contains material not included in the other sections.

Except where otherwise specified, the illustrations of this volume were made after new photographs, executed according to the author's instructions.

January 1959 Ch. de T.

CONTENTS

INTRODUCTION

THE last thirty years of Michelangelo's life, from 1534, which marked the beginning of his permanent residence in Rome, until 1564, the year of his death, constitute a distinct phase in the spiritual and artistic development of the master. Recently it has been emphasized that this period was not an epoch of decadence but rather of a change in Michelangelo's conceptions and in his artistic language. Also there was a shift from the figurative arts of sculpture and painting, to the abstract art of architecture and to poetry.

Perhaps the first one to become aware that a new stylistic period had opened was Lomazzo, who in his *Idea del Tempio* in 1590 said that the Last Judgment marked a "seconda maniera" of Michelangelo (the first being the Sistine Ceiling) and the third the frescoes of the Pauline Chapel. Although Condivi and Vasari had considered his late works of the highest quality, what Lomazzo designated "the second style" he considered worse than the first and the third worse than the second. From that time until the beginning of the present century the works of Michelangelo's late period were treated briefly and often inadequately.

A re-evaluation of the last creative period of the master began at the time of the reappraisal of the art of the Middle Ages, in the first decade of this century, probably under the impact of Fauvism and Expressionism in art. The first signal for the new point of view was given in an article by Worringer on the Pietà Rondanini (1909) and was followed by the memorable essay on Michelangelo by the philosopher Simmel (1910). Then almost a decade passed without a major contribution until Max Dvořák in his 1918-1919 lectures at the University of Vienna (published posthumously in 1928) knowingly re-evaluated the whole late period.

However, the interpretation of the spiritual content of the works of this epoch seems not to have kept pace completely with the historical research on them, in spite of significant observations by the scholars mentioned above and by later ones. The opinions of Condivi and Vasari have been followed in general for four centuries, often hampering a true understanding of these works. The Last Judgment is still usually described as a composition built up in zones revealing the *dies irae*; its great revolving movement connected with the planetary cosmological content has been overlooked. The frescoes of the Pauline Chapel have generally been described since Lomazzo as a "terrifying" depiction of events in "gloomy colors." Actually the range of colors is tender, soft, and silky; their effect is by no means frightening. The two last Pietàs are constantly characterized as "expressions of maternal sorrow" or as "desperate cries for redemption." Actually they incarnate above all the final union of Mother and Son. Here Michelangelo achieved a fusion of forms filled with an ineffable sweetness and tenderness, expressive of the inner peace for which he had yearned throughout his life.

Maurois says of old age: "la vieillesse . . . n'est pas déchéance, mais délivrance." Actually Michelangelo succeeded in transforming his physical decay into spiritual liberation.

THE FINAL PERIOD

In the text, numbers in parentheses not otherwise identified (as v, 2) refer to chapters and paragraphs in the Critical Section of the present volume. Numbers such as (No. 48) refer to the Catalogue of Drawings. References including the designation "Vol. I" "Vol. II," etc. (as Vol. I, p. 41) refer to the earlier volumes of this work, *The Youth of Michelangelo* (2nd ed., 1947), *The Sistine Ceiling* (2nd ed., 1949), *The Medici Chapel* (1948), *The Tomb of Julius II* (1954). Marginal numbers in the text pages refer to the Illustrations.

I. LIFE (1534-1564)

OUTWARDLY Michelangelo's last period is distinguished from the earlier periods by his residence in Rome, which had become the artistic and intellectual center of Europe (I, 1). It was during this period that the artist reached the zenith of his glory. The great rivals of both his youth and maturity, Leonardo, Bramante, and Raphael, had already died by the end of the second decade of the sixteenth century. As the only survivor of the Golden Age of the Renaissance in central Italy, he dominated all of Italian art. Among the younger artists of the time there were several who were gifted (Pontormo, Rosso, Bronzino) but none of comparable genius. They surrounded Michelangelo with admiration and reverence, regarded him as a supernatural phenomenon, called him "divino." His works were considered the supreme standard of art and all imitated his style, even artists of Venice, like Tintoretto, and those of the Northern countries, such as Frans Floris and Marteen van Heemskerck. European art became after 1540 Michelangelesque.

The question of what motivated Michelangelo to move to Rome in September 1534 cannot be answered with assurance. His earlier residence there had certainly been motivated by his love for Tommaso Cavalieri. From a letter of September 1534, to Febo di Poggio (Frey, *Dicht.*, p. 525) we know that at that time Michelangelo had already decided not to return to Florence "non tornerò più di qua." Later, however, at the end of the fifties, he changed his mind. In several letters from 1555 and 1557 he states that the reason for his absence from Florence was his activity as the supervisor of the work on St. Peter's—he could not leave the Fabbrica di San Pietro without committing a great sin; his absence would bring great damage to the whole of Christianity: "Sarebemi grandissima vergogna in tutta la Christianità, e a l'animo grandissimo peccato" (Milanesi, pp. 537-538).

But at first there were certainly other reasons that kept him away: foremost among these was the transformation of Florence into a duchy, which must have appeared to his republican mind as a form of enslavement. Michelangelo, whose political sentiments were much closer to the old Florentine republicans Leonardo Bruni and Matteo Palmieri than to his contemporaries Macchiavelli and Guicciardini, obviously did not wish to live in a Florence that had become completely subject to the Medici. It is true that in his letters he never mentioned the real reason for his voluntary exile, but there are unquestionable references to it: the Bust of Brutus (see Vol. IV, pp. 76*ff*), *Vol. IV, 88-93* the madrigal on Tyranny, the epigram about Night, and a letter by del Riccio. These documents will be briefly analyzed in what follows.

During his final stay in Rome the artist remained in contact with a great number of Florentines, and among these was the historian Donato Giannotti, Michelangelo's *amicissimo*, who was a city secretary in Florence during its last period as a Republic,

just as Macchiavelli had been (1, 2). Compelled by his belief in independence and freedom for the Republic, Giannotti had continued his feud with the Florentine tyranny after he had been banished to Rome, where he became secretary to another Florentine exile, Cardinal Niccolò Ridolfi. Michelangelo certainly discussed with Giannotti the tragic fate of their city and the question of tyrannicide. Giannotti, who treated this theme in several of his works, placed himself squarely on the side of such tyrant-slayers as Brutus and Cassius. He objected to the fact that Dante had consigned these two to Hell. In Dante's time (*Inferno*, xxxiv, 64; *Paradiso*, vi, 74), one condemned Brutus not only because he had slain his benefactor Caesar but because, by killing Caesar, he had also slain the founder of the Roman Empire who had brought peace to the Roman world. Boccaccio is perhaps the first to reveal a change in the evaluation of Brutus: "Non vi è sacrificio più accetto del sangue di un tiranno" (*De casibus virorum illustrium*, II, 15). In the course of the Renaissance there developed a Brutus cult. Brutus was set up as an ideal by the Florentines who wished to liberate their city from the Medici. Michelangelo expressed his conviction of the necessity of tyrannicide through the Brutus Bust which he executed for Cardinal Ridolfi at

Vol. IV, *89* the request of Giannotti (Vasari). The Bust expresses heroic indignation—a disdain apparently of those who would destroy freedom (see Vol. IV, pp. 76ff). Around 1545, about six years after the execution of the Bust of Brutus, Michelangelo wrote a madrigal (Frey, *Dicht.*, CIX, 48) which contains a similar attitude toward tyrants: here Florence, personified as a beautiful woman, speaks to the Florentine exiles. The latter lament the servitude of their native city and the injustice that is being done to it because one individual had confiscated that which was the property of all. ("Un sol s'appropria quel ch'è dato a tanti.") But Florence comforts her audience: "Col gran timor non gode [il tiranno] il gran peccato. . . ."

Michelangelo seems to have seen in the fall of the Republic, the death of liberty; in the forceful seizure of the government by Cosimo, the act of a tyrant. Proof of this is also the epigram about Night (Frey, *Dicht.*, CIX, 17), one of the statues in the Medici Chapel. This epigram, so full of profound bitterness, probably dates from 1545, the year in which the Medici Chapel was opened to the public. The allegorical figures of the Medici Chapel seem to have had only a philosophical significance when Michelangelo conceived them in the 1520's; they symbolized Time which devours all things. (See Michelangelo's lyric fragments, Frey, *Dicht.*, XVII.) The epigram, written a quarter of a century later, shows that the master had substituted a political interpretation for the original one. (See Vol. III, p. 73.)

In the mid-forties, perhaps just at the time of his illness in 1544, Michelangelo seems to have suffered most as a Florentine patriot. He was at that time in close connection with Luigi del Riccio, descendant of an old Florentine family, who was expelled from his native city and who became in Rome an agent of the bank of Strozzi-Ulivieri in the service of Roberto Strozzi, likewise exiled, an arch-enemy of the Medici (1, 3). In June of 1544, exhausted by his strenuous work, Michelangelo

became seriously ill. Luigi del Riccio had him taken to the home of Roberto Strozzi in Rome, provided him with all imaginable care, and "tore him away from death," as Michelangelo was to say later. Undoubtedly there took place long conversations between the artist and Luigi del Riccio. The imagination of the two must have become inflamed during these talks when they discussed the problem of the freedom of their native city. On July 21, 1544, del Riccio wrote to Roberto Strozzi in Lyons and passed on to him Michelangelo's thanks, to which he added the artist's moving request: "He begs you to send news and to remind the King [Francis I] what he had said to him through Scipione and later through the Courier Deo: namely, that he would at his own expense erect an equestrian statue on the Piazza dei Signori, if the King would restore to Florence her freedom" (Gaye II, p. 296). This offer has been interpreted (Dorez) as a disguised criticism of Francis I because he had scrapped the old French-Florentine treaty in a time of need, i.e. when the Emperor Charles V came to help Pope Clement VII with the siege of Florence. It would seem closer to the truth to see in this offer an attempt by Michelangelo to spur the French king to fulfill his traditional duty, that is, to liberate Florence.

One should not forget that in the imagination of the Florentines, there always lived the ideal image of a great, wise, and just emperor who would save the city. During the Middle Ages, this dream was applied to the Holy Roman Emperor (as in Dante); with the Renaissance the image was shifted to the French Capetians. It was always with the French kings that the Florentines found a supporter and an ally. When Michelangelo brought forth his request, he was following the guelphian tradition: he saw in Francis I the dreamed-of liberator. (It is not known if Michelangelo's offer actually reached Francis I but it is likely that exiled Florentines living in France made it known.)

Michelangelo's gift to Roberto Strozzi should also be mentioned here: the two marble Slaves which are today in the Louvre. What Michelangelo had presented to *Vol. IV, 4-17* Strozzi as a symbol of his gratitude, Strozzi offered to Francis I, perhaps, as has been assumed (Dorez), to persuade the king to restore to Florence its independence.

On the other hand, it should be mentioned that a few years later, in 1548, Michelangelo denied in a letter to his nephew Lionardo, that he had any connection with the *fuorusciti* and stated that he considered that he had passed his convalescence not in the house of Roberto Strozzi but in del Riccio's room: "Mi son guardato insino a ora del parlare e practicare con fuorusciti . . . circa l'essere stato in casa degli Strozzi, io non tengo d'essere stato in casa loro, ma in camera di Messer Luigi del Riccio, il quale era molto mio amico" (Milanesi, p. 211). In 1552 (Milanesi, p. 279) and 1553 (Milanesi, p. 289) Michelangelo repeated his contention that he had never been in contact with the Florentines. These letters are probably to be explained by Michelangelo's fear that the nephew, who had remained in Florence, might be punished by the authorities for his uncle's commonly known republicanism. But these letters should not deceive us as far as the true convictions of the artist are concerned.

[5]

During the last twenty years of his life, this Florentine republicanism seemed to diminish. The testimonies of his bond to Florence show a progressive transformation in his love of that city, which steadily became less passionate and more objective. Even as an old man the artist was still proud of the fact that he belonged to an old Florentine family and that he was of noble lineage (Milanesi, pp. 197, 237, 271, 492, etc.). But at the age of eighty his strong opposition to the current government of Florence receded, a fact which would have seemed irreconcilable with his ideals of ten years before. We see Michelangelo (from ca. 1554) in friendly correspondence with Duke Cosimo. And when the citizens of Florence commissioned him with the design of their church in Rome, San Giovanni dei Fiorentini, the artist undertook the commission only on condition that he receive "una licenza e commessione dal Duca" (permission and commission from the Duke). Therefore from this point on he recognized the Duke as ruler of Florence.

It would appear that during the last decades of his life Michelangelo gradually came to recognize the transcience of all local patriotism. A more universal and more spiritual ideal developed in his mind, the ideal of the citizen of Christianity. Now he directed his activities and thought according to the demands "di tutta la Cristianità" (Milanesi, pp. 537, 538; from 1555). His political conceptions broadened and became spiritualized, embracing not only Florence but the entire Christian world. His political convictions dissolved into religious ones. His only concern from this point on was to work for the glory of God. Art became only a means to serve Him (Frey, *Dicht.*, CXLVII). We should, therefore, conclude that the old man, now close to eighty, declined to return to Florence, no longer for political reasons, but because he was bound to Rome by religious and ethical considerations. He worked on St. Peter's, as he himself said, "solo per l'amore di Dio e per la riverenza al Principe degli Apostoli" ("solely for the love of God and out of reverence for the Prince of the Apostles"). Yet in March 1557 he did seriously think of moving to Florence and he mentioned this plan in a letter to Cornelia Colonelli (Milanesi, p. 542).

Clement VII must have known that Michelangelo was strongly drawn to Rome and that it was only there that he felt he could again be creative. It was therefore the Pope's desire to find some worthy commission for him in Rome (Condivi, p. 150). He found such a task in the new decoration of the altar and entrance walls of the Sistine Chapel. Michelangelo went to Rome for this purpose, but two days after his arrival, September 26, 1534, Clement VII died. At the beginning of his Roman sojourn, the artist remained aloof from the Papal Curia, chiefly because he wanted to finish the Tomb of Julius II. But the new Pope, Paul III Farnese, insisted vehemently on retaining Michelangelo's services for himself. The Pope, being old, was aware that he had little time remaining to realize his projects with the artist. Paul III knew well how to treat Michelangelo. He sensed that with "soft words one could obtain whatever

one wanted" from the master—as Soderini had observed even during Michelangelo's youth (Gaye ii, p. 92). An intimate relationship developed between the Pope and the artist, not unlike that which had existed between Julius II and Michelangelo. Paul III's inclination toward Michelangelo was expressed, among other things, by the various briefs which he issued favoring the artist: on September 1, 1535, he included Michelangelo among the Papal Familiars—he nominated him as the Supreme Architect, Sculptor, and Painter of the Apostolic Palace (Pog. ii, pp. 742-747); on November 17, 1536, he issued a *motuproprio* in which he declared Michelangelo free of all obligation to the Rovere heirs, stating that Michelangelo had been constrained against his own will to serve Clement VII and in turn himself, Paul III (Pog. ii, pp. 748*ff*). Michelangelo's release from this obligation was to last until he finished the Last Judgment, but after this fresco was completed, the Pope again wanted to retain Michelangelo's services to decorate the small palace chapel, the Paolina, which had just been completed. In 1540 the Pope issued two *motupropri* in which he declared Michelangelo free from any claims which the consuls of the College of the Scarpellini and Marmorarii of Rome might lay on the artist (Pog. ii, pp. 753*ff*). Michelangelo also accepted the post of High Commissioner of St. Peter's at the insistence of Paul III. He was given powers which had been granted to no previous architect at the Papal Curia.

Michelangelo's love for the Pope manifested itself in turn in many little attentions (his several gifts of Trebbiano wine, Milanesi, pp. 182, 204; a basket of pears, Milanesi, p. 225, etc.). He was deeply grieved by the death of the Pope (Milanesi, p. 260). The commissions given to Michelangelo by the Farnese Pope were the most significant undertakings available at that time in Europe. Paul III was, like his illustrious predecessors of the Renaissance, a great humanist and a patron of the arts, yet at the same time he was also deeply religious and reaffirmed the morality of the Church. These two inclinations were displayed in his desire to reconstruct the Mother Church of Christianity, St. Peter's and the Capitolium, the piazza which was destined to become a center of the civic life of Rome. Both commissions were given to Michelangelo. Through these works, the artist gave to the physiognomy of the Eternal City a new aspect, which is still preserved. In addition to these two supreme artistic undertakings, Paul III also commissioned Michelangelo with the completion of his palace, the Palazzo Farnese, and the fortifications of the Borgo. In the field of painting, Michelangelo executed the Last Judgment and the Pauline Frescoes for the Pope (i, 4). Other works, which he completed during the period of this pontificate but for other patrons were the Bust of Brutus, the Rachel and Leah for the Tomb of Julius II, and two small works in 1537 for the Duke of Urbino, a bronze horse (today lost), and a saltcellar (of which a project drawing is in the British Museum) (i, 5). The greatness of the assignments and the productivity inspired in the master by these works for Paul III remind one of the splendor of the creative period under Julius II. Strangely enough, the chief works of this period (Last Judgment, the Pauline Frescoes,

St. Peter's) were all begun by Michelangelo against his will, and at the insistence of Paul III. The master himself wanted to devote his time to finishing the Tomb of Julius II (Condivi, Vasari), but he had to submit to the will of the Pope. It is all the more noteworthy that Michelangelo succeeded in creating out of these unwelcome commissions works which became completely representative of his art.

The next Pope, Julius III (1550-1555), was a great devotee of the Jesuits and at the same time a hedonist. Michelangelo's activities mirror to a certain extent both tendencies of the Pope: on the one side, the artist offered to Ignatius Loyola in 1554 "per sola devozione" the execution of a plan and model for the church of Gesù, and he worked on his late Pietàs; on the other hand, in 1552 he worked on designs for the Exedra and the stairway of the Belvedere, the principal court of the Vatican which was intended for the feasts and tournaments of the glittering papal court. The projects *223ff.* preserved in drawings from this period (Christ cleansing the Temple, Gethsemane, late Crucifixions) are testimonies of the visionary religious style of the late Michelangelo.

Paul IV, Carafa (1555-1559), the successor of Julius III on the papal throne, was a church-minded ascetic who was feared because of his strictness and abruptness. For him it was more important to have the reputation and the vigor of the Church renewed than it was to grant commissions for great works of art. The war with Spain, the need for money, the worry about ecclesiastic reform and the new puritanical spirit all combined under this Pope to break the old tradition of artistic patronage. Nevertheless, for religious reasons he felt it worthwhile to have the work on St. Peter's furthered. Michelangelo could continue to work in his capacity as supervisor on this church. A consequence of the prevailing prudery is found in the fact that some of the naked figures of the Last Judgment were partially painted over at this Pope's order. The dry style of Pirro Ligorio, the architect, Taddeo Zuccari, the painter, and Guglielmo della Porta, the sculptor, was more to this Pope's taste than the exuberance of Michelangelo.

The following pontificate, that of Pius IV (1559-1565), is again one characterized by a tendency to the secular. He kept a brilliant court and scandalized the Romans by his dissolute private life. He held Michelangelo in great favor and thus invested him with complete power over the Fabbrica di San Pietro. In arguments over the construction of this church, the Pope remained on the side of the master: when the Building Commission of St. Peter's turned against Michelangelo in 1563, under the influence of Nanni di Baccio Bigio, the Pope refused to have Michelangelo released from the position. During this period, the last of the master's life, Michel- *88* angelo brought to completion his ultimate style in sculpture (Pietà Rondanini, last version) and architecture. At the behest of Duke Cosimo the First, the new projects for the Church of San Giovanni dei Fiorentini were executed. There followed, at the request of the Pope, the conversion of the Terme di Diocleziano into a church, Santa Maria degli Angeli. The Pope also commissioned Michelangelo to make new projects

for the gates of Rome, and the Porta Pia was executed according to the artist's plans. The final architectonic work by Michelangelo, the Cappella Sforza in Santa Maria Maggiore, was executed by his pupil Tiberio Calcagni, who followed in general the master's plans (I, 6).

After the Paolina frescoes he could no longer paint, but he continued to sculpt from a physical need, as a kind of therapy (Vasari), and not for commissions. He worked a great deal during the night because of his insomnia and it is reported that he made a kind of cap from paper on which he put a lighted candle, by which he could have the necessary light to work without encumbering his hands. Blaise de Vigenère (Steinmann-Wittkower, no. 2011), who saw him at work during his late period, describes the impetuous furor with which he cut the marble. This observation testifies to the spontaneity of Michelangelo's work even at this period.

Apart from his own work, Michelangelo, who became the almost unlimited ruler over all fields of art, affected contemporary art through his *advice and assistance* to other artists. His opinions were regarded as oracles and anything of importance made by artists in Florence and Rome was subjected to the judgment of the master. Following Michelangelo's counsel, Guglielmo della Porta did the tomb of Paul III, Vasari the tombs of the Del Monte in San Pietro in Montorio, Leone Leoni the tomb of Giovanni Jacopo de' Medici in the Cathedral at Milan, which latter assignment had been attained through Michelangelo (Gotti I, p. 346). Michelangelo's advice was sought by Duke Cosimo and Vasari concerning the works in the Ducal Palace in Florence (Gaye III, p. 29 and Gotti II, App., no. 38). Moreover, Michelangelo helped young artists with sketches for their paintings, as, for example, Ascanio Condivi, Giovanfrancesco Rustici, Daniele da Volterra, Marcello Venusti, Bartolommeo Ammannati, Tiberio Calcagni, Bronzino, etc.

From the point of view of *artistic development*, the last three decades of Michelangelo's residence in Rome show three phases: they seem to be, in a way, a repetition of the three phases of his previous life-cycle, but now on another level.

The late period begins with a new youth for the sixty-year-old master, a miraculous rebirth which was produced through his passion for Cavalieri. It is surprising to see that after the resigned spirit and the elegiac mood of the period of the Medici Chapel there appears once more, in the Last Judgment, the first great work of Michelangelo's last period, the feeling of passion and of overflowing strength, reminiscent of his youthful work, the Battle of the Centaurs. This marked the beginning of a new, second life-cycle. Following this, there is a period characterized by the subduing of these energies, as seen in the frescoes of the Pauline Chapel, the Rachel and Leah of the Julius Tomb, and the drawings between 1540 and 1550, a phase which corresponds

approximately with that of the Sistine Ceiling in the first cycle. With the Pietàs of the final phase there appear the slender proportions, the passive, broken movements and the sense of peace which seem to mirror the period of the Medici Chapel, but again on another level since the forms lose their individual quality and seem to be about to fuse.

The extraordinary *appreciation of Michelangelo's art* is manifested in the grandiose commissions which he received from patrons belonging to the highest social strata. In addition to the Popes from Paul III to Pius IV, François I was very much interested in obtaining a work by Michelangelo (Milanesi, p. 509). He sent Primaticcio to Italy in February 1546 to have casts made of Michelangelo's Pietà in St. Peter's and of his Christ in Santa Maria sopra Minerva. The king of Portugal wished to have a Madonna della Misericordia by Michelangelo (Francisco de Hollanda, p. 193). And the widow of Henry II, Catherine de Medici, asked the artist in 1559 to execute a bronze equestrian monument of her husband.

256

Also, it was at the end of this last period that Michelangelo produced works of art which had not been commissioned, but which he did either out of friendship (for Cavalieri and Vittoria Colonna) or purely for himself. It is true that in his youth, upon the death of his patron, Lorenzo de' Medici, he modeled for himself a larger than life-size marble figure of Hercules (Condivi, Vasari), but he did this primarily to draw the attention of art connoisseurs to his gifts as a sculptor in the hope of securing commissions. But the last two Pietàs of his life and some of the drawings having religious subjects seem to have been dictated only by an inner need: they are like confessions or lonely prayers. The personal nature of these works is exemplified by the Florentine Pietà, which, as we know, was destined by the artist for his own tomb, and by the Pietà Rondanini, on which he was working six days before his death. These works may be viewed as Italian precursors of the intimate "religious confessions" of the aged Rembrandt in his drawings and paintings.

77
88

From the beginning, Michelangelo did not address himself in his works to any particular segment of society, nor did he flatter his patrons by including them in his compositions. His art was universal in its aim. Through his art he spoke to all mankind. His works were rightly called "monuments of humanity *sub specie aeternitatis,* monuments of humanity's afflictions, struggles, and hopes" (Dvořák, p. 33). It follows that his art cannot be interpreted as a direct expression of the spirit of the Papal Curia nor of the taste of the contemporary "upper class." It is precisely because of his universal aims that those who were able to understand Michelangelo's art have always been a limited group, the spiritual élite of their time.

It was in this late Roman period that *the cult of Michelangelo* began, with the

writings of Giannotti (ca. 1545), F. de Hollanda (1548), Varchi (1549), A. F. Doni (1549) and finally the biographies by Vasari and Condivi.

Vasari's first edition of 1550 contains, of all the living artists, only Michelangelo's biography and this biography is treated at the end as the culmination of the whole *Vite*, as the absolute summit of the Florentine artistic development from Cimabue on. Michelangelo, Vasari says, has been sent to earth by Divine Providence to save us from our errors in our effort to imitate nature through art and to stand as an example of perfection, not only in painting, sculpture, and architecture, but also in true moral philosophy and in poetry. Michelangelo is to be admired not only in his works but also "in his life, in the sanctity of his habits, and in all his human actions." That is why he is "called by us celestial rather than terrestrial" (Vasari, 1550, pp. 8f).

Condivi's biography of Michelangelo, partly based on the artist's own recollections, was published in July 1553, a little more than two years after Vasari's: In its dedication to Pope Julius III Condivi says that he hopes that his efforts "will merit the favor and the grace of your Holy Sanctity and the name of servant and disciple of Michelangelo, the one the Prince of Christianity, the other the Prince of the art of drawing" (Condivi, p. 2). Here the appreciation of an artist seems to attain unprecedented heights—Michelangelo is elevated to the same rank as his patron, the reigning Pope.

The glory (*la fama*) of artists rose slowly along with the emancipation of art from handicraft, a process which began in Florence in the fifteenth century. But now in the mid-sixteenth century with Michelangelo we see that not only has the artist Michelangelo become famous, but there is an aura surrounding the person Michelangelo. The artist as a *man* is as important, sometimes even more important, than his work. Vittoria Colonna is supposed to have said to Michelangelo (according to Francesco de Hollanda, p. 21): ". . . those who know you in Rome value the person in you more highly than the works, whereas those who do not know you personally appreciate only the smaller part of you, i.e. the works of your hands."

It is the generosity of Michelangelo's heart that V. Colonna appreciated. He on occasion would refuse commissions from princes, even of kings, while helping his poor garzoni and less gifted artists. "You follow the example of the Savior," she said, "like him, you cast down the proud and raise up the lowly" (Francesco de Hollanda, p. 21). Thus not only is Michelangelo's art the object of veneration, but now, the man himself. This is an indication of a new degree of artistic freedom. Until now the artist sang the praise of his patron, but now the divinization is transferred to him (Zilsel).

Varchi's *Due Lezioni* contained two lectures which he had delivered in 1547 at the Florentine Academy (Milanesi, p. 524). Varchi in his first lecture concerning the sonnet "Non ha l'ottimo artista . . ." (Frey, *Dicht.*, LXXXIII) treats Michelangelo as poet and undertakes for the first time in public to analyze the artist's friendship with Tommaso Cavalieri according to the theory of Platonic love. In the second lecture he

treats the problem of the relative merits of painting and sculpture. On this subject Varchi asked the opinions of the most celebrated artists of his time (Vasari, Bronzino, Pontormo, Tasso, Francesco da Sangallo, Tribolo, Cellini) and published their replies. He also asked Michelangelo through Vasari, but the artist's first answer seems to have been short and without interest. On a supposedly second approach by Varchi, Michelangelo answered in the spring of 1547 (Milanesi, p. 522) saying that he had believed formerly that the art of painting was good inasmuch as it resembles relief, and that relief (sculpture) is poor inasmuch as it resembles painting; that he considered sculpture as the "lantern" of painting. However, he goes on to say that under the influence of Varchi, he had changed his mind, and was now of the opinion that the two arts are actually of the same value since they originate in the same intelligence. This change of mind is characteristic of the late universalism of Michelangelo. In the letter to Varchi the artist also gives his definition of the two arts: "Io intendo scultura, quella che si fa per forza di levare; quella che si fa per via di porre, è simile alla pittura. . . ." This definition reverts to Alberti and Leonardo who used it, however, in a different way by applying the "per forza di levare" to sculpture in marble and "per via di porre" to sculpture in terracotta. The origin of the definition is found in Aristotle (*Metaphysics* ix. 6). A copy of Varchi's *Due Lezioni* was offered to Michelangelo by the author in January 1550 (Milanesi, p. 527).

At the end of 1560 or the beginning of 1561 Leone Leoni cast the bronze medallion in honor of Michelangelo, of which he sent four copies to the master (Gotti i, p. 346). On the recto there is a portrait of Michelangelo in profile, in accordance with the Renaissance tradition of perpetuating the fame of an individual. On the verso is a 376 composition that was probably made after a drawing by the master himself. It represents a blind old man, resembling the master, with his dog, groping his way through life. The inscription (Psalm 51:15) alludes to the religious conversion of the master (Steinmann, *Portraitdarstellungen*, no. 50).

Together with fame and riches went social advancement for his family. This was what Michelangelo had greatly desired. This is reflected in the marriages of his niece and of his nephew, marriages in which the artist was very much interested and which he guided from afar. The niece, Francesca, married Michele di Niccolò Guicciardini, from a noble old Florentine family (Milanesi, p. 163). Michelangelo was highly satisfied and gave as a dowry one of his holdings at Pozzolatico.

The aged master was also intensively occupied from 1547 until 1553 with the problem of the marriage of his nephew Lionardo, a marriage which Michelangelo desired with all his heart in order to see the continuation of the family name: "Accioché l'esser nostro non finisca qui." The various girls who were suggested as suitable for the nephew interested Michelangelo with respect to their families as well as to their persons. But since he lived far from Florence and thus had no means of knowing these Florentine families, he limited himself to general advice and suggestions, which reveal his noble conception of life: "ti dico che tu non vadi dietro a

danari, ma solo a la bontà e alla buona fama" ("I tell you that you should not be concerned with money, but only with goodness and with good reputation.") And two years later in 1551 he wrote: "non mi pare che tu . . . abbi a guardare a dota, ma solo a la bontà, a la sanità e la nobiltà" ("It doesn't seem to me that you should look at dowry, but at goodness, at health and at nobility.") (Milanesi, pp. 271, 274, 275, 277-290, 294-297.) Lionardo finally married one of the daughters of Donato Ridolfi, Cassandra, in May 1553. The Ridolfi were a distinguished, noble family of Florence, and Michelangelo was satisfied with his nephew's choice. He sent two rings, one diamond and one ruby, as a gift. From this marriage three sons were born: Lionardo, 1554; Lodovico, 1555; and in 1568, four years after the death of the master, there was born Michelangelo, who called himself Michelangelo il Giovane.

To raise the prestige of the family, Michelangelo decided to buy for Lionardo a "respectable" house (Milanesi, pp. 197, 199, 202, 206, 208, 212, 213, 229-241, 253-259). Michelangelo had an appreciation for the prestige value of property which he rated higher than its mere material value. Thus he wrote to Lionardo: "una casa onorevole nella città, fa onore assai, perchè si vede più che non fanno le possessioni" (Gotti I, p. 288) ("a respectable house in town creates respect because it can be seen better than possessions"). He had been concerned since 1546 with the genealogy of the Buonarroti to prove to his nephew the antiquity and prominence of the family.

Although his two most intimate *friends* in the late period, Tommaso Cavalieri and Vittoria Colonna, were both members of the highest aristocracy, he retained his solidarity with the poor and lowly. His interest in them is manifested by the alms which he gave anonymously from time to time (Milanesi, pp. 270, 302-303, 321, 334, 360, 362). Further proof is found in his affection for his servant Urbino and in later years for Urbino's widow, Cornelia Colonelli and their two boys, whose affairs he supervised for some three years, from 1558 to 1561. Cornelia left Rome after the death of her husband and returned to Casteldurante to live with her parents. She remained in contact with the master, whom she adored, and whom she called "patre amatissimo" in her letters, which she signed "figliola amorevolissima." A simple person, she was generous and of high moral character. She jealously preserved every memory of her husband and of Michelangelo. From one of her letters, December 13, 1557, it is learned that Michelangelo had drawn two portraits of her two sons (Gotti I, pp. 334f), which the Duke of Urbino wanted to examine. It had been made clear to the widow that she should offer these portraits to the Duke, who felt they possessed "gran bellezza." She made this offer reluctantly and then pleaded with Michelangelo that he let Marcello Venusti make copies of them. In other letters Cornelia told Michelangelo that she wished to remarry, and sought his help and advice in a manner that also testifies to her high ethical standards. Finally, in April 1559, she married a young Doctor of Law, Giulio Brunelli from Gubbio.

[13]

The inevitable consequences of Michelangelo's fame were intrigue, jealousy, and calumny. The attacks against him assumed new vigor after the death of Antonio da Sangallo in October of 1546, since Michelangelo fell heir to his great commissions in architecture and received, moreover, additional important assignments: completion of the Palazzo Farnese, fortification of the Borgo, plans for the new Capitol, and appointment as the architect of St. Peter's. The exact execution of his intentions was later assured by a group of friends: Cardinal di Carpi, Donato Giannotti, Francesco Bandini, Tommaso Cavalieri, and Francesco Lottini. Opposed to Michelangelo was a clique largely recruited from the friends of the late Antonio da Sangallo. They sought to depose Michelangelo by means of calumny. They denounced him to the Deputati di San Pietro who actually turned against the master (Gotti I, p. 211). The leader of the "Setta Sangallesca," as Vasari called them, was Nanni di Baccio Bigio, who imputed Michelangelo's honor and described his works as "cose pazze et da bambini" ("demented and childish things"). We learn of these invectives from a curious letter by Ughi of May 15, 1547 (Gotti I, pp. 349f). It was probably to put an end to these intrigues that Paul III issued the breve on October 11, 1549, in which he appointed Michelangelo for life as *Commissarius, prefectus, operarius, et architector* of St. Peter's (*Rep.f.Kw.*, 1906, p. 400). In spite of this, we learn that in 1551 accusations were made against Michelangelo that his plan for the southern apse of St. Peter's (the Cappella del Re di Francia) did not take proper account of the lighting conditions (Vasari VII, p. 232). Thereupon, in January 1552, the new Pope, Julius III, issued another breve which repeated the contents of the earlier one (*Rep.f.Kw.*, 1906, p. 403). Shortly after the death of Julius III in March 1555, under the new Pope Paul IV Carafa, the attack was resumed and as a result Pirro Ligorio, an enemy of Michelangelo, was assigned as one of the architects to St. Peter's (Vasari VII, p. 245). However, in December 1559, Pius IV reconfirmed the appointment of Michelangelo as chief architect of St. Peter's (Vasari VII, p. 257).

The most dangerous intrigues were formed in 1562 and 1563. Nanni di Baccio Bigio asked the Duke Cosimo, to hire him as architect of St. Peter's (Gaye III, p. 66). In 1563 an open conflict developed between Michelangelo and the Deputati della Fabbrica as a consequence of Nanni's insistence, but fortunately Pius IV saw through these schemes and dismissed Nanni's claims. (Daelli, no. 26; Vasari VII, p. 266).

The main problems that bothered Michelangelo at the end of his life were those of *death and the salvation of his soul*. The time at which a human being becomes aware that his individual life-span is limited comes much later than the abstract awareness of transience and is usually a turning-point. The perspective changes. From then on a creative man usually becomes conscious that the remainder of his life is not long enough to realize his aspirations fully. Michelangelo recognized that old age has a special character: "I am old, and death has stolen from me the ideas of my youth,

and he who does not know what old age is should wait with patience until it arrives, since before that he cannot know what it is" (1547, letter to L. Martini). With the decline of physical forces and spiritual elasticity he came to feel that old age was a sickness: "I bear with patience the sufferings of old age" (1550, to G. Franc. Fattucci). "How does old age treat you?" he asked Fattucci in 1549, and added: "I wrestle with Death." Another time he said: "There exists no thought within me in which Death is not sculpted" (1555, to Vasari). He feared death at the bottom of his soul, but he developed as a remedy against it a true *ars moriendi*. The last thirty years of his life were in some ways a preparation of his soul for a dignified death: "I try day and night to become familiar with Death that he may not treat me worse than any other old person" (1557, to Duke Cosimo). On the occasion of the death of his beloved servant Urbino, he said, "his dying taught me to die, not with regret, but with desire for death" (1556, to Vasari; Milanesi, p. 539).

For Michelangelo, life is not separated from death; death is rather an inescapable component of life. He said: "if life pleases us, then death too should not displease us since it comes from the hands of the same Creator." Therefore death does not come from without: from our birth on it is woven into our very existence. To this conception of death there corresponds the stoical attitude with which Michelangelo sought to approach death throughout his life (I, 7).

But even greater was his concern for the salvation of his soul. And from this point of view he now condemned his own past life, considering it as wasted. At this point his artistic activity became truly a worship of God. His soul was filled with repentance, for he was conscious of his inability to save himself through his own strength alone. He tried to believe in salvation through the absolute goodness and love of the Redeemer. Yet he had moments of doubt and he suffered deeply because of them, reproaching himself for his own weakness. The late poems as well as the works of art reflect clearly these inward worries.

In the Last Judgment, in the frescoes of the Pauline Chapel, and in the Crucifixion drawings, the fears and feelings of guilt are expressed—whereas in the Pietàs and the Annunciations his belief in Divine Mercy and Divine Love is incarnated.

We know from a letter of Daniele da Volterra that the eighty-nine-year-old master used his chisels for the last time on February 12, 1564, six days before his *death* (Daelli, no. 34). He worked standing that whole day on the Pietà we call the Rondanini. Two days later his struggle with death began. On February 14 he was seized with an indisposition, yet he would not allow himself to be put to bed. Probably he sensed that he would not rise again. A pupil, Tiberio Calcagni, who visited him that day, found him out of doors (Daelli, no. 27). The next day, February 15, although he had a high fever, he sat by the chimney. He was already "debole di testa et di gambe" (Daelli, no. 28). By February 16 he was finally forced to go to bed. Now he

88

[15]

felt that the end was at hand and he expressed the wish that his body should be sent to Florence, saying that he wished at least to return to his native city in death since he could not return in life (Gaye III, p. 131). This was a last manifestation of his loyalty to his native city (Gotti I, p. 358; Gaye III, pp. 126, 131). His death struggle lasted two more days. Vasari reports that shortly before his death, the master made a testament in three phrases: he left his soul in the hands of God; his body to the earth; and his belongings to his nearest relatives, asking them that in the moment of his death they remember the death of Christ. On February 18, around five in the afternoon, Michelangelo died in the presence of his most beloved Tommaso Cavalieri, his pupils Daniele da Volterra and Diomede Leoni, his faithful servant Antonio del Franzese, and his two doctors Federigo Donati and Gherardo Fidelissimi (Gaye III, p. 126).

An inventory of Michelangelo's belongings was taken the next day, February 19, by the notary of the Governor of Rome in the presence of Cavalieri and Pier Luigi Gaeta (Gaye III, p. 127; Gotti II, p. 358; Frey, *Handz.*, p. 114). Much less was found in the house of Michelangelo than had been thought. The artist had had many of his drawings burned. As for works of art, the house on the Macello dei Corvi contained only three unfinished marble statues and ten cartoons. The statues were a St. Peter, "clothed as a Pope," identified by us as the statue of Leo X or Clement VII (Vol. III, pp. 173, 235); a Pietà, obviously the Pietà Rondanini; and a small Christ Carrying the Cross, which is lost today. Among the cartoons, five were architectural drawings and the rest were of figures. Among these latter mention is made of a Pietà with nine figures drawn only in outline, today lost. The cartoon with the "three big figures

248 and the two putti" is certainly identical with the so-called Epiphany in the British Museum. This piece was given to the notary on February 26, 1564. There was a study for an Apostle for a statue in St. Peter's which went to Daniele da Volterra. Finally, there was Christ's Farewell from His Mother, which was inherited by Tommaso Cava-

209-210 lieri. Perhaps the Cambridge drawing of the same subject is a preparatory sketch for this cartoon. The rest of the objects were given to Lionardo Buonarroti who, more-over, acquired from Michele Alberti and Jacopo del Duca some small drawings which had been given to them by the master.

On February 19, the body was transported to the church of SS. Apostoli, by the Confratelli di San Giovanni Decollato to which Michelangelo had belonged, where a simple funeral service was held. Lionardo Buonarroti arrived on February 21, order-ing immediately that the body should be transported to Florence according to Michel-angelo's last wish (Gotti I, p. 358). But it seems that the people of Rome did not want to permit this, considering Michelangelo as their own (Vasari VII, p. 287). This must have been the reason that the coffin had to be sent to Florence secretly, disguised as a bale of merchandise (*Esequie*, p. 23; Vasari VII, p. 293). It arrived there on March 10 and the next day was taken by the artists of Florence to the church of Santa Croce. In the sacristy Vincenzo Borghini, the director of the Academy, had had the coffin

opened and the body, according to the *Esequie,* was found to be without sign of deterioration. Meanwhile, Lionardo requested a burial place in this church, the parish church of the Buonarroti (Daelli no. 31). Lionardo, together with Daniele, proposed to erect in this same church a monument to Michelangelo in which his figure of the Vittoria and the blocks of the workshop of the Via Mozza were to be used. Daniele *Vol.* IV, *28ff.* intended to execute the plan for this monument. The realization of the project had to be abandoned, however, because, although he seemingly agreed with the plan, the Duke wanted to appropriate for himself the statues in the workshop of the Via Mozza. Thus Vasari's proposition to Lionardo to substitute the Pietà now in the Duomo 77 (which Michelangelo had originally designated for his own tomb) for the Vittoria and the other blocks from the Florentine workshop may have been motivated by the Duke. Vasari advised Lionardo to try to obtain the Pietà from Pier Antonio Bandini for this purpose (Daelli, nos. 32, 33; Vasari, *Carteggio,* p. 377). Although this plan seems to have failed, Lionardo nonetheless felt obliged to offer the workshop statues to the Duke (Gaye III, pp. 131, 135; Vasari, *Carteggio*). As a result no statue by the master himself was finally employed in the funerary monument of Santa Croce, but new statues of no real artistic merit were executed for it by minor sculptors. The Duke assigned the task of directing this project to Vasari, rather than to Daniele and Jacopo del Duca, probably in recognition of Vasari's services in obtaining for him the statues of the Via Mozza. For the iconographical program, the President of the Academy, Vincenzo Borghini, was also consulted. Work on the monument was begun in 1564, but was not finished until 1572. Nothing is more alien to the spirit of Michelangelo than these cold, sophisticated Mannerist allegories represented in exaggerated poses and movements (I, 9).

No less inadequate were the *Esequie,* the solemn memorial services held for the master. The Florentine Academy asked the Duke, shortly after Michelangelo's death, for permission to hold these services (March 9, 1564) and decided that the funeral oration should be given by the Academician Benedetto Varchi and that the artistic direction of the solemnities should be in the hands of Bronzino, Vasari, Cellini, and Ammannati—all Mannerists. The Academicians decided to hold this memorial service not in Santa Croce, but in San Lorenzo, the basilica of the Medici family, which contained Michelangelo's chief Florentine work, the Medici Chapel. In the church choir they erected a sumptuous catafalque, designed by Zanobi Lastricati, which is described in the *Esequie* and by Vasari. Two of the preparatory drawings made by Lastricati are still in existence (Munich and Milan), and there is also a painting of the monu- *Vol.* IV, *235,* *236* ment by Agostino Ciampelli in the Casa Buonarroti. The intention was to associate all the artists of Florence with this supreme homage which was rendered to the man whom they had regarded as the highest incarnation of their art (I, 8). The memorial service was held on July 14, 1564, in the presence of the President of the Academy, eighty artists, twenty-five students, and many notables of the city (not present were the Duke, who was out of the city, Cellini, and Francesco da Sangallo). Three funeral

orations by Benedetto Varchi, L. Salviati, and G. M. Tarsia were published in special pamphlets that same year. The purely external pomp, the empty declamatory phrases of the speakers bear witness to the fact that Michelangelo was misunderstood by his younger contemporaries. They admired and deified Michelangelo chiefly as a virtuoso, but remained untouched by his qualities. It was not until the time of Stendhal and Delacroix that these unique qualities of Michelangelo were rediscovered.

II. THE LAST JUDGMENT

General View
260a-271

WHEN we compare the Last Judgment of Michelangelo with earlier representations of the same theme in Byzantium and in the West, we observe that instead of a composition of horizontal zones, symbolizing the hierarchies of heaven and earth according to the cosmological tradition of antiquity, and dominated by the *Rex Gloriae*, the work of Michelangelo represents for the first time a unified dramatic event in which all of the innumerable figures participate. The gesture of Christ finds manifold reflections in the masses of human bodies near him and even in the far distances. The event has not a merely symbolic character as in representations of the Middle Ages, but seems actually to happen before our eyes. And it is the dramatic unity that strikes the beholder.

According to Condivi and Vasari the order of Pope Clement VII was to paint a Last Judgment on the altar wall and the Fall of the Rebellious Angels on the opposite entrance wall of the Sistine Chapel. We do not know when Clement VII commissioned these frescoes. Until now it has been assumed that the order was given during the second half of 1533. In attempting to date it more precisely Dorez and Wilde cite the letter of Sebastiano del Piombo of July 17, 1533, which he wrote from Rome at the behest of the Pope, and they suppose that the sentence "farvi [a Roma] contrato de tal cossa che non ve lo sogniassi mai . . ." refers to the commission of the Last Judgment and the Fall of the Rebellious Angels. These scholars assume that the actual details of the commission were discussed during the meeting of the Pope and Michelangelo at San Miniato al Tedesco on September 22, 1533 (II, 4).

Another source is a report of Agnello of March 2, 1534, referring to a letter of February 20 which speaks not of a Last Judgment but of a *resurrectione* which Michelangelo was to execute on the altar wall above the old altar. "[Il papa] ha tanto operato che ha disposto Michelangiolo a dipingere in la cappella et che sopra l'altare si farrà la resurrectione, si che già si era fatto il tavolato" (II, 5). The scaffolding referred to was thus erected more than one year before the scaffolding for the Last Judgment (April 1535) and two years before the actual beginning of this fresco. Agnello's report is actually a *terminus post quem* for the commission of the Last Judgment. This later date would correspond with the dates concerning the technical preparation of the wall for the actual beginning of the work.

In addition to this, Agnello's report is of great importance because it testifies that the artist hesitated at the beginning in accepting the Pontiff's request (II, 6). Yet the Pope succeeded, as the report also states, in persuading the artist to accept. If the Pope's original commission was to paint a Resurrection of Christ, as Agnello's report seems to state, the final gigantic fresco of the Last Judgment would have stemmed from a rather modest project. This expansion of a primary limited theme into a large com-

[19]

plex one is typical of the unfolding of Michelangelo's cyclic works, such as the Sistine Ceiling, the first two projects of the Tomb of Julius II, and the Tombs of the Medici Chapel. In all these cases the artist, after beginning the project, realized that the result would be a *cosa povera*, and consequently gave it up to embrace a gigantic plan which although essentially new did not completely deny its origin.

As is known, the altar wall had originally been decorated, together with the other walls, in the late fifteenth century and its lunettes were done by Michelangelo at the beginning of the sixteenth century. It is possible to envisage the appearance of this wall before Michelangelo began to work on it. As on the preserved entrance wall, there were four zones, one above the other: at the bottom were painted draperies at each side, and above the mensa-altar was Perugino's fresco representing the Assumption, to which the Chapel was dedicated; in the second zone were two historical frescoes by Perugino, with which the typological cycles on the longitudinal walls began (the Birth of Christ at the right and the Finding of Moses at the left); in the third zone (and at the same height as the windows of the lateral walls) two windows, probably painted like those on the entrance wall opposite; in the corners, two portraits of the first Popes, SS. Linus and Cletus, and flanking a central pilaster two figures, Christ and St. Peter, all represented in painted niches. The two lunettes at the top of the wall were done by Michelangelo while he was decorating the ceiling, and in them were represented the earliest ancestors of Christ. Below the central corbel, finally, there was a coat of arms of the Rovere (II, 7). These horizontal and vertical divisions of the wall into eight main fields lacked unity and therefore did not suit the artistic intentions of Michelangelo.

In 1525 the altar wall seems to have been damaged by the burning of the draperies. It is likely this fire was one of the immediate causes for Clement VII's decision for a new decoration of the altar wall (II, 8). If the damaged parts included the figure of Christ in the third zone as is probable, it would explain the new project of a Resurrection mentioned by Agnello. At this time there was no Resurrection in the chapel, as the original one by Ghirlandaio on the entrance wall had been badly damaged in 1522 when the pediment over the entrance door fell down. It seems iconographically consistent that the Pope would have had executed a Resurrection on the altar wall below the prophet of the Resurrection, Jonas. There is also a liturgical basis for the use of this scheme, because the services which took place in the chapel culminated at the feast of Easter with the Resurrection of Christ (II, 8a).

We may assume that a group of drawings of the Resurrected Christ, which stylistically has to be dated in the mid-thirties of the sixteenth century and the purpose of which could not be explained until now, can be thought of as preparatory studies for the intended Resurrection fresco above the altar. Moreover, these sketches are anticipations of the Christ of the Last Judgment, showing the Apollonian beardless nude figure and in some cases a similar gesture (II, 10). (Also the Resurrected Christ fitted into the true concept of Christ in his second coming.)

[20]

Michelangelo had the earlier decoration of the altar wall just described completely removed and transformed the enormous surface into a single field.

The preparation of the altar wall for the fresco took about a year. The scaffolding for the Last Judgment was put up shortly before April 16, 1535, for it is on this day that the payment to the carpenter, Perino del Capitano, was recorded. The next step was the removal of the old frescoes and cornices (II, 12).

Vasari says that Sebastiano del Piombo, at that time one of Michelangelo's intimates, convinced the Pope that he should have this large composition executed not in fresco but in oils, a procedure which he himself was accustomed to using. Without consulting Michelangelo, Sebastiano gave the order to prepare the wall for oils. Michelangelo let the workers proceed without protest until he was to begin the work, when he declared that oil painting was good only for women and for lazy people like Fra Sebastiano, and gave orders to have the whole plaster coating removed. The accuracy of this story is confirmed by the secret records of the Treasury of the Vatican; on January 25, 1536, in fact, the first plaster coating of the wall was removed (Dorez).

Then Michelangelo had the wall which is about 17 m. high lined with a thin layer of bricks so that it leaned slightly forward, about 28 cm. It is said that Michelangelo ordered this to prevent dust from settling on the future fresco.

The wall was completely prepared according to the *Ricordi* of Michelangelo around April 10, 1536. The artist decided to execute the painting by himself and in fresco. Only his servant Francesco Amatori, called Urbino, assisted him as color-grinder (II, 13). Michelangelo could not have begun the work on the fresco until the period between April 10 and May 18, 1536, according to Dorez (II, 12). By January 1537, the impatient Pope was urging completion of the work, and on February 4, 1537, he made a personal visit to the Chapel (Dorez).

The interest in the fresco was widespread in Italy. On September 15, 1537, Pietro Aretino wrote a letter to the artist in which he gave advice about the *concetto*; but Michelangelo turned it down with the comment that a great part of his work was completed (Milanesi, p. 472). This may well have been a deliberate exaggeration. In a letter to the Duke of Urbino, on November 26, 1537, G. M. della Porta wrote that Michelangelo is "continuamente occupato alla pictura della Capella di Sisto" (Gronau, *J.d.p.K.*, 1906, Bh., pp. 7f). This is also probably an overstatement for if he had been continuously busy the church functions would have been impeded, which was not the case. There seems to have been only one interruption, that of November 1538 (Steinmann). In December 1540, Michelangelo must have completed the upper portion of the fresco since on the fifteenth of this month the carpenter Ludovico was paid for lowering the scaffolding. In this period probably belongs the anecdote by Vasari concerning the visit to the Chapel by the Pope accompanied by the Master of Ceremonies, Biagio da Cesena, who objected to the naked figures and who for this reason was punished by Michelangelo, who made him the Minos in the Last Judgment. Condivi does not relate this story but Steinmann, *Sixt.Kap.* (II, p. 511 n. 4),

points to another source, independent of Vasari (L. Domenichi, *Facetie*, Florence, 1562, p. 242).

According to Vasari three quarters of the fresco was finished when the Pope made this supposedly first official visit. It is not known, however, how far down Michelangelo had finished the fresco when the scaffolding was lowered. We can assume that it had been completed down to the second and main cornice of the lateral walls. Below this the modeling, the colors and the lighting are slightly different. Moreover the composition no longer deals with masses but rather with individual plastic figures (II, 14).

Michelangelo worked on this lower portion for almost another year (II, 16). He mentions the intensity of his work in a letter of August 25, 1541 (Milanesi, p. 167). A few months before its completion an accident occurred: Michelangelo fell down the scaffolding and hurt his leg (II, 15).

The fresco was unveiled on All Saints' Eve, October 31, 1541, on which occasion Paul III personally said a High Mass in the Chapel (*Rep.f.Kw.*, XXIX, p. 398). Three weeks later, on November 19, 1541 (Pog. II, p. 770), the removal of the scaffolding was paid for.

The idea of decorating the small walls of the Sistine Chapel, the wall of the entrance and that of the altar, goes back, as has been said, to Clement VII (Vasari). It may be supposed that the *Fall of the Rebellious Angels* was planned for the entrance wall as a counterpart to the orginally intended Resurrection on the altar wall. The immediate reason for having the entrance wall as well as the altar wall of the Sistine Chapel redecorated seems to have been that both the original frescoes on this wall (The Resurrection by Ghirlandaio and the Struggle of the Archangel Michael with the Devil for the Body of Moses by Signorelli and Gatta) had been destroyed when the pediment of the door had fallen down in 1522 (Steinmann, *Sixt.Kap.*, I, pp. 166 and 516 nn. 3, 4). However, the project for this wall of the Fall of the Rebellious Angels had been probably abandoned when the new project for the altar wall, the Last Judgment, emerged.

Michelangelo's sketches for the Rebellious Angels were executed in painting, according to Vasari, by a Sicilian artist in Santa Trinità dei Monti; this copy was however destroyed in the eighteenth century and no preparatory drawing by Michelangelo for this composition survives. It has been assumed that Rubens' Fall of the Rebellious Angels (Munich, Alte Pinakothek) may reflect it. The flowing movement of the masses is in the spirit of Michelangelo and reminds one of his sketch for the Last Judgment in the Casa Buonarroti. Probably this device appeared first in Michelangelo's sketches for the Fall of the Rebellious Angels, whence he transferred it to his earliest sketches for the Last Judgment (II, 17).

133

[22]

Depiction of the Last Judgment as it developed over the centuries, first in the Near East and from the end of the eleventh century in Italy, derived from a combination of various Biblical passages such as Daniel and Job, the Vision of the Apocalypse, the Gospels, especially that of St. Matthew, and also from the Sermon on the Second Coming by Ephraim the Syrian (+373) (ii, 18).

The earliest Last Judgments in the East and in the West represent the hierarchical order of the macrocosm ruled by Christ. They show in a static equilibrium a composition in horizontal zones dominated by the frontal, enthroned *Rex Gloriae* extending his arms in a symmetrical gesture. Not the action of the Judgment but the eternal justice of the world order is stressed. This pattern has its origin in the cosmological concepts of antiquity (see the Topography of the Cosmas Indicopleustes) and in the triumphal compositions of Imperial Roman art which probably also descends from the ancient cosmologies (Millet, Grabar).

263, 264

The first to change this pattern slightly was Giotto (Padua, Cappella Arena). Although he kept the symmetrical disposition in horizontal zones in the upper section and thereby the hierarchical structure, he timidly suggested an event within this static frame, namely, the institution of the Kingdom of God. Proceeding downward from the feet of Christ is a river of flame which at the right sweeps the Damned into Hell, while on its other side a procession of the Elect, led by the Virgin and Angels, solemnly ascends, apparently to occupy the place left empty by the Damned. The new serene and optimistic outlook of Giotto includes the figure of the Judge, who is—for the first time—inclining his head in the direction of the Elect, inviting them to Paradise. It suggests that Sin will disappear from the world, and only the bliss of the Chosen will remain.

266

From the middle of the fourteenth century, however, pessimism becomes predominant. In Traini's fresco (Pisa, Camposanto) Christ turns toward the sinners and raises his right hand in damnation, baring his wound with the other. Although the artist retains the symmetrical structure in zones, he tries to show the effects of the Judgment. This compositional type found followers in fifteenth century artists, such as Fra Angelico, Bertoldo di Giovanni, Giovanni di Paolo, and Fra Bartolommeo (ii, 18).

267

268-271

With Michelangelo the static zonal structure of the hierarchies was abolished and the dramatic action of the Judgment became all-important. The fresco of Michelangelo marks a turning-point in the iconography of the Last Judgment by introducing a revolving dynamism which unites the earthly and heavenly spheres—a sort of cosmic whirlpool. Even Christ, up to now calmly seated, is shown striding forward in the clouds, summoning humanity from all corners of heaven and earth and magically drawing it towards him. Michelangelo evokes one metaphysical moment, the epitome of the Judgment. He shows one space—that of the universe, rather than separate and unconnected spheres one above the other. He depicts a single naked humanity struggling with the same fate. Saints, Angels, Elect, Damned, form one race of Titans in contrast to the earlier Last Judgments, in which the figures were clearly differentiated,

General View

the Saints by their halos, the Angels by wings, and even the social position of both Elect and Damned, by costume.

In abolishing the traditional Last Judgment type, Michelangelo created a new dynamic unity whereby the event can be experienced in its dramatic entirety for the first time. A study of the *preparatory drawings* for the Last Judgment indicates to some extent the course which the artist took in arriving at his final goal (II, 19).

132
266, 268, 269
The first extant *concetto* of Christ surrounded by the Apostles and Elect (Bayonne, Musée Bonnat) is still connected with the earlier tradition, for Christ as well as the Apostles are seated. Giotto, Fra Angelico, and Fra Bartolommeo represented Christ surrounded by a semicircle of enthroned Apostles. With Michelangelo the semicircle becomes a full circle. By representing all the figures nude he gave an antique aspect to this traditional pattern. The Apostles, all seated on clouds and some looking down to the earth, resemble an Olympian *consilium deorum* debating the fate of humanity. (Although the attribution of the Bayonne sketch is doubtful, the idea expressed therein reverts to Michelangelo.)

133
The first preserved sketch of the whole conception of the Last Judgment in the Casa Buonarroti shows clearly that the artist began by taking the old altar fresco into consideration. The empty rectangular field at the bottom must have been, according to Wilde, the place for the old Perugino altar. Michelangelo's fresco was to surround this altar and serve as a background and frame for it. He was disturbed here by Perugino's conception, which was not of his time and which did not correspond to his personal ideas. Thus, instead of complementing the aforesaid altar, Michelangelo created an independent composition with its own center and relegated the altar to secondary rank. He completely rejected the solution which could have reconciled his composition with the existing altar, that is, the traditional arrangement of several horizontal zones, one above the other, symmetrically distributed about a central axis. He conceived instead a grandiose and dynamic plan. The sketch excludes the two lunettes and also seems to make clear that the artist had not considered using the whole width of the wall. His idea apparently was to set the fresco into painted frames or borders.

The composition in this sketch is surprisingly novel and it has been said that in several respects it is bolder than the final version. The scene is set in a cloudy sky. Christ, seated on a cloud, is the magical center of the dramatic event. His gesture seems to be the *causa efficiens* of the whole drama. This gesture draws up to him the Elect and at the same time catapults the Damned into the abyss. All the movements of the individual figures are consequences of this one gesture. By means of it Michelangelo achieved for the first time in a composition of the Last Judgment a true unity of time and space.

The sources for this new conception in the Casa Buonarroti drawing obviously do

not lie in the monumental tradition. They are found in small representations of the Last Judgment such as medallions and engravings, and above all in Michelangelo's conceptions of ancient myths of punishment.

The structure in horizontal zones was already abandoned in these small Judgments, for example in the medallion by Bertoldo di Giovanni made for Filippo de' Medici 276 (verso) and in the engraving of Cesare Reverdino, which probably dates from the 277 1530's. The influence of the medallion on the fresco has been noticed by Bode (II, 20). Yet the similarity to the Casa Buonarroti drawing seems to be even more striking. Several elements of the medallion correspond to those of this drawing—the damning gesture of Christ, the four small trumpeting Angels below him, and the kind of dais at bottom center which serves as a pedestal for two Angels, one turned in the direction of the Elect and the other in that of the Damned. To this last motif corresponds Michelangelo's use of the top of the old altar frame as a kind of pedestal for two figures, probably Angels, one looking in the direction of the Blessed and the other casting the Damned into the abyss. The circular composition in the medallion also anticipates Michelangelo's curve in the upper section of the drawing.

The artist's attempt to assimilate the traditional figures and groups of the Last Judgment (i.e. Christ in the center, the interceding Virgin, St. John the Baptist, trumpet-blowing Angels, Elect, and Damned) with ancient mythical conceptions seems of even greater importance (II, 21). By conferring upon his Judgment the character of a mythical Greek event, he obviously intended to stress its universal aspect. The nude athletic body of Christ recalls Zeus casting the lightning and is indeed developed 121 from the Zeus in the artist's drawings of the Fall of Phaeton. The connection with Vol. III, 151, 152 the ancient myths of punishment is apparent. The wild assault upon heaven by the Elect and the desperate struggle of the Damned evoke an immediate association with ancient Gigantomachias. The two groups seem to be derived from the Titans' assault of Olympus. In Michelangelo's creation there exists no conflict between pagan mythological form and Christian content.

When we consider the possibility that Michelangelo was working on the Fall of the Rebellious Angels for the entrance wall of the Sistine Chapel shortly before he executed the Casa Buonarroti drawing, it seems quite likely that he had been possessed by ancient mythical conceptions in the earlier project and transferred them to the Casa Buonarroti drawing.

The ascending and catapulting masses of figures were what made the greatest impression on later artists. The Last Judgment by Tintoretto in the Madonna dell'Orto, Venice, reveals, besides the inspirations coming from Michelangelo, a completely different spatial conception. While with Michelangelo surface and space are in an equilibrium and the whole composition is spread out on the surface to reveal only afterwards the spatial values, in Tintoretto the spatial effect is achieved by a tension between a *coulisse* in the foreground and the sharp diagonals which lead the eye into depth. The movement in Tintoretto's canvas does not show the revolving device of

Michelangelo but instead a downward cascading and simultaneously an upward attraction by Christ.

Bernardo Strozzi (Genoa, Palazzo Bianco) also suppressed, under the influence of Michelangelo, the horizontal zones and supplanted them by vertical rising movements. Inspired probably by the Phaeton drawings of Michelangelo he transformed Christ into an Apollo who hurls arrows from his upraised hand. Strozzi's spatial conception also comes from Michelangelo, although he transforms it according to the Baroque concept. The relief-like extension on the surface is pierced in several places, and as a consequence the depth values are augmented. The pessimistic and tragic conception is replaced by a triumphal one—no Damned is visible, only the ecstatic Saints of Paradise. Strozzi's canvas is an Italian counterpart of the large and small Last Judgments of Rubens in Munich to which its composition is also related, the chief difference being that the Italian master keeps to objective representation and does not yet accept the subjective vantage point which is the basis of the Rubens compositions. It may be also noted that the uninhibited flowing movements of the figure masses of the Casa Buonarroti drawing anticipate the Baroque style of Rubens and Strozzi more than does the final version.

133 As we have said, in the Casa Buonarroti drawing Michelangelo had not yet taken into account the full dimensions of the altar wall. Due to its asymmetry this composition would have not been suited for a monumental wall decoration. Michelangelo must have soon thought about eliminating this asymmetry in order to make better use of the surface of the wall. By inserting a corresponding group similar in shape to that of the Elect in the empty space at the right, he could establish symmetry and monumentality. With this purpose apparently in mind he executed the London

139 sketches of the Martyrs and the struggle of the Damned in which the general configuration is similar to the group of the Elect in the Casa Buonarroti drawing. The flowing movements of the masses are also similar.

We may conclude that when Michelangelo decided to suppress the old altar, he thought of a symmetrical composition with a cluster of figures on each side of Christ. In the London sketch the Martyrs are already disposed, as they will be in the final

9 version, in a semicircle and several among them are similar to those in the fresco,

137 an indication that this sketch may be somewhat later than another one in the Uffizi and may be intended to complete the composition of that in the Casa Buonarroti. The idea of the rebellious Damned waging an open battle against the Angels appears

136 for the first time here and in a rapid sketch of the Vatican. Above the Martyrs there is a group of figures coming forward in an arrangement which the artist did not use in the Last Judgment but did use later in the right upper group of the Crucifixion

59 of St. Peter in the Pauline Chapel. In the group of Martyrs, directed movement and organized attack replace the manifold activities of the Uffizi Martyrs. St. Philip and St. Sebastian appear here as they will in the fresco, but St. Catherine and the other Martyrs differ in their poses.

[26]

The sketches for the Resurrection of the Body at Windsor seem to be a further 140 development of the left lower section of the Casa Buonarroti drawing. These are by no means isolated sketches but an early compositional idea for this part of the final fresco. Michelangelo first drew on the left half of the sheet the circular composition about a dominating central motif which is a first *pensiero* for the whole scene. As in the London sketches the drawing again is looser in its composition than the fresco. 14 The artist made at the right of the sheet several further sketches of one of the Resurrected being carried upside down by two or three angels with a devil pulling him back to the grotto of Limbo. In the fresco this grandiose group of interwoven bodies was executed from the right center sketch but with a loss of some of the drawing's dramatic fluid quality.

The rest of Michelangelo's preserved drawings for the Last Judgment which are only a small part of the designs actually executed, do not give a complete picture of the genesis of the compositional idea since they represent individual groups or isolated figures. Their study gives insight into the transformations of single motifs. To these sketches belong the sheet in the Uffizi for the central group, a second sheet in Bayonne 137 for the group at the left of the center, and three rapid sketches in the Codex Vaticanus 138 3211 for an Elect, for the group of the Damned, and for the figure of St. Lawrence. 134-136

In the Uffizi drawing Christ is standing with his left leg forward—no longer seated 137 as in the Bayonne sketch and the Casa Buonarroti drawing. Although the movements of the arms remain approximately the same (right arm damning, left hand showing the wound) they now become even more forceful. The Virgin, kneeling on a cloud, seems to appeal to Christ in passionate intercession and she is here more closely united with the Judge than in the Casa Buonarroti sheet. The group of Martyrs is a step in the direction of the final version, although less developed than the Martyrs of the London sheet. They appear to be using their instruments of martyrdom as weapons, urging Christ to do justice—an idea which corresponds to the text of the Apocalypse and to the mediaeval Roman tradition of the Last Judgment. These martyrs kneel on a kind of "cloud-fortress." Some of them, SS. Philip, Blaise, and Lawrence, anticipate those of the fresco. Also the motif of the Elect embracing each other, which the 9 artist sketched above the Martyrs and which is known in some Last Judgments of the Quattrocento (Fra Angelico, Giovanni di Paolo) appears in the fresco. 270-271

It is possible that it was to complement this fragment of composition with a corresponding group at the other side of Christ that Michelangelo executed the second Bayonne sketch. Although the main figure, seen from the back and holding a cross, 138 directly anticipates the corresponding figure in the fresco (St. Andrew), the other figures are different and recall the urging Martyrs of the Uffizi drawing, which might 137 indicate that at that moment Michelangelo intended to group figures of Martyrs symmetrically on both sides of the Christ-Judge.

After Michelangelo had clarified in such improvised sketches the composition of the whole and the main groups and figures, he executed, we may assume, many

detailed studies of single figures of the fresco, of which only a few have come to us. In these studies Michelangelo drew, apparently from life or from small wax models made from life, poses and movements. He put great emphasis on the anatomical structure of the body, on bones and muscles in motion. He did not, however, lose sight of the unity of the whole body, even when he drew it only in parts (backs, chests, legs, arms, etc.). These studies are richer in anatomical details than the corresponding figures in the fresco. They bear witness to how conscientiously Michelangelo worked, following the typical method of the Renaissance according to which the artist first made general sketches and then had to execute many detailed studies.

145 Among these studies the most important are that for St. Lawrence in Haarlem and
146-148 those for three of the resurrected Dead in London and Oxford.

1 The *fresco of the Last Judgment* is conceived—and this point should be stressed— as an autonomous artistic and spiritual entity (II, 22). It was not intended to be considered as a part of the Chapel's already existing pictorial decorations; it has to be contemplated in itself. Michelangelo's Last Judgment harmonizes artistically neither with the cycles of the lateral walls nor with the artist's own ceiling frescoes. The scales of the figures differ from both the Quattrocento frescoes and the ceiling, and also the plastic and coloristic treatment does not correspond with them. Even iconographically the Last Judgment is not too closely connected with the cycles. It can hardly be considered as a culmination of the program of the earlier frescoes; it was Michelangelo who destroyed, at least partly, the iconographical unity by sacrificing to his Last Judgment the two initial pictures of the Quattrocento cycles and the two lunettes at the top.

Michelangelo did not resort to the usual means of clarifying the relationship between the architectural interior and space in his painting; the latter does not appear as a scene which seems to unfold behind a kind of proscenium. There is no framework or border. The west wall seems suddenly to have disappeared.

However, the master did take into consideration the *spiritual purpose of the Sistine Chapel.* The fresco is intended as a complement to the mensa-altar, located in the center below and before it, and as a spiritual preparation for the believer about to receive the sacrament. The arousing of emotion by this reminder of the cosmic fate of humanity aims at helping make the believer worthy of salvation (see Frey, *Dicht.,* CLX). The Last Judgment is related to the Crucifixion, symbol of mankind's salvation through Christ's sacrifice, and a crucifix stood upon the old altar as can be seen in

Vol. II, 255 the earliest engraving of the Chapel interior by Lorenzo Vaccari (1578). It seems also likely that the grotto Michelangelo represented just above the altar signified Limbo which is here associated with the crucifix and the function of Christ as Savior (II, 23).

The artist also took into account the fact that the Pope was to be the principal

beholder in the Sistine Chapel. There were two main vantage points in the Chapel from which the Pope could observe the fresco; namely, from the papal throne below the Prophet Jeremiah and in front of the second pilaster of the left wall, and from a small secret window that looked out from a little chamber built by Julius II in the first bay of the right wall just below the nude seated figure in Perugino's Baptism of Christ. Here the reigning popes could follow the mass in comfort without being noticed. The small window is still in existence but the chamber has been walled up. The room is mentioned by the master of ceremonies of Julius II, Paris de Grassis (Cod. Corsin. 981, fol. 223; cf. Steinmann, *Sixt.Kap.*, I, p. 559 n. 4). These two points of view most probably explain certain peculiarities of Michelangelo's composition.

When the Pope sat on the throne the compositional "wheel of fortune" was turned away from him. But from the secret window in the opposite side the full impact of the composition would strike the beholder, a fact which explains the slightly asymmetrical deviation employed by Michelangelo (II, 24). It is toward this side that Christ, the figure mass behind him, the Martyrs, and the Damned are turned and it is the true vantage point for the fresco in the Chapel. By orienting his fresco toward the secret chamber Michelangelo succeeded in creating a significant connection between his composition and the purpose of the Sistine Chapel as the Cappella Palatina.

The principle of directing a composition towards one main hidden vantage point occurs also in other works by Michelangelo, for example in the Medici Chapel where only the priest facing the chapel from behind the mensa-altar can take in the entire composition. Later, in the Capitol, the best viewing position is located at the landing of the double staircase of the Palazzo dei Senatori, by which the Senators entered or left (II, 25).

In the *structure of his fresco* Michelangelo was apparently guided by two other *General View* chief concerns: to organize the large wall so that the grouping of the figures with intervals between the groups should enliven the whole surface, and to move the spectator and shock him with the effect of standing not before an illustration but rather in the presence of the events of the Last Day itself.

Michelangelo must have been inspired by the plastic possibilities offered by the surface of the wall: his world of figures seems not to be applied from outside according to an *a priori concetto*, but it seems rather to have slumbered within the wall, as in an enormous monolith from which the artist had only to free and model it. This method is the same as that already described in reference to the Sistine Ceiling and to the reliefs and sculptures where Michelangelo freed the figures from the blocks in which he saw them imprisoned (II, 28).

Since the Quattrocento cornices of the lateral walls project into the surface of the altar wall, Michelangelo made allowance for them in the distribution of the groups. In fact the height of the three horizontal zones of the fresco is determined by the

cornices of the lateral walls (Wilde), without following too rigid a pattern. The central axis of the composition had its origin in the existing corbel, and at each side of this axis the figures are approximately symmetrical: for each group on one side there is usually a corresponding group on the opposite side, and each salient figure finds on the other side an antithetical figure. In the zones Michelangelo seemingly reverted to the zones of the earlier Last Judgment but actually, in his design there is neither hierarchical distinction nor strict separation between the zones. Rather, they lead into one another.

This zonal structure of the work is however subordinated to a novel and dynamic conception. Christ is conceived as a magical central force and circular streams of figures revolve around him. The masses of human bodies form two circles, an inner one around Christ and an exterior one. These two circles are linked together through the figure of *Ecclesia*. Thus, Michelangelo succeeded in reconciling a revolving movement with the "ornamental" requirement of horizontal zones as determined by the cornices. To fill out the lunettes he invented two circular compositions which fit into the archlike outlines and yet are integral parts of the great rotation.

To insure an equal intensity and continuity of the effect on the observer of these revolving movements, Michelangelo partly disregarded normal *perspective*. His fresco has several points of sight, one above the other. There is no *di sotto in sù* for the upper zones of the fresco. This would have emphasized the elements near the spectator and lessened the effect of those farther away. Rather, each zone has its own perspective. The dimensions of the figures in the upper zones are noticeably bigger than those in the lower. By this method, "art corrects the defects of Nature, rendering the farthest parts as sensible to the eye as the nearest" (Chantelou). Moreover, a sort of crescendo is created toward the upper sphere; in the main zone the enlarged figures overflow the limits of the wall. In the contracts for the Piccolomini Altar (1504) and for the Tomb of Julius II (1513) the master had stipulated that the figures at the top should be larger than those at the bottom "because they are farther from the spectator's eyes." Thus enlarged, these forms as they rise above the viewer become more monumental. Only within the individual groups does the artist admit perspective foreshortening. The dimensions of the figures are moreover determined by their objective importance in the drama. The beholder has the impression of seeing "objective reality" as revealed to the spiritual and not to the physical eye (II, 29).

An *aerial perspective* for the ensemble is also lacking. Michelangelo used it only partially in the distance without destroying the effect of plastic solidity of the figures in the first plane. Instead of the neutral background of the Middle Ages or the abstract space of Mannerists, we are conscious of the empty space of the universe. Michelangelo accepts neither the measurable Euclidean space concept of the High Renaissance, nor the irrational and abstract space of the Mannerists. It is the infinite space

of the universe that he evokes not as seen from the earth, however, but from a point outside our world. He thus heightens and surpasses the spatial achievement of the Renaissance by retaining its concreteness and at the same time introducing the infinity of space animated by dynamic currents.

The human figure is conceived by Michelangelo as an organic entity in the manner of Renaissance artists, but he raised it to heroic proportions and avoided any purely decorative treatment of the human body in the fashion of the Mannerists. His work imparts neither the illusionistic image of the Renaissance artists nor the effect of the artificial and arbitrary "figure arabesques" of the Mannerists—he seems to conjure up an ontological reality. In the Middle Ages the infinity of Heaven had been symbolized by a flat, golden or blue background. After Michelangelo, in the seventeenth century, the infinite was suggested through aerial perspective and a real sky filled with clouds and light. Michelangelo stands between these concepts of the mystic and the human. He opens the limitless space of the universe as if seen from another planet, by means of a pale, gray-white sky at the horizon which shades upward into a steady ultramarine blue, and by impressively contrasting this background with the massive plastic, warm brownish bodies of the figures and with the dark hills in the lowest foreground.

The places in which energy accumulates, wherein Michelangelo condenses the figures into tightly knit groups, alternate with empty blue spaces which are the points of calm. These areas complement and balance each other. A rhythm comparable to that of a poem flows through the whole.

The innumerable bodies in the composition seem to be torn along by the whirlpool which rotates about Christ from left to right. The spectator's eye is carried from one group to another, first in the large circle and then into the smaller, ending with the figure of Christ. It is a spiral movement from the periphery to the center from which it then forcefully radiates to the periphery, coming to rest in the diagonals of the Cross and the Column of the lunettes, as well as in the outlines of the ascending Elect and the falling Damned. These diagonals are but the reflections of the four diagonals outlined by the arms of Christ.

Michelangelo must have had, like Leonardo, an intuitive knowledge that the organisms of the microcosm of man and of the macrocosm of the universe are of analogous structure and life rhythm. What is outside in the world is at the same time inside man and the converse of this is also true. So he gave in his Last Judgment, the macrocosm, the organic shape which he derived from the microcosm. The central group around Christ is the "heart of the universe" in and around which flows and from which pulsates all cosmic circulation. As Leonardo had already said "man is the model of the universe."

In his fresco the artist took into account the actual *lighting* of the chapel. He

placed the main figures of Christ, the Virgin, the Apostles, the Prophets, Sibyls, and Martyrs in the best lighted zone, that of the windows. The eye of the spectator is immediately drawn to this zone. Beneath it the natural light becomes gradually dimmer and Michelangelo, inspired by this gradation, progressively darkened the colors of the flesh of the figures. In the main zone and in the lunettes, the flesh color is brown with smoke-colored shadows; in the lower regions it becomes ashen-gray with black shadows. The gradation of the flesh-coloring is emphasized by the following of a contrary pattern in the background: the sky is brightest at the horizon, and becomes darker in the upper zones (II, 30).

There is no strong *light-shadow* contrast which would diminish the effect of the plastic substance of the figures, nor is there a single source of light for the whole composition. The light comes partly from Christ and partly, according to an old workshop tradition, from the upper left. But in the whole the light is diffused and Michelangelo makes use of chiaroscuro only to emphasize the plastic modeling of single figures.

In the Last Judgment Michelangelo renounced the rich range of *colors* of the Sistine Ceiling. He used only two dominant colors, the warm gray-brown flesh color of the nude bodies and the cold ultramarine blue of the air, which becomes at the left bottom grayish-white and shows at the right above Hell reddish reflections of the fire of Hell. Time has altered the ultramarine of the background and probably also the brown flesh colors. A few additional colors are introduced but they are always subordinate to the bichromatic unity of the whole. For example, the Virgin's robe is no longer the traditional cheerful pink-red with a bright blue mantle. The red is transformed into pale lilac and the bright blue into a subdued pale blue with white reflections. These individual colors are partly absorbed in the light, as, for example, the olive-green, the blue, the orange, the rust-red which pales into gray. Also, these spots of color remain isolated and thus cannot enter into the harmony of the whole. At the bottom of the fresco somber tones dominate—gray-blue, charcoal brown, greenish black and ash-gray. The delicate and cool *changeante* tints of the Sistine Ceiling are replaced by a contrast between the opaque and heavy brown of the bodies and the dull blue of the air. Michelangelo's is the first great work to show such reduction of the color range in large scale. The bichromatic color scheme is perfectly suited to its tragic and gloomy content (II, 31).

260a-271 Before Michelangelo, artists had chosen to represent the moment after the Judgment has been given and Humanity has been irrevocably divided into Elect and Damned. In evoking the moment of the arrival of Christ just before the decision, in depicting an imminent event rather than a past fact, Michelangelo succeeded in creating in the spectator a tension of fear. Looking at the fresco, one has the feeling of actually

witnessing the Judgment. To heighten this effect of immediacy Michelangelo left his composition without a painted frame.

In the paintings of the Renaissance where the motif of an arch or portal or window-like frame is employed, the beholder receives the impression that he is in a kind of "atrium" from which he looks out into another world. In spite of the suppression of this usual separating proscenium in Michelangelo's fresco, the beholder has no sensation of being directly included in the world of the painting. This results chiefly from the fact that linear and aerial perspective in the usual sense are lacking and the effect of the whole is that of a relief. Michelangelo evoked an ultimate reality in the chapel instead of merely giving the illusion of an optically perceived world. This seems to be the chief reason for the overpowering effect of the fresco.

An examination of the single groups and figures reveals the power of the creative imagination of the master, the vastness of his thought and of his poetic gift and his astonishing ability to translate them into human bodies. So original is his treatment that his borrowing from literary and iconographic tradition is not immediately obvious and is sometimes overlooked.

The most important and almost the only *literary source* for Michelangelo was the Bible, which he consulted directly. This resolute return to the original source is a new and characteristic feature of Michelangelo's state of mind in old age, in contrast to his free paraphrasing of Holy Writ in the Sistine Ceiling. That Michelangelo read and studied the Bible in a personal way, reported by Vasari and Condivi, may be inferred from his introduction of themes from the Holy Book which had not been used in earlier representations of the Last Judgment. In an original way he combined the Gospels with the Old Testament and the Apocalypse. It is clear that Michelangelo chose for the main scene a passage of the Bible which had not until then been depicted in the form he used, i.e., Matthew 24: 30-31, the *adventus Domini*: the arrival of Christ on the clouds of heaven in the presence of the sudden assembly of *omnes gentes*, all tribes of humanity, instead of the usual enthroned *Rex Gloriae* above people already divided into hierarchical categories (Matt. 24: 31-46). The choice of this scene permitted Michelangelo to visualize the Last Judgment as a drama (II, 33). He may also have consulted Rev. 1: 7 and Dan. 7: 13-14. The unusual representation of the Judging Christ as an Apollo, i.e., the Sun, may have been inspired partially by John 3: 19. The terrified humanity, which also had not been depicted in earlier representations of the Last Judgment, where only the Damned were frightened, seems to have been derived from Isa. 13: 6-9.

Further proofs that Michelangelo reverted directly to the Bible are the motifs in which he deviates from the iconographical tradition in order to follow the Scripture. The motif of the Angels with the Books of Life and Death is unknown to the artistic [12] tradition, but occurs in Rev. 20: 12. When Michelangelo represented seven (or eight)

trumpeting Angels instead of the traditional four mentioned by Matt. 24: 31, he consulted Rev. 8: 2, 6-9 (Vasari and Condivi). Michelangelo could have found inspiration for the trumpeting Angels as personifications of the winds blowing life into the Resurrected in Ezek. 37: 1-9. While pictorial tradition could have furnished models for Michelangelo in certain cases, his preference apparently was to revert to the Bible

14 itself. In the scene of the Resurrected at bottom left, for example, which had been already represented according to Ezek. 37: 1-9 by Signorelli, Michelangelo not only followed Signorelli's fresco, as Condivi testifies, but also the Bible. This becomes apparent in the manner in which he represented the subsequent phases of the resurrection of the flesh from skeletons into bodies. In the floating Elect he seems to have followed St. Paul, 1 Thess. 4: 16-17 (II, 32b).

Beside the Bible, the other supposed literary sources are either of secondary importance or had no influence at all on the master. Although Varchi, Vasari, and Condivi mention the *Divina Commedia* as a source, there are only a few motifs that may possibly stem from it. According to Steinmann, the general disposition of the central group about Christ in a circle is inspired by the heavenly rose in the *Paradiso*, XXXI, 1-3, where Dante says that the Saints are placed like the petals of a rose in Heaven ("in forma di candida rosa / mi si mostrava la milizia santa"). But in Michelangelo's group one can hardly detect a resemblance to a rose—this circular group seems rather to

272, 273 derive from Western imitations of Byzantine examples of the Summoning of the

275 Elect, as in Fra Angelico. Christ's magnetic attraction for the Elect is also mentioned by Dante, *Paradiso*, XXVIII, 127-129. ("Questi ordini di su tutti s'ammirano, / e di giù vincon sì, che verso Dio / tutti tirati sono, e tutti tirano.") But this compositional pattern had already been used, for example, in Leonardo's Epiphany, Uffizi, and it is quite possible that Michelangelo took it from there. Only the motifs of Charon and

15 that of Minos seem to revert directly to Dante (*Inferno*, III, 109-111 and V, 4-6) (II, 32).

Michelangelo was a great admirer and connoisseur of Dante's work (see Giannotti, Varchi, Vasari, Condivi), and it is surprising to see in the single motifs the independence of his imagination from that of the poet. However, Michelangelo's creative method is analogous to that of the poet's: it is proper to say that he created his Last Judgment "a guisa di Dante" as Lomazzo would have said, and not in imitation of Dante. He, too, worked with "illuminating images," as Jacques Maritain calls the poetic metaphors and analogies (II, 34).

The doctrine of justification by faith alone of the *Spirituali* probably influenced three motifs of this fresco, an influence which will be discussed in the following chapter. That there was no direct influence of the *Dies Irae* of Tommaso da Celano on Michelangelo's Last Judgment has been recently proved (II, 32a).

Freed from the didactic schemes of tradition, Michelangelo tried to humanize and dramatize the traditional concepts and to revert directly to the primary source. In the case of Michelangelo's Last Judgment no detailed theological program can be presumed. One of his chief sources was, as has been shown, the Bible. The rigid

didactic system of the Middle Ages is abandoned; the action of the Judge amid the arriving humanity in the cosmic space is the chief theme. Important parallels can be found in Michelangelo's own poetry from which several motifs, which the artist has incarnated in his fresco, shine forth. These analogies are obviously the most reliable single guide to an understanding of the master's thoughts (II, 32c).

Now to what extent did Michelangelo think of *specific persons* in creating the main figures? And according to what principle did he arrange the various groups?

The witnesses of the Christian faith, the Saints, were recognized in certain instances by Vasari and Condivi, who enumerate St. Peter (Vasari), St. Bartholomew (both Vasari and Condivi), St. Lawrence (both), St. John the Baptist (Condivi; Vasari calls this figure Adam), St. Andrew (Condivi), St. Sebastian (Condivi), St. Blaise (Condivi), St. Catherine (Condivi). Condivi also mentions the Apostles and Vasari the Prophets. The rest of the identifications remain generally problematic.

The question of which principle Michelangelo followed in the disposition of the groups in this work was first treated by Thode (*Ma.*, III, 2, pp. 574*ff*). He supposed that their arrangement corresponds to the "choirs" of the Middle Ages: Patriarchs, Prophets, Apostles, *Confessores*, Martyrs, Monks, and Virgins, as they appear, for example, in the hymn *De Omnibus Sanctis* (Daniel, *Thes. Hymn.*, I, 297, 256; II, 26). Thode points out that in art these choirs were represented in such works as the Ceiling of the Cappella Brizio in Orvieto by Fra Angelico and Signorelli. The choir of Martyrs above the Damned is actually depicted by Michelangelo. But according to *9*
Thode the group at the right near Christ would be the choir of Apostles since St.
Peter and St. Bartholomew are there; the group at the left near Christ would be that *17*
of the Patriarchs because of the figure which Vasari calls Adam; that in the back at *16*
the extreme right would be the choir of the Prophets because several figures are *9*
depicted as blind and because of the bearded, aged man whom Thode identifies as Moses; the group in front would be the *Confessores*. In the back at the extreme left there is a group which would be the choir of the Sibyls "because of their fantastic *8*
costumes," and the group in front of them would be the choir of the Virgins. It is therefore, according to Thode, an assembly of all the Saints. However, the identification of the groups remains questionable, except for that of the Martyrs, which was made by the master himself when he added their attributes. The so-called choir of Patriarchs could hardly be placed on Christ's right, and, moreover, the figure which Thode, following Vasari, calls Adam is, according to Condivi, St. John the Baptist, a more likely interpretation, since the figure is holding a skin. Also misplaced would be the figure of St. Andrew if he were to appear next to Adam, as would not be the case if this figure were St. John the Baptist (II, 36).

This neat division of the groups actually contradicts the spirit of the work in which the artist deliberately left many of the figures in anonymity. It should be

stressed again that Michelangelo depicted the *adventus Domini* where, according to the Bible, *omnes gentes* are assembled about Christ. And the artist represented in fact the human race itself *sub specie aeternitatis* from its beginning to its final hour. This humanity is depicted predominantly by anonymous groups pressing about Christ; these massive groups with closed silhouettes express admirably the collective being of mankind. The few historical figures who might be recognized have been chosen from *46,47* all periods of the history of mankind: from Adam and Eve to figures from the Old *48* and New Testaments, figures from the Middle Ages (Dante) and finally to contem- *55* poraries (Michelangelo's self-portrait). All of humanity is present, the notion of time is suspended (II, 36). Probably those figures which press toward Christ are all representative of the Christian era *sub gratia*: the Apostles, the Saints, and the Christian Heroes. The groups of figures which are farthest from Christ and distinctly separated from that group about him would represent pre-Christian humanity (the periods *ante legem* and *sub lege*). This depiction of the past and present of mankind in a simultaneous view was by no means Michelangelo's invention. This mingling of epochs can be found existing in Dante's *Divina Commedia* and in paintings of the Trecento as, for example, in Francesco Traini's Triumph of St. Thomas Aquinas, Pisa, Santa Caterina, where St. Peter and St. Paul, the Evangelists, Plato, Aristotle, and the vanquished Averröes, are present. In paintings of the Quattrocento, artists often represented their patrons and members of their families as assisting in the Holy Scenes (Botticelli, Ghirlandaio, etc.). Here the anachronism is not a true mingling of periods but a translation of the past into the present. It is explained by a tendency to profane the Biblical scenes and to flatter patrons by elevating them to the same rank as the holy personages, who also often have the faces of contemporaries. But with Raphael's *Stanze* in the Vatican the mingling of periods becomes more meaningful. For example, when in the School of Athens, besides Pythagoras, Euclid, Plato, Aristotle, and other sages of antiquity, there appear the great artists of his own time he is trying to unite them in an ideal Golden Age. The Expulsion of Heliodorus from the Temple takes place in the presence of Julius II, the reigning Pope. Through this device Raphael tried to show that the depicted event is not an isolated historical happening of the past, but an ever-present "eternal allegory." Michelangelo, in the upper section of his fresco, links all the periods of mankind's history, representing his contemporaries as subject to the same common fate as the rest of the human race. By including simultaneously representatives of all periods around Christ the master achieved for the first time since the Trecento a true vision of supernatural timelessness.

In the lower zone at the left a livid sky in the pale light of dawn stretches above a *14* ravaged earth which ejects the massive bodies that it has held too long. Some of them *38,39* are breaking through the earth's crust, freeing their bodies, sometimes still skeletal, with great difficulty; others still half-buried wait for the hour of deliverance with an

expression of fear or resignation or a terrible smile on their faces. While some crawl like larvae, others try awkwardly to rise with the aid of angel-genii, only to be pulled *33* downward again by the demons of the earth (II, 53). Some have just begun to soar toward the upper spheres, carried away by their yearning alone. A bearded, tonsured *26, 27* man in the lower left corner, cloaked in a monk's robe, is bringing consolation to a *32* group of sick and exhausted "prisoners of the earth." This is probably the Arch-deacon St. Stephen, who is performing acts of charity (Matt. 25: 25 and Acts 6: 1), as in earlier Roman examples of the Last Judgment, like the thirteenth century panel in the Vatican (II, 52). *265*

Above this zone the law of gravity ceases to have its usual effect. Freeing themselves from terrestrial attraction, the gigantic bodies float awkwardly upward. They are not *10* represented as blessed Elect but as shipwrecked beings who, with swimming movements, try to save themselves from the earth. It is significant that their poses and gestures partly repeat those of the soldiers in the earlier Battle of Cascina (1504), who, *Vol. I, 232* surprised by the enemy while bathing, scramble up the bank of the Arno. The floating bodies in the Last Judgment are raised by the Virtues, which are their special properties, their driving forces. The Virtues, therefore, are enacted—dynamically symbolized—rather than represented, as heretofore, as static allegorical figures holding their traditional attributes. A Negro couple clutch desperately at a long rosary held *25* by a figure which is bent forward and stands on a cloud. The rosary has the appearance of a chain and perhaps the artist meant it as the chain of Faith, *la catena della fede* of which he spoke in one of his poems (Frey, *Dicht.*, CLI). Others are floating unsupported, with eyes closed as in a dream, raised by the invisible wings of their desire (Dante, *Purgatorio*, IV, 28). At the left a figure with his arms half raised and to the *28* right of him two monks are carried by Hope: "dall'infima parte alla più alta / in sogno *27* spesso porti ov'ire spero" (Frey, *Dicht.*, LXXVIII). Finally there are others who are raised by the help of Charity: they grasp the hands of those who have already *24* found support on the clouds and lean down to help the oncoming to safety (II, 54).

In the main zone of the fresco, above a second range of clouds in a sort of ὑπερουράνιος τόπος is assembled an enormous multitude consisting of both sexes, all ages and all times. This is not the traditional assembly of the Elect in Paradise. No *8, 9* face is lighted by an expression of bliss; all are, rather, distorted by fear.

The athletic nude figure of Christ with his youthful beardless face and floating hair *4* is like an ancient Apollo, and this conception was obviously inspired by the Apollo Belvedere. He is in reality somewhat smaller than the framing figures of St. John the Baptist and St. Peter (as in the Byzantine Last Judgments) but he nevertheless domi- *263* nates because, in a sudden appearance, he steps on a higher cloud in the center of an egg-shaped, pale yellow halo. It is the *adventus Domini* on the clouds of Heaven according to St. Matthew. He advances with a powerful stride and raises his right arm in a cursing gesture while with his left arm he seems to reject all supplications. His right arm detaches itself from the silhouette of the body, which stands forth in front

[37]

of the yellow halo. The power of the gesture is emphasized by the shroud which describes a curve around the body and prepares the eye of the beholder for the terrifying effect. Yet Christ's physiognomy does not reflect any rage; with his immobile face and half-closed eyes, he seems an impersonal executor of a higher duty, the Will of God, and not an incarnation of the *dies irae* (II, 38).

It has often been said, and rightly so, that this is no longer the Christ of the Gospels, but rather a divinity of Olympus. This fact has been interpreted as a manifestation of the fundamental paganism of the artist, which also reveals itself in other features such as the Angels without wings, the Saints without halos, the nudity of almost all the figures, the Charon and Minos scene, etc. It is thought to be a striking paradox that the Last Judgment painted for the Chapel of the Popes in the Vatican in fact "celebrates the paganizing of Christian art." But it is in actuality because of this paganized treatment of the forms that the artist was able to express the universality of his concept: the cosmological *Fatum* of humanity. All Michelangelo's work from his earliest efforts deals with this problem of man's relationship to fate. But that he saw fit to express it on the main wall of the Papal Chapel in all its terrifying aspect, is an indication of how unwilling he was to compromise, either as an artist or as a man, with convention and public opinion. Raphael's frescoes executed in the Vatican during the time of Julius II and Leo X had to celebrate the triumphs of the reigning Popes or to depict their periods as a new Golden Age. Although Michelangelo's fresco contains no such flattering allusions, it was nevertheless accepted by the Papal Curia and indicates how the mood of that body changed under Paul III, making possible not only the painting of such an awesome admonition but the acceptance of it as decoration suitable to "elevate the beauty and majesty of the Papal Chapel."

4 The Virgin who is shrinking in fear turns her head away from the Judge, looking downward toward the ascending souls. She is at Christ's immediate right, close to his body and smaller than her Son. Twisted by grief, she withdraws into herself and no longer intercedes actively in behalf of humanity. She too—like Christ—is a kind of synthesis of ancient and Christian concepts. Michelangelo fused Mary with the ancient *284* kneeling Venus. The pose of the Virgin is indeed, as has been observed (Gertrude *283* Coor), an almost exact repetition of the ancient statue of the crouching Venus and Cupid. The best example of the group, of which several copies still exist, is that in Naples, Museo Nazionale. The relationship is substantial: the Venus is looking down at Cupid with love, and this expression of love is exactly what Michelangelo wanted to evoke in his Virgin. The difference, though, is that the profane love of the ancient goddess is transformed, in Michelangelo's Virgin, into the Christian *caritas* and *misericordia*, as Mary looks down at the ascending souls (II, 39).

Justice and Mercy, the two main virtues which were attributed to the Judging Christ and which were usually symbolized by the sword and the lily coming out of Christ's mouth or by allegorical women holding these emblems on either side of the Savior, seem to be incarnated separately here in Christ and in the Virgin. Christ stands for

Divine Justice alone and the Virgin takes on the compassionate role of Mercy. Together the two figures form a unity and seem to embody two qualities of a higher being (II, 45).

These two examples manifest Michelangelo's relationship to antiquity during this phase of his development. The purely archaeological or antiquarian approach to ancient art, which was predominant with his predecessors was of only minor importance to him; he assimilated at once the ancient conceptions. In ancient statuary he recognized the archetypical "ideas" of cosmic powers, which Christian art expressed too, yet not in such universal language.

The fresco is rich in further examples of this creative assimilation of ancient motifs. The relationship between the group of the two heroic women in the left upper zone (*Ecclesia*) and the ancient Niobe group in the Uffizi has been noted long ago. (It is [20] true that the Uffizi Niobe group was unearthed in 1583, that is, around forty years after the completion of the fresco, but the similarity between the two groups is so striking that we have to assume that the artist knew another copy which today is lost.) The protective gesture of Niobe who seeks to hide her daughter in her motherly lap, is certainly equivalent to the protective gesture attributed to Ecclesia, who thus receives the ascending soul. It seems only natural that, in conceiving the latter, the association with the Niobe group presented itself to Michelangelo's imagination (II, 46). Similar is the association between the Angels blowing their trumpets and the ancient [12] wind gods (II, 58).

In the powerful bodies of St. Bartholomew and Dismas Michelangelo paraphrased, [19, 21] as has been observed, the torso of Belvedere—at that time probably the most outstanding example of the dynamic conception of a human body modeled as from within.

The main figures around Christ, the Apostles and Saints, seem, by directing their imploring gestures to him, to try to stop the catastrophe; yet their movements are frozen by fear. St. John the Baptist is holding his hair shirt with paralyzed hands, [16] staring in terror at the Judge (II, 40); St. Peter holds the enormous gold and silver [17] keys of Heaven toward him in the hope of arresting the damnation; and behind him, St. Paul raises both his trembling hands in instinctive recoil (II, 42-43). The attributes of the Saints serve as instruments to arrest Christ's damnation (the keys of St. Peter and the knife of St. Bartholomew) or as instruments which the Saints attempt to hide in order to conceal their sufferings (St. Andrew, close to the Virgin, who is seen retreating and is viewed from the back, may be motivated by *misericordia* in hiding his cross.)

The figure masses at the outer edges are each divided into two groups. Those closer [8, 9] to the beholder seem to be representatives of the *tempus legis*. At the right a group of naked, athletic, seated men dominates and at the left a corresponding group of haggard, exhausted, seated women clothed in idealized garments. Both groups seem to debate the Judgment excitedly, perhaps without realizing its imminence. The group of men may be, as has been supposed, the Chorus of Prophets, or it could represent

Jewish heroes. The group of women may be the Chorus of Sibyls (their clothes remind us of those of the Sibyls of the Sistine Ceiling) but they could also be Jewish heroines. Behind these groups on each side there is a multitude that seems to represent the earliest period of humanity, the *tempus legis naturae*. In the farthest corners of the lateral throngs there are two dominating figures which may represent the primal parents of humanity: at the right side the bearded old man, much larger than the other figures, would be Adam, holding by the armpits as a father would carry his child, another bearded old man, much smaller than he; at the left the aged woman, characterized as the primal mother by her huge pendant breasts, would be Eve. The hypothesis that the old man at the right is Moses is not convincing because his usual attributes, horns or rays of light, are lacking (II, 51). In these same groups, but closer to Christ, one figure stands out on each side. On the right is an old white-bearded man who approaches the central group, seemingly with eyes closed and with faltering step. This could well be Abraham, Father of the Jews with his son, Isaac (Feldhusen). The corresponding figure at the left would then be Sarah, his wife (II, 48). At the right, between Adam and Abraham there are several couples embracing each other. This motif was used by Michelangelo first in the Bayonne drawing. However their embrace is not a joyful expression of the Elect finding each other in Paradise but rather an impetuous clinging together in terror as of the shipwrecked. Other figures have already understood the imminence of the Judgment and they hear the thunder with anguish or they implore the Judge to desist.

At each side a single larger figure in the foreground serves as a link between the period *sub gratia* and the period *sub lege*. At the right is a gigantic young man carrying on his back an enormous cross which is also supported in part by an old man behind him, and which is being kissed by a young woman at the right. This re-enacting of the Carrying of the Cross is analogous to the use which other Martyrs make of their instruments: it prevents the Damned from reaching the Upper Regions. It also explains the fact that the bearer of the cross looks down at the struggling human beings below. There is, however, no vengeance in his expression: the repetition of the Passion of Christ is in itself a reproach to human conscience. The Cross is therefore here a symbol of justice and at the same time a precious relic. It is no accident that Michelangelo combined in this figure motifs from two of his earlier statues: the Dying Slave of the Louvre in the torso and the raised arm and the Victory of the Palazzo Vecchio in the position of the legs. Indeed the carrying of the cross was both slavery and victory. Since it is unlikely that this figure represents a second aspect of Christ as a Man of Sorrows as complement to his depiction as Judge (although we cannot rule out this possibility completely), it is probably Dismas the Good Thief who here recapitulates Christ's passion. Indeed it was a tradition in Byzantium to represent in the Summoning of the Elect Dismas with his cross, at the bottom right (II, 47).

Just as Dismas seems to be a second personification of the main character of Christ as Justice, so the "Niobe group" at the left may be a second personification of the

chief quality of the Virgin, *misericordia*. The shielding and saving of mankind are expressed here by a woman of heroic stature who looks toward the Virgin and receives to her loins a young kneeling woman seeking refuge. It should not be overlooked that in Byzantine paintings of the Summoning of the Elect, there appear at the bottom 272, 273 left Abraham with the Blessed Souls in his bosom. One may well ask whether this heroic woman is not a translation in Christian terms of Abraham's bosom: instead of Abraham it is now Ecclesia who receives and protects a Soul as Niobe too received her daughter. At the other side of the fresco, behind Dismas, the corresponding seated woman would then represent the figure antithetical to Ecclesia, who would be the 21 personification of the Synagogue. Whether it is possible simultaneously to call this group Magdalene Receiving a Woman Who Has Sinned, as certain authors have interpreted it, is of no particular consequence. Michelangelo's essential idea was clearly to express *misericordia*. The disposition of these two figures, Ecclesia and Synagogue conforms to the prescriptions of iconography which place the Church to Christ's right and the Synagogue to his left (II, 46).

Below St. Peter, the Prophets, and Dismas is a group of Martyrs holding the instru- 9 ments of their torture. Plunged into remembering their own terrestrial existence, they mimic with dream-like gestures the fate which they endured on earth. The kneel- ing St. Sebastian, an Apollonian youth, makes the motion of drawing an imaginary 52 bow, repeating the action of his executioners. Yet, instead of the bow, he holds the arrows of his martyrdom in his left hand. St. Blaise, whose head was completely re- 257, 262 painted in the sixteenth century, was originally not looking in the direction of Christ but concentrating on the hackles which he moves with his hands, evoking the gestures of his torturers as they tore away his skin. St. Catherine, who was originally nude and 257, 262 was also repainted in the sixteenth century, seems to repeat the rotation of the broken wheel with iron spikes. St. Simon wields his saw, recalling the martyrdom which he had endured; St. Philip is erecting the cross on which he had been crucified. These martyrs no longer condemn mankind in anger as in the Uffizi drawing. By their very 137 existence these phantoms of conscience become, in the recollection of their martyrdom, a reproach to humanity and hold back the struggling Damned from Heaven. Here it is again apparent that Michelangelo did not want simply to represent the external physical actions of these athletic figures; rather, he used their physical appearance to exemplify purely spiritual conditions. They are "spiriti in carne involti" (Frey, *Dicht.*, CIX, 103). The artist employs Dante's technique of using the forms of the visible world as symbols of the *moti dell'animo* (II, 50).

Below the Martyrs appears the entangled group of sinners—rebellious Titans not 11 submitting to fate but struggling desperately against it. This group, anticipated in the London sketches, has now become the incarnation of the Vices and corresponds 139 antithetically to the group of the Elect saved by their virtues. One may recognize Pride in the rebellious giants in the center and at the left; Avarice, in the figure upside 30 down, with his big money bag and keys; Luxury in the libidinous aged man at the 31

right who is punished by a Demon in the organ of his vice; Despair, probably in those who give up all resistance and let themselves slip down into the abyss (II, 56).

At the bottom, on the lead-colored Acheron, there is a boat with Charon and the Damned. Their group, a dark silhouette, stands before a smoky background that glows with fire. Charon, reminiscent of a satyr, with the bulging eyes of a madman, stands on the gunwales brandishing an oar. This figure might have been, as has been said, inspired by Dante's *Inferno*, III, 109-111; in any case this literary source seems to be closer to Michelangelo's conception than the Charon of Nardo di Cione in Santa Maria Novella or that of Signorelli in Orvieto. The terrified Damned, forming two groups, which illustrate two phases of their movements, hurl themselves howling in horror, as though magically attracted, into Hell. The whole configuration of this group recalls the silhouette of the old fire river which swept away the Damned in Byzantine Last Judgments and in that of Giotto in Padua. Two of the Damned are carried on the backs of winged Demons, a motif which seems to be inspired by Dante (*Inferno*, XXI, 25-36) and by Signorelli's fresco in Orvieto; others are pulled by iron hooks down into the "realm of Minos." In the right lower foreground stands Minos, the triumphant Prince of Hell and here again Michelangelo may have been inspired by Dante (*Inferno*, V, 326) even though with Dante it is the tail of Minos and not serpents which coil around his body. Yet in Etruscan tomb painting (Tarquinia) serpents are attributed to infernal divinities. Michelangelo's Minos, a fat sadist, looks with cruel satisfaction at the unfortunate (II, 55).

The Demons, although anthropomorphic, have faces which sometimes look like those of lions or apes and goats. Studies of the animal passions in man seem to be at the root of such masks. In these studies Leonardo preceded Michelangelo but his creations were to show the analogous effects of passions on man and animals. In the case of Michelangelo perhaps one should recognize in this resemblance between man and animals the Pythagorean idea, taken up again by Plato and Cicero, that the souls of those who during their lives "were full of vices or who violated divine or human laws" were punished after death by being reincarnated in the form of an inferior organism, an animal. It is characteristic of Michelangelo's spiritual-dramatic conception that he suppressed the traditional topography of Hell as he did the traditional Paradise. For him, Hell is in the soul of the self-destroying, passion-dominated figures and in the flowing movement of the two groups which hasten to their own destruction.

Finally, three groups of genii, i.e., wingless angels, two in the lunettes, the third below in the center, link the ascent at the left and the fall at the right, and contribute further to the circular movement of the whole composition. The genii in the lunettes appear as though swept by a storm caused by Christ's sudden appearance. Subordinated to the great revolving movement of the overall composition, they carry at the left the Cross, the Crown of Thorns, the Dice (no longer visible in the fresco but recognizable in the old engravings) and at the right, the Column of Flagellation, the Sponge, and the Ladder—symbols of the Passion of the Lord and witness to the crime of man-

kind. Swept away by whirlpools, the angel-genii cling to the instruments of the Passion like flotsam. And yet their action around the Cross is reminiscent of the Raising and of the Carrying of the Cross, while the figures around the Column evoke in their revolving movement the action of the Flagellation (II, 57).

In the left lunette, the artist accentuated the ascending diagonal with the Cross which continues the upward movement of the Elect; in the right lunette, the Column describes a descending line which is extended into the group of the Prophets at the right. There arises a connection between the Cross, the Column, and the figure of Christ. These first two seem to have been summoned forth by his gesture as reminders of his Passion and Death and they are bound magnetically to this gesture of command in repeating, as has already been mentioned above, the diagonals of the outlines of his arms.

Below the Judge, on a cloud that seems to approach from the depths of space, are angel-genii blowing trumpets to awaken the Dead and others who hold the Books of Life and Death. The book at the left in which are inscribed the good works of the Elect is small; that at the right in which are written the bad works of the Damned is large. Four of the trumpeting angels at the left have the puffed-out cheeks of the ancient personifications of the four winds; they seem to make the effort of resuscitating the bodies by trying to blow souls into them. The four other angels with trumpets at the right side, except for one, do not use their instruments (II, 58). *12*

Below in the center, just above the altar, there is a large grotto, peopled with ape-like demons and troglodyte-like human beings. This grotto has been called the "Mount of Hell," but it is more likely Limbo, for Hell is actually toward the lower right corner. And since the grotto is part of the earth, since souls are raised from it and saved, the assumption that it is Limbo seems to be justified (II, 59). *13* *14*

In summary, Michelangelo's process of invention and realization of the single groups is like that of a poet, since he also works with metaphors and analogies. He does not illustrate the Bible directly but he recreates each scene of the fresco according to a personal, inner experience: so the resurrected are like people suffering from fever, awakening at dawn after the nightmare of their terrestrial existence. The figures floating upward resemble people drifting on the crest of a dream or swimming in an attempt to save themselves from earthly life. The Prophets and Sibyls wait, huddled together as if in fear of an impending storm. The figures in the lunettes cling to the instruments of the Passion like people cast adrift from a wrecked ship, struggling in a swirl of air which resembles whirlpools of troubled waters. The Martyrs defend their own souls as in a dream, brandishing the instruments with which they were tortured. The sinners are rebellious Titans of a gigantomachia; the Damned, demented people who commit suicide; the trumpeting angels form the shape of a cloud *14* *10* *8, 9* *6, 7* *9* *11, 15* *12*

from which winds seem to be blowing, and Limbo (in the lower center) is like a grotto inhabited by troglodytes who resemble gorillas.

Again it should be stressed that the whole is no longer an abstract, geometric arrangement but a nature-metaphor: a cross-section of the space of the Universe in which, above a narrow segment of the Earth's crust, plastic and soft like the body of a woman (*Terra Mater*), the figures ascend like smoke, wafting skyward from small dormant volcanoes (Justi), to condense then into clouds represented in the stage of formation in the second zone; those of the main zone above are already formed into huge storm-clouds through which the "sun," that is Christ, emerges suddenly; and the clouds at the top, in the lunettes, are torn by hurricane winds.

Leonardo had already observed that if one contemplates clouds or a dirty wall for a long time, one may see in their pattern all kinds of figures or even landscapes. It is in this sense that Michelangelo brings out from the configuration of these "clouds" the multitude of figures. Thanks to these nature-metaphors, the artist made it possible for the beholder to participate more directly in the Drama.

Into the great eschatological Drama of humanity Michelangelo inserted, like Dante in the *Divina Commedia*, his personal tragedy. The malediction which comes from the menacing arm of Christ seems to project itself in a diagonal not unlike a bolt of lightning. The eye of the spectator is directed toward this discharge by a slight asymmetry in the upper zone of the fresco which has already been pointed out: the main figures of the two lateral groups of this zone, that of the new Niobe and that of Dismas, emphasize this deviation toward the right, and the two figures sitting at the feet of Christ, St. Lawrence and St. Bartholomew, seem to swerve away from the lightning. It seems to pierce successively the skin which St. Bartholomew holds, the figure of a desperate damned soul below it, and finally the body of the damned soul who throws himself from the boat of Charon into the abyss. The desperate damned, seen in frontal view, is huddled into himself in fear, and is being pulled down by three demons as heavy as lead. His mouth is that of a gorgon mask, his uncovered eye is staring and he is holding his hand before his face in a gesture (already represented in ancient art) of the utmost desperation as if his mind were to realize the dimensions of his terrible fall (II, 61). On the skin held by St. Bartholomew, there is a tragic mask with a grimace of pain: the portrait of Michelangelo himself. It is the artist's empty skin which the Saint holds in his hand (II, 62). One may ask if, in the two other figures below in the path of the lightning, we should not recognize the final phases of the artist's own damnation. Michelangelo, following an Italian compositional pattern, might have incarnated in these two figures successive phases of the same event: the cursed soul leaves his mortal skin in the hand of St. Bartholomew and falls into the abyss. If this interpretation of the artist's depiction of his descent into Hell is accepted, it

is perhaps not too unlikely that the head of the woman enveloped in a widow's veil, appearing just behind St. Lawrence, is that of Vittoria Colonna (II, 63). She is casting ¹⁸ a look of pity upon the tragedy of her friend. This hypothesis would be supported up to a certain point by the following verses of a sonnet which Michelangelo addressed to Vittoria:

> "Dunque posso ambo noi dar lunga vita
> In qualsia modo, o di colore o sasso,
> Di noi sembrando l'uno e l'altro volto;
> Si che mil anni dopo la partita
> Quanto voi bella foste e quant 'io lasso
> Si vegga . . ."
>
> (Frey, *Dicht.*, CIX, 92)

> ("Therefore I can give to us both long life
> In either way, in color or stone,
> And either face shall resemble us;
> So that a thousand years after death
> How beautiful you were and how sad I was
> Shall be apparent. . . .")

One might also suppose that the young man whose profile appears just behind St. Bartholomew and who is a pendant to the woman with the veil, is St. Thomas and ¹⁹ at the same time an image of Michelangelo's friend Tommaso Cavalieri (Thode); hands joined, he seems to pray for the soul of the artist (II, 64). It is known through Vasari (Milanesi VII, p. 271) that Michelangelo drew a portrait of Cavalieri, lost today. On the other hand, the brutal figure of St. Bartholomew, bearing the knife with which he has skinned Michelangelo, shows a strange resemblance, as has already been observed, to Pietro Aretino, who was a real castigator of the artist (II, 44). The Saint has a skull of the same shape, the same nose with large dilated nostrils and the same beard as Aretino's portrait by Titian in the Pitti Gallery in Florence. The correspondence between Michelangelo and Aretino would explain sufficiently the role which the artist reserved for the latter in his fresco (II, 66). On September 15, 1537, Aretino sent a letter to Michelangelo in which he described his conception of the Last Judgment, giving, so to speak, advice to the master working on his fresco. This lively phantasmagoria of the Last Judgment is a masterpiece of pictorial writing of the sixteenth century. Aretino imagines the tragedy of mankind in a landscape with the Anti-Christ and the personifications of the Four Elements of Nature, of Time, of Life and Death, of Hope, Despair, and Fame as the protagonists, and the fearful humanity as a kind of chorus. His vision seems to be inspired by the theater and also by the pictorial concepts of Venetian painting and is diametrically opposed to Michelangelo's sober, dramatico-plastic *concetto*. To this letter, Michelangelo replied in polite but ironic

terms (Milanesi, p. 472). He declared that he regretted not being able to follow Aretino's advice because a great part of his fresco was already finished. Answering Aretino's request as to whether he could write about him, he says that he agrees and even begs ("supplico") Aretino to do so. When he calls Aretino "unico di virtù al mondo," the irony becomes evident. On January 20, 1538, Aretino wrote again requesting, as a recompense for the devotion which he boasted of having for Michelangelo, some of the cartoons which the artist usually threw into the fire: "Cartoons," he says, "which will give me pleasure during my life and which I will carry with me into the tomb." Michelangelo remained deaf to this request. Perhaps when the artist was working on the central part of his fresco, he wanted to "reply" to Aretino by representing him as his executioner in the guise of St. Bartholomew. Aretino renewed his request in April 1544. Almost a year later Michelangelo sent Aretino several drawings, probably with an accompanying letter, today lost. However, Aretino was dissatisfied with the drawings and pretended to be disillusioned, asking for further sketches but Michelangelo did not answer. Finally Aretino in his letter of November 1545 took vengence, giving to Michelangelo a moral lesson and declaring that in the Last Judgment Michelangelo has shown "as much impiety of irreligiousness as perfection in painting," and he exclaimed, "I as a baptized person feel shame at the illicit license . . . which you have taken in expressing your concepts." He finished by saying, "in a bathroom and not in a most holy choir would it have been right to do as you have done." These three criticisms, impiety, illicit license in the iconography, and the inappropriateness of his treatment to the holy place, soon became the basic props of the attacks of the writers of the Counter-Reformation against Michelangelo's Last Judgment. So it happened that one of the most blasphemous men of the Renaissance became the first to unleash the acid criticism of the moralizers of the Counter-Reformation against the Last Judgment of Michelangelo. Aretino's successors, Gilio da Fabriano in the lead, were, however, priests (II, 67). But the cynical Aretino himself did not take his own attack too seriously and was not ashamed five months later to ask Michelangelo for more drawings, "with which you are so generous to the fire and so stingy to me."

The spiritual mentor of Michelangelo, Dante, has been recognized in one of the faces 48 of the chorus of the Elect at the right rear, near the Savior (II, 68).

Attempts by other historians to find portraits of Julius II, Clement VII, and Paul III, in the fresco, seem less convincing (II, 69).

35 Finally, Vasari reports that Minos is a portrait of Biagio da Cesena, Master of Ceremonies of the Vatican, whom Michelangelo consigned to Hell since he had criticized, in the presence of Paul III, his Last Judgment because of its many nudes.

But the personal tragedy and the reminiscences of his own life remain subordinated to, and almost hidden behind, a general conception of the fate of human souls after

death. This would seem to be the most important aspect of the fresco. Michelangelo has not only expressed with unique force an eschatological vision—he did not confine himself to characterizing and to communicating human terror before annihilation—but he has also revealed a *cosmologic-religious vision* (II, 70).

The eye of the spectator plunges into a space freed from all contingencies of place and time: the limitless space of the universe—medium for the free movement of cosmic forces. It is from the Infinite that the forms emerge and mass together. They are magically attracted by the figure of Christ and accumulate thickly around him. *Christ is here the center of a solar system*: around him revolve all the constellations of the universe. It is not by chance that Christ appears here as a young man with a perfect body, beardless and with long, curly hair, so much like Apollo. Antiquity fused the personality of Apollo with that of Helios, giving the former the two opposing powers of the Sun: that of growth and that of annihilation. On the other hand, since the first centuries, Christianity has identified Christ with the sun, and has conferred upon him the properties of Helios: from the *Sol Invictus*, it made the *Sol Iustitiae*. Michelangelo found the idea at hand of fusing Christ with Apollo. The figure of the nude pagan God is a more universal concept than the traditional clothed figure of Christ. And this is possibly the reason that Michelangelo casts the Christian content into the ancient form (II, 71).

Fusions of this kind were not rare at that time. It is enough to recall again a letter by Sebastiano del Piombo to Michelangelo of July 17, 1533, in which he advised the master simply to use his drawing of the abduction of Ganymede by Zeus in the form of an eagle for a representation of St. John the Evangelist being carried to Heaven by his symbol, the eagle; he thought that it would be sufficient to add a halo to Ganymede to transform him into St. John the Evangelist.

The description of the Last Judgment in Matt. (24: 29) is also a cosmic vision. It says that "immediately after the tribulation of those days shall the sun be darkened, and the moon shall not give her light, and the stars shall fall from heaven, and the powers of the heavens shall be shaken." However, Michelangelo follows instead the ancient astral myths, in which the presence of innumerable souls in the sky is a peculiarity. According to them, each soul should rejoin after death its eternal home on its star, and each star has its irrevocably determined place in the great revolving movement of the macrocosmos (cf. Cicero, *De Republica* VI. 13, 13). "For Nigidius Figulus, for Posidonius of Apameus, for Cicero when he follows Pythagoras, for many anonymous people whose epitaphs proclaim their faith, the souls, liberated from the body, rejoin the concentric circles, where the divinity of the aether is moving. . . . The stars which circulate in the aether, all participate in its incorruptible essence and communicate it to all the souls which have been able to ascend to them . . . so the sky palpitates with the innumerable lives of humanity" (Carcopino) (II, 72).

This Pythagorean conception was taken up again during the Middle Ages, by Dante among others (*Paradiso*, IV, 52), who came to know it through the intermediary of the

[47]

Timeus of Plato and who rejects it. That this conception was also known to Michelangelo is proved by one of his poems (Frey, *Dicht.*, CIX, 12): "Ma poi che 'l spirto sciolto / Ritorna alla sua stella. . . ." "But after the spirit is freed, it returns to its star. . . ."

It is perhaps also from Pythagoreanism that Michelangelo took over the idea of the attraction of the Elect by the Sun-Christ ("Sol me rapuit") which explains how the Elect in the fresco ascend without wings, magically attracted by the Christ-Apollo, although this is not the only source of this motif. Pythagoreanism probably also supplies the idea of the degradation of human souls to animals, which had already helped us to explain the partial transformation of the Damned.

Finally, these astral myths, it seems, inspired Michelangelo to insert the revolving movement into his composition. It cannot be explained simply as a compositional pattern (Riegl) (II, 73). It expresses the sidereal whirling of the universe, the idea of which has haunted humanity since earliest times. This fundamental concept can be found in the primitive Bronze Age drawings cut into rock in the form of the "Wheel of the Sun"; it is the basis for the myth of Ixion; it inspired the "Wheel to draw up the souls" of Manicheism, as well as the "Wheel of Life," the "Wheel of Fortune," *278-282* the "Wheels of Transmigration," the "Wheels of the Four Seasons," the "Wheels of the six ages of the world," etc. (II, 74).

In some earlier examples of the Last Judgment the circle appears as well with a cosmic significance, as symbol of the *orbis universus* (II, 75). So it can be seen in the *272* so-called *Dalmatica* of Charlemagne in St. Peter's, in the Roman Last Judgment of the *265,275* mid-thirteenth century in the Vatican, in Fra Angelico's Last Judgment (top center *274* section) in the Accademia of Florence, in a Florentine woodcut, ca. 1480, in which the Zodiac appears in the circle representing the globe of Heaven and in the Byzantine *273* Callings of the Elect. Michelangelo's idea was to transform the static geometric circle into a free-flowing circular movement embodied in figure-masses. It is a representation of the invisible cosmic currents by means of visible bodies. He evoked thereby the laws of the universe and in this he has only Leonardo as predecessor. Both Leonardo and Michelangelo grasped the invisible forces of the macrocosmos, but Leonardo admired in them the aesthetic harmony of the circular and spiral movements of the elements, water, fire, air (II, 76). Michelangelo revealed the tragic dissonance in the struggle between a Titanic human race and the even more powerful whirling movement of the universe. Leonardo looks with the dispassionate interest of the artist-scientist upon the life of the cosmos; Michelangelo with the passion of a religiously impelled being. He is interested in the forces of Nature not in themselves, as Leonardo was, but in their relationship to the fate of the human soul.

Other artists of the sixteenth century, Italian as well as Northern, tried to express the same idea in a different way. They introduced into their compositions of the *279-282* Last Judgment the allegorical images of the "Wheel of Fortune" or the "Wheel of

Life"—a more superficial, but more readily comprehensible method of representation (II, 77). In all these works the law of fate is fused with the idea of Divine Justice.

Michelangelo, however, expressed in his Last Judgment the general laws of the universe with an intensity unknown until then, and without recourse to the superficial allegorical images of his time. His work is not only an eschatological conception, but a prodigious cosmic vision. Man, the son of Earth, formed from its clay, obeys new powers after death. A new age begins for him then—freed from the law of gravity, he enters the realm of the Sun. This is the end of Tellurian rule and the beginning of the Uranian—a pure and direct revelation of cosmic *Fatum*. This may explain the cathartic effect of the fresco which the spectator feels after the first shock is overcome.

By means of the central place which Michelangelo reserved in his composition for the sun (Christ-Apollo) whose magic power determines the unity and the movement of his macrocosmos, the artist came, of himself, to a vision of the universe which, surprisingly, corresponds to that of his contemporary Copernicus. Yet he could not have known Copernicus' book, which was published in 1543—at least seven years after Michelangelo had conceived his fresco. In fact, both men took up the heliocentric concept of the universe which had already been formulated in antiquity (Aristarchos of Samos). But Michelangelo was more radical than Copernicus who, in spite of his heliocentrism, kept the traditional Ptolemaic cosmic structure of a limited universe. Michelangelo abolished the circular spheres and conceived of a free limitless space of the universe filled with revolving energies (II, 80).

The idea of the unlimited space had also been known since ancient times but it was only after Michelangelo that Giordano Bruno (and those who came after him) made of it the nucleus of philosophy and religious conceptions. Bruno expressed this in his *Cena de le Ceneri*, in his *De Immenso et Innumerabilibus* and in his *De l'Infinito Universo e Mondi.*

The importance of Michelangelo's Last Judgment in the development of the European spirit reveals itself fully when one takes into account its cosmologic significance. The two guiding principles of modern times, heliocentrism and the concept of infinite space, are manifest for the first time in his work (II, 79).

———————

In its form Michelangelo's Last Judgment belongs to the High Renaissance, which it surpasses. The idea of integrating into the Last Judgment the ancient myths of Helios and Gigantomachia, the representation of the whole event through naked figures, often in the poses of ancient statues, the insertion within the symmetry of the whole the principle of balanced opposites correspond to the humanistic ideals of the Renaissance. The gloomy, oppressive mood which emanates from this infinite space

and the anticipation by the figures of an imminent catastrophe in the face of which humanity is powerless correspond to the spirit of the Italian Catholic Reformation. If the humanists of the fifteenth century had believed that man is master of his own destiny, their successors—and above all Michelangelo—became aware that he is a puppet in the hands of Fate. The Renaissance symbol of Fortune, governed by man and represented by a human figure at the tiller of a sailboat, gives way again to the mediaeval symbol: the Wheel of Fortune upon which man sits no longer in control of his destiny. And Michelangelo's composition with its revolving movement could be considered an enormous Wheel of Fortune, formed of human bodies (ii, 78).

The Last Judgment of Michelangelo is the sum of his personal religious experience. The artist's intent seems to have been to present the Last Day in all its terror as concrete reality. In its realization the fresco surpasses even this, and raises the beholder to a cosmic-astronomic vision. The event is represented no longer from the divine and not yet merely from the human point of view, but from the point of view of the relationship of cosmic forces to man.

The fact that we are not able to determine the historical place of the Last Judgment with the usual stylistic categories (Renaissance, Mannerism, Baroque) does not mean that Michelangelo stands outside the historical development, but only that our categories are too narrow. The fresco fits into the historical period in which it was conceived; it is actually the period's most representative manifestation. Michelangelo gave voice in the Last Judgment to the anguish and crisis of conscience of mankind at the particular historical moment of the schism in the Christian Church in a particular place, the capital of Christendom. It is this historical reality in a deeper sense which determines the meaning and form of his work, and this is the reason why we are unable to classify it stylistically.

Thus Michelangelo imparts a specific spiritual purpose to his Last Judgment: to stir the conscience of the beholder. The Last Judgment was misunderstood either as the manifestation of a *virtuoso*, who wanted only to show his perfect mastery of the art of representing the naked human body (Vasari, Condivi) or it was recognized as a religious work but as a manifestation of the Counter Reformation (Hettner, Justi), or, on the contrary, as a Protestant sermon (Carrière). In truth it is connected directly with none of these currents but it mirrors the shaking of the religious conscience within the Catholic Church and the reawakening of man's cosmic awareness (ii, 81).

This specific spiritual message of the work explains also why Michelangelo did not try to adapt his Last Judgment to the earlier fresco cycles decorating the Sistine Chapel, and why he conceived it as an autonomous spiritual and artistic entity.

III. MICHELANGELO AND VITTORIA COLONNA

During the years Michelangelo was working on the Last Judgment, he was so much absorbed in the problems of mankind's collective guilt and fate and, at the same time, in his own sense of sin and inevitable punishment that he must have felt an intense need for a spiritual helper to give him a firmer base in his anguished moral struggle and deliver him from his solitude. Therefore, it must have been a fortunate circumstance that he became acquainted just at that time with a great, noble woman, Vittoria Colonna.

Vittoria Colonna herself had suffered much in her youth and she had experienced the same religious crises as Michelangelo, but she had overcome them by retiring from worldly life and had attained a serene and balanced outlook. Thus she was well prepared to understand Michelangelo's state of mind; she was able to bring to the master a human concern, warmth, and a tender goodness for which he felt a deep gratitude. Cloaked with the fascinating prestige of the highest, most ancient lineage and family connections of Italy, she was surrounded and worshiped by the spiritual élite of her day. Her incomparable tact and finesse, her noble bearing, which contemporaries confused with beauty, her profound classical and literary learning, a certain gift as poetess, the noble aims and forms of her life, and the aura which suffering had given her spirit and appearance—all this made of her for Michelangelo the personification of human perfection, or rather the incarnation of almost transcendent qualities for which he longed but which he could not attain alone. Perhaps the magic of this woman's presence, its mysterious radiation, was more important for the master than the actual content of her words, letters, or poems directed to him. It was these indefinable, unreachable qualities that raised him to that state of bliss in which he could overcome his inner difficulties and become able to create again.

Vittoria Colonna was descended from one of the oldest noble houses of Italy (III, 1). Born in 1490, in one of the family castles, Castello di Marino, she was fifteen years younger than Michelangelo. At an early age she was married to Francesco d'Avalos, Marquis of Pescara, but her marriage was not happy: she loved but she was not loved in return. Leading at that time a rather solitary life, she sought the friendship of outstanding humanists and poets like Molza, Castiglione, and later Tasso. Castiglione, in the introduction to his *Cortigiano* (1524), wrote of her as a woman "whose virtue I have always venerated as something divine . . ." (III, 2). At that time she wrote poems inspired by classical authors, especially Ovid. On the death in 1525 of the Marquis of Pescara she renounced the world and retired to convents "to be able to serve God more quietly" ("per poter attendere a servire Dio più quietamente"). She meditated on religious problems and began to write her *Canzoniere Spirituale*, one part of which consists of poems dedicated to the memory of her husband, and the other of religious and moralizing poems. She said: "I write only to free myself from my inner grief." ("Scrivo sol per sfogar l'interna doglia. . .") Her masterwork is not her poetry

but her life itself. The greatness of her personality is found in her profound influence. She was connected with almost all the celebrated men and women of her period (III, 3). She edified all those with whom she came into contact, revealing to them "the solid basis of faith," as Marguerite D'Angoulême, Queen of Navarre, said. "Not only," wrote Cardinal Giberti, "does she surpass all other women, but, moreover, she seems to show to the most serious and most celebrated men the light which is a guide to the harbor of salvation" (III, 4).

But it was Michelangelo who elevated this woman to the rank of Beatrice and Laura, those two great inspirers of spiritual love. While, however, these had to die to be transfigured into angelic beings, into incarnations of Divine Intelligence and Grace in the eyes of their poets, Dante and Petrarch, Vittoria Colonna knew this spiritualization during her lifetime, thanks to the poems of Michelangelo. She is for the artist the instrument of his moral perfection; through her he feels reborn (*rinato*) and his rough soul "of little value" seems to him to be perfected by the virtue of this woman (Frey, *Dicht.*, CXXXIV). She is the bestower of Divine Grace and the mediator between the Divinity and himself (Frey, *Dicht.*, CIX, 82). Michelangelo places her in the heavenly spheres. Her beauty appears to him divine (Frey, *Dicht.*, CIX, 8), her visage angelic and serene (Frey, *Dicht.*, CIX, 46). He asks her aid in climbing the precipitous road which leads up to her, because his own strength is insufficient:

"A l'alto tuo lucente diadema
Per la strada erta e lunga
Non è, Donna, chi giunga,
S'umiltà non v'aggiugni e cortesia:
Il montar cresce, e'l mio valore scema,
E la lena mi manca a mezza via."

(Frey, *Dicht.*, CIX, 76)

One finds in these verses the Platonic *élan* of the earlier poems of the master written to his friend Cavalieri, but purified of sensual elements. The love for woman here appears to be an image of the love for God. This is a religious attitude reminiscent of the love ideal of the High Middle Ages, the philosophical basis of which is the writings of St. Thomas Aquinas (III, 5). This attitude found its supreme poetical expression in the *dolce stil nuovo* of the thirteenth and fourteenth centuries. But, whereas in the Middle Ages spiritual love was considered as an absolute ideal, valid in all circumstances, which could be realized only through an asceticism directed against one's own nature, Michelangelo discovered the value of this feeling at a period in his life when it harmonized with a stage of his inner personal development. The aged master transferred the role of motherhood to Vittoria Colonna: he found in her that tenderness (*pietà superna*) which the child Michelangelo, who lost his mother when he was only six years old, had missed. He also found in her a spiritual mentor

and purifier of his soul. But the fact that Vittoria Colonna played the role of an "ideal mother" is sublimated and almost hidden by the religious adoration in which he held her.

Michelangelo's earlier loves for women are known only through his poems. This poetry shows that he had known passionate love in his earlier years as well as in his maturity and that he suffered because of it. The verses written to the "donna bella e crudele" show that his passion was unrequited (III, 6). Vittoria Colonna was perhaps the first woman to give him sincere friendship. The poems and letters which Michelangelo wrote to the "Alta Signora" or "Divina Donna," as he called her, are written in a humble, reverent tone. He feels himself unworthy (*indegno*) before this admired being. This humility transcends that which is found in the conventional courtly poetry of the sixteenth century—it is an inner attitude and an expression of Michelangelo's real self-abasement in his pride. The artist does not bow before the socially prominent lady, but before the lofty personality.

In some respects it seems that the artist exaggerated the qualities of Vittoria Colonna. Her "divine beauty" was praised many times during her lifetime, not only by Michelangelo, but also by the Petrarchist poets, especially those of Naples. Such praise at that time was a convention owed to every woman of high birth. The rare authentic portraits of the Marchesa show a woman with a high forehead, a long masculine nose, and a somewhat protruding lower lip (III, 7). On the whole, it is an energetic face, which was rightly called a "feminine incarnation of masculine strength." Michelangelo indeed exalts in one of his madrigals this masculine side of Vittoria: "Un uomo in una donna, anzi uno dio / per la sua bocca parla . . ." (Frey, *Dicht.*, CXXXV).

The artist is also, like his contemporaries, full of admiration for the Marchesa's sonnets which a contemporary Pirogallo calls "perfect, and full of precepts and inventions" ("perfetti, e pieni di dottrina e di invenzione"). But one may admit that her talent as a poetess does not exceed that of the average conventional contemporary poetry derived from Petrarch. Her poetry does not express a personal tone and cadence. The metaphors which she uses are generally rather artificial (III, 8). No comparison is possible with the glowing quality of Michelangelo's poems.

It is chiefly through Vittoria Colonna that Michelangelo became acquainted with the most important religious current of this period, the so-called "Italian Reformation" (III, 9). After the death of Savonarola, his disciples continued to fight for an internal reform of the Church, which was the great subject of the Council of Pisa (1511) and of that of the Lateran (1512). Men of intense religious feeling founded the *Oratorio del Divino Amore* with the same intention of renewing the faith. Several members of the Oratorium will later play a role in the movements of the Italian Reformation and Counter-Reformation: Sadoleto, Giberti, Contarini and Carafa, who later became Pope Paul IV. After 1527, the year of the Sack of Rome, the Oratorium of the Divine Love was dissolved and a large part of its members fled to Venice, where they met other outstanding ecclesiastics: Cortesi, Priuli, Pole. In 1535, several

members of this group were created Cardinals under Paul III and constituted the *Consilium de emendanda Ecclesia.*

Meanwhile the movement of the Northern Reformation penetrated to Naples with Juan Valdés (III, 10). Coming from Spain around 1531, he lived in Rome until 1534, then, until his death in 1541, in Naples. Before his departure for Italy, Valdés had been influenced by Erasmus, as has been shown by Bataillon. His creed was based on the sentences of St. Paul: "For by grace are ye saved through faith; and that not of yourselves: it is the gift of God" (Ephesians 2:8) and ". . . a man is justified by faith without the deed of the law" (cf. Romans 3:28). This idea, expressed also by Savonarola in his *Trattato dell'Umiltà,* was the point of departure for the doctrine of justification by faith alone.

A small circle of cultivated men and women from high ecclesiastical and secular society gathered around Valdés. After his death, the Naples group transferred itself to Viterbo, to the cloister of Santa Caterina, where the Cardinal Reginald Pole was dominant. We also find in this Viterbo circle Flamini, Carnesecchi, Vittorio Soranzo, Alvise Priuli, and finally Vittoria Colonna.

The essential point of the creed of this group consisted in its conception of salvation. Valdés and his circle believed in justification by faith alone, independent of works and religious practices. This doctrine is a spiritualization of the dogma of salvation. The accent, placed until then on the material fact of the *infusio gratiae* through the Sacraments and through the priest as intermediary, is placed now on the attitude of the believer's soul in his relation to the Sacrifice of Christ. Grace depends on man's faith. The radical manner in which this doctrine was expressed is attested by a small book, at that time much read in Italy, entitled *Del beneficio di Gesù Cristo crocifisso verso i Cristiani,* published anonymously and written by Fra Benedetto da Mantova (III, 11). In it the following sentence on justification can be found: "The justice of Christ is sufficient to make us the Children of Grace, without any good works on our part; these cannot be good unless we previously make ourselves good and just by faith before executing them, as St. Augustine maintains." At the same time the soul becomes conscious of its powerlessness to save itself through works. It is this pessimistic aspect of the dogma which will play a role in the poems of Vittoria Colonna and of Michelangelo.

Like all the other members of the circle of Valdés, Vittoria Colonna also accepted this doctrine. Some of her poems paraphrase it; for example:

> "Con la croce, col sangue e col sudore,
> Con lo spirto al periglio ognor più ardente,
> E non con voglie pigre et opre lente
> Dee l'uom servire al suo vero Signore."
>
> (V. Colonna, LII)

Another example in which she reaffirms that it is the Will of God that we be saved through faith alone is: "Il Padre Eterno del ciel . . .

Vuol la nostra virtù solo per fede."

(V. Colonna, xxxi)

When Valdés settled in Naples in 1534, Vittoria Colonna left for Ischia and it is not known whether she had an opportunity to meet Valdés personally. If not, she could certainly know his ideas through Ochino, who was spiritual adviser to the Marchesa between 1534 and 1541, or even through Giulia Gonzaga, friend of Vittoria Colonna and ardent disciple of Valdés.

The position of Vittoria Colonna concerning justification by faith alone was defined by Carnesecchi before the tribunal of the Inquisition when he was interrogated in 1566 (III, 12). Carnesecchi said (*Carteggio di Vittoria Colonna*, p. 332): "[Vittoria Colonna] attribuiva molto alla gratia et alla fede in suoi ragionamenti. Et d'altra parte nella vita e nelle attioni sue mostrava di tenere gran conto dell'opere facendo grande elemosine e usando carità universalmente con tutti, nel che veniva a osservare e seguire il consiglio, che ella diceva haverli dato il cardinale [Pole], al quale ella credeva come a un oracolo, cioè che ella dovesse attendere a credere come se per la fede sola s'havesse a salvare, e d'altra parte attendere ad operare come se la salute sua consistesse nelle opere. . . ." This compromise ". . . that she should believe as though only by faith could she be saved and, on the other hand, she should do [good] works as if her salvation consisted of works [alone] . . ." reconciled the external with the internal, the traditional creed with the new ideas. This was also precisely the attitude of Michelangelo.

It is not known precisely in which year Michelangelo became acquainted with Vittoria Colonna but it is supposed that it was in 1536 or 1538 (III, 13). That year Vittoria Colonna lived in the convent of San Silvestro in Capite in Rome, and she usually met Michelangelo on Sundays in San Silvestro a Monte Cavallo, a Dominican convent, where they discussed, among other things, religious problems. These discussions are reported, somewhat freely, by Francisco de Hollanda in his *Four Dialogues on Painting* (III, 14).

Francisco de Hollanda was a young Portuguese painter, who, sent by his king, was traveling in Italy in 1537-1538 and who made the acquaintance of Michelangelo during the latter year. About ten years later (ca. 1547-1549) he wrote the *Four Dialogues on Painting* in which he described the meetings between Vittoria Colonna, Michelangelo, Lattanzio Tolomei, nobleman and nephew of the cardinal of Siena, and himself on three successive Sundays in the small Church of San Silvestro a Monte Cavallo and in the adjacent garden of its cloister. (In the fourth dialogue neither Vittoria Colonna nor Michelangelo took part.) These dialogues, although partly fictional, have the merit of evoking the spiritual atmosphere of the day.

[55]

San Silvestro a Monte Cavallo is located on the slope of the hill of Monte Cavallo near the entrance to the upper gardens of the Colonna. Little remains today of the inner decoration of the church as it was in the mid-sixteenth century. There remain, however, a few works of art which probably adorned the church around 1538, as for instance a sculptured Virgin of the Duecento, severe and frontal in composition, in the second chapel to the right. The door on the left side of the transept leads to the tiny garden of the convent; this is but the remains of the large original garden which extended in the mid-sixteenth century to the foot of the hill. In this period there opened from the garden a splendid view of Rome up to the Borgo—the same view which one still has today from the Quirinale. Such was the setting for the meetings between Vittoria Colonna and Michelangelo.

According to the *Dialogues* of Francisco de Hollanda, the meetings began with commentaries by Friar Ambrosio on the Epistles of St. Paul, after which they discussed chiefly artistic problems. It should be stressed again that the Epistles of St. Paul were the point of departure for the doctrine of justification by faith alone. The artistic theme discussed in the first meeting was the relationship between Flemish and Italian painting; in the second meeting they made up a list of the more important Italian paintings and of the works of Michelangelo. On the third Sunday, when the Marchesa was absent, Michelangelo spoke of the importance of drawing for war strategy and of religious painting in general; they also discussed the appreciation of painting in Spain and Portugal and finally talked about the so-called grotesque ornaments.

In one of his letters to Vittoria Colonna, probably of 1540, Michelangelo wrote: "[Ho] riconosciuto e visto che la grazia di Iddio non si può comperare e che 'l tenerla a disagio è peccato grandissimo." (Milanesi, p. 514) ("[I have] understood and seen that the Grace of God cannot be bought, and that to hold it in disregard is a very great sin.")

In a sonnet to Vittoria Colonna, Michelangelo expresses his doubt on the value of good works:

"Chieggio a voi, alta e diva
Donna, saper, se 'n ciel men grado tiene
L'umil pechato che'l superchio bene."

(Frey, *Dicht.*, CIX, 97)

("I ask you, high and divine lady, to know whether
in Heaven humble sin has less value than
the supreme good.")

In a whole series of poems of the artist's last period one can find the doctrine of justification by faith alone:

"O carne, o sangue, o legnio, o doglia strema,
Giusto per vo' si facci el mio peccato."

(Frey, *Dicht.*, XLVIII)

[56]

("O flesh, O blood, O wood [of the Cross], O
extreme suffering, through you may my sin be
made just.")

Or:

"Tuo sangue, [Signor], sol mie colpe lavi e tochi."

(Frey, *Dicht.*, CLII)

("May your blood alone, [Lord], wash and touch my sins.")

The same idea is expressed again when he says:

"[Signor], col tuo sangue l'alme purghi e sani,
Dal 'infinite colpe e moti umani."

(Frey, *Dicht.*, CLXV)

("[Lord], with your blood you purify and heal souls
From the infinite sins and actions of men.")

(See also: Frey, *Dicht.*, CXXIII.)

In another poem he paraphrases Valdés' idea that good works do not represent a
personal merit, but are only the manifestation of the action of God through the soul
of man.

"Tu sol [Signore] se' seme d'opre caste e pie."

(Frey, *Dicht.*, CLIV)

("Thou alone [Lord] are the seed of chaste and
pious works.")

This concept reverts to St. Augustine and was upheld in the bosom of the Church
itself during the Council of Trent, as Jean Baruzi has shown. One must not attribute
it exclusively to Luther's Reform.

All these verses reveal that Michelangelo knew the doctrine of justification by faith
alone; he has even illustrated this doctrine in the Last Judgment. When Michelangelo
conceived the first project for it (ca. 1534), he did not yet know Vittoria Colonna,
but during the execution of the fresco he became a friend of the Marchesa, whose
spirit left its mark upon the final conception. The influence of the religious ideas of
the *spirituali* also seems evident in some details of the fresco.

In the early projects, in the Casa Buonarroti sketch and the Uffizi sketch, the Virgin *133, 137*
is shown leading struggling humanity toward heaven, and, in her pose and gestures,
Michelangelo still follows the traditional motif of intercession. In the final version *General View*

the artist represents the helplessness of humanity in the face of *Fatum*, and the Virgin no longer intercedes; she clings to herself in fear and looks down with mercy to the struggling Elect. The Saints around Christ who attempt to stop the execution of the Judgment are also helpless before this Judge: their intercession is vain. Here Michelangelo followed the same conception as Vittoria Colonna: we know from the records of the trial by the Holy Office against Carnesecchi that she believed that "the Saints do not intercede," a detail which Lanckorónska has brought out (III, 15).

At the left side of the fresco one sees wingless figures floating upwards, partly without help, as if borne up by ecstasy. Some rise by means of the rosary (i.e. prayer), still others by the charity of their fellows, as described above. It is a slow and difficult ascension, carried out by faith and through the magic attraction of the Christ-sun. This motif of the fresco may be directly inspired by the doctrine of justification by faith alone.

In the group of the Rebellious Damned on the right side we have seen the struggle of the souls who, proud of their own strength, do not believe in the power of God. This explains their abandonment by the cosmic forces. Michelangelo expresses the idea that without faith and without God's help even the most powerful are helpless. This is but another aspect of the doctrine of justification by faith alone.

Thus viewed as a religious document, the final version of the Last Judgment becomes an important expression of the basic tenet of the Catholic Reformation.

In the works of art executed by Michelangelo for Vittoria Colonna between ca. 1538 and 1547, which in part are known to us only through copies, the new religious ideas are expressed chiefly by a transformation of the traditional iconographical types. All these changes contribute to emphasize the sacrifice of Jesus Christ—the crucial point of the doctrine of justification by faith. However, their iconographical innovations are still cast into the forms of the earlier works. The figures still belong to the powerful and almost pagan race of the Last Judgment and do not yet fully harmonize with the new spiritual content.

From the Marchesa's letters it is obvious that she was not able to appreciate the boldness of Michelangelo's style (III, 16). In one of them, written probably in reference to the drawing of the Pietà or the Crucifixion by Michelangelo, she says: "One cannot see a better executed, more lifelike and more finished image." ("Non si può vedere più ben fatta, più viva e più finita imagine.") She especially praises the fact that it is "subtly and marvelously done." She says also: "I have never seen a more finished thing." ("Non vidi mai più finita cosa.") These sentences reveal that Vittoria Colonna appreciated (as Cavalieri had before her) the careful finish of the works of Michelangelo. It must be noted that these works, executed for the Marchesa, as well as those executed before for Cavalieri, are in a somewhat cold, classicizing style. We may conclude from this that Michelangelo made concessions to his beloved's taste. He offered

gifts which he knew would please her. Like Cavalieri before her, Vittoria Colonna had therefore a certain influence even on the style of Michelangelo.

One of the works mentioned in the correspondence around 1540, between the artist and the Marchesa (*Carteggio di Vittoria Colonna*, pp. 206, 208), and also described by Condivi (p. 202), was a *Christ Crucified* "in the attitude of a living being, his face turned toward God the Father, and between two angels" (III, 17). These indications suffice to identify the composition with that of the drawing in London *164* and other copies of a lost original. According to the Renaissance tradition, the cruci- *172* fied Christ was shown already dead. Michelangelo represents him still alive as he was represented in the early Middle Ages. Not, as then, in the attitude of a victor with the royal diadem on his head, but as a sufferer with twisted heroic body and eyes turned toward Heaven, saying, "My God, my God, why hast thou forsaken me?" (Matt. 27: 46). Michelangelo wanted to move the Marchesa by his tragic image of Christ. The two angels, like echoes of this suffering, weep beside him, and one of them points to Christ's wound with his hand. Before Michelangelo, these angels had had the function of collecting the blood of Christ in chalices—they usually did not express the suffering and the greatness of his sacrifice. The idea of showing Christ on the Cross, not dead, but undergoing his agony, becomes understandable if we realize that the intention of the artist was to make palpable the greatness of the sacrifice. Attention may be drawn to the contrast in the gestures of the two hands of this crucified Christ: the right shows the palm with the forefinger pointing upward; the left is partly clenched with the fingers curled downward. This may be an allusion to the old symbolism of the right side as the side of good and the left as the side of evil. Michelangelo prob- ably used this motif for the first time in the drawing made for Vittoria Colonna in which the bar of the cross is horizontal. The artist later used the same distinction in the positions of the hands in his late group of drawings in which the cross is occasionally Y-shaped. One cannot, therefore, draw any conclusion as to a significant connection *225-231* of this motif with a cross of either shape.

In this composition there are empty spaces at bottom to the right and left, giving *164* the impression that it is unfinished. It may be supposed that Michelangelo wanted to complete the composition with the figures of the Virgin and St. John, as may be seen, in fact, in a painted copy attributed to Marcello Venusti in the Galleria Doria in Rome *172* and in contemporary engravings. Two preparatory drawings, probably by Venusti, one of the Virgin and the other of St. John, are in the Louvre where there is, more- *165-168* over, a rapid preparatory sketch, possibly by Michelangelo, for the figure of this Virgin (III, 18).

There exists an alternate version of this composition in which the Virgin, St. John, and the two angels are repeated, but the Christ on the Cross is now dead. Here his head has dropped onto his chest; his arms are extended farther upward; his position is in *contrapposto*, as it was in Michelangelo's earliest Crucifixion in Santo Spirito in Florence. Engravings show the whole composition; the best among them is that of

171 Lafreri of 1568 (III, 19). There is a drawn copy in the Louvre of the Christ alone
338, 339 (Delacre 169) and a miniature in the Missal of Cardinal D'Armagnac of 1549—a
date which is the *terminus ante quem* for this version.

171 Since the outlines of the three main figures of the engraving of 1568 correspond
to the shapes of the three marble blocks in a sketch by Michelangelo in the Archivio
170 Buonarroti (III, 20), we may deduce that the master wanted to execute this concept
in marble figures larger than life size as the dimensions of the blocks are indicated by
Michelangelo. The Crucifixion was to be four braccia high, approximately 2.33 m. and
the figures below the cross three and three-quarter braccia, more than 2.20 m. in
height. The outline of each of the three figures of the engraving fits well into the shape
of its corresponding marble block in the drawing. Although Michelangelo drew the
Virgin's block smaller than that of St. John, they are actually planned to be of the same
height (3¾ braccia each). The reason he drew the left block smaller is that he showed
the group in perspective foreshortening. The point of view of the beholder is shifted
somewhat to the right.

The character of Michelangelo's handwriting in the Archivio Buonarroti sheet
points to the 1540's. It is therefore possible that the idea of making this gigantic
marble group came to Michelangelo on the occasion of the death of his friend Vittoria
Colonna in 1547.

In any case the type of the living Christ with twisted body and head and eyes
pathetically turned upward (i.e. the first version for Vittoria Colonna) became the
prototype of the most important later Crucifixion-type in Italy as well as in the North:
El Greco's Crucifixion in Paris, Louvre, is a reversed version of it; Guido Reni,
Rubens, Van Dyck, and other artists of the seventeenth century followed (III, 17).

Vasari (1568, p. 249) and Condivi (p. 202) mention another composition which
Michelangelo made at the request of the Marchesa: *a dead Christ between the knees
of the Virgin* and supported by two little angels. On the shaft of the cross behind the
group there is an inscription obviously to be attributed to the Virgin, "Non vi si
pensa quanto sangue costa"—a sentence taken from Dante's *Paradiso*, XXIX, 91 (and
there referring to the Spread of the Gospel). Condivi says that the cross resembles
that of the "Bianchi" at the time of the plague of 1348, which was at that time located
in the church of Santa Croce. Condivi seems to have made an error as far as the date
is concerned, since the religious movement of the flagellants called "Bianchi" appeared
in Spring 1399, a year in which there was another outbreak of the plague in North
Italy. The Bianchi wandered from town to town, carrying a crucifix at the head of
their procession, crying out, "Pace e Misericordia," and the male members flagellated
themselves. It is not likely that the Bianchi preferred any particular form of the
cross as one would deduce from Condivi's sentence. The miniatures in the Chronicles
of Giovanni Sercambi, Lucca, Archivio di Stato, representing scenes of the life of the
340 Bianchi, show crosses with a horizontal bar. The print by Bonasone after Michel-
angelo's Pietà shows that the cross was here Y-shaped, yet it had a horizontal bar at

[60]

the top. It is possible that the cross in Santa Croce to which Condivi refers had the same form. That Michelangelo was inspired by the "Croce dei Bianchi" of Santa Croce is not surprising in view of the fact that the artist was at that time greatly concerned with sin and penitence (see his poems), which also played a prominent role with the Bianchi. It should also be borne in mind that Santa Croce was the parish church of the Buonarroti, in the quarter where Michelangelo lived when in Florence, where his family had resided for many generations, and where he bought several houses. Vasari briefly repeated what Condivi had written and in the Life of Marcantonio, mentioned an engraving published by Lafreri and executed by Beatrizet. These descriptions make it possible to identify the composition of which the original as well as numerous copies exist (III, 21). *159, 340-358*

In the undated letter to Michelangelo mentioned above, Vittoria Colonna writes about a drawing, which is probably this Pietà, but it could also refer to the Crucifixion just discussed: "I had the greatest faith in God that He would give you a supernatural Grace to make this Christ: then I saw it so marvelous that it surpassed in all ways all my expectations: then, encouraged by your miracles, I desired that which I now see marvelously fulfilled, that is, that it is most perfect from all sides and one could not wish more, nor come to wish so much." ("Io ebbi grandissima fede in Dio che vi dessi una gratia sopranaturale a far questo Cristo: poi il viddi sì mirabile che superò in tutti i modi ogni mia expettatione: poi facta animosa dalli miraculi vostri, desiderai quello che hora meravegliosamente vedo adempito, cioè che sta da ogni parte in summa perfectione, et non se potria desiderar più, nè gionger a desiderar tanto. Et ve dico che mi alegro molto che l'angelo da man destra sia assai più bello, perchè il Michele ponerà voi Michel Angelo alla destra del Signore nel dì novissimo. Et in questo mezzo io non so come servirvi in altro che in pregarne questo dolce Cristo, che sì bene et perfettamente havete dipinto, et pregar voi me comandiate in tutto et per tutto.") This letter clearly indicates the role of Michelangelo's drawings in the religious life of the Marchesa: she believed the works of the artist to be realized by virtue of Divine Grace and considered them as objects invested with divine forces of a miraculous nature which comforted her in her private devotion.

From a letter of the Bishop of Fano of May 12, 1546, to the Cardinal Ercole Gonzaga, we learn that Cardinal Pole—at that time spiritual adviser to the Marchesa— was willing to give his drawing of Michelangelo's Pietà to Ercole when he learned that the latter wanted it. Cardinal Pole said he would not consider this gift as a loss, since he could procure another copy from Vittoria Colonna (K. Frey, *Q.u.F.*, I, p. 139). Therefore, two copies, both by Michelangelo, must have existed (III, 37).

These two originals seem not to have been identical. The many existing copies form indeed two distinct groups which presumably go back to the two prototypes. The original of the earlier version is, possibly, preserved in a badly damaged drawing in the Isabella Stewart Gardner Museum in Boston (III, 22). It is a black-chalk drawing *159* on paper turned yellow and cut at top and bottom. Originally the whole cross was

visible at the top as described by Condivi. This is a presentation sheet executed with the loving care and soft *sfumato* peculiar to this category of drawings made by Michelangelo for Cavalieri and Vittoria Colonna. The group appears isolated without landscape background: only the rocks emerge in the foreground, forming a kind of pedestal; no horizon is visible. The fluent modeling of the corpse, the inner logic of even the smallest fold, the expressive face of Christ with a broad, firm nose, the dreamy and sad expression of the little angels with half-closed eyes, and the Virgin's face where tragic pain appears without theatrical exaggeration are characteristics of Michelangelo.

354 The original version of the second drawing is lost. The unfinished marble relief in the Museo Cristiano of the Vatican seems to have been made in the workshop of the master, for the "crosshatchings" executed by a toothed chisel represent a technique characteristic of Michelangelo (III, 23). However, the modeling is rather weak. An assistant (though probably neither Pierino da Vinci nor Jacopo del Duca, to both of whom it has been attributed) began this relief and perhaps Michelangelo intended to finish it. In any case a drawing, which is now lost, may be supposed to have served as a model for it.

159 The differences between the two versions are distinct although slight. In the drawing in Boston the hands of Christ hang lifelessly, while in the relief they are stiffly out-
354 stretched and the right hand makes the gesture of benediction. In the drawing, the right foot of Christ is visible behind the left; in the relief it can hardly be seen. The hands of the Virgin are outstretched in a gesture of despair in the drawing but in the plastic copy the fingers are spread in the gesture of an *orante*. The Virgin's foot, which is covered in the drawing, is bare in the relief. The angel at the right is seen in profile in the drawing, but is frontal in the plastic copy and the drapery of this putto is also different. On the one hand all the prints and painted copies derive directly or indirectly from the Boston drawing; on the other, all the reliefs and plaques derive directly or indirectly from the prototype of the Vatican relief.

In the Boston drawing the scene is conceived as a symbolic event: it is not unlike a "mystic wine press" made of human bodies with a rotary movement around Christ; in the relief it is a cult image where Christ is more ostentatiously presented to the beholder. We may conclude that the drawing in Boston is the first version and the relief in the Vatican stems from the second version by the master.

The origin of this composition, curious for a Pietà, can perhaps be best explained as a fusion of two iconographic types: the Virgin with the Child placed between her knees and Christ in his grave supported by two angels (III, 25). In his youth, Michel-
Vol. I, 44, 100 angelo had made such Virgins which suggest that the Child is still protected in the
96 maternal womb as, for example, the Virgin of Bruges and sketches in London and Paris. In the Pietà for Vittoria Colonna, Michelangelo substituted the body of Christ for the Child and added the small supporting angels, which derive from a tradition especially favored in Northern Italy, such as Donatello's relief in Padua, Santo, and paintings by Mantegna and Giovanni Bellini. The resulting group with the vertical

body between the knees of a seated figure and one angel on each side, reminds us at the same time of a Trinity type, for example Dürer's woodcut of 1511 (Bartsch, no. 122), or Agostino Veneto's print of 1516 (Bartsch, no. 40), made after Andrea del Sarto and influenced by Dürer's woodcut. Michelangelo might have felt this resemblance himself since he adapted his later Pietà in the Cathedral of Florence even more to this Trinity type. Looking at this Virgin the beholder is reminded of the words which she is saying in this moment of the Passion, as written in the fourteenth century Franciscan treatise, *Meditazioni della Vita di Cristo*: "E levati li occhi in cielo, con lagrime e con tutto 'l suo affetto disse: Padre eterno, io vi raccomando lo Figliuolo mio e l'anima mia, . . . laquale io lascio co' lui nel sepulcro."

359 360

Michelangelo created in the Pietà for Vittoria Colonna a severe, somewhat stiff, symmetrical composition enclosed in a hexagon, accentuating the upward movement of the Virgin's head and arms in contrast to the downward tendency of the body of Christ. The whole pattern presents a cross built of human bodies repeating in the lines of the Virgin's arms the diagonal bars of the "Croce dei Bianchi" of Santa Croce.

The Pietà which Michelangelo created in his youth for St. Peter's showed a traditional composition: the dead Christ lying on the lap of the Virgin. The accent was placed on the Virgin. In both versions of the Pietà for Vittoria Colonna it is Christ who becomes the focal point of the composition. The Virgin shows her grief in her gesture of despair and seems to evoke the immensity of the sacrifice, and the angel-putti are an echo of this grief. The harmonious, balanced, and organic beauty of the group of the first Pietà of St. Peter's is supplanted by a somewhat artificial composition in the Colonna versions. These are of an abstract symmetry and of an almost geometrical regularity. They are no longer the artistic translation into a plastic group of a concrete and human situation, but religious symbols, diagrams of a doctrine. Since the sacrifice of Christ is a fulcrum of the belief of justification by faith alone, it seems probable that Michelangelo now put the body of Christ vertically in frontal view in the center, to create a visual equivalent of this doctrine.

Vol. I, 30-35

This composition exerted a considerable influence on succeeding generations and had a certain importance for the religious art of the second half of the sixteenth and early seventeenth centuries. The copies made during the lifetime of Michelangelo show the reinterpretation of the master's idea by contemporary artists.

340-358

In the mid-sixteenth century there was a reaction against the softness of Michelangelo's late style, and Beatrizet and G. B. Cavalieri "amended" the model according to an intransigent, crude, and hard plastic ideal. In their engravings, the stiffness of the bodies and drapery as well as the hardness of the rocks, is almost metallic: they remodeled this late work into the style of the young Michelangelo of about 1504 (Battle of Cascina). Simultaneously, other artists like Venusti and Bonasone tried to exploit the pictorial possibilities of Michelangelo's late style. It is characteristic from this point of view that Venusti completed the composition by adding a landscape which is here still a relatively discreet background but which becomes later an im-

341, 342 *346, 340*

portant setting in the hands of the Flemish artist who made the copy formerly in Gotha. Finally, as late as around 1579, Agostino Carracci in his engraved copy assimilated the soft manner of the aged Michelangelo, adding a preference for rounded forms, following those of Raphael and Correggio.

No one, with the exception of El Greco, has understood the religious depth of the expressions in Michelangelo's Pietà for Vittoria Colonna. All the other copyists have interpreted the Virgin as a pathetic actress and have not grasped the beauty of

her lonely, tearless suffering. In his paintings (Philadelphia Museum of Art, and New York, Hispanic Society of America) El Greco has fused Michelangelo's Pietà in the

cathedral of Florence with the Pietà for Vittoria Colonna: from the former he took the general configuration of the compact group in the form of a triangle, the body of Christ and the two supporting figures; from the latter he borrowed the lone Virgin at the summit turned toward Heaven with a sorrowful expression. It is not only the composition which is here inspired by Michelangelo but also the spirit of the group (III, 26).

A further work which Michelangelo executed for Vittoria Colonna is mentioned in one of her letters, July 20, 1541: Vittoria Colonna prays to the Lord that after her return she may again find Michelangelo with the image of Christ in his soul as he had so well represented it in his drawing of the *Samaritan Woman* (III, 27). This work is lost and known only through copies, among which the best seems to be the

engraving by Beatrizet (Bartsch, no. 17). The composition is reduced, as in the other works for Vittoria Colonna, to parallel vertical axes. In the center is Jacob's Well, and behind it a tree marks the central axis; at the right is Christ and at the left the Samaritan woman. Michelangelo followed rather closely the Gospel of St. John (4: 3ff). The tired Christ is sitting on the well and asks the Samaritan woman: "Give me to drink." She is astonished that a Jew would accept water from a Samaritan: "How is it that thou, being a Jew, askest drink of me which am a woman of Samaria? For the Jews have no dealings with the Samaritans." This is obviously a symbol of the new Christian brotherhood of men and at the same time an expression of the immediate relationship of man to God. But it is also the contrast between the "living water" of Baptism, and the stagnant water in Jacob's Well. The gestures of the two figures seem to show that Michelangelo was conscious of this traditional interpretation. This is the contrast between inner faith and external belief. Christ is represented with a similar gesture in the earlier panel by Filippino Lippi, Venice, Seminario (see Scharf, *Filippino Lippi*, Vienna, 1950, fig. 103). A sonnet by Vittoria Colonna (Tordi, *Sonetti inediti di V. Colonna*, Rome, 1891, LXXXIX), which deals with the Samaritan woman is, as has been observed (Wyss), in close relationship to this composition. According to the sonnet: "One should pray in spirit and in truth, and no longer in the ancient temple or on the Sacred Mountain."— ("In spirito et verità doveasi orare, e non più al tempio antico o al Sacro monte.") These verses seem to show that Vittoria

Colonna interpreted this Biblical passage in the spirit of Valdés, that is, that prayer must be made directly and without the Church as an intermediary.

In a *Holy Family* (ca. 1536-1540), called *Il Silenzio*, which may have been executed for the Marchesa, and which is in the same spirit as the other works treated in this chapter, it is again the Child and not the Virgin who is the center of attention. The original of this composition, a large red-chalk drawing, was recently discovered in the collection of the Duke of Portland (III, 28). Asleep on his mother's lap, the Child is the object of the adoration and meditation of the Holy Family: the Virgin, St. Joseph—whose pensive pose reverts to that of the Prophet Jeremiah on the Sistine Ceiling—the little St. John, and two or three angels only lightly sketched in outlines between the Virgin and Joseph, all contemplate the Child as though they had a presentiment of his Passion. In this case, too, the sacrifice of Christ becomes the actual theme. The Child's position reverts to an ancient Cupid type (Harriet Anderson) and recalls also that of the dead Christ in Pietà compositions. Below his body there is an hourglass in a niche—a symbol of transience. Again this is not a historical scene but a symbol of all adorations bestowed upon the Savior.

The prototype of this composition seems to be the lost Madonna di Loreto by Raphael (1512), a copy of which is preserved in the Louvre (III, 29). Here, too, the Child lies before the Virgin, not sleeping but in the moment of awakening. The Virgin is holding a veil above him. This composition was directly or indirectly, perhaps through a lost early version by Michelangelo, paraphrased by Sebastiano del Piombo in his Madonna del Velo in Naples. Here the outstretched Child is sleeping and the Virgin, St. Joseph, and the little St. John are contemplating him. The Virgin lifts the drapery, age-old symbol of revelation. The disposition of the figures in Il Silenzio is very similar to that of this Virgin of Sebastiano made some twenty years earlier and the gesture of her left hand seems directly derived from it. However, this gesture is not motivated by a veil in Michelangelo's Il Silenzio. Should we suppose with Thode that Michelangelo had made an earlier sketch of this composition and given it to Sebastiano whose Madonna del Velo would be a paraphrase of it? Then Il Silenzio could be considered as a second version of an idea of the master, dating from about 1520. A similar *concetto* can be found in Lorenzo Lotto's Virgin with the Sleeping Child and Saints, from 1533, Bergamo, Accademia Carrara, where the Child also has the motif of an ancient Cupid.

Although the *Christ on the Mount of Olives* is not mentioned in the correspondence between the artist and the Marchesa, it is likely that the first version of this also was made for Vittoria Colonna. Judging from their style, the sketches in the Codex Vaticanus 3211 for two of the Apostles of this composition appear to have been made in the mid-forties (III, 30). About seven years later, Michelangelo again appears to have taken up this theme and to have made the sketches on a sheet, today in Oxford, which can be dated approximately on the basis of its stylistic closeness to the sketches for the Pietà Rondanini (III, 31). The definitive composition is also lost and known

158

308

235, 236

237

323 only through copies, among which probably the best one is that by Marcello Venusti.
322 Venusti's preparatory drawing is in the Uffizi and the painting in Rome, Galleria Doria.

Michelangelo here follows Luke 22: 39ff and not Matt. 24: 36ff. The artist uses the mediaeval device of neglecting the unity of space and time, and of representing Christ twice in the same space; at the left he is kneeling in prayer on the Mount of Olives, as he says: "Father, if Thou be willing, remove this cup from me: nevertheless, not my will, but Thine be done." It is, however, important to notice that the chalice and the angel, which should appear in the sky comforting Christ (Luke 23: 43) have been suppressed by Michelangelo. Christ is in complete solitude in his agony as he prays directly to God. The influence of the ideas of the *spirituali* and of Vittoria Colonna once more seems likely. Beside this figure, Christ appears a second time; he has now arisen from prayer and is coming toward his disciples, saying to them: "Why sleep ye? Rise and pray, lest ye enter into temptation." This is the next episode, according to the Gospel. The significance of this scene is made clearer by a sonnet of Vittoria Colonna (V. Colonna, CXXIII), in which the awakening of the disciples becomes the symbol of the awakening of faith in humanity (III, 32).

235-236 As has been said above, the two sketches in the Codex Vaticanus seem to be earlier: in them Michelangelo takes up traditional motifs in the representations of the Apostles —the Apostle reclining like a River God and the motif of the crouching Apostle with his head bent over his knee. The thirteenth century mosaic of San Marco in Venice,
320 Duccio di Buoninsegna's Gethsemane picture in the Opera del Duomo in Siena,
321 Giovanni di Paolo's small panel in the Pinacoteca Vaticana are examples in which these two motifs already occur.

237 Michelangelo's Oxford sheet seems to be later than the Vatican sketches since two of its figures anticipate the final version, known through Venusti's copy.

248 The cartoon of the so-called *Epiphany* in the British Museum in London also has an abstract-symmetrical composition made up of three parallel verticals, reminiscent of the works done for Vittoria Colonna (III, 33).

The Virgin, of heroic stature, is sitting full face in the center of the composition. Below her, and between her legs as if hidden, the Christ Child is sleeping. This is obviously a development of the same idea that Michelangelo expressed in his youth, for example, in the the Virgin of Bruges, in which the Child's position was that of an infant in the womb. In the cartoon, he is in the position of one new-born. The young St. John is approaching and seems to discover the Savior. St. Joseph is standing at the right behind the Virgin. On her other side a young man arrives, probably St. John the Evangelist or, according to Thode, the Prophet Isaiah who predicted the feast of the Epiphany. He makes a questioning gesture to the Virgin, probably asking her where the new Savior is. The Virgin seems to keep the secret to herself and seems also to forbid St. Joseph to answer as she pushes him back. The presence of the Savior is esoteric; he exists only for the initiated—those in whose souls he has been revealed, and does not appear for those who are outwardly searching for him. The

Epiphany of the Lord is here a purely internal revelation. By this conception, Michelangelo gave a new meaning to an age-old iconographical tradition.

This composition may have been executed around 1550, shortly after Michelangelo had finished the Crucifixion of St. Peter in the Pauline Chapel. The figure at the left reminds one of the youthful giant in the right background of the Pauline fresco. Yet *73* the technique seems to be further developed here in the direction of the late spirit- *249, 250* ualized style of the master. The chiaroscuro is gently executed, giving the whole the effect of a vision.

Finally, in the works in which Michelangelo represented the Meditation of Solitary Hermits, he deepened and made more precise his conceptions of the life dedicated exclusively to the contemplation of God.

From this group of works two compositions of *St. Jerome in the Desert* are still ex- *254* tant. The first is a pen drawing in the Louvre with the inscription *Ieronimus Sanctus* appearing twice at the top in the handwriting of Michelangelo (III, 34). The character of the writing is that of his youth. Probably a youthful sketch of ca. 1505-1506 was retouched years later by the master himself. The condition of the drawing is such that it is difficult to pronounce judgment; however, the inscription and certain qualities of draftsmanship speak in favor of Michelangelo's authorship. St. Jerome is naked, kneeling in a lightly sketched grotto, holding the Crucifix in his right and a stone in his left hand. An ascetic penitent retired from the world (like those of Fra Filippo Lippi, Leonardo), this giant has moreover the appearance of a troglodyte, framed by his cave. His head anticipates that of Michelangelo's Moses. His body, of powerful and heavy proportions, seems almost rooted in the earth through his spread knees. Michelangelo imagines him, as a primordial being, who seems to make an effort to hold himself upright—an image of the earthbound misery of man.

Michelangelo later took up this same theme again in a drawing which is today lost and after which Marcello Venusti executed a painting supposedly for the Cappella Mignanelli in Santa Maria della Pace, today also lost (III, 35). Up to now only an engraving by Sebastiano da Reggio, of 1557, has been connected with this compo- *252* sition. It may be mentioned here that the preparatory study of M. Venusti still exists in the Boymans Museum in Rotterdam. St. Jerome is sitting in his grotto but here *251* the theme of penance is transformed into a deep contemplation of the Crucifix, which the saint holds in his hand and arm. He supports his chin with his hand, in the typical pose of melancholy meditation—a pose developed from the Prophet Jeremiah of the Sistine Ceiling. The motif of the position of the legs is reminiscent of the statue of Moses.

In 1548 the *Spiritual Exercises* of Ignatius of Loyola, whom Michelangelo admired, were published. Therein Ignatius treats of spiritual seclusion for the purpose of meditation on the Life, Passion, and Resurrection of Christ. It is not necessary to

[67]

suppose a direct influence—Michelangelo's drawing might have been inspired rather by Vittoria Colonna, ca. 1546-1547—but it is nevertheless interesting to note the analogous conceptions in Michelangelo and in the founder of the Jesuit Order.

This composition, finally, inspired Rubens in his St. Jerome panel of 1608, formerly in Sanssouci, Potsdam (III, 36).

The friendship of Vittoria Colonna and Michelangelo had a common basis in religion. "It was," as Vittoria Colonna said, "bounded by the tie of the Christian knot." Both came from a humanistic, liberal, and highly cultured Catholicism—the Catholicism of the Renaissance. Through the high ethical standards of Valdés, this Catholicism was transformed and became closer in essence to Northern Protestantism, without yet becoming identical with it. On the other hand, it is sharply differentiated also from the militant Catholicism of the Jesuits. The religious influence which Vittoria Colonna exerted on Michelangelo lay precisely in this liberal, deepened Catholicism which was turned toward a reform of the believers' souls and toward the inner reform of the Church.

Both outlived this period. In 1542, with the Inquisition, the Counter Reformation began. From this moment on, the religious development of Vittoria Colonna and Michelangelo went in different directions. Intimidated by the Inquisition, Vittoria Colonna broke with her religious past and followed closely the trend of the Counter Reformation. In her fear of being declared a heretic by the Holy Office, she broke with her friends who became Protestants, like Ochino and Carnesecchi, and even turned over Ochino's letters to the Holy Office. She associated with the Jesuits and Capuchins at the end of her life. Michelangelo, on the other hand, whose soul was fortified by Vittoria Colonna's in the early period of their association, remained faithful to his religious ideas. He was almost the only important representative of this older, liberal, and humanistic Catholicism after the establishment of the Inquisition.

Alone among all the notable personalities of the circle of Valdés, Michelangelo was never bothered by the Holy Office nor constrained to choose between the Church and the Reformation. This privileged position was probably due to the universal admiration for his art and to the fact that he was deemed inoffensive in view of his age and of his relatively solitary life. Nevertheless certain malignant rumors accused him of heresy, as for instance, the well-known letters of Pietro Aretino, mentioned above, and an anonymous letter of March 19, 1549 (Gaye II, p. 500). On the occasion of the inauguration of the Pietà by Baccio Bigio in Santo Spirito, Florence, an exact copy of that of Michelangelo in St. Peter's, this unknown person wrote: "There has been unveiled a Pietà in Santo Spirito which has been sent by a Florentine to that Church, and people said that it had its origin in the inventor of filth, saving the art but not the devotion, Michelangelo Buonarroti. All the modern painters and sculptors

to imitate such Lutheran caprices paint or sculpt nothing else today for the Holy Church . . . than figures to bury [undermine] faith." ("Si scoperse in Santo Spirito una Pietà, la quale la mandò un Fiorentino a detta chiesa, et si diceva che l'origine veniva dallo inventor delle porcherie, salvandogli l'arte ma non devotione, Michelangelo Buonarroti. Che tutti i moderni pittori et scultori per imitare simili caprici luterani, altro oggi per la Santa Chiesa non si dipigne o scarpella . . . che figure da sotterar la fede.") But the Church, as has been said, paid no attention to these denunciations.

Finally, on the subject of Vittoria Colonna, Condivi had heard Michelangelo say that he "regretted nothing so much as that when he went to visit her at the moment of her passing, he did not kiss her forehead or her face, as he did her hand." Shortly after her death, Michelangelo wrote in one of his letters: "[V. Colonna] felt the warmest affection for me and I not less for her. Death has robbed me of a great friend." (. . . la quale [i.e. V. Colonna] mi voleva grandissimo bene, e io non meno a lei. Morte mi tolse uno grande amico," Milanesi, p. 528). Symonds observes that Michelangelo uses here the masculine gender, "uno grande amico" and it may be added that he did so perhaps to emphasize that this was a spiritual and not a physical, although intimate, attachment (III, 38). Michelangelo also composed several poems inspired by the death of this friend among which the most gripping begins as follows:

> "Tornami al tempo, allor che lenta e sciolta . . .
> M'era la briglia e'l freno,
> Rendimi il volto angelico e sereno . . ."
>
> (Frey, *Dicht.*, CXIX)

IV. THE FRESCOES OF THE PAULINE CHAPEL

THE two frescoes of the Pauline Chapel, the Conversion of Saul and the Crucifixion of St. Peter, gave Michelangelo the opportunity to apply his new understanding of macrocosmic forces to specific events. In them he revealed again the cosmological fate of man as shown previously in his Last Judgment.

Michelangelo had not yet finished the Last Judgment when Pope Paul III commissioned him in October, 1541 to decorate his private chapel, newly erected by Antonio da Sangallo the Younger, with two frescoes on the shallow central fields of the lateral walls (IV, 2). This chapel, called Pauline from the name of the Pope's Patron Saint, is situated to the north of the ancient Basilica of St. Peter's and is connected with the south wall of the Sala Regia. Begun probably at the same time as this latter room, in 1537, a mass had already been celebrated in it in January of 1540, which indicates that the chapel was more or less finished at that time (IV, 3).

One of the frescoes was begun at the end of October or beginning of November, 1542 and was probably finished before July 12, 1545. On this date Paul III visited the chapel. In the month of August of this same year the sums necessary for the preparation of the other wall were paid. The second fresco was begun in March 1546. When the Pope again visited the chapel on October 13, 1549, the painting was not yet completely finished. Probably it was in the beginning of 1550 that the final touches were put to it.

The documents do not contain any information on the question of which of the frescoes was begun first, but from the style and composition there is no doubt that the Conversion of Saul on the left wall is closer to the Last Judgment and thus earlier than the Crucifixion of St. Peter on the opposite wall (IV, 6).

The two compositions are conceived as dynamically supporting the orientation of the architecture of the chapel: the movements contained in them are directed toward the altar. This manner of composition, first developed by Michelangelo in the Medici Chapel, will bear fruit in, among others, Tintoretto's two large canvases to the right and left of the choir of San Giorgio Maggiore in Venice and in Caravaggio's two canvases in the Cappella Cerasi in Santa Maria del Popolo in Rome where even the subject matter is derived from Michelangelo.

The choice of the subjects, the glorification of the two Apostle martyrs and founders of the Roman Church, was ideally suited to the decoration of a private chapel of the Pope. What is surprising is that the Conversion of Saul is not opposite a Delivery of the Keys by Christ to St. Peter, but opposite a Crucifixion of St. Peter, which scene should have had its complement instead in a Beheading of St. Paul. Vasari, in his first edition of 1550, still speaks of a Delivery of the Keys, an assertion which he corrects in his second edition of 1568. It is probable that originally Michelangelo intended to

oppose these two subjects. It was perhaps only after having finished the first fresco that he modified the plan (IV, 1). The Conversion and the Martyr Scenes offer two successive stages of an existence dedicated to God. They are conceived not only as historical events but as confessions by the artist. They gave Michelangelo an opportunity to visualize his own conversion and his consciousness of the collective guilt which he shared with all humanity.

The Conversion of Saul

The Acts of the Apostles (9: 1-8; 22: 6-10; and 26: 12-16), tells how Saul, the enemy of the Christians, was transformed into Paul, the Apostle of Christian faith. There is no indication in the Bible that he was a horseman and in fact in the oldest representations of his Conversion no horses had been shown. But since the twelfth century the Conversion had become an equestrian scene: the horse has stumbled and fallen forward and the rider has been vaulted over the animal's head. This was a motif originally used for the depiction of the vice *superbia* and was transposed to the Conversion of Saul, probably to indicate his chief sin. This type was still alive in the sixteenth and in the seventeenth centuries, for example as found in Rubens (Berlin). However, the Florentine Renaissance created another type in which St. Paul, a bearded old man, already has fallen to the ground while a servant attempts to halt his escaping horse. The entourage of the Saint is arranged in an approximate circle about him. Thus we find the scene represented by Benozzo Gozzoli (New York, Metropolitan Museum), by an anonymous Florentine engraver of about 1460-1470, and in Bartolommeo di Giovanni's drawing in the Uffizi, which Michelangelo might have known as H. van Dam van Isselt has pointed out; to this type belongs Raphael's cartoon for the tapestry originally intended for the Sistine Chapel. It is to this tradition that Michelangelo turned, but he transformed the scene completely (IV, 9).

295

296

297

Around the figure of Christ as he issues from the sky float, like satellites about a heavenly body, the wingless angels, magically attracted and yet isolated from him. Christ is seen in foreshortening as he suddenly descends towards Saul, with his right arm extended and his left pointing towards Damascus, the silhouette of which appears in the background of a hilly desert landscape. A ray of pale yellow light falls from his right arm down among the group of soldiers and strikes Saul prostrate. His frightened companions try to flee in all directions without understanding what has happened.

Contrary to the sacred literary tradition, but in line with the earlier Florentine examples (especially Benozzo Gozzoli and Bartolommeo di Giovanni), Michelangelo represented Saul as an old man with a long white beard, not unlike the artist himself. With his mouth partly open, with the closed eyes of a blind man and deep furrows on his forehead, he has the expression of a man who, with terrifying clarity, understands

58

61

in one instant the errors of his life and also the true fate of mankind. Suddenly he becomes a seer in his blindness—a kind of idealized self-portrait of Michelangelo, an incarnation of the moment in which his soul opened to conversion. Beyond the particular event, one feels the absoluteness of the drama between eternal forces and the human being. Necessity appears in the form of the great curve traversing the space. Yet, the final effect is no longer tragic: the colors have not the earthen and sad tones of the Last Judgment but those of a delicate beauty. The tender lilac and the light green of Saul's garments (a harmony of colors which first appears in the lunettes of the Sistine Ceiling), the pale lemon-yellow of the clothing and raspberry-red of the cap of the soldier bending down to support Saul are enframed by the bronze-yellow and black-lilac of the figures on both sides. These colors confer the unreal effect of tapestries upon the fresco. This range of colors seem to indicate a return to the harmonies of the lunettes of the Sistine Ceiling (IV, 10). The plastic forms are enveloped in a delicate chiaroscuro; the execution becomes tender and sensitive.

In the distribution of the figures on the surface, in the clarity of the main lines of the composition, in the logical sequence of the groups, the beholder may recognize the old virtues of Italian fresco painting, heightened here by the introduction of dynamic currents and the strict principle of causality between the heavenly and earthly scenes.

In the Conversion of Saul all the figures move in a restricted foreground behind which extends a vast hilly desert. The figures and the effect of empty space create a tension as in the Last Judgment. The figures live on a surface which is traversed by dynamic currents. The principal figures correspond antithetically at top and bottom and on each side of the composition. The heavenly scene is conceived as the prefiguration of the earthly scene. Saul is a "reflection" of his archetype the Christ, exactly above him; to a frontal figure at the top answers a frontal soldier below; to an angel seen from the back, a soldier seen from the back. Yet the principal figures are also animated by a circular movement which originates in Christ at the top left, touches earth in the curve of the body of Saul and then rises up through the large figure of the soldier at the right with his back to the beholder and finishes with the angel-genii at the top right in the heavens.

Besides the great revolving movement one notices also on the left side of the fresco a movement toward the spectator and on the right side a movement in the opposite direction. The result is that Saul is as if pushed forward to dominate the lower section of the painting. As a point of departure for the eye of the viewer, Michelangelo has introduced the two young soldiers who enter the field of the picture and are cut off at the bottom, beginning a diagonal which is continued by the rearing horse which leads to the angel, seen from the back, and to Christ. Pink, light blue, and lilac are the predominant colors in the soldiers' garments.

The necessity of using curving bodies in this composition led Michelangelo to search out models in certain of his sketches executed earlier for the Medici Chapel:

thus in the pose of Saul, the artist takes up with a slight modification the motif of the River Gods which he had projected for the Medici Chapel—a pose which he had also used for his Venus in the composition Venus and Cupid. The soldier who is protecting his head with his shield has his prototype in one of the soldiers of the drawing of the Resurrection of Christ, London, executed around 1532-3, and the soldier who corresponds to him on the other side and who is seen from the back derives from the soldier at the right in Michelangelo's second drawing of the Resurrection at Windsor (IV, 11).

Vol. III, *61, 267*

Vol. III, *286*

Vol. III, *146*

Vol. III, *145*

In the composition of this fresco, the artist proceeded from the balanced symmetry of the classical pattern. In the Conversion of Saul there are on both sides of the horse, which is in the center and is the apex of a triangle, two groups of eleven soldiers each. But the originally symmetrical pattern is disturbed by the dynamic path of the "thunderbolt" coming down from Christ. The transformation of the classical archetype seems to be effected by this primordial force.

Michelangelo again accentuated the analogy with natural events through artistic metaphors, as when he gave the group of angels the shape of a cloud and Christ the form of the movement of a thunderbolt. As in nature each movement is accompanied by a subordinated countermovement, so we see here, too, a countermovement parallel to the great rotation, which emphasizes its intensity even more. To the magic attraction of the Christ corresponds the centrifugal force which keeps the angels at a distance. The diagonal of the rearing horse is but a faint echo of the violent parallel downward sweep of Christ; the large main curve from the left foreground to the right second plane is answered by a subdued countermovement which is set in motion by the pair of frontal figures at the right and which goes to the pair of figures seen from the back at the left.

64

Although bound from the point of view of composition both in the main curve and in the diagonal, the two figures which are climbing from the foreground and are partly cut by the lower frame seem to be untouched by the event. These are figures from everyday life carrying provisions in sacks on their backs and only partly aware of the drama taking place. They are not conventional *repoussoir* figures which have the function of framing the composition and providing depth; rather they serve to enlarge visually the surface of the painting and to connect the spectator directly with it.

The head of the horse of the Conversion of Saul was recently restored (1953) and another horse's head beneath came to light, a discovery published for the first time by F. Magi (*Ecclesia*, 1953, pp. 584ff), who maintains that it alone is by Michelangelo and that the head which was removed in the restoration was not by the hand of the master. The approximate date of the actual over-painting was not specified by Magi (IV, 12). However, it seems probable to this writer that both heads were by Michel-

66

67

angelo and should be interpreted as two versions; the second was painted over the first, probably to give the horse a more fiery expression. By its profile position, it was more impressive than the first which is almost in three-quarter view. Michelangelo must have made the second version shortly after the first; it cannot be attributed to the painter who later executed some draperies on the angels in the upper zone.

300 There is proof of this in the engraving of Nicolas Beatrizet (Bartsch, xv, 255.33), made before the new drapings were painted but showing nevertheless the second version of the horse's head, and also in a hitherto unpublished mid-sixteenth century draw-

299 ing (Paris, Bibliothèque Nationale, Cabinet des Estampes), in which the draughtsman indicated with darker ink the draperies of the angels, and in which the horse's head is also identical to that of the second version. This drawing is not a copy from the already altered fresco, but a project for the drapery alterations. It was made probably to explain these amendments to the Pope. The proof that it precedes these is to be found in the fact that two of the draperies differ from the final alterations (IV, 13).

In the Conversion of Saul, Michelangelo completes the traditional external conception of this theme by adding a depiction of the internal conversion: as in the earlier paintings of this subject the vision of Christ is still represented, but it is here identified with a cosmic force and for the first time Saul's face reveals the conversion as an event within his soul. He no longer looks upward but appears to be blind and turned within himself, and in this respect Michelangelo's treatment became the prototype for Caravaggio's Conversion of Saul in which, however, the artist goes still further and eliminates the figure of the Christ and the host of angels (IV, 14).

The Crucifixion of St. Peter

According to tradition St. Peter was crucified like the Savior, but head down at his own request since he did not consider himself worthy to suffer the same kind of torture as Jesus Christ. Michelangelo had to conform to this tradition but whereas all his predecessors had followed it literally and represented St. Peter crucified with his head at the foot of the Cross, a position which lessened the effectiveness of the

301 expression of the face (e.g. Stefaneschi altar, Pinacoteca Vaticana; Predella of Masaccio, Berlin; Filippino Lippi, Florence, Cappella Brancacci), Michelangelo found a solution which permitted him to reconcile the tradition with the necessities of artistic expression (IV, 18). With him the Cross of St. Peter is not in the usual vertical

59 but in a diagonal position perhaps inspired by earlier representations of the nailing of Christ on the Cross. The executioners are about to raise the cross and to put the lower end into a hole which is being prepared by a youth. The gigantic body of St. Peter, considerably bigger than the figures around him, is not nailed to the cross in a rigidly straight position as in the earlier examples, but is curved, with the head

68 turned toward the spectator upon whom the Saint fixes his gaze—a gaze that is the

real visual and psychological focal point of the whole composition. The executioners have sad faces as they slowly elevate the cross.

Each of the lateral borders is filled by two groups of figures, one behind the other and also one above another. Those at the left are ascending, at the right descending steps. These movements are connected above by a central group behind the cross and at the lower right by a group of women, thus forming a revolving movement, continued in a spiral by the figures who form a corona around the cross. The individual movement of each figure in the picture is subordinated to the formation of this spiral, which determines their actions so that they become agents of the great revolving movement.

Again the figural scene is spread out in the foreground like a relief and abruptly separated from the landscape of the background, with its rows of bare hills, the placement of which parallels the surface of the fresco. There results a singular transfiguration of the earthly scene into an event which takes place in cosmic space.

In the Crucifixion of St. Peter the point of departure of the composition was a pattern reminiscent of Michelangelo's early Battle of Centaurs: two interlocking triangles, one culminating in the Speaker at the top, and the other an inverted triangle pointing to the Digger. This static structure, however, is almost without effect because Michelangelo inserted the spiral rotation from left to right, a kind of whirlpool which envelops all the elements. It becomes again like a wheel from which there is no escape. *Vol. 1, 3*

There are groups of soldiers at the left, pilgrims young and old of both sexes at the right, and the disciples of the Saint at center top. Again Michelangelo inserted a group, cut at the bottom, the function of which is to create a transition between the beholder and the fresco. These are the four mourning women petrified by fear, two of whom look at the martyr, while the others gaze at the beholder. *69, 71* *73, 70* *74*

The captain of the cavalry, relegated to the second plane at the left, indicates the martyrdom with his right hand but there is no commanding will in his gesture and he is turning as if to ask advice from his neighbors, the nearest of whom has the features of the young Michelangelo (IV, 19). The young disciple in the center just above St. Peter addresses the captain and makes a gesture of astonishment and pleading, seeming to express the sentiments of the whole group. Perhaps he wants to intercede on behalf of the martyr but his companions hold him back through fear and indicate that he should remain silent. From the background at the right arrives a group which has just climbed a hill as if after a long journey through deserted spaces, and which advances toward the scene under the leadership of a young man. Its movement is taken up again in the foreground by another group, at the head of which descends a Herculean old man with his arms crossed and with an expression of deep resignation on his face which recalls that of the old Michelangelo. *69* *75* *70* *73* *72*

No visage expresses hatred, only fear, resignation, and guilt. The event unfolds like the realization of a foreordained destiny. The limits of time and space disappear. The

witnesses come from all points of the horizon and file in an eternal circle past the accomplished crime.

The Apostle Peter, reminding one of the chained Prometheus, is the only one who
68 seems to be fully aware of what is happening. His gaze fixes upon the spectator with a reproachful intensity, revealing the vastness of his suffering for the misery of humanity. As in the Conversion of Saul, this fresco is more than a representation of the historical scene. It is a personal confession of the artist's views about human fate.

But Michelangelo again, as in the companion work, has attenuated the cruelty of the scene by a range of harmonious colors which is likewise a return to the coloring of the Sistine Ceiling. An orange-colored evening sky glows on the horizon above the blue mountains in the background. This glowing sunset sky, inspired perhaps by Venetian paintings of the early sixteenth century, is a pacifying element above the cruel martyrdom. Moreover, the tender moss-green of the ground, the silky discreet bouquet of the figures: light blue heightened to white, soft raspberry-red, pale lemon-yellow (all reminding one of the idealizing colors of Trecento frescoes), the tender *sfumato*, all this supersedes the tragic effect of the scene and sets a serene mood. No tone remains isolated, since even the primary colors, red, blue, and yellow, are softened by a white light which harmonizes them with the whole (IV, 20).

58 The style of the Conversion of Saul, which still showed the elongated figures with open gestures and which was thereby related to the Last Judgment, becomes, in the Cru-
59 cifixion of St. Peter, heavier and more compact. The single figures with closed gestures are enlarged in relation to the surface of the fresco, and the groups are inserted into rectangular blocks with simplified outlines. A minimum of outward movement seems to contain a maximum of psychic emotion. This is the style which appears perhaps
Vol. IV, *47, 48* for the first time in the Rachel and Leah (1545) of the Tomb of Julius II and which will become characteristic of Michelangelo's drawings in the next decade.

The differences between the two Pauline frescoes may be explained in part by the subjects, but chiefly by the development of the artist which goes in the direction of simplification and stereometrization. In old age the tendency in Michelangelo became stronger to see each individual human life and happening only as a metaphor or symbol of immutable natural laws which were for him then the real essence of existence. The more he felt the reality of these laws, the more individual existence became empty for him, and the more the earthly landscape transformed itself into cosmic space. In this direction of the gnosis of the inner structure of the universe the frescoes of the Pauline Chapel are perhaps the extreme limit that he reached.

The Last Judgment and the two frescoes of the Pauline Chapel are the last monumental paintings made by Michelangelo. The technique of the fresco presupposes a promptness of decision and rapidity of execution—a complete spiritual domination by the artist of the subject and a great sureness of hand. Michelangelo was still in

possession of these qualities but after having finished the second fresco at seventy-five years of age he had to give up this technique.

It has been pointed out that the late frescoes of Michelangelo are closely connected to the works of such early Tuscan Mannerists as Pontormo, Rosso, Beccafumi, and it was even supposed that the works of this group directly influenced Michelangelo's Last Judgment and the Pauline frescoes. The crowding of figures in the first plane, the restriction of figural composition on the surface of the painting, and the tension between this surface and the depth of space—this discord is also characteristic of the works of the early Mannerists (H. Hoffmann) (IV, 21). But it should not be overlooked that there is a basic difference in that, with the Mannerists, the position of the figures is still chiefly determined by the ground on which they stand, whereas in Michelangelo, currents of forces determine the relationships of the figures, lifting them out of earthly space and removing them to the dynamic cosmic space. Even in the boldest works of the early Mannerists, each figure acts for itself and in spite of the principle of filling out the surface, the world of the picture remains constructed according to earthbound natural laws. There are lacking the unifying force-currents which in the frescoes of Michelangelo determine the movements. Only in Tintoretto and under Michelangelo's inspiration shall we find again this "planetary" principle of movement in space applied to figural compositions. However Tintoretto uses this principle, not as Michelangelo to represent the tragic destiny of mankind in its conflict with cosmic forces, but to reveal its godlike character in harmony with these forces.

The point of departure of the early Mannerists in their surface composition was actually the new style of the Sistine Ceiling of Michelangelo and came to fulfillment in Barocci at the end of the century. Michelangelo's late frescoes are also developed from the Sistine Ceiling but arrived at their style, apparently independently of the Mannerists, by suppressing the architectonic structure in order to emphasize the dynamic forces alone.

The Cleansing of the Temple

Closely connected with the frescoes of the Pauline Chapel from the point of view of composition are the sketches by Michelangelo for a Cleansing of the Temple. It is a kind of synthesis of the two Pauline compositions and may have been done around 1550. Only these preparatory sketches and copies survive (IV, 25). It is also not known to what end he prepared the sketches.

Michelangelo followed the Gospel (Matthew 21: 12-13), but at the same time the theme was an allusion to the inner reformation of the Church and the purification of souls, a theme which at that time, as we have seen, was much discussed by the enlightened minds of Italy. This meaning Marcello Venusti understood in his copy in London when he identified the Temple with St. Peter's. Indeed he set the scene in

241 to 247

317

[77]

an architecture with spiral columns inspired by the so-called column of Solomon, still in St. Peter's. It is therefore the symbol of the cleansing of the Church.

In the earlier representation of this scene, e.g., by Giotto, Christ is already in the center and on both sides of him two symmetrical groups of merchants are represented. However, the movement of Christ and of the money-changers conforms to the picture surface. Michelangelo's first compositional pattern with Christ seen from the side *242, 243* is in this tradition, but in the second and final version, of which there exist also several variants and which show Christ frontally, he inserted a semicircular movement *244-246* reminiscent of that of the Pauline frescoes. At the right side this movement recedes and after describing a half-circle behind Christ, comes out into the left foreground. This whirling movement appears as a consequence of Christ's gesture in raising his arm to strike the merchants—a gesture which is not without similarity to that of the *246* Christ of Michelangelo's Last Judgment. However, by the time of the last version of the Cleansing of the Temple this gesture has lost its dramatic violence. Without effort Christ expels the merchants, by his simple presence, as light drives away shadow. The revolving movement around Christ constituted by the figures near him is seconded by the movement of the figures in the outer row which open fanlike giving the whole group the silhouette of a segment of an arc. One may ask whether Michelangelo did not perhaps intend this scene for the lunette of the entrance wall of the Pauline Chapel.

The succession within this group, which leads to the final version and to Marcello Venusti's copy, can still be followed approximately. The first version seems to be No. *242, 241* 230 to which belongs also the Oxford drawing (No. 211); the second step is No. 231 *245, 242, 247* and the two fragments of a composition in No. 230 and 234; the final version—which *246, 317* was copied by Marcello Venusti—is No. 235, which is really a synthesis of No. 230, *244* left group, No. 233, and No. 234. Designed on six pieces of paper and pasted together, it contains all the chief motifs: the massive figure of Christ ready to strike; the giant, muscular figure of a nude money-changer seen from the back with his overturned table; a smaller rectangular table at the left; one woman with a basket of fruit and another with a basket of pheasants on her head; several figures with assorted containers; one figure with a sack behind his head.

This impressive *concetto* inspired two celebrated later treatments of the subject, *318* that of the youthful El Greco (of which six versions survive), who took over and *319* reduced the rotary movement around Christ, and that of Rembrandt in his etching of 1635 (Bartsch, no. 69). The latter borrowed several motifs from Michelangelo and took the figure of Christ from Dürer's small woodcut Passion (Bartsch, no. 23). He integrated them in a Baroque diagonal composition with rich contrast of light and shade, suppressing however the whirlpool movement of Michelangelo (IV, 26).

V. THE LATE RELIGIOUS DRAWINGS

It was in the last two decades of his life, after the death of Vittoria Colonna in 1547, that Michelangelo created his most beautiful religious poems and works of art. Freed from deference to Vittoria's taste for the *rifinito,* he could now express his religious sentiments more freely and in a more spiritualized language than before.

The inner life of Michelangelo in this last period oscillated between surges of burning faith and inner emptiness, between awareness of an intimate communion with God and a desperate feeling of being separated from him. All of his religious poetry expressed the anguish of waiting. He created religious verses in what he called the *intervallo*—his moments of depression. Born of the poignant supplications of a desperate aged man who no longer has faith in himself and who is crushed by his sense of guilt (Frey, *Dicht.,* XCVII, CLI, CXL), his religious poems do not contain praises of God, but rather imploring prayers to the merciful goodness of the Savior.

In one group of his sonnets, Michelangelo sums up his life and remembers with regret time needlessly wasted and ends by imploring Divine Grace to forgive him (Frey, *Dicht.,* CXLVII, CL, CXLVIII, CLV, CLVII). The poems of the last group seem to be paraphrasings of Petrarch's sonnet no. 365. But the harmonious and easy rhythm of Petrarch takes on in Michelangelo a grave and sober cadence which mounts from one verse to the next and plunges, cascading with an irresistible power. Not only in the ideas but even in the music of the words there resounds the desperation of him who searches for Mercy and it is this state of mind which sets the mood for these poems, whereas metaphysical nostalgia had been the spiritual climate of his earlier Platonic love poetry.

But it is in his late works of art and chiefly in his drawings and sculptured Pietàs that Michelangelo expressed his feeling of blessedness and Grace. There emanates from them a kind of consoling certainty that at the end of the struggle there awaits ultimate peace. This message we know from the late works of other great masters who lived to an advanced age and which are all of a surprising similarity, reflecting a universal "style of old age." Michelangelo was led to transform his style to make it the instrument of this new conception. His late sketches are incarnations of mystic visions of the Divine, created by a spiritual effort which has as its aim the raising of the artist's soul above his instincts to the contemplation of the spiritual. It seems that the aged Michelangelo felt that the way to salvation was to fill his soul with these religious images. They offer striking resemblances, even in their formal character, with the religious visions of all ages, as we know them through the descriptions of the mystics and works of art of the greatest visionary painters.

The religious images of Michelangelo appear lighted by a troubled inner glow, and seem enveloped in a light mist which renders their contours fluid. The bodies of the figures lose their physical substance, their silhouettes become simplified, sometimes almost rectilinear; the outlines become somewhat loose and the forces which formerly swelled them diminish and even vanish. Realities of the soul, these images derive

their substance from the imagination of the artist alone. They appear on the white paper independent of any definite space, and become vague toward the periphery. This is because they derive from the process of the creation of inner mental images. The spiritual effort which begets them cannot simultaneously produce the numerous elements which go to make up a complete world (v, 1).

This transformation of Michelangelo's art appears in a series of drawings representing *Christ on the Cross between the Virgin and St. John,* which may be dated by their style about 1550-1556, i.e., after the Crucifixion of St. Peter in the Pauline Chapel (1550) and before the Annunciation in Oxford (1556-1561). The heart of these compositions is no longer Christ and his sufferings alone but rather the human sentiments which are aroused by the death of the Lord and which are incarnated in the pain-wracked Virgin and St. John. The real purpose of these drawings is apparently to reveal how the Crucifixion is reflected in the artist's consciousness. In the first drawings of the series, as in his poems, the artist evokes the remorse, the feeling of guilt, and the weight of the responsibility which man bears for this crime. But in the drawings presumed to be later, Michelangelo found in his own individual way the meaning of the Crucifixion: he reached its sense through a personal development.

Michelangelo's meditations on the death of Christ seem not to have been presentation sheets but projects for a group in marble. In fact, on the back of a Windsor drawing there is an outline, hitherto overlooked, for a marble block of the same size as the Christ on the recto, which leads us to believe that the master again planned to execute these drawings in a larger-than-life-size marble group—like the earlier Crucifixion projects for Vittoria Colonna. These seven late drawings, all variations on the same theme, may have been executed in rapid succession, but nevertheless show a development in their conception.

The badly damaged sheet in the Louvre may be the earliest of the series. The curving figures of the Virgin and St. John are still close in style to the figures of the Conversion of Saul. Symmetrical in their poses, they seem to walk forward from under the Cross to meet Christ in humility as the "new Mother" and the "new Son." In the Middle Ages the Virgin beneath the Cross was sometimes identified with the Church and St. John with the Synagogue; there is perhaps a faint echo of this tradition in the veiled head of St. John.

The next drawing, which is in Windsor, shows Christ again with raised arms, but this time the form of the Cross itself corresponds to the diagonally upraised arms. Michelangelo might have adopted this form of the Cross from the Croce dei Bianchi formerly in Santa Croce, as noted by Condivi and Vasari in speaking of the Pietà for Vittoria Colonna. The motif of St. John's arms crossed over his chest is one that Michelangelo had already used in his Last Judgment and which recurred in the St. John of the Crucifixion for Vittoria Colonna. The Virgin, barely sketched, raises her head toward Christ whose face turns slightly to the right. At the foot of the Cross Michelangelo rapidly sketched the figure of Mary Magdalene. It is to this Christ

that Michelangelo reverted in his last years when he made the rapid sketch in the Codex Vaticanus, except that he turned the sunken head into a profile. 234

The next sheet is probably that in London. Here the Christ is similar to the Louvre 225 sheet yet the Cross has the same Y-form as in the Windsor drawing. Christ is stretched on the Cross in contrast to the Virgin's and St. John's slightly bowed bodies. Now it is the Virgin who has crossed her arms over her breast as though she were shivering and St. John seems to be listening with his arms held out in a gesture of attention, poignant translations of the master's feelings.

In the second Windsor drawing Christ is again on a T-shaped cross but with arms 226 raised in upward diagonals. His body, showing many *pentimenti* has approximately the curve of the Vittoria Colonna Christ. The gestures of the two figures below, 164 depicting despair, are developed from the London sheet just mentioned. The Virgin again recoils with her arms crossed and St. John again seems to be listening—either to Christ's death cries or to the thunder which accompanied his death. The silhouettes of both figures have here block-like shapes.

The Oxford drawing shows the two figures below the Cross again in stereometric 229 simplification. However, they are no longer St. John and the Virgin—as they have been thought to be until now—but two male figures: probably Longinus the centurion at the left, and Stephaton the soldier at the right who offered the sponge to Christ. Longinus has a cap identical to those worn by the soldiers in the Crucifixion of St. Peter in the Pauline Chapel and the garments of Stephaton are not, as they 71, 72 appear at first sight, those of a woman, which would be longer, but those of a Roman soldier. It would not be possible at any rate to represent, according to the iconographical tradition, St. John at the right side of Christ and at his left, the Virgin. Christ is emaciated, his body broken in zigzag outline. The artist illustrated Matthew 27: 54 or Mark 15: 39, when at the moment of Christ's death cry the centurion is converted. The two soldiers are striking incarnations of the guilty conscience of Michelangelo because of Christ's death. Longinus is fleeing like a murderer from the scene of the crime and Stephaton raises his hands to his temples in horror and despair.

On the back of this drawing there has recently been discovered, upon the removal 230 of a sheet of paper long since pasted upon it, another Crucifixion sketch which seems to be a fair copy of the recto, made by Michelangelo himself. This sketch shows no corrections.

In what is probably the last drawing in this group, in London, the feeling of guilt 231 and desperation has been overcome: the death on the Cross has become the symbol of the redemption of humanity by Grace. The Virgin and St. John press against the legs of Christ as if they were looking for protection and for a remedy for their despair. They feel themselves safe under the arms of the crucified Savior, which stretch above them like a shelter. The death of Christ now takes on all its original meaning as a symbol of redemption.

Various other late drawings testify to the same transformation in Michelangelo's
art. One of the most characteristic among them is an *Annunciation* in Oxford which
can be dated, thanks to an inscription on the same sheet, between 1556-1561. Around
the late thirties Michelangelo had already worked on an Annunciation known only
through copies by Marcello Venusti. Michelangelo had conceived it at that time as
a dramatic scene in motion, inspired either by Dante, *Purgatorio*, x, 43 or by a sonnet
(CIV) of Vittoria Colonna, either of which would seem to furnish an explanation
of the gesture of the angel. Vittoria, following Dante, says that the angel "stamps
the lofty message in the Virginal heart." The Virgin is standing and leaning against
a reading stand, and the angel is coming forward in the direction of the Virgin.
Behind her is a bed with a canopy: this is the *Thalamus Virginis*. The idea of
representing the Annunciation in this setting, although known since the Trecento,
was seldom used in Italy but became popular in the Northern countries. In Italy
the setting was usually an open loggia, signifying the Temple. Michelangelo still
retains this idea by a small statue of Moses breaking the tablets of the Law.
The meaning seems to be that with the Annunciation of the birth of Christ the
old Covenant vanishes and the new Covenant takes its place. The angel does not
follow tradition by making the sign of benediction nor by pointing upwards to
God, but makes a gesture, analogous to that of God the Father in the Creation of
Adam on the Sistine Ceiling, imparting the message of the new Life to the Virgin.
The Virgin, with arms spread, seems to open herself for the conception. Through
these interpretative gestures the supernatural event becomes "rationalized." It is
interesting to note that this more "natural" conception of the gesture of the Angel,
inspired by Dante, can be found in the Annunciation of Fra Angelico, Cortona, Museo
Diocesano.

Surveying the various Annunciations of Michelangelo, it may be observed that the
artist created two types: only at the end did he merge these two and spiritualize the
scene. Either the angel is of the same size as the Virgin and approaches her from the
side (as in the Marcello Venusti copies just mentioned) or the angel, smaller in size
than the Virgin, is flying down to her. Both of these types had been known in Italian
art since the Middle Ages. A second example of the first type is the London drawing,
which up to now has been connected with either the panel in San Giovanni in Laterano
or the lost panel of the Cesi Chapel, Santa Maria della Pace. The simplification of
the Virgin's silhouette, the transformation of the abrupt gestures into softer ones,
the spiritualized expression of the face, all speak in favor of a later date, ca. 1545.
The iconography is the same as in the Lateran panel—the Virgin makes the gesture
of receiving. She is now in the process of rising from a seated position. In the first
version her right hand reached farther down to the top of the reading stand, which
originally was lower.

To the second type of Annunciation belongs the now lost picture for the Chapel
of Agnolo Cesi in Santa Maria della Pace in Rome. Michelangelo made this compo-

sition at the request of Cavalieri. The composition is known through the copies by Marcello Venusti: a drawing in the Morgan Library, New York, formerly in the Lawrence collection, and a small panel in the Corsini Gallery in Rome. Here the Angel is smaller than the Virgin and is descending from above her. Otherwise the concept is similar to the Lateran version; again the Angel is imparting the message which the Virgin receives with raised arms. There is again a statuette of Moses on the reading stand. The Virgin is turning and forms a *figura serpentinata*. That this composition reverts to an original by Michelangelo is testified to by a genuine preparatory drawing in the Codex Vaticanus for the Virgin's right hand. (The connection has been established by J. Wilde.) On the verso of the sheet is a draft of a letter datable April-July 1547, giving a *terminus a quo* for this composition.

205

To the same type belongs the drawing in London in which again the Angel, smaller than the Virgin, is descending to Mary. The left hand of the Virgin originally made a movement similar to that of the Cesi Virgin, which, however, Michelangelo changed in a *pentimento* so that she is holding her veil. This *pentimento* makes it rather doubtful that this drawing is a preparatory study for the Cesi Annunciation, because, if it were, the first version of her left hand, identical to the Cesi composition, would not have been changed. Therefore we may suppose that this sketch is somewhat later than the Cesi Annunciation. For it the inspiration was, in addition to the Cesi Virgin, one of the Sibyls of Giovanni Pisano in Pistoia (Wilde).

204

The latest Annunciation in Oxford of 1556-1561 is a synthesis of the two earlier types. It is a translation of a purely internal event. The figures of God the Father and the Dove of the Holy Ghost, traditional motifs of the Annunciation, are suppressed as in the earlier Annunciation drawings of the master. The two figures have different degrees of reality. The seated Virgin is matronly and stocky. The ethereal Angel-genius is like Mary's vision, a light and transparent being floating above the ground who seems to come from very far away. The difference between reality and vision which these two figures symbolize is emphasized by the difference in drawing and proportions—heavier in the massive Virgin, lighter in the slender Angel. The real subject of this composition seems to be the inner message of the arrival of the suffering Son. Actually the Angel seems to have the aspect of a Christ; he is a beardless, wingless male Apollonian youth. Perhaps Michelangelo wanted to show that the Virgin had a revelation of the future sufferings of the Redeemer before the actual Incarnation. This is but a variation of Judges 13: 7 and also corresponds to a tradition of the Middle Ages in which the Angel sometimes appears bringing the Cross of the Passion together with the glad tidings.

208

Originally the artist, following tradition more closely, had drawn both figures differently; the Virgin in the initial version seems to have expressed surprise. Her right leg was drawn back in a momentarily dramatic movement which the artist later changed by placing the right leg behind the left in a quiet immobile attitude. The head of the Virgin, larger and farther to the left, probably expressed surprise. The Angel was orig-

inally in a different pose, with his legs touching the ground. Only in a *pentimento* did Michelangelo transform and spiritualize this figure into a floating one. His active gesture became a passive one.

Finally, there are two late *Virgin drawings*, one in Windsor and one in London. Both show the motherly Mary, with tragic presentiments, embracing the Child with a protective gesture; the Infant clings to his mother and kisses her with the intensity of a last farewell. In the pose of the Virgin and Child in Windsor Michelangelo followed his earlier type of the Madonna del Latte in which the Child is astride the Virgin's knee and turning around toward his Mother's breast. This motif had haunted the master since his youth as is testified by the sketches of ca. 1503 in the Louvre, the Albertina, the masterful drawing in the British Museum of ca. 1525-1530, and the marble Virgin in the Medici Chapel. In the Windsor drawing, however, the Child is no longer nursing but kissing his Mother's mouth, a combination of two types in which Michelangelo took the pose of the Child from his earlier Madonna del Latte versions, inserting into it the motif of the tragic embrace. This latter motif also reverts to tradition and appears as early as the Virgins of Giovanni Pisano and Donatello in which the Child savagely clutches at his Mother while she kisses him sadly. Already here in the Trecento and Quattrocento examples the human quality of the Mother is raised to that of the heroic Prophetess or Sibyl which directly anticipates Michelangelo's interpretation of the Virgin.

Michelangelo, in various stages of his development, made use of the motif of the embracing Virgin. In an early drawing in the Louvre (ca. 1503-1505) he returned to Donatello's Pazzi Madonna: the motif of embracing and that of the two heads in profile are essentially the same with the two masters, yet the passive Child of Donatello is transformed into one actively embracing. In a rapid sketch of the late twenties in the British Museum, Michelangelo again took up the motif of Giovanni Pisano's Virgins in Padua and Prato or of Donatello's relief of 1457 in Siena.

The Virgin in Windsor is of massive and bulky proportions, reminding one of the Virgin of the Annunciation of 1556-1561 and may have been executed at that time. Also the simple folds which frame the legs and which might be inspired by ancient paintings (*la Dea Barberini*), are typical of this period. In a comparison of this late Virgin with the London sheet—a preparatory study for the Medici Virgin in which the slender proportions, the long neck, the aristocratic small face, feet and hands, are of the elegance of his Giuliano de' Medici—the difference becomes more palpable.

The London sheet, which is perhaps the last extant drawing of the Master, represents a standing Virgin with the Child, a type already used by Michelangelo in a few earlier works (for example, the early drawing in the Louvre, the Virgin in the Cappelletta of the project for the Tomb of Julius II, 1513, and the second version of this Virgin on the monument itself, made according to drawings of Michelangelo by Domenico Fancelli and Raffaello da Montelupo). The body in this drawing had originally been

102

99

98, 101

Vol. III, 49

96

Vol. III, 128

102

101

103

97

Vol. IV, 95

Vol. IV, 59

more in profile and somewhat more bent. The head had been in three-quarter profile, placed more to the right; Michelangelo changed it, giving it approximately the position of the head of the Virgin on the Tomb of Julius II. In the Infant he repeated roughly the posture of the Child in one of his early Virgin drawings in the Louvre. There is a belt around the Virgin's waist; the hatchings between the legs and the often repeated outlines should perhaps be interpreted as a transparent veil from which her body emerges so clearly that the figure appears to be nude. The vague black chalk lines seem to envelope the figure like an aura, giving it the quality of a dream. Traced with trembling hand, this Virgin, awkward and clumsy, her body hardly modelled, her knees slightly bent, is standing holding the Child who embraces her tenderly. It is a return to the primordial Woman; it is a vision, freed of all contingencies, of motherly Love. The almost complete abandonment of precise plastic language revealed here is the most sublimated expression of the spirituality of the late Michelangelo. This explains the rarity of sculptures made by the artist in this period of his life. In fact, sculpture by its very material and technique is much less well adapted to translating such visions. Nevertheless Michelangelo did attempt to express them in the only two sculptures on which he worked in the last decades of his life—the two "Pietàs."

THE last messages of Michelangelo as a sculptor are two unfinished marble groups which have usually been called "Pietàs"—a title which does not, however, describe them accurately.

The scene of the Pietà representing the lonely Virgin with the corpse of Christ on her lap, not mentioned in the Gospels, focuses on the moment following the Deposition and preceding the Entombment. It is an extraction from the Lamentation made up of many figures but it follows the pattern of the Virgin and Child. The mystics of the late Middle Ages like Suso and San Bernardino da Siena had described how the Virgin, after the Deposition, took the body of her Son in her lap, imagining him as a Child again. (Often this idea was represented by a corpse with the proportions of a child.) To this type belongs Michelangelo's early Pietà in St. Peter's (Vol. I, pp. 89ff, 145ff).

77-83 The *"Pietà" of the Cathedral in Florence* is in fact a fusion of a Deposition and a Lamentation. The body of Christ, after the Deposition, is surrounded by the Virgin, Mary Magdalene, and Joseph of Arimathea (called Nicodemus by Vasari and Condivi). Lamentations usually include, in addition to the figures mentioned, Nicodemus, St. John, and the Egyptian Mary and they hold up the body, worship the dead Christ, and say a final farewell. This scene is not mentioned in the Bible but has a rich literary tradition in the late Middle Ages and has often been represented (e.g. by Cimabue at Assisi, Giotto, A. Lorenzetti, Giottino and Fra Angelico). The body of Christ is in all these examples horizontally outstretched with the mourning figures usually seated around him (VI, 3).

But there have existed since the late Trecento, Lamentations in which the body is held erect by the Virgin and Mary Magdalene. Examples of this rather rare type
370 are: Giovanni da Milano's panel in the Accademia of Florence, 1365, in which the
371 corpse is surrounded by the three Marys; Giovanni di Pietro da Napoli's in the Gallery of Fine Arts, Yale University, in which the corpse is held up by the Virgin and surrounded by the other two Marys, St. Anne, and St. John; Cosimo Rosselli's panel in Berlin, Kaiser Friedrich Museum; Andrea del Sarto's Composition engraved by
360 Agostino Veneto (Bartsch, no. 40) in which, however, the body is surrounded by
372 three angels; and most important in this connection, Fra Filippo Lippi's Lamentation in the Cherbourg Museum, in which the compositional pattern and the protagonists anticipate directly Michelangelo's group—the erect corpse is held up by the Virgin and Mary Magdalene, one on each side, and behind at the top appears the bearded head of St. Joseph of Arimathea. This is the iconographical type which inspired Michelangelo's so-called "Pietà" in Florence (VI, 5).

Before dealing with the group in the Florentine Cathedral, mention may be made of a somewhat earlier drawing by Michelangelo belonging to the same category and developed from the Pietà for Vittoria Colonna. This is a fragment of a *Lamentation*

(Haarlem, Teyler Museum) of which another small piece has recently been found 217 and which may be dated around 1547 (Panofsky). Here Christ is also, as in the Vittoria Colonna Pietà, in vertical position and is held up by the Virgin who kisses his head. 159 This motif will play a role in Michelangelo's group in Florence. The right arm of Christ bent upward by the Virgin in the first version of this sketch reverts to an old tradition (cf. Giovanni da Milano, 1365). Three more figures, two Marys and St. John, 370 complete the group.

The Lamentation in the Cathedral of Florence is a plastic group composed of four 77 figures as in Fra Filippo Lippi's composition. The body of Christ seems to slump to the ground but is held up under the armpits by the Virgin and Joseph of Arimathea. The silhouette of his emaciated yet athletic body is broken in a zigzag as in the Pietà for Vittoria Colonna. It is noteworthy that his dimensions are much larger than those of the three surrounding figures, a fact which is not apparent at first because of his position. The role of the two angels of the Pietà for Vittoria Colonna is played now by the Virgin and Mary Magdalene while the place of the Virgin is occupied by the cowled figure of Joseph of Arimathea.

The rigid and abstract composition for Vittoria Colonna, the silhouette of which is enclosed in a hexagon, becomes here a group full of life and suppleness with the figures closer together. The general configuration is that of a tall, narrow cone. The artist tried to mitigate the effect of the material heaviness of the bodies by presenting them no longer in frontal view (as the Pietà for Vittoria Colonna) but from a side view with a narrow angle, and by rendering the body of Christ slender, elongated, and almost skeletal. His body, twice broken (this may have been still more impressive when the left leg had not yet been destroyed by the master), seems to slip downward and the Virgin with closed eyes and a face transfigured by a supernatural bliss, receives him into her arms. Their heads touch (a device perhaps developed from the above- 83 mentioned motif of kissing) and the Mother's head serves as a support for that of Christ. St. Joseph of Arimathea holds the right arm of the corpse and seems to move 77,78 the body from the side of Mary Magdalene to that of the Virgin on whose back he rests his left hand in an ineffably tender gesture of protection. He unites the Mother 80 and Son in a kind of ultimate *sposalizio*, looking down on them with deep emotion. This spiritual marriage is the essence of the *concetto*. Once more the symbolism of the two sides plays its role: the right side, that of Mary Magdalene, is the side of life and the left side, that of the Virgin, is that of death; this may explain why Michel- angelo reversed the two figures which in Fra Filippo Lippi were on the opposite sides. A personification of Providence, Joseph of Arimathea fulfills the reunion of the Mother and Son desired by Mary. Human pain seems to be overcome; the living figures are filled with the same mysterious sweetness and sense of blessedness that can be read on the serene features of the dead Christ. The heads of Christ and Mary are 83 fused together: they penetrate each other as do their feelings. Each of them is but a nuance of the blessedness which results from their participation in Divine Love.

Michelangelo seems to have come to terms with death, which now appears to him to offer the supreme peace of the soul.

The technique of the Lamentation in Florence shows an alternation between polished and rough surfaces: the body of Christ is completely modelled except at the neck, the head, and the left hand; the forms of the Virgin and Joseph of Arimathea, on the contrary, were left unfinished. On the rough surfaces, the light becomes more diffused, giving to the heads of Joseph of Arimathea and the Virgin an inner glow reminiscent of the late drawings of the master. It seems that Michelangelo here purposely left some of the surfaces unpolished: he may have found in their illuminated roughness an appropriate means to emphasize the spirituality of these figures (VI, 4).

81-83

The conception of this group and the beginning of the work can be dated before 1550, since Vasari mentions it in his first edition, written ca. 1547 and published in 1550, in which he calls the group a Deposition. In 1553, the artist must have still been working on this group since Condivi mentions it as unfinished. Before the death of his servant Urbino (December 3, 1555), Michelangelo partially destroyed the work. According to Vasari (1568) the reason for this was, besides the fact that the marble was not flawless, that Urbino's constant insistence that the master finish it infuriated him. Tiberio Calcagni, another pupil, gathered the pieces together and restored the group except for the left leg of Christ. Michelangelo blocked out the Mary Magdalene, as may still be seen on the rough parts on the back where his toothed chisel work can be recognized, but it was Calcagni who finished the figure; what can be seen of it today from the frontal side is completely Calcagni's work.

78

79

We know that Michelangelo wanted this group to be placed on the altar of his own burial chapel and Joseph of Arimathea is an idealized self-portrait (cf. letter of Vasari to Leonardo Buonarroti of March 18, 1564). Like other late works, this group has the significance of a personal confession of the master (VI, 2).

81, 82

In the Pietà for Vittoria Colonna the presentation of the body of Christ to the beholder was still the most important consideration. In the Lamentation in Florence this motif is augmented by an intimate and purely human event, the reunion of the Virgin with her Son. Only Magdalene, finished by Calcagni, looks directly at the beholder as if to draw his attention to the Passion of Christ; she fulfills a function similar to the angel in the Madonna in the Grotto by Leonardo.

354

The *Entombment of Palestrina*, now in Florence, Accademia, reverts in its composition to the Florentine Pietà, but is actually a reversed version, from which one figure has been omitted: the upper body of Christ, his head, his dangling arm, and the figure of Magdalene, correspond in mirror image to that in Florence. The head of Joseph of Arimathea becomes here that of the Virgin; the fourth figure is lacking. The left hand of the Virgin in Florence becomes the right hand of the new Virgin— but it remains foreign to the composition.

84-87

77

The flatness of the whole relief-like group, the incongruousness of the proportions, the weakness of the modeling, the inequality of the treatment of the marble do not seem to us to be in the style of Michelangelo. Therefore we would assign this group to a pupil (VI, 7-12).

The *Pietà Rondanini*, the last plastic work of Michelangelo, is mentioned neither in Vasari's first edition nor by Condivi. In the second edition Vasari (p. 220) reports that after Michelangelo mutilated the Pietà now in the cathedral in Florence, "it was necessary to find some marble so that he might spend some time every day in sculpting. And another piece of marble was placed at his disposal upon which another Pietà had been roughly hewn, different from that [i.e. in Florence] and much smaller" (VI, 14).

We do not know when Michelangelo began the first roughly-hewn version but it is supposed (Baumgart, D. Frey) that it was possibly around 1552, i.e., later than the inception of the Florentine Pietà. The resumption of this first version followed the partial mutilation of the Florentine Pietà, which must have happened at the end of 1555, i.e., before the death of Urbino on the December 3 of this year. The last attempt to make a completely new composition from the block occurred in the last months of Michelangelo's life, since Daniele da Volterra reports in a letter (Daelli, no. 34) that he saw Michelangelo standing at work on the Christ of the Pietà on the Sunday before Lent (February 12, 1564), six days before the master's death.

There is no doubt in looking at the block that the artist originally must have planned quite a different group from that which we see today. He himself seems to have destroyed the original version, which was apparently quite well advanced, to form something which cannot be considered simply a further development of the original plan but rather a radical transformation, revealing an ultimate and significant change in his conception.

The preparatory sketches, preserved on a sheet in Oxford, show in two different compositional types, the body of Christ being carried to the tomb. In both types the body is in a vertical position. In the two sketches belonging to the first type, Christ is carried by two male figures, probably Joseph of Arimathea and Nicodemus, one on each side. This scene is described in the Gospels (John 19: 38-39; Luke 23: 53; Mark 15: 46). In both sketches the three figures form a grandiose rectangular block of complete unity: it is a truly sculptural concept. This type might have been derived either from the Colonna Pietà, where two angel *putti* are holding the body of Christ in a vertical position, or perhaps from certain early Quattrocento Entombments such as that of Fra Angelico (Munich, Alte Pinakothek), where the body is supported by Joseph of Arimathea and is flanked by the Virgin and St. John.

Michelangelo's second type of Entombment on the Oxford sheet contains only

two figures, a standing one, which may be the Virgin or Joseph of Arimathea, and the dead Christ. There are three sketches belonging to this type.

The earliest is undoubtedly the second on the left, since here, in the opposing bend of head and knee, we still find the old *contrapposto* which Michelangelo in his early youth was the first to introduce in his representation of the Crucifixion. Mary, who appears to be standing on a higher level, is looking down on the body.

In the second sketch—the one at the extreme right—the *contrapposto* has already been abandoned; the head and knees of the Christ are bent in the same direction. By this repetition, the body appears to hang down much more limply than in the first sketch. At the same time, the painful effort of Mary to hold up the body is emphasized. Her head is drawn twice: first, on the left, as in the earlier version, bent downwards; then, quite near to it on the right, it is corrected in such a way as to turn it towards the right in the opposite direction to the body.

In the last sketch—that on the extreme left—the same motifs remain but the group, instead of being in a frontal position, is turned sideways and the turn of Mary's raised head appears in still greater contrast to the hanging head of Christ (VI, 15).

In these sketches Michelangelo accentuated the tension between the heaviness of the body and the effort required of the standing figure to support it. Compositionally this type seems to follow a northern pattern of the late Middle Ages, which represents the Holy Trinity with God the Father standing and similarly supporting the dead Christ under his armpits. Examples are the Holy Trinity of the Master of Flémalle, a wooden statue from Bearn now in the Archiepiscopal Museum in Utrecht and a German woodcut of the mid-fifteenth century, which might have been known in Italy too. However, the representations of the late Middle Ages do not show the tense contrast of forces as it appears in Michelangelo's sketches. The master translated the concept of the late Middle Ages into the Renaissance idiom. By this means he produced an effect quite different from that of the earlier works: it is by the contrast in the heroic Herculean body, which in spite of its strength is broken and lifeless, that the ancient tragic conception of man's fate is attained. This Christ is like a mortally wounded hero being carried to the tomb.

The last Oxford sketch is the key to the reconstruction of the original version of the marble group. The relationship between this sketch and the sculpture is shown by certain fragments remaining in the block: a portion of the original head of the Virgin, which was turned upward toward the right and which is now a part of the head-veil (the forehead, the bridge of the nose, and the eyes can still be detected), her left leg, in addition to the polished right hip and the fragment of the polished right arm of Christ. All these parts reveal that the dimensions of both figures were originally larger and that while the body of Christ was probably completely finished and polished, the Virgin's head was only roughed-out. As to the polished legs of Christ, which have always been considered as belonging to the initial version, one

should take into account that the proportions are much more slender than those of the Herculean legs in the Oxford sketches. One may therefore conclude that they belong to a reworking of the first version at the time of the resumption of the work around 1555. This hypothesis would accord with the words of Vasari quoted above, that Michelangelo actually took up work on a piece of marble upon which another Pietà had been roughly hewn. In the initial version the legs of Christ may well have had the Herculean proportions of the Oxford sketches. Both variants of the first version actually depict (as do the preparatory sketches) an Entombment where a figure is carrying the body of Christ with great effort, supporting him under the armpits (VI, 18).

In the last version of the marble group, made almost a decade later, Michelangelo *88* transformed the torsos and the heads of both figures according to a completely different concept which also has its tradition. Here he abolished the antithesis between the passive heaviness of the corpse and the effort of the living body to hold it up. He reduced the size of the group and made vertical the position of the body of Christ to join it more closely to that of the Virgin. To both heads he gave now a similar posi- *92* tion. The artist achieved this effect by hewing the new body of Christ directly from the part of the block belonging to the Virgin: the new head of Christ is carved from the right shoulder of the Virgin, the new arms of Christ are sculptured from the *90, 91* sides and thighs of the Virgin's body. (Moreover Dagobert Frey discovered traces of an earlier variant of the second head of Christ.) The original left shoulder and a part of the chest of Christ became transformed into the new left arm and hand of *93* the Virgin. The position of the head of the Virgin is changed to a frontal view, bent slightly forward to correspond to the position of Christ's new head.

Although it is unlikely that Michelangelo consciously borrowed anything from earlier representations of this theme, nevertheless the transformed group also follows a traditional pattern; he approached it spontaneously as if from his subconscious memory. It is the Mediaeval type representing the Virgin next to the suffering Savior, supporting him and showing him to the beholder. This type is known in *367, 368, 369* Italy as well as in the Northern countries. In a Catalan example (in the Museo Borgogna in Vercelli), where the Virgin, in addition, has her cloak wrapped around Christ, as in the representations of the Madonna della Misericordia, Mother and Son are already closely united (VI, 17).

In Michelangelo there is no sign of any demonstrative gesture toward the beholder by the Virgin, but the idea of her supporting Christ nevertheless seems originally to have guided the present position of her left arm. However, in the actual execution the effect which it produces is that the Virgin is bending over Christ from above and *94* pressing his body closely to her own. She seems to rest on him and yet Christ appears *88* to seek support from her body with both of his arms. His slender, emaciated corpse cannot be sustained by his dangling legs. Both of the bodies, completely without force, with their flat, simplified forms suggest with great intensity the fusion of Mother and

[91]

Son. This union of the two beings, "attaccati insieme" as the old Inventory says, is especially impressive when one sees the group in profile from the left: the two bodies together form a single arc. The image of the traditional *compassio Mariae* is transformed into a vision of the communion in love of the two beings (VI, 16).

In this work the master superseded at last the Renaissance principles of causality and the representation of the rationally possible. What he achieved is an image contradicting the law of gravity and yet speaking with utmost immediacy to the heart of the beholder. The result surpasses the earlier art of Michelangelo; even the Florentine Pietà remained within the Renaissance rationalistic conception. It can be compared rather with a few late works of Rembrandt (like the Prodigal Son in Leningrad, Hermitage) where the renunciation of ideal realism and rationalism also leads, not to abstraction (Mannerism), but to a more profound and more concrete language of the spirit. A fully articulated body would here only detract from the essential: the inner gesture. The soul speaks more directly through the rough-hewn marble where the forms are merely suggested. As in the Florentine Pietà the roughness of the surfaces of the marble block softens the contrast of light and shade and helps to diffuse the light so that the group seems to glow from within.

This final message of Michelangelo conveys a glimpse of an ultimate peace after the life-struggle.

Although surprisingly different from any earlier work of Michelangelo, this Pietà should not be interpreted as a complete deviation from the master's lifelong aims. It is true that instead of the heroic struggle of fully developed perfect bodies, here we have broken powerless beings existing only by divine mercy—and mirroring Michelangelo's own physical and spiritual state. Nevertheless it can be considered from a certain point of view the culmination of his art: always his work had transcended the pure formal harmony of the High Renaissance and instead had conveyed an existential message of the spirit. But until now he tried to reconcile his spiritual striving with the normative forms, the rational structure of the High Renaissance conception. Only in the Pietà Rondanini did he definitely sacrifice the Renaissance conception of art, to be truer to himself and to express the inner gesture of the soul alone.

CONCLUSION

Michelangelo attained the religious state manifested in his last works in profound loneliness. It was neither the naïve faith of the Middle Ages nor the artificially cultivated ecstatic discipline of his contemporary Ignatius Loyola. Michelangelo's gropings give to his last message a moving depth: the state of beatitude is here always transfigured by the torment which he had to endure in order to reach it. The late drawings and the two last Pietàs could be called silent prayers. The external and material image of Christ and the Virgin is supplanted by an inner image inspired directly— as the Catholic Reformers would have said—by the Holy Ghost.

Savonarola in his small book *Della Orazione Mentale* had already said: "The Lord desires inner worship without external ceremonies" and "ceremonies are like medicines for those souls which do not have real fervor." The idea of this inner worship was expressed again by Valdés in his *Cento e dieci divine considerazioni*, no. 63, and this passage clarifies once more the character of the last works of Michelangelo. Valdés says that the image of the Crucified Savior should evoke in the soul the actual suffering of Christ. Once the soul has attained this suffering, the eyes of the body turn away from the external representation and concentrate on the inner image of the suffering itself. Faith is no longer founded upon the account of the suffering, but upon its revelation—as Valdés says, not upon the *relazione* but upon the *revelazione*.

From the very beginning until the last period of his life Michelangelo was led in his art to grasp the "Idea" which shines through visible forms. He disdained all naturalistic reproduction of the *fallace* reality, which deflects the soul from the only true reality, the *forma universale* (Frey, *Dicht.*, LXXIX). Michelangelo is supposed to have said, "good painting is nothing but a reflection of the works of God and an imitation of his brushwork, a music and a melody, which only a noble spirit can express and he only with effort" (F. de Hollanda, p. 31). It was with an ardent enthusiasm in his youth and a mystic urge in his old age that he tried to recreate the "divine melody" within his art. Through this conception the artist is no longer an imitator subordinated to visible nature, but a Promethean creator who in his works reveals "real nature." However, this new and proud role of the artist was rejected by Michelangelo when he became fervently religious in the last period of his life.

Michelangelo believed that this change of heart was a complete break with his whole past: he looked upon his former life as a sustained error, and repented deeply the lost time. This attitude is translated into poignant poems, in which three features are dominant: repentance for his past as manifested by throwing off his former ideal of beauty, now called by him "mortal beauty" and soon to be replaced by "divine beauty"; the necessity of praying to God for the help needed for faith (it is strange to find here the same images as in the poems dedicated to Vittoria Colonna, the steep

road that must be climbed no longer toward the ideal woman, but to reach God); and finally, the arrival at the haven of peace and salvation.

Actually Michelangelo's early Platonism and late Christianity are not irreconcilable. Both included detachment from the world, ardor for perfection and enthusiasm to raise oneself to the "upper regions." They are united by transcendent spirituality, and from this point of view Michelangelo's Platonism certainly can be considered a prelude to his late Christian spirituality. Michelangelo erred in believing that he had to deny his past, for this past was in reality a preparation for his ultimate period. At the patriarchal age, when the bonds between man and the world are severed, the love of God harmonizes with the master's physical and spiritual condition.

In retrospect Michelangelo's inner development itself appears as a kind of work of art in which we find the chief stages of human ascension. The driving force of his personality remained the ardent desire, *l'ardente desio*, for the upper spheres and it was not without effort that he reached them. This gradual catharsis characterizes the development of his personality as well as the structure of his individual works.

CRITICAL SECTION

Some facts mentioned previously in the text will be repeated here, accompanied by documentary proofs, bibliography, or both.

I. NOTES ON CHAPTER I: LIFE

1. The sources for the last thirty years of Michelangelo's life can be found in Milanesi, Gotti, Frey (*Briefe* and *idem, Dicht.*). All important dates have been assembled in Thode's chronological table ("Annalen," I, pp. 430ff). The reasons for Michelangelo's not wanting to return to Florence are treated in Tolnay, *Werk u. Weltbild*, pp. 27ff. Concerning Michelangelo's renown, see E. Zilsel, *Die Entstehung des Geniebegriffs*, Tübingen, 1926; A. E. Brinckmann, *Michelangelo, Vom Ruhme seines Genies*, Hamburg, 1944.

2. Further information concerning Donato Giannotti is contained in our Vol. IV, pp. 131ff and Tolnay, *Werk u. Weltbild*, pp. 27ff. Cf. also: R. Ridolfi, *Giannotti, Lettere a P. Vettori*, Florence, 1932, and *Dialogi di Donato Giannotti*, ed. by D. R. De Campos, Florence, 1939; Tietze, "Francisco de Hollanda und Donato Giannottis Dialoge und Michelangelo," in *Rep.f.Kw.*, 1905, pp. 295ff; Gordon, "Brutus," in *F. Saxl Memorial Essays*, London, 1957, pp. 281ff. Gordon shows that Michelangelo's defense of Dante's opinion on Brutus and Cassius expressed in Giannotti's *Dialogi* comes from Landino's Commentary of *Inferno*, XXXIV. On the Brutus cult of the Renaissance, see also H. Baron, *The Crisis of the Early Italian Renaissance*, Princeton, 1955.

3. For further information concerning Luigi del Riccio, cf. L. Dorez, in: *La Bibliothèque de l'Ecole des Chartes*, LXXIX, 1918, pp. 184ff; Ernst Steinmann, *Michelangelo e Luigi del Riccio*, Florence, 1932.

4. Concerning artistic activity in Rome during the papacy of Paul III, cf. Dorez, *La Cour du Pape Paul III d'après les registres de la Trésorerie secrète*, Paris, 1932, and Pastor V.

5. The saltcellar and the bronze horse made for the Duke of Urbino in 1537 are documented by Gronau, *J.d.p.K.*, 1906, *Beiheft*, pp. 7ff; Wilde, *Brit. Mus. Cat.*, no. 66. *Vol.* IV, *285*

6. With reference to the artistic activity during the papacies of Julius III, Paul IV, and Pius IV, see the surveys and bibliographies given by Pastor VI.

7. Michelangelo's conception of death is treated in a book by A. Tenenti, *Il senso della morte e l'amore della vita nel Rinascimento*, ed. Einaudi, 1957, pp. 317f. We could consult this book only after completion of this manuscript. Tenenti arrives at a conclusion similar to ours (in *Werk u. Weltbild*), namely that the *ars moriendi* played a role in Michelangelo's spiritual preparation for death. Tenenti refers to Savonarola's *Predica del bene morire* as one of the sources.

8. Concerning the *Esequie* of Michelangelo, see the letters of Vasari of March 4, 1564 (Vasari, *Carteggio*, II, pp. 28ff) and July 14, 1564 (*ibid.*, pp. 86ff); Steinmann, *Portraitdarstellungen*; Thode, *Kr.U.*, II, pp. 517ff.

9. Concerning the Michelangelo monument in Santa Croce, erected at the expense of Lionardo Buonarroti by Vasari with the collaboration of Borghini, Valerio Cioli, and Battista Lorenzi, see Thode, *Kr.U.*, II, pp. 528ff and Steinmann, *Portraitdarstellungen*, pp. 75ff.

With reference to the so-called Tomb of Michelangelo, Rome, SS. Apostoli, Thode (*Ma.*, I, pp. 486f, following Niccolò Ratti) has proved that it is probably the monument of a professor of Medicine, Ferdinando Eustachio.

II. NOTES ON CHAPTER II: THE LAST JUDGMENT

Vatican, Sistine Chapel.
Fresco.
H. 17 m. (with base) W. 13, 30 m.

CONDITION:

General View 1. The fresco, which was until recently described as being in ill repair, is in reality in relatively good condition. This view, opposed to the general pessimism of the scholars, was first expressed by Biagetti, pp. 129ff, who gives the best recent survey of the fresco's condition. It is painted on excellent *intonaco*. An old, deep crack at the bottom center rises slightly to the right as high as the figure of St. Bartholomew. The Trumpeting Angels have suffered most, since for centuries a great canopy was placed against the wall during solemn celebrations. The top of this canopy scratched the wall at the level of these Angels.

Biagetti is of the opinion that the variation in the blue areas is not the consequence of water damage, as was believed formerly, but that it has resulted from a chemical change in the pigments used. Another reason for the change of the colors was the smoke from candles which noticeably affected the second zone of the fresco. Biagetti believes that Michelangelo worked *a secco* in various parts of the fresco, especially to obliterate the borders of the *intonaco* sections. The white brush strokes in the lower part of the fresco are, according to Biagetti, also *a secco*, and beneath them there should be the original color of the sky (p. 135). But this suggestion has been disproved: the strokes are *a fresco* and nothing has been found underneath them.

2. The *later overpaintings* can be determined by a comparison of the fresco with
257-259 the oldest copies, that of Marcello Venusti (1549), Naples, and the earliest engravings. Altogether, according to Biagetti thirty-six figures were partly draped by later hands. The names of the artists who did this work and who were called jokingly *braghettoni* by the Romans are, in chronological order: Daniele da Volterra, Girolamo da Fano, Domenico Carnevali (1565-1569), Cesare Nebbia (1586) and Stefano Pozzi (mid-eighteenth century). We have exact information concerning only Daniele da Volterra, who worked in the Chapel in 1565 (document published by Biagetti 1944, note to p. 145). He painted draperies of the fresco *a tempera*; in addition, Daniele repainted *a*
262 *fresco* the head and right arm of St. Blaise and the green dress of St. Catherine. The St. Blaise did not originally look toward Christ but in the opposite direction; the St. Catherine was originally completely nude.

3. Under Pope Gregory XIII (1572-1585) the altar platform was slightly raised 45 cm. Steinmann and Biagetti suppose that at that time a strip approximately one m. at the bottom of the fresco was destroyed. This supposition is based on the copy of
257 Marcello Venusti in Naples, where more ground is visible at the base. This hypothesis is, however, not convincing because the emptiness at the bottom of Venusti's copy

is in marked contrast to the compressed style of Michelangelo. We may suppose that, if any, a much smaller strip (ca. 45 cm.) was destroyed at the bottom.

Concerning the cleaning of the fresco, we retain the following dates for such work: 1625, under Pope Urban VIII, "spolveratura" (Pog., p. 779, no. 2 and p. 783, no. 7); 1712, a cleaning reported in the manuscript of Taja; in the second half of the eighteenth century, according to the supposition of Biagetti, p. 151, there must have been a restoration and cleaning; 1825, the restoration of Camuccini, the documents of which are published by Biagetti (pp. 151 and 187*ff*); 1903, fastening of the *intonaco* and cleaning under the direction of Ludovico Seitz (Cf. *L'Arte*, 1906). The most recent cleaning was made in 1935-1936 under the direction of Biagetti.

The preservation of the fresco was a preoccupation of the Popes from its early days: two years after its unveiling, Pope Paul III created on October 26, 1543, a special position for a *mundator picturarum capellarum palatii* for the frescoes; he nominated Michelangelo's servant Francesco Amatore (see the document in Mercati, p. 179, no. 6). Paul IV nominated as Amatore's successor on August 18, 1557, Adriano Spina (Pog., p. 760). Under Pius IV, there followed on December 27, 1562, Giovanni Antonio Varesio (Pog., p. 761). Under Pius V on February 15, 1566, Giovanni Battista Cavagna (Pog., p. 762). Innocent XII, on June 9, 1693, nominated Carlo Maratta to this post (Mercati, pp. 193*f*). Finally, 1737, Francesco Belloni is mentioned as *mundator*, the last notice concerning this position (Biagetti, p. 148).

4. Opinions differ *concerning the date of the commission of the Last Judgment and the Fall of the Rebellious Angels*. The first reference to the commission was made, according to Dorez, *La Cour*, p. 146 and Wilde, *Graph.Künste, 1936*, pp. 7*ff*, around July 1533, as mentioned in a letter from July 17 by Sebastiano del Piombo (Milanesi, *Corr.*, p. 106). According to Steinmann (*Sixt.Kap.*, II, p. 479), the commission was made on the occasion of a meeting between Clement VII and Michelangelo on September 22, 1533, in San Miniato al Tedesco. According to De Campos, 1944 (p. 5), it was after October 1533, when Michelangelo returned to Rome. December 10, 1533, the date of the return of Clement VII from France, is considered by this author as a *terminus a quo*.

4a. *Concerning the factual history of the Last Judgment*. The sources for the history of the Last Judgment are published by Pog., pp. 742*ff*; Pastor IV, 2, pp. 567*ff*; Dorez, "L'Achevèment de la Chapelle Sixtine," *Revue des Deux Mondes*, 1932, pp. 915*ff*; *idem, La Cour du Pape Paul III d'après les registres de la Trésorerie Secrète*, Paris, 1932, 2 vols.; Mercati I, pp. 167*ff*.

The best presentation of the factual history of the Last Judgment can be found in Dorez, *La Cour*, I, pp. 143*ff*.

5. The report of Agnello from March 2, 1534, referring to a letter of February 20, is published by Pastor IV, 2, p. 567 n. 2. This passage has been considered by Pastor and De Campos as referring to the Last Judgment. But it is difficult to imagine how the resurrected dead of the Last Judgment could have been represented above the

old altar. De Campos interprets the word *tavolato* as a provisional bridge. F. Hartt in *Essays in Honor of G. Swarzenski*, Chicago, 1951, p. 152, supposed rightly that the report refers to a Resurrection. However, Hartt did not offer arguments in favor of this hypothesis and overlooked also the likely connection of this project and the group of drawings mentioned in our Catalogue, Nos. 163 to 167.

124-130

That the report refers to a Resurrection is also supported by Condivi (p. 150), who states that Clement VII, before he proposed the Last Judgment, thought of other themes: "[Clemente VII] havendo sopra ciò più e più cose pensate, ultimamente si risolvè a fargli fare il giorno del estremo Giudicio."

6. The report of Agnello concerning the hesitation of the artist in accepting the Pontiff's request confirms the reports of Condivi and Vasari. According to the latter, Michelangelo also at first declined the request of Paul III to execute the Last Judgment.

7. The original decoration of the altar wall, before Michelangelo began his work on it, is hypothesized by Wilde (*Graph.Künste, 1936*, p. 8) in the following manner: on the whole, the altar wall was decorated as the entrance wall still is today, with these deviations, that the vault did not reach between the two lunettes as far as the upper cornice, but was taken over by a corbel of the fifteenth century, which exists even today, that the altar wall had only two papal portraits, of Petrus and Linus, in the corners, and that there was a larger field in the center containing a painting of Christ. At the bottom center was the altar painting, a fresco representing the Assumption by Perugino (the chapel was consecrated to the Assumption).

2

According to the recent hypothesis of van Regteren-Altena (*Bulletin van het Rijksmuseum*, 1955, pp. 75ff) Sebastiano del Piombo made a new project for the altar painting of the Sistine Chapel also representing an Assumption. Van Regteren-Altena believes the drawing now preserved in the Prenten Kabinet of the Rijksmuseum to be the preparatory drawing for this painting. However, Perugino's altar painting had a rectangular shape, as is attested to by Michelangelo's drawing in the Casa Buonarroti, whereas Sebastiano's composition ends in a semicircle at the top.

133

According to the opinion of earlier scholars (e.g. Steinmann, Sauer) there were, however, four figures in the third zone, those of the Savior and St. Peter on either side of a central pilaster, and those of St. Linus and St. Cletus in the corners. The implication is clear that the present corbel must have been executed later, in the sixteenth century, whereas originally the vault extended down to the upper cornice and was supported by a pilaster, as on the entrance wall. This opinion is supported by the drawings in Windsor Castle, copies after Michelangelo's Ceiling (Vol. II, Fig. 261) and by the engravings of Ottley of the lunettes, which he made in 1827 after a drawing of the sixteenth century. In both cases one sees below Jonas a large coat of arms of the Rovere which is very similar in shape to that on the opposite wall. The presence of this coat of arms on this wall is also attested to by Vasari (p. 209) and Condivi (p. 158), who tell the following story: Paul III asked Michelangelo to replace this coat of arms by his own, that of the Farnese. Michelangelo, however,

1

declined, probably out of respect for Julius II. It might have been at this time that Michelangelo decided to eliminate the coat of arms completely, in order to have more room for his fresco. Wilde's hypothesis that the corbel is from the fifteenth century is, therefore, unlikely.

8. Concerning the motives of Clement VII in deciding on new decoration for the altar and entrance walls, Steinmann (*Sixt.Kap.*, I, p. 559 n. 7) offers two hypotheses, both very reasonable: first, that the Pope, knowing that Michelangelo desired to come to Rome, wanted to offer him a suitably great commission there, and secondly, that both the altar and the entrance walls had probably been in bad condition, the altar wall, as a result of the burning of the draperies in 1525, and the entrance wall, due to the collapse of the pediment of the door in 1522. As a consequence both walls required redecoration. Sauer (p. 536) is of the opinion that the real reason was dictated by the iconography: the decoration of the chapel was probably considered unfinished as long as it lacked a representation of the Last Judgment, which according to him, was to be the finale for the three cycles already decorating the chapel. This opinion is adopted by De Campos. But in the text we have shown that the Last Judgment cannot be considered a necessary culmination for the existing cycles, although it does not conflict with them iconographically. Nor did Michelangelo himself conceive of it as being connected with the decoration already in existence.

8a. *The Liturgy and the Fresco Decoration of the Chapel.* All the facts reported here are taken from Steinmann (*Sixt.Kap.*, I, 165ff):

According to the *Ordo Romanus* by de Grassis the services which were celebrated in the presence of the Pope in the Sistine Chapel during the church year were: eight vespers, five matins, and twenty-seven masses. Masses for deceased Popes, Cardinals, Emperors, and Princes were also celebrated but these do not belong to the regular services. Indeed the Sistine Chapel is not a funerary chapel but a palace chapel. The consecration of the Golden Rose (in this case a symbol of Christ) was one of the special feasts celebrated there. For Christmas Eve nine readings from the Gospels were offered; on the Saturday of Passion Week (*Sabato Santo*) the Choir sang twelve prophecies chosen from the story of the Creation through the last of the Prophets.

Consequently, in these readings from the Gospels and the Prophets from Christmas through Easter the whole story of salvation was included. And it is this story which forms the program of the frescoes on the walls and on the ceiling of the Chapel.

The readings and the Gospels dealt with the life of Jesus from his birth to his death and resurrection. The Prophecies began with the first chapter of Genesis dealing with the Creation of the world up to the time of the Flood. The fourth, ninth, and eleventh Prophecies were taken from the story of Moses (the Flight out of Egypt, the Crossing of the Red Sea, and the Receiving of the Law). Therefore the ceremonies celebrated in the Chapel seem to have determined the subject matter of the artistic works which were to decorate it later. "The mysteries and revelations which the ear

perceived from the altar and the chancel were reinforced by visual images in the frescoes" (Steinmann).

From the readings given on the Saturday of Passion Week it becomes clear that the Creation of the World, the forebears of Christ, and the Prophets themselves could have become the only possible subjects for the paintings of the ceiling to complete the existing cycles. The whole culminated in the Easter message: the Resurrection of Christ. Therefore it also becomes clear on the basis of the liturgy that the Resurrection of Christ should have been painted on the altar wall as a finale and that the Last Judgment does not fit in this pattern. The Last Judgment would have been more fitting as decoration for a funerary chapel than for a palace chapel.

9. The reason why Clement VII finally chose, after long meditation (Condivi), to change the program for the altar wall painting from a Resurrection to a Last Judgment cannot, therefore, be explained on iconographical grounds. Rather, the explanation should be sought in the shift in the general mood between the Council of the Lateran and the Council of Trent. Concern and fear overtook the best men of the Church as a consequence of the almost universal corruption of the clergy and of the breaking away from the Church in the northern countries at the outset of the Reformation. A characteristic expression of the general mood of the times can be found in a letter of 1535 by Cardinal Gaspare Contarini to Monsignor Galeazzo Florimonte, Bishop of Aquino: ". . . Hor io vorrei che tutti i vescovi, cardinali et il papa fossero chiamati al concilio et la loro vita, dottrina, professione fosse esaminata, et gli indegni . . . fossero rimossi . . . et in luogho di questi surrogati humili, dotti di dottrina di spirito, casti, poveri, timorati. Et vedereste come le chiese fiorirebbono, come i popoli correrebon lor dietro. . . ." (*Quattro Lettere di Monsignor Gaspare Contarini*, Florence, 1558, p. 53, quoted after Tacchi-Venturi.) A similar explanation for the decision to paint the Last Judgment has been given also by Pastor, Lanckorónska, De Campos. According to Pastor, the motif was a remembrance by the Pope Clement VII of the recent Sack of Rome, which appeared to many people as a Judgment of God. The fear of divine retribution and the consciousness of their own sins determined the general mood after the *sacco di Roma* (Mâle IV, p. 21; Lanckorónska).

10. Concerning the group of drawings of the Resurrected Christ which we connect with the fresco first projected for the altar wall, see the note in the Catalogue of Drawings, p. 175*f.*

11. The cartoon for the Last Judgment was certainly finished before the Pontificate of Paul III since reference is made to it as having been done under Clement VII in the breve of 1536 (Pog., p. 749).

12. Concerning the preparation of the altar wall, see the documents published in Steinmann (*Sixt.Kap.*) II, p. 766, no. 1; Pastor V, p. 842; Frey, *Studien 1909*, pp. 139*ff*; Mercati, pp. 167*ff*. Of greatest importance are the works of Dorez in: *Comptes rendu de l'Académie des Inscriptions et Belles-Lettres*, 1905, pp. 233*ff*; *Revue des Deux Mondes*, 1932, pp. 195*ff* and *La Cour de Paul III*, Paris, 1932. Mention should also be made of F.

de Navenne, *Rome, Le Palais Farnese*, Paris, 1914, pp. 363*ff*. Dorez has determined, on the basis of the documents acquired by Ferdinand de Navenne, that the date of the inception of the fresco was between April 10 and May 18, 1536. Biagetti, p. 107, and De Campos, 1944, arrived at a similar date.

13. Concerning Francesco degli Amatori da Casteldurante, called Urbino, who died December 3, 1555, and who was a painter and sculptor, a pupil and friend of Michelangelo, we know that he was the only assistant of the master during the execution of the Last Judgment. He received for his work, which consisted chiefly of grinding pigments, four scudi monthly (Steinmann, *Sixt.Kap.*, II, p. 490, no. 1; Mercati, pp. 768*ff*). Michelangelo was very fond of him (see his poem in Frey, *Dicht.*, CLXII) and became the executor of his will. After the completion of the fresco, on November 18, 1541, Urbino received sixty ducats as a tip (*mancia*) from the Pope (Steinmann, *Sixt.Kap.*, p. 770). On October 26, 1543, the Pope nominated him as *mundator picturarum capellarum palatii* (Mercati, pp. 178*ff*). This office was maintained under this title until the eighteenth century (see above, p. 99).

14. Concerning the question how much of the fresco Michelangelo had completed by December 1540 when the scaffolding was lowered, opinions differ. Usually Vasari's sentence has been quoted, "haveva già condotto a fine più di tre quarti dell'opera" (p. 165), in connection with this date. Although this sentence seemingly contradicts the proposition presented in our text, one should take into consideration that in the upper section of the fresco there is a much greater concentration of figures than in the lower, so that the section above the second cornice might have been considered by Vasari to comprise three quarters of the total work.

15. Vasari reports that Michelangelo fell from no little height from the scaffolding, and that he refused the care of a doctor until, against his will, Baccio Rontini insisted on caring for him (Vasari 1550, pp. 160*ff*; 1568, pp. 161, 163). The same incident is also reported in a letter by Niccolò Martelli, *Il primo libro delle lettere*, Florence, 1546, pp. 9v and 10r.

16. The Last Judgment was finished, according to Dorez, December 15, 1540, and it was unveiled on the Vigil of All Saints, October 31, 1541 (Steinmann, *Sixt.Kap.*, II, p. 776).

17. *Concerning the Fall of Lucifer and of the Rebellious Angels*:
The project of a fresco treating this subject for the entrance wall of the Chapel is mentioned by Vasari, in 1568 (p. 149) (not mentioned by Vasari in 1550 nor by Condivi). Vasari indicates that there existed a fresco copy after Michelangelo's drawings for this composition, made by a Sicilian painter in the Chapel of St. Gregory in the transept of Santa Trinità dei Monti in Rome. Steinmann (*Sixt.Kap.*, II, p. 524) furnishes two further proofs of the existence of this copy: Giulio Mancini (*Cod.Capp. Vat.*, fol. 27) mentions the copy, attributing it hypothetically to Pontormo, and Gaspare Celio, *Memoria dei Nomi delli artefici . . . di Roma*, Naples, 1638 (manuscript in the German Archeological Institute in Rome), also mentions the fresco copy.

These frescoes were destroyed in the eighteenth century. No drawing by Michelangelo seems to have survived. It is, however, possible that motifs of this composition were

133 taken over by the master in his Casa Buonarroti sketch for the Last Judgment (as has been supposed also by von Einem). That the Fall of the Damned by Rubens (Munich, Alte Pinakothek) may reflect the lost composition by Michelangelo has also been assumed by Thode, *Kr.U.*, II, pp. 75*f.* Sentences of Vasari (p. 149), also support this hypothesis. (Thode also supposes that a drawing by Bronzino [Florence, Uffizi, 4982 F] representing the Fall of the Rebellious Angels is a free copy after Michelangelo's composition.)

18. In the short survey given in the text of the origin and development of the Last Judgment representations we have used the results of Paeseler, "Die römische Weltgerichtstafel . . . ," in *Kunstgeschichtliches Jahrbuch der Bibl. Hertziana*, II, 1938, pp. 336*ff*; Grabar, *L'Empereur dans l'art byzantin*, Paris, 1936, pp. 208, 250*ff* (for the derivation from triumphal concepts of the horizontal zones one above the other) and G. Millet, *La Dalmatique du Vatican*, Paris, 1945, pp. 14*ff* (for the derivation from cosmological concepts).

266 In our analysis of Giotto's Last Judgment we did not take into consideration Offner's remark (*Corpus*, III, part 2, 1, plate 19) that the face of Christ expresses anger since it could be rather a look of compassion; in any case he turns toward the Elect.

267 On Francesco Traini's Last Judgment in Pisa (which Longhi, *Mitteilungen d. Flor. Inst.*, 1932, pp. 136*ff*, attributes to Vitale da Bologna), see also M. Meiss, *Painting in Florence and Siena after the Black Death*, Princeton, 1951, pp. 76*ff*, who also emphasizes that here for the first time in the representation of the Last Judgment, Christ addresses the damned alone. This author overlooks the direct influence of the *Dies Irae* on Traini, a fact which had been pointed out by Lanckorónska, *Annales*, pp. 122*ff*.

19. The development of the idea of the Last Judgment in the drawings of Michelangelo was presented in a somewhat different way by Steinmann (*Sixt.Kap.*, II, pp. 589*ff*) and Thode (*Kr.U.*, II, pp. 5*ff*). Concerning the individual drawings see our notes in the Catalogue of Drawings, pp. 182*ff*.

276 20. The influence of the Medallion of Bertoldo di Giovanni has been noted in connection with the fresco by Bode (*Bertoldo di Giovanni*, p. 29), but he did not mention the relationship to the Casa Buonarroti drawing, which is actually much closer.

21. The use of ancient myths as a starting point for Michelangelo's imagination in his Casa Buonarroti drawing of the Last Judgment, instead of the usual didactic theological concepts, has been stressed by Tolnay, *Jugement*, 1940, pp. 125*ff*.

22. Our view that the fresco is conceived as an autonomous entity and not as a part of the existing cycles is in contrast to the opinions of Sauer and Feldhusen.

23. It is to Feldhusen's credit that she treated for the first time the relation of the

13 Last Judgment to the altar. But since she sees in the grotto a "mountain of Hell" in-

stead of Limbo she arrives at a somewhat different conclusion. Christ's descent into Limbo is actually a prefiguration of the Last Day. It was considered as a first victory of Christ, granting deliverance to the prisoners of Hell, anticipating the final resurrection of the Dead, at the moment of the second Advent, which is the second triumph of Christ (see Grabar, *L'Empereur dans l'Art Byzantin*, Paris, 1936, p. 250). Salvation is granted by the sacrifice of Christ, symbolized by the Crucifix which stood on the old altar table, as we pointed out in the text.

Concerning the cross which originally stood on the altar of the Sistine Chapel the following is known (Steinmann, *Sixt.Kap.*, I, pp. 547, 555, 559, 580 n. 2): In 1483, on the date of the consecration of the Chapel, there was on the altar a precious cross containing a relic of the Holy Cross executed for Paul II and adorned with pearls and precious stones. It was set up in the center of the altar between six candelabra and the two gold-plated silver statues of the Apostle-Princes, St. Peter and St. Paul. This same cross was mentioned again in 1486 as being in the center of the altar; but under Clement VII, it was replaced by another cross which also contained a relic of the Holy Cross. This second cross had previously been preserved in St. Peter's. During the Sack of Rome this cross disappeared, but it was found again a few years later (Steinmann, *Sixt.Kap.*, I, p. 582). It was this second cross which stood on the altar when Michelangelo painted his fresco.

24. The assymmetrical deviation of Michelangelo's composition has not thus far been explained in the literature.

25. Concerning the principle of one main hidden vantage point in Michelangelo's composition see Tolnay, *Arch.Buon.*, and *idem*, *J.d.p.K.*, 1930 and 1932.

26. *Concerning the style of the Last Judgment*: The first to give a short description *General View* of the style of the Last Judgment was Vasari, 1568, pp. 161 and 167, who admired the unity of the painting which "seems to have been made in one day." Michelangelo shows, according to him, "la via della *gran maniera* e degli ignudi," and representing only the human body "ha lassato da parte le vaghezze de'colori, i capricci e le nuove fantasie di certe minutie e delicatezze che da molti altri pittori non sono interamente . . . state neglette." In other words it is in an uncluttered style, concentrating on what is significant.

In the individual figures each part of the body is treated as an organic entity, having a life of its own; yet it remains a vital part of the whole. The outline, composed of a series of convex rather than wavy lines (Panofsky), becomes more powerful and the modeling, although differentiated in details, is nevertheless united by the whole undulating surface. The heavy labored movements seem checked by invisible obstacles. These nudes seem to be pervaded by a flow of palpitating life which swells from within the shell of the body; nevertheless, the inner forces are no longer able to radiate through the whole of the body, as in Michelangelo's earlier figures: the body's sheer mass seems to oppress both will and yearning.

All the figures of the Last Judgment are essentially similar: the athletic women

[105]

have bodies like men; the aged are like the young, distinguished only in their features. The effect is, however, enriched by the varied movements and poses.

The origin of this style is to be found less in the sculptures of the Medici Chapel with their elongated forms than in the earlier style, that of the Sistine Ceiling with its more powerful "Roman proportions"; but in the Last Judgment Michelangelo renounces the rhythmic sinuous outlines and the harmonious easy movements of the

77-95 Ceiling. Only in the second half of the last Roman period as in the two late Pietàs, do the slender "Florentine proportions" reappear.

27. *Formal Analogies*: Michelangelo used several motifs from his own earlier works in the Last Judgment; in addition, in some instances he made use of ancient proto-types, and there are also a few direct borrowings from Bertoldo di Giovanni's medallion

276 of Filippo de' Medici (Bode) and from Signorelli's Cappella Brizio in the Cathedral

285b, 286 of Orvieto (Vasari). The ancient and Quattrocento sources of inspiration have been discussed in the text. The following remarks therefore deal mainly with derivation from Michelangelo's own works.

General View The central group around Christ is in its structure a new version of Michelangelo's Battle of Centaurs and of the lower sketch for the Brazen Serpent in Oxford (No. 107). In the left lower group there recurs the motif of the legs of Adam in the Creation of Adam of the Sistine Ceiling. Among the floating figures there are several developed

10 from Michelangelo's Resurrection drawings. The figure bending down to pull up another, at the left in this zone, is, as has been said, a more powerful version of a motif of the Battle of Cascina as are also the figure behind it, with outstretched arm, and the nude below it, seen from the back. The Elect being pulled up and seen from the back is at the same time a new version of the figure of the Virgin in the first

132 drawing in Bayonne, and the Elect at the left of it is anticipated in the Casa Buonarroti

133 drawing.

7 The angel genius in the right lunette at the base of the column is an almost exact repetition of one of the figures of the top sketch of the Brazen Serpent of Oxford (No. 107), but here it is more massive and powerful.

28. The *conception of the wall* by Michelangelo as a "monolith" is analyzed in relationship to the Sistine Ceiling in Vol. II and in relation to the Last Judgment in Tolnay, *Jugement* and *Werk und Weltbild*, p. 101. The same principle in sculpture is analyzed in Vol. I, pp. 113, 117 and Vol. IV, p. 121. Feldhusen and von Einem, (*Kunstchronik*, p. 90) agree with our view.

29. *Concerning Michelangelo's "perspective ralentie,"* see Baltrusaitis, *Anamor-phoses*, Paris (1955), p. 7, who has demonstrated, that if one stands on the axis of the fresco before the steps of the altar, the level of each horizontal zone corresponds to an angle of sight.

Justi (pp. 336f) has already pointed out that each part of the fresco has its own vantage point and that Michelangelo sacrificed the unity of perspective. Lomazzo, *Trattato*, I, p. 45 and II, p. 179, had already commented in 1584 upon the reduction in

the size of the figures proceeding from the top downward, i.e. in inverted relationship to their distance from the beholder and he maintains that this method serves to make the observer see all the figures in the same size. We have seen that Michelangelo stipulated this same device in his contracts for the Piccolomini Altar (1504) and in the contract for the Tomb of Julius II, 1513 (see Vol. IV, p. 33). Thus Lomazzo's observation concerning perspective seems pertinent for the two earlier works by Michelangelo. But with the Last Judgment, this is no longer the case since the difference in dimensions is such that the higher figures remain considerably greater than those of the lower zones, regardless of the position in which the viewer is standing. Haendcke, *Kunstchronik*, 1903, col. 57*ff*, explains this anomaly by supposing that the artist wanted to place the viewer directly before the Judge: "Michelangelo schaut von oben nach unten, vom Himmel zur Erde." But the figures at the bottom are not seen in bird's-eye view. The painting does not take into account the vantage point of the beholder—it is conceived as an "objective reality."

30. *Concerning the lighting*: it should also be mentioned that the darkening of the flesh color at the bottom of the fresco may have been produced in part by the smoke of the altar candles.

The first to describe lighting in the Last Judgment was Lomazzo, *Trattato*, I, p. 405, who says that "Michelangelo ha solamente osservato *un* lume principale. . . ."

31. *The problem of the coloring* has been treated in the monographs only briefly. The analysis of lighting and coloring by Harry Mänz, *Die Farbgebung in der italienischen Malerei . . .* (Thesis, Munich), 1934, pp. 59*ff*, suffers in our opinion from the fact that the description of the contrast of light and shadow is somewhat exaggerated, almost as though Michelangelo were a disciple of Caravaggio. For example, "Das Licht bricht gewaltsam in die Finsternis ein . . ."; actually, the background of this work is not dark and the light instead of penetrating it, hovers upon the plastic forms. In the description of the colors, Mänz remains with the details and fails to mention the essential bichromatic effect of the whole.

32. *Concerning the literary sources*: the influence of Dante had already been mentioned by Michelangelo's contemporaries: Varchi, *Due Lezioni*, 1549, pp. 115*ff*, Vasari, and Condivi. The importance of the Dante influence was greatly exaggerated by scholars at the beginning of this century. According to Kallab, pp. 138*ff*, the Saints of the Last Judgment are in many cases influenced by the *Commedia* and he also believed that the whole idea-structure of the fresco stemmed from this work (besides Dante, he mentions the influence of Savonarola and of the Bible). According also to Steinmann (*Sixt.Kap.*, II, pp. 559*ff*), numerous elements and indeed the tone of the whole work are inspired by Dante. So, for example, the mood of vengeance (*vendetta*), which we interpret as fear, supposedly reverts to *Paradiso*, XXI, 140. Adam and Petrus as leaders of choirs are supposed to correspond to *Paradiso*, XXXII, 118*ff*, but the figure which Steinmann, following Vasari, calls Adam is actually St. John the Baptist. Moreover, Adam and Petrus are seated beside each other in Dante. Most of the

references listed by Kallab and Steinmann seem to be forced. There are, however, three additional motifs, mentioned by Steinmann, which may be inspired by the *Divina Commedia*, but these are by no means certain: a) the Elect seem to be raised

26, 27 in ascent by the invisible wings of their desire, as it is expressed in *Purgatorio*, IV, 28 ("*con l'ali . . . del gran desio*"), but this metaphor can also be found in one of Michelangelo's poems, Frey, *Dicht.*, LXXVIII; b) the motif of the winged devil who carries

286-288 one of the Damned on his shoulders (this motif occurs twice in the Last Judgment and before Michelangelo in Signorelli's Orvieto fresco); in the *Inferno* there is also a devil who supports on his shoulders one of the Damned, Bonturo Dati (*Inferno*, XXI, 25-36); c) the motif of a Damned who gnaws at the back of the head of another at

35 the right below Minos; this motif occurs in *Inferno*, XXXII, 124*ff* and the possible connection with Michelangelo was first pointed out by Guattani. An even stronger Dante influence was seen by Borinski, *Die Rätsel Michelangelos*, 1908, pp. 312*ff*. A reaction to these exaggerated tendencies appeared in the sharp criticism of Borinski by Farinelli, *Michelangelo e Dante*, Turin, 1918, who rejected all the Dante influences with the exception of the Charon and Minos scene inspired by the *Inferno*. The question was also treated in its true proportions by Lanckorónska, *Annales*.

32a. Besides Dante the influence of the sequence *Dies Irae dies Illa* (which is a kind of paraphrase of passages of Holy Writ) by Tommaso da Celano has been cited, first by Gilio da Fabriano, fol. 102r, then by Hettner, *Italienische Studien*, 1879, p. 265, by Springer, *Raffael und Michelangelo*, 2nd ed., 1883, II, p. 279, and by Sauer, 1907, pp. 540*ff*. De Campos, *Illustrazione Vaticana*, 1932 and 1944, also follows these authors. This thesis was shown to be untenable by Lanckorónska, *Annales*.

32b. *The importance of the Bible* as a source had already been mentioned by the old biographers, Condivi and Vasari. Its importance has been stressed for the first time among modern authors by Thode, *Kr.U.*, II, 1908, pp. 24*ff* and *Ma.*, III, 2, 1912, pp. 568*ff*. For Thode, too, the *Dies Irae* is an important source, whereas he recognized that Dante's influence was almost negligible. He says: "Aus der Urquelle der Bibel hat Michelangelo seine Inspiration geschöpft." Thode offers a great many citations from the Bible, which, however, fit only in part. In any case he must be credited with having emphasized again the great importance of the Bible. De Campos, 1944, pp. 47-50, for example, thinks that the real source was the *Dies Irae* and that the Bible was only a secondary source, mediated by artistic tradition: "La Bibbia ha agito mediatamente, ossia a traverso opere d'arte."

After Thode, the importance of the Bible was stressed by Lanckorónska and especially acutely by Feldhusen. The latter recognized that the Bible served not as an iconographical program but as a source of inspiration. Instead of didactic lessons connected with the Last Day, Michelangelo represented the spiritual and moral experience of the Judgment.

In our text we refer to the particular passages in the Bible that must have been Michelangelo's sources of inspiration because they were not illustrated in earlier Last

Judgments. Of especial importance is Matt. 24: 30-31, Rev. 1: 7 and perhaps Isa. 13: 6-9.
Here are the quotations:

a) Matt. 24: 30-31: "And then shall appear the sign of the Son of Man in heaven: and then shall all the tribes of the earth mourn, and they shall see the Son of Man coming on the clouds of heaven with power and great glory. And he shall send forth his angels with a great sound of a trumpet, and they shall gather together his elect from the four winds, from one end of heaven to the other."

b) Rev. 1: 7: "Behold, he cometh with the clouds; and every eye shall see him . . . and all the tribes of the earth shall mourn over him." (See also Daniel 7: 13.)

c) Isa. 13: 6-9: "Wail ye: for the day of Jehovah is at hand; as destruction from the Almighty shall it come. Therefore shall all hands be feeble, and every heart of man shall melt; and they shall be dismayed; pangs and sorrows shall take hold of them. . . ." The joy of the Elect he suppressed.

Concerning this second coming of Christ, see the Sermon of Ephraim the Syrian, analyzed by Gabriel Millet, *La Dalmatique du Vatican*, Paris, 1945, pp. 14*ff*. In Byzantine and Western representations of the Last Judgment Matthew 19: 28 and Matthew 25: 31-46 were always chosen i.e. the scene when Christ is sitting on the throne of Glory and judging humanity. (Sant'Angelo in Formis, Torcello, Baptistry *263, 264,* in Florence, Giotto, Fra Angelico, etc.). Further motifs in Michelangelo's fresco *266, 268* which may come from the Bible are:

d) *Christ* as the personification of the sun: John 3: 19, "And this is the judgment *4* that the light is come into the world. . . ."

e) The *Virgin* as "wife" of Christ: Matt. 25: 8. *4*

f) The *Trumpeting Angels*: Rev. 8: 2 (Condivi, Vasari). *12*

g) Books of *Life and Death*: Rev. 20: 12. *12*

h) The stages of the resurrection: Ezek. 37: 1-9. See our text. *14*

The question as to whether there existed, in addition to the Bible, a list of Saints which Michelangelo had been requested to include in his fresco cannot be decided. An example of such a request is contained in the contract for Fra Bartolommeo's Last Judgment dated January 8, 1499, which he had to paint for the cemetery of Santa Maria Nuova in Florence (published in *Rivista d'Arte*, VI, 1909, pp. 62*ff* and von der Gabelentz, *Fra Bartolommeo*, I, pp. 137*ff*). It stipulates that Christ, the twelve Apostles, the Hierarchies of the Angels, the Virgin, the Prophets Elias and Enoch and the Archangel St. Michael had to be represented "with all the things belonging to that Judgment, according to the forms which the Holy Gospel tells us of the first Sunday of the advent of Christ. . . ." The disposition and the interpretation of these elements is, however, left to the artist. Such a list, although not identical with this one, could also have been specified in the case of Michelangelo's fresco, which indeed contains in prominent positions certain holy figures (e.g. St. Lawrence and St. Bartholomew) *18, 19*

which do not occur in traditional Last Judgments. This would not signify that Michelangelo's own artistic freedom was hampered in any way. We have called attention elsewhere (Vol. II) to the fact that the High Renaissance artists were not simple illustrators of programs imposed from without but were free creators of form as well as spiritual content. In Michelangelo's fresco, too, the didactic schemes of the Hierarchies of the Angels, the Heavenly Tribunal, St. Michael holding the balance, Paradise, and Hell are eliminated. There remains only the drama of the *Adventus Domini* with the Last Judgment, and its reflection in the multitude of human souls.

The poem of St. Jerome on the fifteen signs of the Last Day as a possible source for Michelangelo was pointed out by Springer, *Rep.f.Kw.*, VII, pp. 378*ff*, but except for Thode, *Kr.U.*, II, p. 40, he was not followed by later investigators.

Feo Belcari, *Rappresentazione del dì del Giudizio*, a popular mystery play of the late Middle Ages, shows according to Thode, *Kr.U.*, II, pp. 46*f*, analogies with the fresco; but this mystery play is based on the same passages which Michelangelo could consult directly in the Bible.

32c. Several of the *master's poems* are quoted in the text in connection with the interpretation of certain figures; other may be mentioned here:

a) The identification of Fatum and Fortune (Fortune's wheel) can be found in Frey, *Dicht.*, LVIII:

> "Fortuna è'l tempo dentro a vostra soglia,
> Non tenta trapassar . . ."

Frey, *Dicht.*, CIX, 44:
> "Fortuna aspra e ria . . ."

b) The *motif of the upward floating of the soul* can be found in several poems, Frey, *Dicht.*, XIX:

> "Per appressar' al ciel, donde derivo . . ."

Frey, *Dicht.*, XCVII:

> ". . . quell'interno ardore
> Che mi leva di terra, e porta 'l core
> Dove per sua virtù non gli è concesso . . ."

Frey, *Dicht.*, CIX, 76:

> "Il montar cresce . . . e la lena mi manca"

Frey, *Dicht.*, CIX, 103:

> "E donde in ciel ti rubò la natura,
> Ritorni, norma agli angeli alti e chiari . . ."

Frey, *Dicht.*, CXXXIX:

> ". . . alzo il pensier con l'ali, e sprono
> Me stesso in più sicura e nobil parte."

c) Concerning the *fall of Michelangelo*, cf. Frey, *Dicht.*, XLVIII:

> "Caduta è l'alma, che fu già sì degna . . .
> Predetto suo iniquo stato."

d) For the *skin with the self-portrait*, one may quote Frey, *Dicht.*, LXXXVII: 

> "Deposto il periglioso e mortal velo,
> C'ancor ch'i cangi 'l pelo . . ."

For the *expression of the self-portrait*, cf. Frey, *Dicht.*, LXXXI:

> "La faccia mia ha forma di spavento . . ."

e) The *look of mercy of Vittoria Colonna*, Frey, *Dicht.*, XLI, XLVIII, and XCVI:

> "S'i begli occhi e le ciglia
> Con tua pietà vera volgi . . ."

f) Finally concerning Michelangelo's conceptions of Death, Judgment, and Redemption (through baptism) see his poem (Frey, *Dicht.*, CLX) to which Sauer (II. 2, p. 542) has already called attention:

> " . . . il *ciel* ne dié tal segno,
> Che scurò gli occhi suoi, la *terra* aperse,
> Tremorno i *monti* e torbide fur l'*acque*."

33. In the earlier representations of the *parousia* the triumphal rather than the dramatic aspect of Christ's second coming was always stressed. For the earlier Byzantine representations see Grabar, *L'Empereur*, pp. 249*ff*.

34. *Concerning the "illuminating images."* We have already emphasized elsewhere (Vol. II, pp. 24*ff*) that Michelangelo purposely used poetical metaphors—what Jacques Maritain calls "illuminating images" (see his brilliant book: *Creative Intuition in Art and Poetry*, New York, 1953)—by means of which the action portrayed suddenly becomes understandable as a cosmic event. In the case of the Last Judgment, as has been said in the text, the most important of these illuminating images are the Sun and its magic forces identified with Christ and the cosmic current-forces around the sun corresponding to the sidereal rotations (Tolnay, *Jugement*, 1940). The analogy with a thunderstorm had been observed several times, for example by Thode (*Ma.*, III, p. 599) when he says: "Aus der Gewitterwolke, die . . . die Erde in Düsternis hüllend, dahinstürmt, zuckt der Blitz, zugleich vernichtend und reinigend." He quotes Matthew 24: 27: "For as the lightning cometh out of the east, and shineth even unto the west; so shall also the coming of the Son of man be"—a sentence which might have inspired Michelangelo according to Thode.

35. The earliest representation of skeletons in a scene inspired by the Resurrection of the Dead is probably a drawing by Leonardo in Windsor (12.388) ca. 1500. We find it also in Signorelli's fresco of the Resurrection of the Dead in the Cappella Brizio in Orvieto (1499-1504), the influence of which on Michelangelo has been stressed by Vasari and earlier scholars. In Signorelli's fresco the skeletons still revert to the Dance of Death tradition (see L. Guerry, *Le Thème du Triomphe de la Mort dans la Peinture Italienne*, Paris, 1950). The skeletons which are already clad with muscle appear like nudes *ecorchés* and, finally, there are, standing in groups, those who have been completely resurrected. The different phases described by Ezekiel are here represented

as literary *concetti* rather than as a visual sequence. It was Michelangelo who, for the first time, connected these different phases in his fresco to produce a convincing visual sequence.

14

Concerning the figure of *St. Stephen the Deacon*, see our note 52 below.

36. The whole *upper part of the fresco* was interpreted by Justi (p. 328) as a representation of the Citizens of Heaven in Paradise. Feldhusen accepted Thode's interpretation of the upper section as Choirs, but she differed in the designation of the groups. According to her there would be, at Christ's left, the Choir of the Apostles led by St. Peter, and on the other side, the Choir of the Prophets, led by St. John the Baptist (and not, as Thode supposes, the Choir of the Patriarchs, led by Adam). At the right border of the fresco would be the Choir of the Confessors (led by Dismas), and behind them the Choir of the Patriarchs (and not, as Thode supposes, the Choir of the Prophets). The left border of the fresco would include, in the first plane, the Choir of the Virgins, and, behind them, the Choir of the Sibyls. Between the Choir of the Confessors and the Apostles is the Choir of the Martyrs. This interpretation suffers from the defect, as does Thode's, that the Choir of the Prophets or the Patriarchs can hardly be placed at the right side of Christ if it is to conform with iconographical tradition. Moreover, St. Andrew would be out of place in a Choir of Prophets or Patriarchs. These are some of the reasons for our interpretation of the inner circle of figures around Christ as consisting exclusively of personages belonging to the New Covenant, while those relegated to the outer circles on both sides would belong to the Old Testament.

That there are several saints, not usually represented, in the inner circle and in the Choir of the Martyrs may be explained by the fact that the All Saints' Feast was one of the most important celebrated in the Sistine Chapel. The unveiling of both the Sistine Ceiling and the Last Judgment took place on this same Holy Day. It remains an open question whether the inclusion of these Saints was the wish of the Pope or the College of Cardinals or simply Michelangelo's own idea.

37. *Notes on the individual figures*: the first attempt to connect all the figures included in the fresco with historically known personalities stems from Abbé Rouvier in: L. L. Chapon, *Le Jugement dernier de Michel Ange*, Paris, 1892, written on the occasion of the publication of the engraving by Chapon. Abbé Rouvier gave a name to each of the 391 figures. Further attempts in this direction were made by Steinmann, Thode, and A. Bertini Calosso, *IV Centenario*, pp. 45*ff.* Justi, *Ma.N.B.*, p. 180, expressed doubt as to the possibility of achieving such a goal, an opinion which we share, since, as we stated in the text, Michelangelo's theme was to represent *omnes gentes*. Our identifications in the text are offered merely as suggestions since they are incapable of strict proof.

The relatively few figures that can be identified as historical personalities are represented either because of the general tradition of the Last Judgment, like Christ,

the Virgin, St. Peter, St. Paul, St. John the Baptist, etc. or because of their special importance in connection with the feasts celebrated in the Chapel.

38. The *figure of Christ* is a kind of synthesis of the Damning Christ of earlier Last Judgments from the time of Traini, Pisa, Campo Santo, the Zeus hurling the lightning bolt as he appears in Michelangelo's Fall of Phaeton (Justi, p. 323), and the Apollonian type of Resurrected Christ in Michelangelo's drawings.

The derivation from the Traini tradition (i.e. Traini, Fra Angelico, Giovanni di Paolo, Fra Bartolommeo) is mentioned by Thode, *Kr.U.*, II, p. 21. To this type belongs the Christ of Bertoldo di Giovanni anticipating that of Michelangelo by its nakedness and mentioned for the first time by Bode.

Christ was described by Condivi (p. 162) and Vasari (p. 163) as having an expression of anger. This observation was taken over by Lomazzo and by most of the later critics. This interpretation of the expression of the face was probably inferred from the gesture and transferred to the face, which is actually impassive. Montégut, *Poètes et artistes de l'Italie*, Paris, 1881, p. 276, was perhaps the first to describe the Christ adequately, when he said, "Il est l'exécuteur d'un décret arrêté dès l'origine des temps." Justi (*Ma.N.B.*, p. 322) follows Montégut and speaks of a "schweigender Vollzug einer furchtbaren Pflicht." See also Steinmann (*Sixt.Kap.*, II, p. 530).

The significance of the gesture of the left arm and hand of Christ is still disputed. According to tradition, it should point to the lance wound, see Panofsky, *M. J. Friedländer Festschrift*, 1927, p. 308. But the pointing to the wound is not clearly expressed in the last version as it is in the Casa Buonarroti drawing and in the drawing in the Uffizi; rather the left arm completes the damning gesture of the right in that the Damned are thus warded off. Riegl (p. 39) and Justi (p. 325) have interpreted this gesture similarly.

The resemblance to the Apollo Belvedere was stressed for the first time by A. L. Castellan, *Lettres sur l'Italie* in 1819, I, p. 211 (see Dörken, p. 31). The resemblance of the head to that of the Apollo Belvedere was especially emphasized by Grimm, 1863, p. 81. The Apollonian character, in a more general and spiritual sense, has been stressed by Tolnay, *Jugement*, 1940. (According to Kleiner, pp. 47*ff*, this connection is not the result of conscious thought but is only incidental.) Regarding the substitution of the *Sol Iustitiae* for the *Sol Invictus* of antiquity see Tolnay, *Jugement*, 1940, and below. In the oval-shaped light aureole around Christ, Michelangelo seems to have reverted to the egg-shaped clouds of light which enveloped and protected the heroes of antiquity and those of early Christian art (e.g. Mosaics in Rome, Santa Maria Maggiore). Michelangelo substituted the ancient symbol for the Christian mandorla which, however, derived from it (see Brendel, *G.d.B.A.*, 1944, pp. 5*ff*).

39. The *Virgin* is a synthesis of the traditional Virgin type with kerchief and cloak and that of the ancient crouching Venus and Amor group. This latter interesting connection was kindly pointed out to us by Dr. Gertrude Coor. The Virgin is seated as usual to the right of Christ but contrary to tradition, she is presented as a contrast

to Christ to whom she is now fully subordinated. She is presented in smaller size than her son, and her huddled posture is strikingly opposed to the expansive movement of Christ. Vasari has already interpreted her facial expression as full of "gran timore." Indeed she does not take part in the condemnation proclaimed by her son; rather she turns away in fear of the action. The fact that she is no longer an inter-

133 cessor, as she still was in the Casa Buonarroti drawing and probably in the now lost cartoon, led Carla Lanckorónska, *Annales*, to assume that this figure was changed by Michelangelo as a result of the influence of the ideas of Vittoria Colonna who did not believe in Divine Intercession.

16 40. *St. John the Baptist* is the figure called Adam by Vasari (1568, p. 165) but St. John by Condivi (p. 166) and Lomazzo, *Trattato*, I, p. 30. The latter interpretation seems to be the more likely because of his position at the right of Christ and his hairshirt. Although most scholars follow Vasari, Condivi's opinion was shared by Platner, *Beschreibung Rom's*, 1842, II, p. 254; Lanckorónska, *Annales*; Tolnay, *Jugement*, 1940, p. 134; and De Campos, 1944, p. 30. The similarity in proportions to the Lysippian Hercules Farnese was stressed for the first time by Feldhusen.

41. Between this figure and that of the Virgin we see the back of *St. Andrew*, holding his cross.

17 42. *St. Peter* is holding in his left hand the Golden Key and in his right the Silver Key of Paradise. This variation from the usual representation where both keys are either held in or dangle from his right hand may be explained by the fact that it is his left arm which is more visible to the beholder and therefore the more important of the two keys is put in this hand. G. Weise in *Tübinger Forsch. zur Kg.*, 9, p. 27.

17 43. The figure with the long beard behind St. Peter is *St. Paul*.

18, 19 44. *St. Lawrence* and *St. Bartholomew* are represented in such prominent places, directly below the feet of Christ, because of the calendar of feasts of the Sistine Chapel (Pastor II, p. 690; Steinmann, *Sixt.Kap.*, I, p. 549; Wind, *G.d.B.A.*, 1944, p. 223 n. 32.) The first mass in the chapel was celebrated August 8, 1483, on the Vigil of St. Lawrence's Day, which was the anniversary of the election of Pope Sixtus IV, who built the Chapel. On St. Bartholomew's Day, August 24, 1483, Sixtus IV himself celebrated mass for the first time in the Chapel.

St. Lawrence's right leg is a repetition of the right leg of the Prophet Jonas above him. The pose of the figure reminds us also of one of the *ignudi* of the Sistine Ceil-

156 ing. A study for the right leg is preserved in the Codex Vaticanus. The Saint is holding his grill in his left hand.

That St. Bartholomew has the features of Aretino was first observed by Ricci in *Il Giornale d'Italia*, 1925, June 2. See also Tolnay, *Jugement*, 1940, and Bertini-Calosso, 1942, pp. 45ff. The pose in *contrapposto* shows a resemblance to the torso of Belvedere (Justi, *Ma.N.B.*, p. 328). The head, arms, and legs show an attempt by Michelangelo to complete this ancient fragment. That Michelangelo did make reconstructions of this fragment is, moreover, known through Lomazzo, *Trattato*, p. 38

(see also Thode, *Kr.U.*, ii, p. 303). The Saint is holding in his left hand the skin with the portrait of Michelangelo (see below) and in his right the flaying instrument.

45. Concerning the *symbolism of Mercy and Justice* in the Last Judgment see E. Mâle, *L'Art religieux de la fin du Moyen-Age*, Paris, 1922, 2nd ed., pp. 9, 459; and F. H. Taylor, *Worcester Art Museum Annual Report*, I, 1935-1936, pp. 1*ff*.

46. Concerning the *Mother and Child group*: the large female figure at the left, *20* roughly analogous to that of Dismas, who takes a saved soul unto her lap, is interpreted by us to be *Ecclesia* (see Tolnay, *Thieme-Becker*, 1930). Ecclesia personified as "la Bella Donna" already had occurred in Dante, *Inferno*, xix, 57. That this group recalls the ancient Niobe group was suggested first by Guattani, *Memorie Enciclopediche Romane*, iii, 1808, p. 103. The Niobe group of the Uffizi was, however, discovered only in 1583, some forty years later. Kleiner (p. 45) says, therefore, that since Michelangelo could not have known this group, the similarity must be due to an independent development "selbstständige Formbegegnung." However, the similarities are so striking that we must assume that Michelangelo knew another copy, today lost. This is also the opinion of Feldhusen, who rightly emphasizes that under Paul III, during the rebuilding of Rome, many ancient statues were destroyed (Pastor v, pp. 171, 750). It is in general not valid to assume that an ancient work which no longer exists today could not have existed in the sixteenth century. The relationship between Ecclesia and the Believer is that of Mother and Daughter, just as is the relationship of Niobe to the Niobides. Concerning the Niobe myth in antiquity see K. Kerényi, *Niobe*, Zürich, 1949 and Schefold, in *Phoebus*, i, 1946, pp. 49*ff*. Dante, *Purgatorio*, xii, 37-39, also knew this myth. (Steinmann sees St. Anne in the figure; Kallab, Beatrice and Rachel; Feldhusen, Magdalene and the woman who has sinned.)

47. *Concerning Dismas, the Good Thief*: the figure was called Dismas by Kallab, *21* Steinmann, Justi, and Feldhusen. De Campos sees in it Simon of Cyrenae. We accept the Dismas hypothesis but emphasize in the text that the manner in which this figure re-enacts the carrying of the Cross corresponds to the manner in which the Martyrs in the fresco repeat their Martyrdom. The Cross is here, therefore, a *corpus delicti* of the sins of humanity and a symbol of justice (see Tolnay, *Jugement*, 1940).

The fact that in Byzantine Callings of the Elect Dismas always appears in the lower *272, 273* right corner also tends to support this identification.

48. *Concerning Abraham*: this aged white-bearded figure, belonging to the group *9* which includes our "Adam," could be the patriarch Abraham, in which case the corresponding woman on the other side would logically be his wife Sarah. This figure *8* was called Job by Justi and "probably Adam" by Feldhusen, who considered the youth beside him to be Eve.

49. *Concerning St. Andrew*: this figure has been so named by Feldhusen because of his Andreas-cross, seen in foreshortening. It is called St. John the Baptist by Kallab, and Dismas by Justi, Thode, and De Campos.

9 50. *Concerning the Martyrs*: these figures have been interpreted since the time of Condivi as thirsting for revenge: brandishing the instruments of their torture, they were thought to be appearing before Christ in the role of accusers. This is actually

137 how they appear in the Uffizi drawing, but in the fresco they seem to be reviving their martyrdom in their movements and gestures. Their faces no longer have the expression of hate. Thus Michelangelo spiritualized this group. It was in this sense that Tolnay, *Cod.Vat.*, interpreted this group for the first time; see also *idem, Jugement*, 1940. Our interpretation has been accepted by Feldhusen. On the other hand, Lancko-rónska, *Annales*, believes that the Martyrs are seeking to ward off the damnation of Christ by holding up the various instruments of their torture. But this is true only of St. Peter, and perhaps St. Bartholomew. The figure with the cross seems to be St. Philip, as was first stated by Platner (*Beschreibung der Stadt Rom*, Stuttgart, 1839-1842, II, p. 285).

47 51. *Concerning Adam*: this figure has been called Moses by Thode, Justi, and Feldhusen, but he lacks Moses' characteristics, horns or rays.

32 52. *Concerning St. Stephen the Archdeacon*: the standing figure at the lower left, who leans toward a group of the resurrected, identified also as Ezekiel (Kallab), sometimes as Virgil (Steinmann), or even as an angel (De Campos), is more probably to be understood as the Archdeacon St. Stephen performing works of charity. This denomination would correspond to the tradition of Last Judgments of the Middle Ages, as, for example, the thirteenth century Last Judgment in the Vatican. It is curious that his features resemble those of the ancient busts of Plato (Tolnay, *Jugement*, 1940), e.g. Furtwängler-Urlichs, *Denkmäler griechischer und römischer Skulptur*, Munich, 1911, p. 173, or those of other ancient philosophers. This is perhaps no accident. The neo-Platonism of the Renaissance attempted to reconcile the philosophy of Plato with the Bible. In giving to the Archdeacon the head of an ancient philosopher, Michelangelo may have been trying to suggest that St. Stephen was a man of wisdom with special knowledge of the other world. Berenson thought he recognized in this figure the features of Michelangelo.

14 53. *Concerning the Scene of the Resurrection of the Flesh*: according to Condivi and Gilio da Fabriano (p. 97), Michelangelo painted this scene after the vision of Ezekiel (37: 1-11). The same source was used by Signorelli in his fresco of the Resurrected in the Cappella Brizio. In Michelangelo the successive phases of the Resurrection are connected to the action of preparation for the heavenly ascent.

10, 14 54. *Concerning the Heavenly Ascent of the Elect* who seem to be drawn up by invisible forces: this motif (which reverts to St. Paul, 1 *Thess.* 4: 16-17) is rare in Italy, but it was not as has been thought (Feldhusen, von Einem) completely unknown before Michelangelo. It occurs, for example, in Signorelli (separated, however, from

274 the scene of the Resurrection) and in the Florentine woodcut of ca. 1480. It is, therefore, not necessary to invoke northern influences, as for example, Bosch (Feldhusen, von Einem). That Michelangelo utilized motifs from his earlier work, the Battle of

Cascina, among the downward-reaching figures on the cloud has been observed by Steinmann and Justi.

In this group of floating Elect at the left of the second zone, we have attempted to trace the representation of the feelings which would correspond to the three Cardinal Virtues. Our interpretation is supported to some extent by the analogy to the incarnation of the Vices on the opposing side, the Vices having already been recognized by Condivi (p. 162) and Vasari (1568, pp. 165, 167).

The Negro couple, whom we interpret as representing Faith, are being raised up with the help of a rosary; the rosary had already been mentioned by Gilio da Fabriano (1564), p. 101: "la corona denota l'orationi esser state cagione de la colui salute." The rosary, today partly effaced, was originally a real chain, which also passed through the right hand of the figure leaning above the Negro couple. Panofsky (*Jahrbuch für Kunstgeschichte*, Vienna, 1921-1922, Heft 4, *Buchbesprechungen*, col. 62), supposes a relationship between the chain-like rosary and the "golden chain" of antiquity which connects Heaven and Earth. But Michelangelo himself used the metaphor "la catena della fede" in one of his poems, as mentioned in the text. Steinmann points to Dante (*Purgatorio*, IV, 28: "con l'ali snelle . . . del gran disìo") as source.

55. *Concerning Charon, Minos and, the Damned*: this scene reverts to Dante's *Inferno* (III, 109-111 and V, 5-6), as was mentioned by Varchi, Condivi, and Vasari. The same passage influenced Signorelli in the Cappella Brizio and earlier, Nardo di Cione, in the Cappella Strozzi, Santa Maria Novella in Florence. Michelangelo's Charon is a synthesis of ancient satyrs and horned devils of the Middle Ages. Minos also has satyr form (Justi, Tolnay), but at the same time he is influenced by representations of the Prince of Hell from the Middle Ages, as for example, that of Orvieto (Feldhusen). The motif of the serpents can be found in Etruscan death demons. As has been mentioned in the text, the silhouette of the group of Damned jumping from the boat into the abyss reminds us of the shape of the River of Fire in some earlier Last Judgments, e.g. Giotto.

56. *Concerning the Struggle of the Damned*: this scene was also inspired by ancient Gigantomachia sarcophagi (e.g. Vatican) or ancient mosaics.

57. *Concerning the lunettes*: they represent Angels who struggle with the elements and try to set up the instruments of the Passion. Vasari calls the figures "figure ignude," while Condivi calls them angels. In actuality they are angel-genii. In the erection of the Cross and the Column, the meaning of the Passion is manifest: in the bringing in of the Cross, an allusion is made to Christ's carrying of the Cross and in the rotation around the Column the flagellation scene is evoked (Tolnay, *Jugement*, 1940). Cross and Column are also triumphal signs of the Redeemer (Matt. 24: 30). See: Berliner, "Arma Christi," *Münch. Jahrb.*, 1955, pp. 35*ff*. Both scenes probably revert to the ancient conception of the erection of the Tropaions (Feldhusen).

The Angels are servants and messengers of Christ. We have shown elsewhere (Vol.

II, pp. 63*ff*) that Michelangelo was profoundly influenced by the ancient genii conception and that, for the Renaissance, genii and angels were equivalents.

12 58. *Concerning the Trumpeting Angels*: Michelangelo was, according to Condivi and Vasari, inspired by Rev. 8: 2, 6-9. According to the representational tradition, there were always two or four trumpeting angels in the scene (Matt. 24: 31). Michelangelo shows eight. The four in the left half of the group with their puffed-out cheeks are inspired by ancient wind gods (also Steinmann). There may also be an influence from Ezek. 37: 8-10. The Books held by two of the Angels revert to Rev. 20: 12. However, Michelangelo interpreted the text in an original way; the Scripture does not say that the Book in which the deeds of the Damned are written is large and that containing the deeds of the Elect very small. In previous Last Judgments the inclusion of these books is unknown (occasionally there are scrolls instead).

13 59. *Concerning Limbo*: this grotto has been interpreted until now as the "mountain of Hell" but its location should be according to tradition close to the Damned at the right side. Feldhusen supposes that the fact that the "mountain of Hell" is here located in the central axis of the painting may be determined by the death offertory: "libera animas omnium fidelium defunctorum de poenis inferni et de profundo, lacer. . . ." In the text we have given the reasons why this grotto should be considered rather as Limbo.

60. *Concerning Michelangelo and antiquity*: we have attempted (Tolnay, *Jugendwerke*) to show that the artist fused ancient motifs with patterns of the Italian Trecento. (Wilde, *Eine Studie*, independently came to a similar conclusion.) This has been accepted by Lanckorónska, *Dawna Sztuka*, 1939, pp. 183*ff*, and it is the basis for the article by von Einem, "Michelangelo und die Antike," in *Antike und Abendland*, I, 1945, pp. 55*ff*. See also the valuable remarks by Feldhusen and G. Weise. On the other hand, we can hardly agree with the methods of Kleiner, *Die Begegnungen Michelangelos mit der Antike*, Berlin, 1950.

The experiencing of the entire event of the last day, not from the point of view of a static divine order, but from the point of view of man and his relationship to the macrocosmic forces, is the new feature which linked Michelangelo to the conception of antiquity. The ancient statues are not binding rules for Michelangelo, but only the point of departure for his inspiration. He does not imitate ancient statues exactly, but creates new paraphrases of the archetypical behavior of man already formulated in antiquity. This also explains why he reverted to ancient myths (myths of retribution, battles of giants and centaurs, and Charon and Minos).

29
285a 61. The shielding of the eye by the desperate damned occurs in the ancient mosaic of Piazza Armerina representing a vanquished titan. (This connection was kindly pointed out to us by Rina de Tolnay.)

55 62. The *portrait of Michelangelo* on the skin held by St. Bartholomew was identified by La Cava, *Il volto di Michelangelo scoperto nel Giudizio Finale*, Bologna, 1925. (The present author made the same identification independently in the winter of

1924-1925 communicating his discovery to his friends: Count Karl Wilczek, J. Wilde, and A. Schoen.) A letter by Don Miniato Pitti to Vasari, dated May 1, 1545 (Vasari, *Carteggio* I, p. 148), proves that Michelangelo's contemporaries had already noticed that the skin held by St. Bartholomew did not bear the features of the Saint. In the engraving by Beatrizet, the name of Michelangelo is inscribed just below the skin as a kind of legend.

63. *Concerning the hypothesis of the veiled head of the woman* behind St. Lawrence *18* as a possible portrait of Vittoria Colonna see Tolnay, *Jugement*, 1940. In a poem by Michelangelo (Frey, *Dicht.*, LXVIII) the poet begs Vittoria Colonna to succor him in his predicted pitiable state and in another poem (Frey, *Dicht.*, XCVI) he returns to this idea of his cursed fate. Concerning the known portraits of Vittoria Colonna, see our Note 7 in Chapter III.

64. The head just behind St. Bartholomew has tentatively been identified by *19* Thode, *Kr.U.*, II, p. 56, as St. Thomas with the features of Tommaso Cavalieri. See also Tolnay, *Jugement*, 1940. Other authors (for example, De Campos) see in it the portrait of Urbino, Michelangelo's servant. It is questionable, however, whether the artist would have given Urbino such a prominent place.

65. Concerning the head of St. Bartholomew as a portrait of Pietro Aretino, see our note 44 above.

66. The correspondence between Michelangelo and Aretino has been published by Steinmann-Pogatscher, *Rep.f.Kw.*, 1906, pp. 485*ff*; *Lettere sull'Arte di P. Aretino*, ed. E. Camesasca, Milano (n.d.), Vol. I, pp. 64*f*, 113; Vol. II, pp. 15*f*, 21, 62, 175*ff*, 162, 300.

67. The criticism of the Last Judgment by Gilio da Fabriano (see II, 81) is based on arguments similar to those of Aretino.

It is noteworthy that in Paolo Veronese's trial before the Holy Tribunal in 1573 (Pietro Caliari, *Paolo Veronese*, Rome, 1888, pp. 102*ff*), he defended himself by pointing to Michelangelo's Last Judgment, where, he says, all the figures are represented nude and in different poses with little reverence. The inquisitor, however, took the part of Michelangelo, declaring that in a painting of the Last Judgment no clothing need be presumed and that in Michelangelo's figures there is nothing that is not "spiritual." This reveals that the Inquisition in Venice was more liberal than it was in Rome, where Michelangelo's Last Judgment was criticized, among other things, because of this very nakedness of the figures, which was considered inappropriate both to the subject and to the place it was intended to decorate.

68. *The portrait of Dante* which appears above the tonsured head at the right rear *48* of Christ was first observed by Domenico Anderson and this discovery was published by Nogara in *Rendiconti della Pontificia Accademia Romana dell' Archeologia*, 1934, pp. 170*ff*. (Steinmann believed that the resurrected figure just below our St. Stephen [Steinmann's Virgil] is meant to be Dante; J. Diaz-Gonzalez, *Quello che ho visto nel Giudizio Universale di Michelangelo*, Rome, 1951, sees the profile of Dante's head in the masses of the Last Judgment.)

69. Concerning the presumed portraits of Julius II, Clement VII, and Paul III, see Bertini-Calosso "Ritratti nel Giudizio Universale" in *M.B. nel IV Centenario del Giudizio Universale*, Florence, 1942, pp. 45ff.

70. *Concerning the cosmological Aspect*:

The interpretation of the circles of figures as representations of the revolving motion of the heavenly bodies around the Helios-Christ was first made by Tolnay, *Jugement*, 1940. We supposed that this concept was probably derived from the astral myths of antiquity. Michelangelo could have found allusions to these astral myths for example in Plato's *Timaeus*, chaps. 7 and 8 and in Lucretius *De Rerum Natura* I. 1. 2. Already in antiquity the conception of the stars was linked to the idea of the souls of the dead who find in the stars their home. And from this it becomes evident that Michelangelo's fresco evokes not only the Judgment but also the life of the souls after death.

We are pleased to see that Feldhusen agrees in all main points with our cosmological interpretation. She supposes that in addition to the ancient astral myths, the cosmic visions of the Bible may have inspired the artist (the Apocalypse and the Visions of the Prophets). She mentions, moreover, that the tradition of the Judgment in the Middle Ages also included cosmological conceptions. She offers the suggestion that the artist might even have known the panel of the Vatican with its circular shape and certain Last Judgments containing representations of the zodiac. Our cosmological interpretation has also been accepted by von Einem, *Kunstchronik*, 1955, p. 90, who repeats Feldhusen's remarks and it is set forth in a way similar to ours by Miguel de Ferdinándy in his *El simbolo del macrocosmos en el Juicio Final de Miguel Angel y la tradicion medieval*, Universidad de Puerto Rico, n.d. The rotation is for him, too, not a purely aesthetic device (Riegl) but rather the movement of the macrocosmos. However, he considers only the inner circle of rotation around Christ and says that in the four corners of the fresco there are four more or less separable parts: the two lunettes, the resurrection of the Dead and the Acheron. But the movements in the lunettes seem to be inseparable from the great rotation of the outer circle. Ferdinándy agrees with our conclusion that Michelangelo's Last Judgment is a heliocentric image of the infinite macrocosmos, anticipating the Copernican universe and that of Giordano Bruno. Actually the revolving movement around a center is an archetypal image of humanity and can be found in the Far East, as in the West, from the earliest times.

71. Regarding the substitution of the *Sol Iustitiae* by Christianity for the ancient conception of *Sol Invictus*, see H. Usener, *Das Weihnachtsfest*, Bonn, 1911; *idem*, "Sol Invictus," in *Rheinisches Museum*, LX, pp. 465ff; F. Boll, *Die Sonne im Glauben und in der Weltanschauung der alten Völker*, Stuttgart, 1922; E. Norden, "Die Geburt des Kindes," in *Studien d. Bibliothek Warburg*, III, 1924; F. J. Dölger, *Sol Salutis*, Münster, 1925; Hautecoeur, *Mystique et Architecture*, Paris, 1954, p. 177.

Other examples of such fusions of ancient gods with Biblical figures or Christian saints in the Renaissance are found in A. Warburg, *Gesammelte Schriften*, II, pp. 451ff and J. Seznec, *La Survivance des Dieux Antiques*, London, 1940. Michelangelo had

265

already made analogous assimilations in his youth e.g. between Hercules and David (as has been shown by Tolnay, *J.d.p.K.*, 1933, and *idem*, Vol. I, pp. 150*ff*).

72. Concerning the revolving movement in the astral myths of antiquity see J. Carcopino, *La Basilique Pythagoricienne de la Porte Majeure*, Paris, 1926, pp. 268*ff*.

Dante (*Paradiso*, II, 127-129) also knew the concept of the rotation of the Ptolemaic spheres around the earth.

Concerning the return of the human souls to the Heavenly spheres see also Lucretius, *De Rerum Natura* II. 5. 999*ff*.

73. The probable reason why the revolving movement of Michelangelo's composition has been overlooked was the constant dependence of historians upon the earliest descriptions of the Last Judgment by Vasari and Condivi, who saw in it only a composition in horizontal zones one above the other. Riegl, in *Entstehung der Barockkunst in Rom*, Vienna, 1908, p. 41, was the first to emphasize the circular movement, but saw in it a purely formal compositional pattern and did not mention its significance as the cosmic whirling of the universe.

74. Concerning the *Rotae Mundi* see also F. Cumont, "La Roue à puiser les âmes du Manichéisme" in *Revue de l'Histoire des Religions*, 1915, II, pp. 384*ff*: "Les Manichéens avaient imaginé une machine munie de 12 jarres ou pots qui, tournant avec la sphère céleste, puisait les âmes des morts et les portait jusqu'aux vaisseaux du soleil . . . cette roue n'était autre dans la pensée de Mani que le cercle du Zodiaque." (This article has been brought to our attention by Meyer Schapiro.)

For the Wheel of Transmigration in the East and for the Wheel of the Six Ages of the World, See Baltrušaitis, *Le Moyen-Age Fantastique*, Paris, 1955, pp. 251*ff*.

75. Concerning the circular form as symbol of the *Orbis Universus* or *Sphera Celestis* in earlier Last Judgments, see Paeseler, "Die römische Weltgerichtstafel im Vatican," in *Jahrb.d.Bibl.Hertziana*, 1938, pp. 311*ff*; Gabriel Millet, *La Dalmatique du Vatican*, Paris, 1945; Feldhusen; von Einem, *Kunstchronik*. Ferdinándy calls attention to the fresco of Piero di Puccio representing the "macchina dell' Universo" (Vasari) in Pisa Camposanto.

76. Leonardo represented the circular cosmic forces in his series of Deluge Landscapes, Windsor Castle. See K. Clark, *Leonardo da Vinci*, Cambridge, 1939; *idem*, *Catalogue of the Drawings of Leonardo da Vinci at Windsor Castle*, Nos. 12376-12386; Gantner, *Leonardos Visionen von der Sintflut und vom Untergang der Welt*, Bern, 1958.

77. Examples of the Wheel of Fortune of the Sun and Life can be found in Tolnay, *Jugement*, 1940; Hautecoeur, *Mystique et Architecture*, Paris, 1954, p. 177.

278-282

78. Concerning the *fortuna* symbols in the Middle Ages and in the Quattrocento see Doren, "Fortuna im Mittelalter und in der Renaissance," in *Vorträge der Bibliothek Warburg*, 1922-1923, pp. 71*ff*.

79. The greatest Italian artist who applied and modified Michelangelo's cosmological conceptions of space and movement was Tintoretto. The figures in his canvases

describe circular movements and at the same time seem to revolve upon their axes. This is perhaps the most important aspect of Michelangelo's influence upon Tintoretto, outweighing even the significance of his isolated borrowings in design, proportion, modeling and movements of the figures.

Concerning Tintoretto's cosmological compositions see Tolnay, "The Music of the Universe," in *Journal of the Walters Art Gallery*, 1943, pp. 83*ff*, and Benesch, *The Art of the Renaissance in Northern Europe*, Cambridge, 1945, pp. 125*ff*. (cf. also Tolnay, "Tintoretto's decoration of the Salotto Dorato in the Palazzo Ducale," in *Onoranze Mario Salmi*, 1959 [in preparation]).

80. Michelangelo's cosmological vision in his Last Judgment is not, properly speaking, scientific (although in part probably influenced by the science of his day), but it is primarily religious. The heliocentrism, which was rejected by the official theology of the sixteenth and seventeenth centuries had nevertheless been considered as a valuable religious symbol by Copernicus himself, later by Galileo, by Giordano Bruno, and by such theologians as Berulle (1575-1629), whose writings contain analogies to Michelangelo's conceptions. A world which has the sun, the source of all light, as its center is more in accord with the "Divine Majesty." This is a striking analogy to Michelangelo's heoliocentrism. Berulle said that "this new opinion (heliocentrism), little followed in the science of the stars, is useful and must be followed by the science of salvation." (Quoted from P. H. Michel, "Léonard de Vinci et le problème de la pluralité des mondes," in *Léonard de Vinci et l'expérience scientifique au XVIe siècle*, Paris, 1953, pp. 41*f*.)

81. *Highlights in the appreciation of the Last Judgment since the sixteenth century*:

Vasari and Condivi describe the Last Judgment only in part from their own visual experience. For the rest they rely on their preconceived notions, which derive from tradition. This explains their overlooking the most essential new feature, the revolving movement around the center and the impassivity of the face of Christ.

For both, Vasari and Condivi (p. 158), the Last Judgment is a compendium of the human body: "in quest' opera Michelagniolo espresse tutto quel che d'un corpo humano può far l'arte della pittura, non lasciando indietro atto o moto alcuno," and elsewhere (p. 170) Condivi says: "si vede rappresentato tutto quel che d'un corpo humano possa far la natura." The composition he describes in one sentence as a symmetrical scheme divided into horizontal zones, just as if it were a traditional Last Judgment, "E'l tutto essendo diviso in parte destra et sinistra, superiore et inferiore, et di mezo" (p. 160). He is also bound by tradition in the description of the single scenes or figures, as for example when he says of Christ: "il figliuol de Iddio in maiestà" (p. 162), whereas Michelangelo did not represent Christ as *Rex Gloriae*. Christ for him condemns in anger, "irato maledice" (p. 162), and this may have been the source of the later hypothesis that Michelangelo's Last Judgment is an illustration of the *Dies irae, dies illa*.

Vasari (1550 and 1568) is somewhat more personal in his judgment. First of all,

he ranks the Last Judgment higher than the Sistine Ceiling (p. 163). He too sees in the fresco a kind of compendium of the "perfetta e proportionatissima compositione del corpo humano in diversissime attitudini" and he adds that Michelangelo also represents "gli affetti delle passioni et contentezze dell' animo." And: "rappresenta tutti possibili humani affetti" (p. 167). But he tries, moreover, to characterize the style when he says that Michelangelo, "mostra la via della gran maniera e degli ignudi; e quanto e' sappi nelle difficoltà del disegno." Finally he makes the remark that Michelangelo, "ha lassato da parte le vaghezze de' colori, i cappricci e le nove fantasie." He speaks of the "terribilità dell'arte" of Michelangelo (p. 167); he emphasizes the "morbidezza" of the modeling and the beauty of the "contorni" (p. 169), and he concludes that this is "l'esempio" of the "gran pittura." He describes the Christ, as does Condivi, "con faccia orribile e fiera." He sees "la miseria dei dannati e l'allegrezza de' beati"; he is here blind to the real representation and repeats what he knows about the Elect in a Last Judgment. The "santi e sante si abbracciano e fanno sì festa, havendo . . . la beatitudine eterna." Nothing of such a celebration is actually visible in the fresco.

It was Vasari and Condivi who coined the generally accepted interpretation of the zones of Michelangelo's Last Judgment and of the anger of Christ, and they expressed the idea that the highest merit of this fresco is that it unites, like a compendium, all the movements of the human body and represents all man's passions.

At the end of the sixteenth century, we find again in Lomazzo, *Idea del Tempio della Pittura*, Milano, 1590, the opinions of the earlier biographers, i.e. that the Last Judgment is a compendium of the movements of the human body, that it represents the wrath of Christ and that in some details Michelangelo followed Dante. But Lomazzo no longer appreciates the Last Judgment as the greatest achievement of the artist; he sees in it a "seconda maniera" of Michelangelo which is less perfect than the first, exemplified by the Sistine Ceiling. He adds two new observations: first, he treats in detail the *"perspective ralentie,"* and says (*Trattato*, II, p. 179): " . . . se il pittore avrà da fare una grandissima facciata piena di figure, acciocchè paiano all'occhio che le vede uguali, ad ogni modo la prima più bassa sia più picciola delle altre, e l'altra di sopra si accresca alquanto, e di mano in mano vi si aggiunga sempre proporzionatamente, di modo che all'occhio vengano tutte uguali. Perchè se nella facciata fossero tutte di una quantità e grandezza, non è dubbio che le alte parrebbero troppo minori rispetto a quelle collocate da basso, sì che la facciata in cima sfuggirebbe. E però con tal regola, Michelangelo fece il suo mirabile Giudizio. . . ." (See also Lomazzo, *Trattato*, I, p. 47; I, p. 405.) Concerning the lighting, Lomazzo says, "veggiamo Michelangelo avere solamente osservato un lume principale nelle superficie più ad esso lume, e negli altri di grado in grado averli minuiti proporzionatamente."

The contrary current of opinion had its first proponent, as has been said in the text, in Aretino, letter from 1545, and was carried on by Gilio da Fabriano, 1564. The three chief reproaches against the Last Judgment were: that it is amoral; that it is

in its iconography, contrary to the historical truth, i.e. to the teachings of the Church; and that Michelangelo holds his art higher than his religion. The writers of the Enlightenment repeated these opinions, as for example Mengs, Fréart, Richardson, Volkman, Mariette, Milizia, Azara. Even in the mid-nineteenth century Jacob Burckhardt followed these judgments in part (see Tietze, in *Festschrift P. Clemen*, pp. 426*ff*).

A new admiration for Michelangelo in general and for the Last Judgment in particular appears only in late Classicism with Goethe and in the Romantic period with Stendhal and Delacroix.

Although Stendhal, in his *Histoire de la peinture en Italie*, 1817 (here quoted from the edition by P. Arbelet, 1924), only wanted to make a paraphrase of Condivi, Vasari, and Lanzi, he retouched their judgments and inserted some remarkable observations. First he contributed a new positive appreciation in contrast to Milizia, Azara, and Mengs, whom he considered "vulgar," and proclaimed anew the "grandeur" of Michelangelo's style. These others do not understand, "parce qu'ils sont vexés de je ne sais quelle sensation de grandeur qui pénètre jusques dans ces âmes sèches" (p. 272). He prophesied that "le goût pour Michel-Ange renaîtra" (p. 328).

Stendhal tried for the first time since Vasari, to characterize the style of Michelangelo though Vasari's influence is still perceptible: "méprisant tout ce qui est accessoire, tout ce qui est mérite secondaire, il s'est attaché uniquement à peindre l'homme." And then he adds, again paraphrasing Vasari, "il est allé jusqu'au terrible." He made an acute observation on the representation of the nude: "ce n'est que par la forme des muscles en repos que l'on peut rendre les habitudes de l'âme."

Concerning the whole composition of the Last Judgment, he says: "Michel-Ange a divisé son drame en onze scènes principales" (p. 264). From this sentence one would deduce that he did not grasp the dynamic unity of the composition with its revolving movement. But in the description of these "scènes" he does not proceed in horizontal zones but rather begins at left bottom and progresses through the rising Elect, the group of "Sibyls," the left lunette, the right lunette, the "Prophets," the struggling Damned, the Charon and Minos scene, to return in the center to the "mouth of Hell," to rise from there to the trumpeting angels and to end in Christ. This is a spiral movement, and one may ask whether he did not at least subconsciously feel the impact of the revolving movement. In any case, this sequence in the description is striking if one compares it with the earlier and contemporary descriptions, as for example that by Alexandre Lenoir, "Observations sur le génie de Michel-Ange," in *Annales Françaises des Arts, des Sciences et des Lettres*, 1820, in which one can read: "la composition de cet immense tableau présente une confusion telle que l'oeil distingue à peine les figures qui en forment l'ensemble. Les divers groups dessinent quatre plans différents, placés par étage . . . la confusion qui frappe d'abord vient de ce qu'il [Michel-Ange] n'avait aucune pratique de la perspective aérienne."

In Stendhal's description of the individual figures there are remarks of poetic 9 beauty. Concerning the groups of embracing Elect (p. 266): "Il y a deux groupes qui

s'embrassent; ce sont des parents qui se reconnaissent. Quel moment! Se revoir après tant de siècles, et à l'instant où l'on vient d'échapper à un tel malheur!" Another impressive description is that of the Desperate Damned Soul between the trumpeting Angels and the struggling Damned: ". . . il se tient la tête. C'est l'image la plus horrible du désespoir. Ce groupe seul suffirait à immortaliser un artiste" (p. 267). On the contrary, in the Christ-Judge he sees almost sadistic wrath: "C'est un ennemi ayant le plaisir de condamner ses ennemis. Le mouvement avec lequel il maudit est si fort qu'il a l'air de lancer un dard" (p. 270).

Stendhal is one of the first to mention the coloring: "Certainement le coloris n'a ni l'éclat ni la verité de l'école de Venise: il est loin cependant d'être sans mérite, et devait, dans la nouveauté, avoir beaucoup d'harmonie. Les figures se détachent sur un bleu de ciel fort vif" (p. 271). (This remark about the blue is probably based on the copy by M. Venusti.) He dedicates a chapter to the influence of Dante on Michelangelo, repeating Condivi and Vasari, but also adding this important analogy between the poet and the painter: "Comme le Dante, Michel-Ange ne fait pas plaisir, il intimide, il accable l'imagination, sous le poids du malheur, il ne reste plus de force pour avoir du courage, le malheur a saisi l'âme toute entière" (p. 283), . . . "Comme le Dante, son âme prête sa propre grandeur aux objets dont elle se laisse émouvoir, et qu'ensuite elle peint, au lieu d'emprunter d'eux, cette grandeur. Comme le Dante, son style est le plus sévère qui soit connu dans les arts, le plus opposé au style français" (p. 284).

Delacroix, who never saw the original, wrote twice on the Last Judgment. First, in 1830, in his article on Michelangelo published in the *Revue de Paris,* and a second time in 1837 in an article entitled "Sur le Jugement Dernier" on the occasion of the exhibition of the copy of the Last Judgment by Sigalon in the École des Beaux-Arts (Delacroix, *Oeuvres littéraires,* Paris, n.d.). In the first general article he gives a paraphrase of Condivi and Vasari, enriched by the influence of Stendhal to whom he renders homage. It is from this latter that he takes this sentence characterizing the style of Michelangelo: "Le style le plus sérieux qui fut dans les arts." He considers the Last Judgment, as the old biographers had done, as a compendium of the human body represented in all its attitudes and in all imaginable foreshortenings (p. 48). He speaks of Dante's influence and sees in Christ only vengeance (p. 49).

But in his second article, he gives a penetrating analysis of "le style le plus sérieux et plus chrétien qui fût jamais" and he tries to show that Michelangelo's style is the only one which is perfectly appropriate to such a subject: "Le style de Michel-Ange semble donc le seul qui soit parfaitement approprié à un pareil sujet. L'espèce de convention qui est particulière à ce style, ce parti tranché de fuir toute trivialité au risque de tomber dans l'enflure et d'aller jusqu'à l'impossible, se trouvaient à leur place dans la peinture d'une scène qui nous transporte dans une sphère toute idéale. . . . Michel-Ange avec ces dix ou douze groupes de quelques figures disposées symetriquement et sur une surface que l'oeil embrasse sans peine, nous donne une

idée incomparablement plus terrible de la catastrophe suprême qui amène aux pieds de son Juge le genre humain éperdu . . . c'est son style seul qui le soutient dans les regions du sublime et nous y emporte avec lui" (pp. 219-20). Finally he says: "la fermeté du style est si imposante et si continue qu'il semble que le tableau entier ait été peint à la fois et sous l'inspiration la plus soudaine" (p. 222). This remark is an amplified paraphrase of a sentence by Vasari.

Delacroix assesses Michelangelo's historical place when he says: "Michel-Ange est le père de l'art moderne . . . c'est à lui que s'arrête definitivement ce que j'appellerai l'art gothique, l'art naïf, si l'on veut, mais l'art qui ne brille qu'à des temps marqués" (p. 223).

Among the scholars of the second half of the nineteenth century there is at first a decline in understanding of the Last Judgment. Burckhardt, in his *Cicerone* (1855), adjudged the work as un-Christian in its conception, although he recognized a great richness of "poetical ideas" in it. He repeats the formula of Vasari and Condivi that the artist here took Promethean pleasure in depicting the naked human body in all possible positions. This viewpoint was taken over by Wölfflin in his compact analysis in *Die klassische Kunst* (1898). But Wölfflin further sees "das Grandiose der Anordnung" (the grandiosity of the arrangement) and he emphasizes that the articulating lines are the two diagonals which meet in the figure of Christ. He fails to mention the revolving movement of the composition. This movement was first pointed out, but as a purely formal pattern, by Alois Riegl, *Die Entstehung der Barockkunst in Rom* (1908), (already given in lecture form in Vienna in 1901-1902). He speaks of the "Rotierung um die Achse"; in other respects, however, the picture represents for him "Christ's subjective desire for revenge" (p. 40).

Justi (1909) was the first to attack the Vasari-Burckhardt-Wölfflin view that Michelangelo's principal intent was to display his mastery of the nude figure; Justi recognized (p. 317) that all the various devices employed were simply means to bring the subject matter closer to human understanding. He saw in the composition, above all else, the three zones—but at the same time he speaks of the "successiven Momenten der Handlung entlang einer links aufsteigenden Bogenlinie, die rechts herunter fällt. . . ." He praises the dramatic unity and he recognizes in it that which is "new" in Michelangelo's Last Judgment. It is surprising that along with such pertinent observations one finds in Justi's text metaphors from everyday life that are not suited to Michelangelo's heroic style and that were probably intended to make Michelangelo's work more comprehensible.

Thode (1912) like Justi, stresses the dramatic unity of the conception, which he views primarily as a representation of a *dies irae*, yet he returns to Vasari's judgment of the work as a compendium of nakedness. He sees the composition as being a purely static, strictly symmetrical structure. In this, too, he retrogresses to the former level of criticism. His chief contributions are his attempt to explain the origin of the various

groups of figures from the Bible and his praise of the Last Judgment as the peak of Michelangelo's art.

The pages which Dvořák devoted to this work (*Gesch.d.ital. Kunst*, II, 1928, pp. 110, 127, already given in lecture form in Vienna in 1918-1919) show an increased understanding. Like Justi, he sees clearly that the "Bewältigung des Nackten [scheint] nicht das Ziel und der Grund der künstlerischen Inspiration gewesen zu sein." Again like Justi, he sees in the composition an arch, but he also observes that a wedge is driven into it from above. He was the first to recognize the new conception of *Fatum*, and proceeding from this, he tried to determine the position of Michelangelo's work in the history of ideas: "Das Jüngste Gericht erscheint als das Zeugnis der Zerrissenheit, ja der Verzweiflung von der damals die Besten erfasst waren."

In 1925, Adolfo Venturi (*Storia*, IX, 1, pp. 865*ff*) published his analysis of this work which is marked by fine intuition and is written in expressive language. He stresses the *tragica grandezza* of the presentation of the drama and the monumentality of the "architecture" of the composition. But "l'effetto dinamico delle masse rotanti" is still only understood as a technique of dramatic composition.

The importance of the cosmological aspect of the work as a religious-heliocentric image of the macrocosm, first pointed out by Tolnay, *Jugement*, 1940, has since been recognized by other scholars, especially by R. Feldhusen, *Ikonologische Studien zu Michelangelo's Jüngstem Gericht*, Thesis of Hamburg University, 1953 (not published); by von Einem, "Michelangelos Jüngstes Gericht und die Bildtradition," in *Kunstchronik*, 1955, pp. 89*ff*; and by de Ferdinándy, "El simbolo del macrocosmos en el Juicio Final de Miguel Angel y la tradición medieval," Universidad de Puerto Rico, n.d.

Other surveys of the vicissitudes in the appreciation of the Last Judgment are to be found in Thode, *Kr.U.*, II, pp. 64*ff* and Hans Tietze's "Michelangelo's Jüngstes Gericht und die Nachwelt," in *Festschrift P. Clemen*, Bonn, 1926, pp. 429*ff*.

82. *Copies*: 1) We know from Vasari, VI, p. 578, that Battista Franco made a drawing after the whole composition.

2) The most important copy, assumedly praised by Michelangelo himself, is that of Marcello Venusti (1549) in Naples, Museo di Capodimonte. This praise by Michelangelo is reported by Baglione, *Le Vite . . .*, 1642, p. 20. Other documents concerning this copy are published by Pastor V, pp. 784, 843*f*, doc. no. 46. 257

The value of this copy is to be found particularly in the fact that it preserves the original images of St. Catherine and St. Blaise as they appeared before the repainting of the "braghettone," as it does the nudes which had not yet been overpainted. In the rendering of the poses and movements of the figures, Marcello Venusti tried to be true. But apart from this, the copy is by no means exact since the copyist sought to "amend" Michelangelo. He emphasized the horizontal zones more strongly than they appear in the original and he lessened the effect of the vertical movements, thus destroying the effect of the rotation. He completed the composition at top center by

inserting one of the representations of God the Father taken from the Sistine Ceiling, thus conferring a more optimistic mood to the total picture. At the bottom, as has been mentioned above, he completed the earth by adding an empty strip, thereby lessening the oppressing crowded effect obviously intended by the master. He transformed the colors, making the sky a cold grayish-blue full of clouds, which destroys the effect of the emptiness of infinite space. The warm brown-colored figures seem imbedded in this cloudy sky. It seems that Venusti altered the original to conform to the new spirit of the Counter Reformation. Nevertheless, the copy of Marcello Venusti is thought by several scholars to be a most reliable source for the appearance of the fresco in its original state (Steinmann, *Sixt.Kap.*, II, p. 516; Biagetti, pp. 134*f*; Pastor). They go so far as to maintain that the copy provides a more exact idea of Michelangelo's intentions than does the original. But these scholars exaggerate somewhat in judging the extent to which the fresco has been altered.

3) Venusti's panel was copied in turn in 1570 by Robert Le Voyer, from Orléans (Steinmann, *Sixt.Kap.*, II, p. 517); this copy is today in Montpellier. (See Jarry, *Doc. Inedit sur un Jugement Dernier*, in *Réunion des Sociétés des Beaux Arts*, 1895, p. 616.)

4) Some groups were copied by Alessandro Allori in the Cappella Montaguti, Florence, Santa Annunziata (Vasari, VII, p. 606).

289 5) Ferrara, Cathedral, free paraphrase in fresco in the Apse by Bastianino.

6) Vasari (V, p. 553) copied the Damned in Mantua Sant' Andrea (first chapel at the right).

7) Copy by Sigalon, made 1833 to 1836, Paris, École des Beaux Arts (See Delacroix's article of 1837.)

8) Further copies are listed in Steinmann, *Sixt.Kap.*, II, p. 518 and Thode, *Kr.U.*, II, pp. 17*ff*. None of these lists is complete, however.

9) *Lists of the engravings after the Last Judgment* were drawn up by Heinecken in 1768, Passerini in 1875, Duplessis in 1876, and by Steinmann in 1905 (*Sixt.Kap.*, II, p. 789).

10) It was planned, in accordance with the wish of Paul III, to cover the empty wall below Michelangelo's Last Judgment by a tapestry of gold and colors which was to be executed in Flanders; this seems never to have been realized (Vasari, V, p. 623). Perino del Vaga was commissioned to paint a canvas with half-clothed women, putti, and termini, all holding festoons, which was destined to cover the space of the *basamento* temporarily. This canvas is today in Rome, Palazzo Spada (see H. Voss, *Die Malerei der Spätrenaissance*, Berlin, 1920, pp. 72*f*) and a preparatory drawing for
290 it is in Florence, Uffizi. A document from Nov. 15, 1542, relating to this *spalliera*, is published in J. Ackerman, *Cortile del Belvedere*, Vatican, 1954, doc. 52, p. 160.

III. NOTES ON CHAPTER III: MICHELANGELO AND VITTORIA COLONNA

1. On Vittoria Colonna see A. von Reumont, *Vittoria Colonna. Leben, Dichtung, Glauben im Sechzehnten Jahrhundert*, Freiburg, 1881, and the Italian edition, Turin, 1883; P. Tacchi-Venturi, "Vittoria Colonna fautrice della Riforma Cattolica," in *Studi e documenti di Storia e Diritto*, XII, 1901, pp. 149*ff*; J. J. Wyss, *Vittoria Colonna*, Frauenfeld, 1916 (with bibliography); A. A. Bernardy, *Vittoria Colonna*, Florence (1927); B. Niccolini, "Sulla Religiosità di Vittoria Colonna," in *Studi e materiali di Storia delle Religioni*, 1949-1950, pp. 89*ff*; H. Jedin, "Il Card. Pole e V. Colonna" in *Italia Francescana*, 1947, pp. 17*ff*.

An itinerary of Vittoria Colonna based on the letters, between 1535 and 1547, can be found in Frey, *Dicht.*, pp. 529*ff*.

Concerning the relationship between V. Colonna and Michelangelo, see also especially: Symonds, II, pp. 93*ff*; Thode, *Ma.*, II, pp. 391*ff* and Steinmann, *Sixt.Kap.*, II, pp. 499*ff*.

Concerning Michelangelo's attitude toward the doctrine of justification by faith alone, see H. W. Beyer, *Die Religion Michelangelos*, Bonn, 1926, and Tolnay, *Werk u. Weltbild*. (Hartmann, "Michelangelo als religiöser Charakter und evangelischer Zeuge," in *Deutsch-evangelische Blätter*, 1891, pp. 667*ff* and 747*ff*, and M. Carrière, "Michelangelo und die Reformation," *Z.f.b.K.*, 1869, pp. 329*ff*, in our opinion erroneously interpret the evidence and find in Michelangelo direct Protestant influences.)

Steinmann, *Sixt.Kap.*, II, p. 504, summarizes the relationship between Vittoria Colonna and Michelangelo as follows: "Vittoria Colonna succeeded in diverting the love of this great glowing heart from herself and in directing it to the primordial source of all love." He mentions the process of purification which began in Michelangelo under the influence of the Marchesa and quotes as indications of this, Frey, *Dicht.*, CIX, 5 and CXXXIV, especially version IV, p. 581.

2. Castiglione, *Il Cortegiano*, Introduction, "Essendo avvisato che la signora Vittoria Colonna, Marchesa di Pescara, alla quale io già feci copia del libro [*Il Cortegiano*], contra la promessa sua, ne avea fatto trascrivere una gran parte, non potei non sentire qualche fastidio . . . nientedimeno mi confidai che l'ingegno e prudenzia di quella Signora, la virtù della quale io sempre ho tenuto in venerazione come cosa divina bastasse."

The testimonials by contemporary poets to Vittoria Colonna were assembled by Campori, *Atti e Memorie delle Provincie dell'Emilia*, II, 1878, p. 22 (see also Steinmann, *Sixt.Kap.*, II, p. 500).

3. See *Vittoria Colonna, Carteggio*, published by E. Ferrero and G. Müller, Turin, 1892 (second edition with a supplement). Concerning the trial by the Holy Office against P. Carnesecchi, see pp. 331*ff*.

4. Giberti, *Epistolario*, Vol. II, p. 39 (quoted after von Reumont).

5. For the philosophy of love of the *dolce stil nuovo*, see Vossler, *Die philosophischen Grundlagen zum süssen neuen Stil*, Heidelberg, 1904.

6. The poems for the "donna bella e crudele" were, according to Frey, *Dicht.*, written between 1534 and 1557; according to Rizzi, *Michelangelo poeta*, Milan, 1924, between 1544 and 1546.

It is partly problematical exactly which poems Michelangelo wrote to Vittoria Colonna except in a few instances in which he himself actually wrote a dedication or where the content clearly indicates that the poems were addressed to her. Steinmann, *Sixt.Kap.*, II, pp. 503*ff*, connects with Vittoria Colonna poems of Michelangelo which were written to the "Donna crudele" and which, because of their completely different tone, could hardly have been directed to a lady of such high social standing as Vittoria Colonna. Examples are Frey, *Dicht.*, CIX, 9 and CIX, 55.

7. Concerning the portraits of Vittoria Colonna, see H. Schulze, "Die Bildnisse der Vittoria Colonna," in *Mh.f.Kw.*, 1910, pp. 239*ff*; E. Schaeffer, "Zu den Bildnissen der Vittoria Colonna," in *Mh.f.Kw.*, 1917, pp. 38*ff*; W. Heil, *Pacific Art Review*, 1941, pp. 1*ff*. (Heil publishes a portrait of Vittoria Colonna in the San Francisco Museum, Young Foundation.)

8. The earliest edition of the *Rime* of Vittoria Colonna is *Rime de la divina Vittoria Colonna*, Parma, 1538. The sentence quoted in the text by Filippo Pirogallo, is taken from the Introduction of this edition. Pirogallo admits that there are "scorrettioni" in his edition because he could not copy them from the originals. We are here quoting from the edition published by Barbèra, Florence, 1860.

On February 28, 1551, Michelangelo wrote in a letter (Milanesi, pp. 271*ff*) that he received a small book containing 103 sonnets from Vittoria Colonna. He had these bound together with 40 more sonnets which he received later from the Marchesa and with the letters he received from her from Orvieto and Viterbo. On May 8, 1551, he wrote (Milanesi, p. 273) that he wanted to have the little book of sonnets copied to send it to Fattucci. This latter probably wanted to use it for the edition of Vittoria Colonna's *Rime* which was to appear in that year.

A codex with the *Rime spirituali* of Vittoria Colonna (*Cod. Vat. Lat.* 11, 539), which may have belonged to Michelangelo, was published by E. Carusi, *Istituto di Studi Romani. Atti del Quarto Congresso*, Rome, 1938. There is in the Library of the British Museum a copy of the *Rime* of Vittoria Colonna of 1558 which certainly belonged to the artist and which bears his signature. See Fagan, *The Art of M. A. Buonarroti* etc., London, 1883, p. 183.

9. Concerning the "Catholic Reformation" called also "Italian Reformation," see: *Opuscoli e lettere di riformatori italiani del Cinquecento*, published by G. Paladino, 2 vols. Bari, 1913, 1927; P. Chiminelli, *Scritti religiosi dei Riformatori italiani del '500*, Turin, 1925; F. C. Church, *I Riformatori italiani*, translated by D. Cantimori, 2 vols., Florence (1932-1933) bibliography, pp. 231*ff*; *La Riforma in Italia*, published by F. Lemmi, Milan, 1939 (a collection of texts); D. Cantimori, *Eretici italiani*

del Cinquecento, Florence (1939). An earlier but still useful survey of the problem in Thode, *Ma.*, II, pp. 391*ff*. A. Chastel, in *Humanisme et Renaissance*, 1945, pp. 7*ff*.

10. Concerning Valdés, see: E. Cione, *J. de Valdés*, Bari, 1938. Valdés, *Dialogo de la Doctrina Cristiana*, published by M. Bataillon, Coimbra, 1925, and the *Alphabeto cristiano*, published by B. Croce, Bari, 1938. J. F. Montesinos, *Cartas inéditas de J. Valdés al cardenal Gonzaga*, Madrid, 1931 (with copious bibliography).

11. *Trattato utilissimo del beneficio di Giesù Cristo Crocifisso verso i cristiani*, Venice, 1545. New edition by Babington, London, 1855.

12. Concerning Carnesecchi, cf. note 3 above.

13. Steinmann, *Sixt.Kap.*, II, pp. 499*ff*, supposes that Michelangelo became acquainted with Vittoria Colonna in 1536. That year the Marchesa was in Rome and received the visit of Charles V. The friendship with Michelangelo was probably mediated, as Steinmann supposes, by Tommaso Cavalieri.

Since ca. 1546 Michelangelo visited the Marchesa in the cloister of Sant'Anna dei Funari in Rome, today destroyed, where she lived during the last years of her life. We know about this from a letter of her faithful servant, Spatafora, to Michelangelo (Gotti, II, pp. 140*f*: "Spesso vi [Michelangelo] vedea venire a Santa Anna a ragionare con lei [V. Colonna])."

14. Francisco de Hollanda, *Vier Gespräche; idem, I dialoghi Michelangioleschi*, published by A. M. Bessone Aurelj, Rome, 1924.

Concerning the authenticity of the dialogues, see Tietze, *Rep.f.Kw.*, 1905, pp. 295*ff* (Tietze believes their authenticity doubtful). R. I. Clements, "The authenticity of Francisco de Hollanda," in *Publications of the Modern Language Association*, 1946, pp. 1018*ff* and *Journal of the Warburg and Courtauld Institutes*, 1954, pp. 301*ff*, expressed the view that, on the contrary, the dialogues are authentic. In our opinion, too, the dialogue on Flemish art renders the ideas of the master, whereas in the chapter in which Francisco de Hollanda describes the *aquile* of Italian art, he gives his own opinion. Indeed, the greatest artists of the Quattrocento, who inspired Michelangelo in his youth, such as Masaccio, Quercia, and Donatello, are not even mentioned.

15. Lanckorónska, *Annales*.

16. Vittoria Colonna as a connoisseur of art is treated in O. Buoncuore, "Il gusto artistico di Vittoria Colonna," in *La Cultura*, Naples, 1935, pp. 30*ff*, but chiefly in connection with Titian.

17. Concerning the drawings of the Crucifixion for Vittoria Colonna, see our Catalogue of Drawings, No. 199. The copy by Marcello Venusti, today in Naples, Museo di Capodimonte, was formerly in Rome, Palazzo Cavalieri. This work of Michelangelo as a source of inspiration of El Greco's Crucifixion, Paris, Louvre, hitherto overlooked although significant, is by no means an isolated case. It confirms the observation of Max Dvořák ("Ueber Greco u. den Manierismus," in *Kunstgeschichte als Geistesgeschichte*, Munich, 1924, pp. 261*ff*) who first emphasized the importance of Michelangelo's last works in the development of El Greco.

164

165-169 18. Concerning the drawings of the Virgin and St. John in the Louvre, see our Catalogue of Drawings (Nos. 199, 200, 201).

171 19. The engraving was published by Lafreri, 1568.

170 20. The marble block sketch in the Archivio Buonarroti was first published in Tolnay, *Arch.Buon.*, 1928, p. 461. The form of the block for the Christ reveals that his arms were intended to be stretched out and upward.

21. The problem of the Pietà for Vittoria Colonna is discussed in Tolnay, "Michelangelo's Pietà composition for Vittoria Colonna," in *Record of the Art Museum, Princeton University*, 1953, pp. 44ff.

159 22. Concerning the drawing of the Pietà in the Isabella Stewart Gardner Museum, Boston, see Catalogue of Drawings (No. 197).

354 23. The relief in the Museo Cristiano, Vatican, was published for the first time in Steinmann, *Sixt.Kap.*, II, p. 502. See also: Thode, *Kr.U.*, II, p. 494; Steinmann, "An unknown Pietà by Michelangelo," *Art Studies*, 1925, p. 64. Middeldorf, *Burl.Mag.*, 1928, p. 305, attributes the relief to Pierino da Vinci and refers to the Virgin relief in the Museo Archeologico, Milan, as a close analogy. However, the forms of Pierino are more delicate and his technique more systematic. A. Venturi, *Storia*, X, 2, 1936, p. 177, attributes the relief to Jacopo del Duca.

There is a *bozzetto* in stucco in Rome, Museo del Castel Sant'Angelo, which has recently also been attributed to Jacopo del Duca by M. d'Orsi and published in a photograph in *Bollettino d'arte*, 1954, p. 365.

355 The relief copy in Santo Spirito in Sassia, third chapel on the left, is, in style and technique, close to Pierino da Vinci. This piece was mentioned for the first time in Tolnay, *Thieme-Becker*, 1930; it has been published since by A. Riccoboni, *Roma nell'arte*, Rome, 1942, p. 67 and Tolnay, *Record of the Art Museum, Princeton University*, 1953, p. 56.

A plaque not mentioned in the list in our article in *Record of the Art Museum,*
358 *Princeton University*, is in the Victoria and Albert Museum in a frame identical with those of the Casa Buonarroti and that formerly in the Lanna Collection. (I am indebted for the photograph to Mr. John Pope-Hennessy.) A copy in bronze relief in the Sacristy of Santa Maria in Monserrato is mentioned by Steinmann, *Sixt.Kap.*, II. A copy in miniature by Giulio Clovio is in the collection of Georges Wildenstein, Paris (H. 155 mm. W. 115 mm.). Paraphrase in Pamplona Cath. to be publ. by G. Weise.

24. In our article mentioned in note 21 above, we have noted that there were *two* prototypes from which the copies were made.

25. Concerning the iconographical origin of the Pietà for Vittoria Colonna, see Steinmann, "An unknown Pietà by Michelangelo," *Art Studies*, 1925, pp. 64ff; Panofsky, *Festschrift M. J. Friedländer*, 1927, p. 268. Steinmann indicates as the
96 source the Louvre drawing in which the Child is supported under his arms between the Mother's knees. Panofsky sees a relationship to the representation of the Christ, which often recurs in Northern Italy, supported in vertical position by two putti.

The resemblance to the Trinity type has been pointed out by Tolnay, *Burl.Mag.*, 1934, p. 152. The engraving after A. del Sarto, made by A. Veneto in 1516 (Bartsch, no. 40), contains a Christ inspired by Dürer's Trinity of 1511 (Bartsch, no. 122). The central angel in Veneto's engraving is borrowed from Dürer's Descent from the Cross (Bartsch, no. 14) (this latter observation was made by Ingeborg Fränkel). *360, 359*

26. The influence of the Pietà for Vittoria Colonna is treated also in Tolnay, *Record of the Art Museum, Princeton University*, 1953. Lelio Orsi's Pietà, Modena, Galleria Estense (see Venturi, *Storia*, IX, 6, p. 631) and the Pietà by Palma Giovine in Venice, Ducal Palace, are also inspired by Michelangelo's Pietà. A German copy by Hans Mornick, ca. 1591 (see H. Mahn, *Z.d.d.V.f.Kw.*, 1939, p. 165), was kindly brought to our attention by Gert von der Osten. It is a translation of the heroic conception of Michelangelo into the pathetic German Baroque. *363*

27. *Concerning Christ and the Samaritan Woman*: see Thode, *Kr.U.*, II, p. 464, who enumerates the most important copies. The best copy, the engraving by Beatrizet (Bartsch, no. 17), a drawing copy in the Louvre (Inv. no. 766) and another drawing copy, the whereabouts of which are unknown to us, and of which there is a photograph in the Witt Library of the Courtauld Institute, London, not mentioned by Thode, are published here. A further copy is in Liverpool, Art Gallery. *335*
336
334

The letter of Vittoria Colonna in which she mentions this work is dated July 20, 1541: see *Carteggio*, pp. 268f.

28. *Il Silenzio*, the original drawing, Duke of Portland Collection, has been first published by C. Gould, *Burl.Mag.*, 1951, pp. 279ff. Thode, *Kr.U.*, II, pp. 434ff, gives a list of the copies, among which the best are those by Marcello Venusti in London, National Gallery, and Leipzig, Museum. See our Catalogue of Drawings, No. 196. *158*
310

29. Raphael's Madonna di Loreto is lost; the copy in the Louvre is published in *Klassiker der Kunst, Raphael*.

30. The two sketches for the *Christ on the Mount of Olives* in the Cod.Vat. 3211, fols. 81v, 82v, were first published in Tolnay, *Cod.Vat.*, 1927, pp. 177f. *235*
236

31. Later versions of the Gethsemane include, in addition, the sketches in Oxford, those in London, British Museum, and in Vienna. See Catalogue of Drawings, Nos. 227, 228, 229. *237*
238, 240

32. The connection between the poem of Vittoria Colonna, no. CXXIII, and Michelangelo's Gethsemane has been noted by Thode, *Kr.U.*, II, pp. 461ff, who also gives a list of the copies.

33. *Epiphany*, London, British Museum; see our Catalogue of Drawings, No. 236. *248-250*
Concerning the history of this cartoon and its interpretation, see also Thode, *Kr.U.*, II, pp. 439ff; Wilde, *Brit.Mus.Cat.*, no. 75.

34. The still unpublished drawing of *St. Jerome*, in the Louvre, is mentioned also in Berenson, *Drawings*, no. 1590 A, who considers it as a completely reworked drawing by Michelangelo of the period of the Battle of Cascina. According to him, the inscription is not in Michelangelo's hand. See Catalogue of Drawings, No. 144. *254*

35. The second version of the St. Jerome, probably for the Cappella Mignanelli in Santa Maria della Pace in Rome, has hitherto been known only through two engravings, one by Sebastiano a Regibus, 1557, the other by Cherubino Alberti, 1575; Thode, *Kr.U.*, II, pp. 503f, Steinmann, *Festschrift P. Clemen*, 1926, p. 420 and Wilde, *Brit.Mus.Cat.*, p. 113. A third engraving by an anonymous artist is illustrated in this work.

The drawing in Rotterdam, Boymans Museum, hitherto unpublished and as far as I know not yet mentioned in the literature, is probably by Marcello Venusti.

36. The St. Jerome, by Rubens, formerly Potsdam, Sanssouci, was published by Christopher Norris in *Burl.Mag.*, 1953, p. 391, who noted the Michelangelo inspirations.

37. The letter of the Bishop of Fano to Cardinal Ercole Gonzaga, of May 12, 1546, concerning Michelangelo's drawing of the Pietà, is published by A. Luzio, "Vittoria Colonna," in *Rivista storica mantovana*, I, 1885, pp. 51f, and in Frey, *Q.u.F.*, p. 139.

38. Condivi (p. 202) tells that after the death of the Marchesa, Michelangelo "stette sbigottito e come insensato." See also the moving sonnet written after her death, Frey, *Dicht.*, CLXX.

IV. NOTES ON CHAPTER IV: THE FRESCOES OF THE PAULINE CHAPEL

1. *Concerning the Choice of the Program of the Pauline Chapel*: In the opinion of most scholars, the choice of program was made by Paul III. According to Pastor V, p. 796, Paul III chose the conversion rather than the decapitation of St. Paul, probably, because he solemnly celebrated the feast day of the conversion (January 25) every year in San Paolo fuori le mura. According to Magi, *Ecclesia*, 1953, p. 584, the Pope chose the Conversion either because of devotion to his patron saint or because this episode is a wonderful example of that *grazia divina* about which his contemporaries had so much disputed. The Crucifixion of St. Peter reveals, also according to Magi, a reflection of the times: the Council of Trent (opened in 1542) had as one of its chief aims protection of the primacy of the Roman Church against the Protestants.

In our opinion it is likely that the original program, Conversion and Delivery of the Keys, stems from Paul III; however, the transformation of the program of the second fresco into a Crucifixion of St. Peter may go back to the artist, who used the historic scene to give the subject a symbolic and autobiographic connotation. See also: Tolnay, *Michel-Ange*, p. 88.

2. *History*: Pope Paul III's idea of decorating his private chapel with frescoes is first mentioned—shortly before the unveiling of the Last Judgment—in a letter from his nephew, Alessandro Farnese, to the Bishop of Sinigaglia, Marcus Vigerius, on October 12, 1541 (Baumgart-Biagetti, p. 74).

According to Vasari 1550 (p. 172), written ca. 1546-1547, while the work was still in progress, Michelangelo intended to paint the Giving of the Keys to St. Peter opposite the Conversion of Saul: "Gli [to Michelangelo] fu fatto allogazione d'un'altra cappella, dove starà il sacramento, detta la Paulina, nella quale dipigne due storie, una di San Pietro, l'altra di San Paulo; l'una, dove Christo da le chiavi a Pietro, l'altra la terribile Conversione di Paulo." If Vasari 1550 is right, the artist must have abandoned this iconographical program. Condivi in 1553 (pp. 170ff) mentions the subjects of the actual frescoes. Condivi values both frescoes highly: "ambidue stupendi, si universalmente nella storia si in particulare in ogni figura." In his second edition of 1568 (p. 171) Vasari corrects himself and gives a detailed description of both frescoes. The Conversion of Saul "è condotta con arte e disegno straordinario" and the Crucifixion of St. Peter is full of "molte considerationi notabili e belle."

Since the Tomb of Julius II was still unfinished, Michelangelo did not wish to accept the new commission without first being freed from the duty of the mausoleum. He asked Paul III to make a compromise with Guidobaldo, Duke of Urbino, according to which the two remaining figures—Rachel and Leah—would be finished by R. da Montelupo and Michelangelo would deposit the necessary money in a bank in the Duke's name (Milanesi, p. 485 and Gaye II, pp. 290 and 297; Tolnay, Vol. IV,

pp. 64*ff*, 119*f*). The last contract for the Tomb of Julius II on August 20, 1542 (Milanesi, p. 715) gives Michelangelo his liberty, with certain conditions. The Duke's ratification of this agreement did not arrive immediately and Michelangelo was desperate (Milanesi, pp. 477, 488, 489-491). In a letter to Luigi del Riccio (Milanesi, p. 496), ca. November 11, 1542 (Thode), he wrote that he had decided to remain at home and finish three figures for the Tomb—Moses, Rachel, and Leah (cf. Vol. IV, pp. 121*ff*). Finally the ratification arrived and Michelangelo began the fresco in November 1542 (Baumgart-Biagetti, p. 71). On November 16, 1542, the garzone Urbino received payment for the preparation of colors ("provisione di macinarli li colori"). We know that on February 22, 1543, and on November 15, 1544, Michelangelo was working on the fresco. In June and July 1544, however, work must have been discontinued because of an illness of the artist. The first fresco seems to have been finished on July 12, 1545. On that day Paul III visited the chapel (Diary of *Cerimoniere* Francesco Firmano; cf. Baumgart-Biagetti, pp. 78*f*). Concerning the history of the second fresco, see note 17 below.

57 3. *Architecture*: The Cappella Paolina was erected by Antonio da Sangallo the Younger, for Pope Paul III. The chapel is adjacent to the Sala Regia which is the work of the same architect. No record exists of the exact date of the beginning but it is supposed that both structures were begun after 1537. The Paolina partly replaces an earlier chapel, the Cappella del Sacramento, erected under Pope Eugene IV (1431-1447) and decorated under Nicholas V with frescoes of Fra Angelico. A drawing by Marten van Heemskerck shows the exterior view of this chapel (cf. Egger, *Römische Veduten*, I, 1932, pl. 33).

The rough building of the Paolina chapel must have been ready in January 1540, since the Pope ordered a mass to be held in it on that date (see R. Casimiri, *I Diarii Sistini* [1535-1559], Rome [1939], p. 88). The dates concerning the history of the chapel are collected in Pastor V, 1909, pp. 795*ff* and Baumgart-Biagetti, pp. 71*ff*.

According to Vasari (1568, p. 171), Antonio da Sangallo made the Pauline Chapel "a imitatione di quella di Niccola V." This, however, is not obvious. Vasari in the *Vita* of Sangallo (ed. Milanesi V, p. 466) considers the chapel "cosa vezosissima e tanto bella e sì bene misurata e partita, che per la grazia che si vede, pare che ridendo e festeggiando ti s'appresenti." This judgment contrasts with the sober effect of the interior of the present chapel. It should be remembered, however, that before the fire of 1545 (mentioned in a letter by Michelangelo, Milanesi, p. 513), which destroyed the vault, the chapel might have presented a more cheerful appearance because of the *stucchi* by Pierino del Vaga after drawings of Michelangelo (Vasari, ed. Milanesi VII, p. 216) which decorated the interior at that time. Payments for the *stucchi* are recorded on August 27, 1542. These *stucchi* were only a part of the whole interior decoration which, according to Vasari, *loc.cit.*, was originally projected by Michelangelo. It included, besides the stuccos of the vault, "molte altre cose di pittura," which we can interpret perhaps as referring to the lunettes and to the lateral bays of

the longitudinal walls. Under Gregory XIII new *stucchi* of a heavier style were made. It is at this time, also, that the fresco decoration on the walls and on the ceiling was completed by Lorenzo Sabbatini and Federico Zuccari.

4. Original drawings by Antonio da Sangallo the Younger, for the plan, elevation, and vault decoration of the Cappella Paolina are preserved in the Uffizi, *Disegni architettonici*, nos. 1091, 1125 and 1258. (It is not certain that Uffizi nos. 1234, 1006, and 788 were made for the Paolina.) These drawings are published in photographs by Tolnay, *Illustrazione Vaticana*, 1934, April 16-30, no. 8. The execution of the chapel corresponds to Uffizi no. 1125; Uffizi no. 1091 is a preparatory sketch for no. 1125. Both lunettes above the middle fields of the side walls were probably originally windows. Today the east lunette above the Conversion of Saul is walled up. *291-294* *292, 291*

During the forties, after Michelangelo had begun to paint his frescoes, there are records of further activity on the building of the chapel. The last records concerning the architecture appear during the eighties, when the chapel building was finished (cf. Baumgart-Biagetti, pp. 93*ff*).

5. The division of the chapel walls by pilasters was probably conceived with Michelangelo's paintings in mind. These latter were to decorate the fields between the Corinthian pilasters. In chapels of the fifteenth and early sixteenth centuries the frescoes were usually framed by painted columns or pilasters; marble pilasters were used only to frame reliefs and sculptures (in tombs). Probably for the first time in the Cappella Paolina are frescoes framed by *real* pilasters, in this case of reddish-gray stone. Only such a highly plastic fresco style as that of Michelangelo could be associated with real pilasters without suffering in its effect. The central fields of the walls on which Michelangelo's frescoes are painted recede slightly in relationship to the lateral fields.

We do not know how the bottom zone of the chapel was originally decorated. The drawings of Sangallo in the Uffizi show that they did not have any architectural articulation. Recently these zones were overpainted with a gray color.

6. *Chronology*: The documents do not specify which of the two frescoes was finished first, but stylistically the Conversion of Saul is closer to the Last Judgment and may consequently be earlier. Note especially the figures in the foreground and the group of angel-genii, so like the angels in the lunettes of the Last Judgment. The Crucifixion of St. Peter, on the other hand, with its massive rectangular blocks of figures, opens a new stylistic phase. Most scholars agree with this chronology, which was expressed first by Dvořák, *Italienische Kunst*, II, pp. 129*f*; and then by A. Neumeyer, in *Z.f.b.K.*, 1929-1930, pp. 173*ff*; Tolnay, *Thieme-Becker*, XXIV (1930), p. 523; Mariani, *Gli affreschi di M.*, Rome, 1932; Panofsky, *Nachleben der Antike*, I, 1934, p. 210 (no. 858); Baumgart-Biagetti, pp. 15*ff*; De Campos, *Itinerario*, 1959, p. 276. *58* *59*

Vatican, Cappella Paolina (central field of the left wall)
Fresco.
H. 6.25 m. W. 6.61 m.

58 7. *Condition*: The sky and landscape of the fresco were retouched and the nude angel-genii in the sky were partly draped *a secco* (cf. Baumgart-Biagetti, pp. 41*ff* and pl. xlv). These retouchings were for the most part removed during the restorations of 1933-1934 (with the exception of the drapery of the angel-genius at the left of Christ). The plaster (*intonaco*) which was detached in several places was also fixed to the wall at this time. An earlier cleaning is recorded in 1842.

300 The engraving of N. Beatrizet (Bartsch xv, p. 255, no. 33) shows the figures still without draperies.

8. *Technique*: The painstaking technique of Michelangelo in these frescoes has been well described by Biagetti, in Baumgart-Biagetti, pp. 45*ff*. He has pointed out that Michelangelo used only mineral colors. The plaster (*intonaco*) was prepared with the greatest care. The outlines were transferred by means of perforation (*spolverare*) from the cartoons onto the plaster—with the exception of the angel-genii at top right which were transferred by tracing (*graffito*).

The fresco consists of eighty-five pieces corresponding to the eighty-five days of work (Biagetti, pl. 47). The surface is completely smooth, and there is the greatest finesse and softness in the transitions of the subdued shades of colors and of light to shadows; no brush strokes are visible here in contrast to the frescoes of the early Cinquecento.

58 Michelangelo probably began the fresco in the upper right corner, since here the figures are still traced, as in the Last Judgment, from the cartoon (Biagetti); next he executed the left upper portion, finishing with the lower portions.

61 The quality of the fresco is uneven. Of the highest quality are St. Paul and the
60 figure assisting him. Weaker in execution are the two figures seen from the back at the
64 lower left corner and the angel-genii, especially their faces, in the sky. The method of executing more carefully the central main figures which immediately meet the beholder's eye, and of leaving the peripheral figures to assistants, later became a general custom and can still be found in Rubens.

9. *Subject*: The Conversion of Saul is to be found in Acts 9: 1-8, 22: 6-10 and 26: 12-16.

The earliest representations of this scene show no horse and this conforms with the Scriptures (cf. Dobschütz, "Die Bekehrung des Paulus," *Rep.f.Kw.*, 1929, pp. 87*ff*). Representations with the horse first appear in the twelfth century. There are two main iconographical types: the older one is inspired by representations of *Superbia* in the Prudentius Manuscripts; they show the horse having stumbled forward and the horseman being hurled down. This pattern still lives on in certain repre-

sentations of the fifteenth, sixteenth, and seventeenth centuries, e.g.: Jacopo Bellini, Sketchbook I, pl. 42; Garofalo, Rome, Galleria Borghese; Ruviale, Rome, Santo Spirito in Sassia; Procaccini, Bologna, San Giacomo Maggiore; Salviati, Rome, Galleria Doria; Rubens (1616), Berlin, Kaiser Friedrich Museum, etc. The other pattern, created probably in the thirteenth century (cf. Bible of Verona, ill. in Dobschütz, p. 97), shows Saul on the ground while his horse stands near him. Since the fifteenth century the horse is shown escaping. This type is also known in the fifteenth and sixteenth centuries, e.g.: Miniature of the Bible of Duke Federico d'Urbino, 1476-1478, Vatican; Predella by Benozzo Gozzoli, formerly Florence, San Pier Maggiore, now New York, Metropolitan Museum; Alunno di Domenico (Bartolommeo di Giovanni), drawing, Florence, Uffizi (see H. v.Dam v.Isselt in *Bollettino d'Arte*, 1952, pp. 315*ff*); anonymous Florentine engraving of 1460-1470 (Hind, A II, 10); Raphael tapestry for the Sistine Chapel.

298

295

297

296

Michelangelo adheres to the second type and his fresco is especially close to Gozzoli's *predella* and to Bartolommeo di Giovanni's drawing, Uffizi: his Saul is on the ground with closed eyes, the Christ is foreshortened in the sky, and a horse is seen from the back behind Saul (the horse in this case, however, is not Saul's). In the Quattrocentesque pattern the isolated figures of the soldiers which surround Saul in a circle, move away in all directions; Michelangelo composed two entwined masses on both sides of the horse and connected them to the groups in the sky in a great circular line. This composition, reduced to one plane in the foreground, became the model for Conversions of Saul up to Caravaggio, although the circular movement is not always apparent in them, e.g.: F. Salviati, Rome, Palazzo Doria; attributed to Salviati, Rome, Cancelleria, Cappella del Palio; T. Zuccari, Rome, San Marcello and Galleria Doria (here the gesture of Christ is also inspired by Michelangelo).

295

297

In the fifteenth century versions, Saul is looking at the heavenly vision of Christ and the angels. Michelangelo retained the vision, and even enlarged it, but the Conversion of Saul became with him an inward event: Saul is not looking at the sky, but is dazzled and blinded. This anticipates two Conversions of Saul of the end of the sixteenth century which are conceived as completely inward events, without the heavenly vision, namely: the canvases of Caravaggio, Rome, Santa Maria del Popolo, and Carracci, Bologna, Pinacoteca (1584). Cf. Friedländer, pp. 3*ff*.

61

That the frescoes of the Paolina express, beyond the immediate iconographical subject, a more comprehensive content through their space and figure conception was first emphasized by Dvořák, *Italienische Kunst*, II, pp. 129*ff*; see also Dagobert Frey, *Michelangelo-Studien*, 1920, p. 140, Neumeyer, *Z.f.b.K.*, 1927-1930, pp. 173*ff* and Tolnay, *Michel-Ange*, pp. 88*ff*. The spiritual content is not only the historical action but "the ruling of abstract primeval forces, for the expression of which the subject gives only the pretext" (D. Frey). However, and this has been emphasized in our text, these forces and movements going through the figures and space were most prob-

ably not meant by Michelangelo as merely abstract patterns, but as revelations of cosmic energies.

Contrary to the written tradition but in accordance with the iconographic tradition of the fifteenth century, Paul is represented here with a white beard; in Michelangelo's fresco the angels are without wings and the saints without halos. All these were criticized in the mid-sixteenth century by Gilio da Fabriano, *Due Dialogi*, Camerino, 1564, pp. 89v, 121r.

Henriette van Dam van Isselt (*Boll.d'Arte*, 1952, pp. 315ff) was the first to show that not only are the details in Michelangelo's fresco inspired by earlier works but that the whole composition reverts to tradition, namely to the drawing of Bartolommeo di Giovanni in the Uffizi. This drawing dates from around 1488. At that time Bartolommeo was an apprentice in the workshop of Ghirlandaio. In the same year, in April, Michelangelo came to study with the same master. Van Dam supposes that Michelangelo may have seen Bartolommeo's drawing. That he recalled this drawing more than fifty years later van Dam tries to explain by the fact that Michelangelo might have had before him either Bartolommeo's drawing itself or his painting, made after this drawing, or that Michelangelo made a copy of it in his youth.

Bartolommeo's drawing is, however, not isolated but belongs to a Florentine iconographical tradition of which other examples are the predella of Gozzoli, New York, Metropolitan Museum, and a Florentine engraving of ca. 1460-1470. It is to this tradition that both Bartolommeo di Giovanni and Michelangelo revert.

10. *Colors*: No completely adequate treatment of the color scheme of the Paolina frescoes exists. Until recently scholars described the frescoes, probably on the basis of reproductions, as monochromatic. Thode (*Kr.U.*, II, p. 79) stated that the original character of the colors is almost completely altered and their effect today is "disagreeable, almost ugly" ("Die Farbe wirkt jetzt unangenehm, fast hässlich"). Dvořák and Dagobert Frey (p. 140) said that the frescoes are "colorless" ("farblos").

We have emphasized that Michelangelo departed here from the color scheme of the Last Judgment with its bichromatic effect and reverted in both frescoes to the subdued soft and serene polychromy of the Sistine Ceiling (cf. Tolnay, *Thieme-Becker*, 1930: "Ganz neu—dem Jüngsten Gericht gegenüber—ist die zarte, flaumige Schönfarbigkeit; ein deutlicher Rückgriff auf das Kolorit der Decke"). Baumgart subsequently made a comprehensive analysis of the colors in Baumgart-Biagetti, pp. 21ff.

In the Conversion of Saul the artist employs moss-green, gray-green and blue for the hills of the landscape. He reverts to the harmony of soft lilac and light green of the Sistine Ceiling in the garments of Saul: lilac tunic, light green diagonal sash, neck border, and leg coverings. Darker colors, brownish-red, and dark lilac are placed in the periphery. The protagonist at the left is in a dark gray-lilac tunic; the big figure at the right in back view is in bronze-yellow armor; the horse is black-gray (its

color has altered with time). The red, blue, yellow, and brown areas are subordinated to the colors of the main figures.

11. *Analogies*: Some of the figures are reminiscent of earlier works of Michelangelo, others are inspired by ancient statues, as has been pointed out by Mariani, Panofsky (in *Nachleben der Antike*, I, p. 210), and Magi. The motif of the outstretched body of Saul reverts to ancient River Gods and it was used by Michelangelo from his youth on: it appears first in a figure of the Cascina Cartoon, then in a River God of the Medici Chapel and in the Venus of Michelangelo's cartoon representing Venus and Cupid (Vol. III, p. 195). Raphael, in his Heliodorus and Marcantonio in his Judgment of Paris also reverted to the same ancient prototype (cf. Panofsky, *Rep.f.Kw.*, 1927, p. 33, note). The soldier at the left protecting his head with his shield is anticipated in one of the soldiers of the Resurrection drawing by Michelangelo (No. 110); the *Vol. III, 146* large figure seen from the back at the right is anticipated in a soldier at the right side in another Resurrection drawing (No. 109). The breast plates of the soldiers *Vol. III, 145* remind us of those on Trajan's Column in Rome.

The head of Saul is inspired by that of Laocoön, which was the classic model for the expression of suffering during the Renaissance (Mariani, p. 18). Mariani also pointed to the inspiration from ancient busts of Homer in the face of Saul.

It has been observed that Michelangelo's rearing horse reverts to an ancient model: its movement is close to that of one of the horses in the Dioscuri of Monte Cavallo (Mariani, p. 15).

The two young soldiers in the first plane partly cut by the lower frame, are probably inspired by Northern engravings, such as Dürer's Christ before Pilate, or they are influenced by Italian frescoes in which this Northern pattern had been assimilated, such as those of Pontormo, in the Certosa di Val d'Ema, made between 1522 and 1525 (Mariani, p. 20). It is interesting to note that Michelangelo's figure of Christ inspired that of St. Mark in Tintoretto's Miracle of St. Mark, Venice (Dvořák).

According to Magi the style of the fresco is inspired chiefly by Roman historical reliefs like the Column of Trajan: the representation of masses, the simplicity of the landscape reduced to its most essential elements, the simultaneous presentation of successive moments, and the limitation of the depth of space connect Michelangelo's frescoes with Roman historical reliefs. But it should not be overlooked that most of the motifs are not direct borrowings from ancient art but had already been assimilated by Michelangelo in his earlier works. He used these latter versions in his frescoes. In the Conversion of Saul, moreover, Hellenistic antiquity rather than Roman is used. The connection of the figures with transcendent forces is completely unknown to Roman art.

The dynamic currents which originate beyond the figures and seem to penetrate them can be found earlier only in Leonardo and were first observed in Michelangelo's fresco by Dvořák who considers them as "abstract forces" while we consider them to be natural forces of the macrocosmos.

Michelangelo's dynamic conception did not find immediate followers in Central Italy. Characteristic from this point of view is the Conversion of Saul by Francesco Salviati in Rome, Palazzo Doria, where influences of Raphael and of Michelangelo are united with the old *superbia* type of horse. From Michelangelo he took over two of the figures in the right foreground, one from the Last Judgment and the other, a soldier seen from the back, from the Pauline fresco. The whole is nevertheless closer to fifteenth century paintings: there is lacking the causal sequence of the drama and the *dynamis* flowing through all the elements. The same could be said of a drawing of the Conversion of Saul by Lelio Orsi, collection Fitzroy Phillipps Fenwick (Popham, *Catalogue*, 1935, plate 70) which is a free paraphrase of Michelangelo's fresco and of Taddeo Zuccari's *Conversion of Saul* in Rome, S. Marcello.

The macrocosmic currents of Michelangelo's composition can be found also in Tintoretto's Miracle of St. Mark, Venice, and in Rubens' Conversion of Saul, Berlin. Rubens, however, represents this cosmic curve in perspective foreshortening where Michelangelo represents it parallel to the surface of the picture. With Michelangelo, where the bodies are still plastic entities and at the same time vehicles of the forces, there is a dualism which is transformed by Rubens into a single current of life force.

12. The horse's head was removed in 1953 uncovering another horse's head, which was published for the first time by Magi in *Ecclesia*, 1953, pp. 584*ff.* As we said in the text, since we consider both versions by Michelangelo, the removed head was Michelangelo's own final version. (We are indebted to Dr. Magi for furnishing a photograph of the uncovered head.)

13. There is a hitherto unknown drawing by an artist of the mid sixteenth century in the Bibliothèque Nationale, Département des Estampes, Ba. 6, IV, fol. 2. This drawing (H. 415 mm. W. 520 mm.), representing the composition of Michelangelo's Conversion of Saul, was probably done to show the Pope the loincloths which were to be painted on the nudes and which are distinguished in this drawing by a darker wash.

Since these loincloths are not identical with those finally executed, the drawing cannot be a copy from the fresco but rather a project for the corrections. The head of the horse in this drawing shows clearly Michelangelo's final version.

14. Concerning the Conversion of Saul by Caravaggio, see Friedländer, pp. 3*ff.*

15. *Copies*: see Thode, *Kr.U.*, II, p. 81; Neumeyer, *Z.f.b.K.*, 1929-1930, pp. 173*ff* (on p. 180 Neumeyer gives a complete list of the engravings after the frescoes); Baum-
gart-Biagetti, p. 17 note. Copies include: N. Beatrizet, engraving of the whole composition (Bartsch, no. 33) and G. B. de' Cavalieri, engraving of the whole composition
(unknown to us); copy after one of the soldiers, drawing, Amsterdam, Rijksprentenkabinett.

The engravings have a certain documentary value since they were made before the fresco was retouched and show the later version of the head of the horse.

Vatican, Cappella Paolina (central field of the right wall).
Fresco.
H. 6.25 m. W. 6.62 m.

16. *Condition*: The sky and landscape were retouched. (These parts are indicated *59*
in Baumgart-Biagetti, pl. 48.) The retouching was removed during the restoration
of 1933-1934 and at the same time the plaster, which was detached in several places,
was fixed to the wall.

The engraving of G. B. de' Cavalieri shows stairs in both lower corners of the *303*
composition. The figures mount and descend on these steps. It seems that they were
actually planned by Michelangelo in his fresco. The left one is also present in the
cartoon in Naples (Baumgart-Biagetti, p. 23). In the fresco they are barely visible. *178*

The quality of execution is better than in the Conversion of Saul. Again it is the
central group of St. Peter and the figures around the cross which is most carefully
executed. This high quality is also noticeable in the leaders of each of the surrounding
groups. Less fine in quality and probably partially retouched is the group of women *74*
partly cut by the lower horizontal of the frame in the first plane at the right. The
fresco consists of eighty-seven pieces corresponding to the eighty-seven days of work.
The best description of the technique is in Baumgart-Biagetti, pp. 39*ff* and 53*ff*.

17. *History*: The preparation of the wall for the second fresco must have been
made before August 10, 1545, since on that day Urbino was reimbursed for expenses
incurred, "in fare spicanare e arricciare una facia della Cappella Paulina" (Baumgart-
Biagetti, p. 72). This must refer to the wall with the Crucifixion of St. Peter.

The work was discontinued in January 1546, while Michelangelo was ill for a
short time. Luigi del Riccio took care of him during this time in the Casa Strozzi in
Rome (Steinmann, *Michelangelo e Luigi del Riccio*, Florence, 1932, p. 57, no. 9).
There are payments to Meleghino for ultramarine color on March 26 and May 1,
1546.

On March 29, 1546, Urbino was paid for the scaffolding and it was after this date
in all probability that Michelangelo began his work. (Less likely is the date proposed
by Redig de Campos, *Paolina*, August 10, 1545, because, as we have seen, on that
date Urbino was paid for the preparation of the wall.)

October 13, 1549, Serristori, the ambassador from Duke Cosimo, wrote about
the last visit of Paul III to the chapel (Gronau, *Rep.f.Kw.*, 1907, p. 194): "montò
una scala a piuoli di X o XII scalini per vedere le pitture che faceva il Buonarroti
nella cappella che Sua Santita gli fa depingere" (Baumgart-Biagetti, p. 79). Paul III
died a month later, November 10, 1549. On November 29, 1549, the chapel is
mentioned as not yet completed ("non ancora finita"—Baumgart-Biagetti, p. 80).
Probably in the spring (March 1550) the second fresco was finished.

[143]

18. *Subject*: Earlier legends about the Crucifixion of St. Peter are incorporated
70 in the *Legenda Aurea*. The group above the cross is usually interpreted as the group
of the followers of the Apostle. Its protagonist seems to intercede in favor of St.
Peter (Dvořák), but he is held back by the companion at his left and admonished to
silence by the one at his right.

According to the iconographical tradition, the cross was inverted and the landscape
usually showed the pyramid of Cestius (attributed to Giotto, Stefaneschi Altar, Vati-
can, formerly in Sagrestia del Capitolo dei Canonici; Masaccio, predella, Berlin, Kaiser
Friedrich Museum; Filarete, bronze door of the main portal of St. Peter's; Giovanni
301 dal Ponte, Uffizi [van Marle IX, 78]; Florentine miniature, Laurenziana [van Marle
IX, 108]; Filippino Lippi, Florence, Carmine, fresco, Cappella Brancacci, etc.). Con-
cerning the iconographical tradition of this scene, see Strzygowsky, *Cimabue in Rom*,
pp. 76*ff* and Friedländer, pp. 128*ff*. Michelangelo's innovation was to represent the
cross of St. Peter in diagonal position and to place the scene in a barren, hilly land-
scape. In scenes representing Christ being nailed to the Cross, however, the Cross is
often shown laid diagonally on the earth (see our text) (e.g. the miniatures in the
Petites et Grandes Heures du Duc de Berry, Paris, Bibl. Nat.; Master Bertram, Altar
of the Passion, Hannover Museum, etc.). It is therefore possible that Michelangelo
derived his inspiration from such a representation of Christ's Passion.

Divine intervention was usually not represented before Michelangelo in this scene.
It appears in the seventeenth century, however, with Rubens and van Dyck.

19. The mounted figure immediately behind the captain has the features of the
75 young Michelangelo and in the features of the old, bearded figure in the lower right
72 corner, some scholars (Magi) recognize the portrait of the aged Michelangelo. He
seems to represent himself present at the scene and responsible, as is the rest of
humanity, for the crime.

20. *Colors*: Areas of soft blue, yellow, red, and green gleam around the cross and
these colors recur again in the group of soldiers at the lower left. The effect of the
whole fresco is rich in color and reminds one—as has been said in the text—of the
beautiful harmonies of the Sistine Ceiling. On the whole the color is richer and
warmer than in the Conversion of Saul. The hills in the foreground are pale moss-
green, the mountains in the background are ultramarine and at the horizon in the
sky there is an orange-yellow effect of sunset. This is possibly inspired by Venetian
Cinquecento paintings (Giorgione, Titian).

The chiaroscuro has the soft quality of Leonardo and Correggio.

21. *Analogies*: The compositional pattern with the groups one above the other
may be inspired either by Roman sarcophagi or by the Column of Trajan (Mariani).
For the diagonally laid cross, see our remarks above, in connection with the scenes
of "Christ nailed to the Cross."

Concerning the influence of mannerism on this fresco, see H. Hoffman, *Hochrenais-
sance, Manierismus, Frühbarock*, Zurich, 1938. The group of soldiers at the lower right

corner reminds one of the soldiers at the bottom of the Column of Trajan (Mariani). The kneeling figure in the center under the cross is anticipated in one of the figures of the Battle of Cascina and also repeated in one of the Last Judgment figures (Mariani). The horses go back again to ancient models (see Baumgart-Biagetti, p. 24 note). St. Peter is a fusion of the Tityus-Prometheus type with that of St. Peter (De Campos). *68*

The composition influenced Tintoretto's Golgotha, Venice, Scuola di S. Rocco, 1565 (Dvořák) and Caravaggio's Crucifixion of St. Peter, Rome, Santa Maria del Popolo.

22. *Drawings*: Only one preparatory sketch and a fragment of the cartoon are preserved: a) Sketch of a nude figure in the center below the sarcophagus on the verso of the projects for the tomb of Cecchino Bracci, Florence, Casa Buonarroti, (No. 70), first published by Tolnay in *Münchner Jahrbuch*, 1928, p. 397. The pose *Vol. III, 125* of the figure is a mirror image of the soldier with a lance, at the left side of the fresco near the captain. (This sketch has not to our knowledge previously been connected with the Crucifixion of the Paolina.) b) Fragment of the cartoon representing the group of soldiers at the lower left, Naples, Museo Nazionale: black chalk (see No. *178* 204). The cartoon was first published by Steinmann, "Cartoni di Michelangelo," *Bollettino d'Arte*, v, 1925, pp. 3ff.

23. *Copies*: A panel painting, late sixteenth century, with different landscape. Private property, New York; G. B. de' Cavalieri—engraving of the whole composition; Michele *303* Lucchesi—engraving of the whole composition. Several engravings of single figures *302* exist: a soldier seen from the back by Cherubino Alberti, 1590; the old man with folded arms at the right bottom by N. Beatrizet; St. Peter alone by Michele Lucchesi.

A list of these engravings is given by Neumeyer, *Z.f.b.K.*, 1929, p. 180 and Baumgart-Biagetti, pp. 17, 18 n. Drawing copy after one of soldiers, Princeton Art Mus. *304*

24. *Appreciation of the Paolina Frescoes*: Condivi (p. 170) and Vasari, 1568 (p. 171) in the mid-sixteenth century praised Michelangelo's Paolina frescoes highly. Condivi calls them "stupendi" and Vasari says that they have "arte e disegno straordinario." These terms are similar to those with which they praised the Last Judgment and the earlier works of Michelangelo, and it seems that they did not notice any essential change in his style. But in 1564, the year of the master's death, opinion was already changing, and up to 1918 the frescoes were considered as an expression of the decline of Michelangelo's creative powers. In 1564 there appeared in Camerino Gilio da Fabriano's *Due Dialogi*, the first acid criticism of these two frescoes. He questions the conception of the Christ in the Conversion of Saul which is, according to him, "fuor d'ogni gravità e d'ogni decoro" (fol. 89r) and he accuses the artist of having allowed himself inadmissible iconographical license in certain details, as for example: Michelangelo's Saul is bearded and he has made of the Apostle, at that time eighteen or twenty years of age, a man of sixty (fol. 89v); the angels are wingless (fol. 121r); the saints are shown without halos (fol. 122r). It should be noted that this pious and somewhat narrow-minded priest takes his arguments from the celebrated letter men-

tioned above, by Aretino, of 1545, applying them here to the Paolina instead of the Last Judgment.

At the end of the sixteenth century, Lomazzo in his *Idea del Tempio* (Milan, 1590, p. 53) realized what Condivi and Vasari had not yet seen, that the frescoes of the Paolina represent a new style, a "nuova maniera," which, however, he considered inferior to the two earlier styles, that of the Sistine Ceiling and that of the Last Judgment. It was Lomazzo who created certain opinions which were repeated until recently. He says that the frescoes have an "aria terribile, fiera e piena di gravità che spaventa chiunque li rimiri . . . ," a judgment which was taken up in the seventeenth century by Andrea Scotti, *Itinerarium Italiae*, 1625, p. 354 (first edition probably 1601). This opinion can be found in the twentieth century scholars. However, this estimate does not take into account the real effect of the frescoes, where the "terribilità" is mitigated by the beauty of the color range. Indeed they describe the frescoes as colorless ("farblos"), overlooking the decided return to the beautiful coloring of the Sistine Ceiling.

It is to Dvořák's credit that he restored the appreciation of the Paolina frescoes and that he gave in his Vienna lectures in 1918-1919, published posthumously in 1928 (*Italienische Kunst*, II, p. 128) the first detailed analysis from the stylistic point of view and from that of the history of ideas. He observed the dynamic composition but considered it as representing "abstract movements" without connecting them with the cosmic forces. As we have seen, certain of Lomazzo's habits of thought are still alive in these brilliant analyses. Dvořák's pupil, Dagobert Frey, wrote a very sensible page on the Paolina frescoes in his *Michelangelo Studien*, Vienna, 1920. Walter Friedländer, in his article in *Rep.f.Kw.*, 1925, p. 59, gave an analysis of the space and figural composition and an iconographical study in his article in the *Vorlesungen der Bibliothek Warburg*, 1928-1929, pp. 231ff. Neumeyer, *Z.f.b.K.*, 1928-1929, very capably summarized the results of Dvořák and D. Frey. Tolnay, *Thieme-Becker* (1930), pointed out the new, tender color range. Then came the book of Mariani, *Gli affreschi di Michelangelo nella Cappella Paolina*, Roma, 1932, which has the merit of having called attention to Michelangelo's classical inspirations. The exhaustive book of Baumgart and Biagetti, *La Cappella Paolina*, Vatican, 1934, followed with a detailed description of style, composition, technique, and condition and with the publication, in chronological order, of all the known documents. Baumgart also lists a few drawings connected, according to him, with the frescoes. More recently has appeared D. Redig de Campos' volume, *Michelangelo, Affreschi della Cappella Paolina*, Milano (1950), Tolnay, *Michel-Ange*, pp. 81ff, and W. Friedländer's chapter on the iconography of the Conversion of Saul and the Crucifixion of St. Peter in his *Caravaggio Studies*.

Addendum:

After completion of this manuscript we became acquainted with the article by von Einem, "Michelangelos Fresken in der Cappella Paolina," in *Festschrift Kurt Bauch*, 1957, pp. 193*ff*. We are glad to find that von Einem's interpretations correspond in several points to our own, as expressed in our *Michel-Ange*, 1951, pp. 88*ff*. He agrees with our opinion that the frescoes should not be considered as representations of historical facts, but as Michelangelo's own confessions; that they represent his own religious conversion; that in the features of Saul one may recognize an idealized portrait of the artist (this has also been observed by Dagobert Frey, *Michelangelo*, Cologne, 1942, p. 35, in a study which has not been available to us) and that the essential feature in both compositions is the rotary movement.

Of value is the reference of von Einem to the Conversion of Saul by Signorelli in the Sagrestia della Cura in Loreto as a possible prototype for Michelangelo. The position of Saul, the protective gesture of the soldier who raises his shield, and the corresponding figure on the left seen from the back, are features which anticipate Michelangelo's fresco.

On the other hand, von Einem's evaluation of Raphael's tapestry as the point of departure for Michelangelo ("Ausgangspunkt für Michelangelo," p. 196) is in our opinion somewhat exaggerated. We believe that the Florentine Quattrocento type of Conversion of Saul was of greater importance for the master, as has been stressed also by van Dam van Isselt. Saul is in the fifteenth century representations, as in Michelangelo's fresco, approximately the center of a symmetrical composition, in contrast to Raphael's tapestry where the composition is divided into two unequal groups through which a uniting movement flows from one side to the other.

Whether there is, as Dvořák and after him von Einem suppose, an influence of the ancient marble group called the "Farnese Bull" on the central group of the Crucifixion of St. Peter is questionable. Although we know that Michelangelo greatly admired this group, which was found about three months before work on the fresco was begun, common features are hardly noticeable.

25. *The Cleansing of the Temple*. See our remarks in the Catalogue of Drawings, Nos. 211, 230, 231, 232, 233, 234, 235. *241-247*

26. The fact that the Christ in Rembrandt's etching raises his *left* arm to strike, *319* is a supplementary proof that he copied on the copper plate Dürer's woodcut where Christ raises his right arm. The etching naturally shows the reverse version of Christ.

V. NOTES ON CHAPTER V: THE LATE RELIGIOUS DRAWINGS

The notes on the drawings analyzed in this chapter are to be found in the Catalogue of Drawings under the following numbers: Nos. 249 to 255; 221, 222, 264; 238, 267.

As in works of art of the Middle Ages, in Michelangelo's late religious drawings, perceptible forms help the beholder to grasp the supernatural and invisible. This concept is close, although not identical, to that expressed by Pope Hadrian I: "holy images . . . are honored in order that our minds, *through the visible external form, might be transported to the invisible glory of God* by means of the spiritual emotion produced by contemplation of the likeness of the body which the Son of God accepted for our salvation" (*Mon.Germ.Epist.* v, 56, quoted after R. Berliner, *G.d.B.A.*, 1945, II, p. 275). The difference, however, seems to lie first in the more intimate character of Michelangelo's late religious drawings, which are, so to speak, monologues on the Passion of Christ, and secondly in the sketchy nature of their simplified shapes, which immediately invite the beholder to forget form and concentrate on the religious essence.

VI. NOTES ON CHAPTER VI: THE LAST PIETÀS (AND THE PIETÀ OF PALESTRINA).

DEPOSITION CALLED "PIETÀ"

Florence, Cathedral
Marble in the round, partly polished; the body of Christ by Michelangelo; the front side of Mary Magdalene by Tiberio Calcagni.
H. 226 cm. Width of base 123 cm. Depth of base 94 cm.
The original shape of the block, as can be seen on the base, was pentagonal.

1. *Condition*: It is known through Vasari (1568, pp. 219*ff*), that Michelangelo muti- 77-83
lated the unfinished group himself (the mutilation can still be observed today) and that
Tiberio Calcagni restored it according to Michelangelo's models, "con suo aiuto di
modelli [di Michelangelo] Tiberio la finissi." Calcagni used several of the remaining
fragments: the left forearm and the left hand he pieced together; also the right fore-
arm, which was broken, he put back into position. On the neck of Christ and on the
left hand of Joseph of Arimathea the flat chisel work of Tiberio can be recognized.
Tiberio completed the pieces of marble lacking on the left breast and on the left
hand of Christ. The figure and face of Mary Magdalene, originally roughly hewn
out of the block by Michelangelo (see the back of the figure), were reworked on the
front side with a flat chisel by Calcagni. The right arm of Mary Magdalene was also
broken and put back into position. The left leg of Christ is lacking. It seems that
it was originally made from a separate piece of marble. The purpose of the hole at
the thigh was probably to serve as a slot for the insertion of this leg.

Concerning the restoration by Calcagni, see Grünwald, *Florentiner Studien*, pp. 14*f.*

2. *History*: Michelangelo seems to have begun the group around 1547 since it
is mentioned as still unfinished and in his workshop in the first edition of Vasari
(1550, p. 172; written ca. 1546-1547 according to Kallab, *Vasaristudien*, Vienna, 1908):
"e bozzato ancora in casa sua, quattro figure in un marmo, nelle quali è un Christo,
deposto di croce. . . ." The year 1547 is also the year of the death of Vittoria Colonna.
In 1553 Condivi (p. 174) mentions the incompleted group again. The mutilation took
place before December 3, 1555, the date of the death of Urbino (see Baumgart, *J.d.p.K.*,
1935, and von Einem, *J.d.p.K.*, 1940). Vasari (1568, p. 219) writes that one of the reasons
for the mutilation was the impatience of Urbino, "la importunità di Urbino suo servi-
dore, che ogni dì lo sollecitava a finirla. . . ." Another reason was that the block was not
flawless. Michelangelo lost patience and wanted to destroy the whole group. This, how-
ever, was prevented by his servant, Antonio, who asked for the mutilated group and
received it as a gift. The inventory of Daniele da Volterra of April 5, 1566, mentions the
knee of the Deposition, probably that of the missing left leg: "un ginocchio di marmo
della Pietà di Michelagnolo" (*Il Buonarroti*, I, p. 178; Steinmann-Wittkower, no. 778).

Michelangelo originally sculpted the group, according to Vasari (*Carteggio*, II, p. 59),

for his own tomb and Vasari observes that the head of Nicodemus (actually of Joseph of Arimathea) is a self-portrait: "Perchè se la ricerchete per servirsene per della sepoltura, oltre che ella è disegniata per lui, evvi un vecchio che egli ritrasse se." (See also Vasari 1568, p. 218.)

Francesco Bandini acquired the group for 200 scudi in gold from Antonio and wanted to have it completed by Tiberio Calcagni according to Michelangelo's models. Bandini transferred it to his vineyard on Monte Cavallo. The group remained unfinished, however, because of the death of both Bandini and Tiberio (Daelli, pp. 50-55; Vasari 1568, p. 219).

Just after the death of Michelangelo, Vasari tried to secure the group again for the tomb of the artist—this time for Santa Croce—but he was not successful. See the above-quoted letter of Vasari to Lionardo Buonarroti, March 18, 1564 (cf. Vasari, *Carteggio*, II, p. 59). Vasari (1568, p. 220) mentions the group in the vineyard on Monte Cavallo as the property of Pierantonio Bandini, son of Francesco. In 1652 the group still lay in the Bandini Vigna: "Stà nel giardino che fu del Sig. Cardinal Bandino a Monte Cavallo" (see Ottonelli e Berrettini, *Trattato della Pittura*, 1652, p. 210, and Steinmann-Wittkower, no. 1425).

Between 1652 and 1674 the Deposition was transferred by order of Grand Duke Cosimo III, with the help of the Marchese Montauti and Paolo Falconieri, to Florence and placed in the crypt of the Church of San Lorenzo. Falconieri had wanted originally to put the statue in the Sagrestia Nuova with the other works of Michelangelo but this plan was rejected because the Duke's opinion was that "la statua della Pietà non merita . . . di stare fra le altre opere dello stesso autore, e però si esclude dalla cappella" (see the letter by P. Falconieri to Canonico Bossetti, November 17, 1674, discovered by G. Poggi and published in C. Mallarmé, *L'ultima tragedia di Michelangelo*, Rome, 1929, pp. 79f). It is noteworthy, however, that at the same time the group was highly appreciated by Bernini: "il Cristo ch'è quasi finito tutto, è una meraviglia inestimabile." (See the letter of Falconieri mentioned above.)

In August 1721 at the order of Grand Duke Cosimo III, the group was placed behind the main altar of Santa Maria del Fiore (see the letter of Cosimo III of August 24, 1721, published in Mallarmé, *op.cit.*, p. 83). In the early 1930's the group was transferred to one of the chapels of the north tribune of Santa Maria del Fiore, where it remains.

3. *Subject*: The group is usually called a Pietà, but it is in truth a Deposition and was rightly called such by Condivi and Vasari. As is mentioned above, it was made by Michelangelo for his own tomb which he first desired to have erected in Santa Maria Maggiore in Rome (Vasari 1568, p. 218). The same destination is mentioned in Vasari's letter, quoted above, to Lionardo Buonarroti, March 18, 1564: "È venutomi consideratione . . . che la pietà delle cinque figure, chegli roppe, la faceva per la sepoltura sua . . ." (Vasari, *Carteggio*, II, p. 59). See also the letter of Prete Giovanni di Simone to Lionardo Buonarroti, March 18, 1564, in Daelli, no. 32.

This iconographical type of the Deposition representing the dead Christ in vertical position held between the Virgin and Mary Magdalene and with Joseph of Arimathea behind and above Christ, reverts to a type known in Italian art throughout the Trecento and Quattrocento (see text). To our knowledge the closest to Michelangelo of all previous Depositions, is that of Fra Filippo Lippi, Cherbourg, Musée; it contains the same figures and is also in a similar triangular composition (see our text). Lanckorónska, *Dawna Sztuka*, 1939, pp. 111*ff*, calls the group a "Descent from the Cross"; she mentions as a possible prototype an Italo-Byzantine composition in the Museum of Murano in which, however, the body is supported by the Virgin (left) and by St. John the Evangelist (at the right). *372*

4. *Technique*: The body of Christ was polished by Michelangelo. The head was roughly worked with a toothed chisel. The Virgin was also done with a toothed chisel and remained unfinished. Michelangelo began Mary Magdalene with a toothed chisel: her left arm and shoulder are by him. Calcagni reworked and ruined the front side with a flat chisel and polished the figure. Joseph of Arimathea was done with a pointed chisel by Michelangelo. *77 83,77 81,82,78*

5. *Analogies*: The composition is developed, as has been said in the text, from the Vittoria Colonna Pietà: from here comes the idea of the body of Christ in a vertical position, held under the armpits by two figures, with a third figure crowning the group. The positions of the legs and that of the head of Christ are quite close in both works. The composition seems to be inspired also by certain Trinity representations, e.g. the woodcut by Dürer of 1511 and the engraving by Agostino Veneto after the drawing of Andrea del Sarto. Consequently the Deposition of Florence is a fusion between the earlier Depositions (in the manner of Fra Filippo Lippi) and the indicated type of Trinity representations. The closest iconographical prototype is, as has been said above, Fra Filippo Lippi's Deposition, Cherbourg. *354 359,360 372*

The head of Joseph of Arimathea in the Deposition of Caravaggio also has the features of Michelangelo (Lanckorónska, *Dawna Sztuka*). The Pietà by El Greco, known in two copies (New York, Hispanic Society and Philadelphia, Museum of Art, Johnson Collection) is a fusion of the Pietà of Vittoria Colonna and the Deposition in Florence (Tolnay, *Records of the Art Museum*, Princeton, 1953). *353*

6. *Copies*: Lorenzo Sabbatini, Rome, San Pietro, Sacristy, an exact copy completed with lacking left leg of Christ (see Venturi, *Storia*, ix, 6, fig. 468).

Santa Maria dei Monti, Rome, third chapel at the right, anonymous painting of ca. 1560-1570 (unpublished).

Giacomo Cortese, called Borgognone (copy without Mary Magdalene), Rome, Accademia di San Luca (unpublished).

Anonymous engraving made under Pope Gregory XIII (1572-1585), Paris, Bibliothèque Nationale. *373*

Addendum: After completion of this manuscript we became acquainted with von Einem, *Michelangelo-Die Pietà zu Florenz*, Stuttgart (1956). The author here essen-

tially repeats the content of his article in *J.d.p.K.*, 1940. He follows our chronology
218 of the sketches on the Oxford sheet and he accepts our reconstruction of the first
version of the Rondanini Pietà. He considers it as possible that the inspiration for the
Christ of the Pietà in Florence may have come from Jacopo del Conte's Descent from
the Cross, Rome, San Giovanni Decollato. He hypothetically connects the passage of
Blaise de Vigenère of ca. 1550 with this work.

THE PIETÀ OF PALESTRINA

Florence, Accademia delle Belle Arti.
Marble in the round.
H. 253 cm.

84-87 7. *Condition*: The work is only partly finished: the body of Christ, except the head
and feet, and the right hand of the Virgin are finished and polished. The figures of
the Virgin and of Mary Magdalene are only roughly hewn and form a kind of frame
around the polished body of Christ. The left shoulder of Christ is restored. The two
Marys are worked with a toothed chisel; the right foot of Christ shows the use of
a pointed chisel. In the back of the group at the lower left corner there is recognizable
an ancient architectural ornament, proving that this piece of marble was made from
a block which originally served a different purpose. (See below.)

 8. *Attribution*: First mentioned as a work of Michelangelo by L. Cecconi, *Storia
di Palestrina città del Prisco Lazio*, Ascoli, 1756, p. 111. (See Steinmann-Wittkower,
no. 436.) It was mentioned as a work by Michelangelo for the second time by Fabio
Gori, "Aneddoti e lavori di Michelangelo Buonarroti ignoti ai biografi," in *Archivio
storico . . . della città e provincia di Roma*, Rome, 1875, pp. 5ff. There followed the
article of A. Grenier, "Une 'Pietà' inconnue de Michel-Ange à Palestrina," in *G.d.B.A.*,
1907, pp. 177ff. Wallerstein's "Die Pietà des Michelangelo zu Palestrina," *Z.f.b.K.*,
1914, pp. 325ff is based on Grenier. Among the more recent authors, the following
take the position that this is a work by Michelangelo: Toesca, "Un capolavoro di
Michelangelo: La Pietà di Palestrina," *Le Arti*, I, 1938-1939, pp. 105ff; G. Papini,
"La Pietà di Palestrina" in *Corriere della Sera*, December 28, 1938; and V. Mariani,
"La Pietà di Palestrina a Roma," *L'Arte*, 1939, pp. 3ff. Pier A. Petrini, *Memorie
Prenestine disposte in forma di Annali*, Rome, 1795, p. 259, under 1677, reports that
the group, which was executed from a block which protruded from a mountain face
at this site, was "generally attributed to Gian Lorenzo Bernini or Nicolo Menghini"
(see also Thode, *Kr.U.*, II, p. 281).

 The attribution to Michelangelo has been doubted by: Thode, *Kr.U.*, II, pp. 281f;
Steinmann, *Cicerone*, III, 1911, pp. 339f; A. E. Popp, *Z.f.b.K.*, 1924, pp. 133f; Tolnay,
Thieme-Becker; Lanckorónska, *Dawna Sztuka*, pp. 111f; and von Einem, *J.d.p.K.*,
1940, p. 82 note. Several arguments speak against the attribution to Michelangelo:
85 the total composition is flat; the artist chose a flat block and worked into it from only

one (the frontal) side, in the manner of a relief (see the lateral view). On the contrary, the Pietà in Florence and the Pietà Rondanini are, like the other works of Michelangelo, distinctly three-dimensional. When the work is observed from the rear, one sees that the Virgin has no back since there was no more material for this purpose. Unlike Michelangelo's style, there are deep hollows between the body of Christ and his right arm on the one side, and between his body and Mary Magdalene on the other. These are traits which Michelangelo would hardly have countenanced. The anatomy of the body of Christ does not seem to be developed from within; the forms do not seem to swell outward; rather the muscles and bones seem to be graphically superimposed from outside with a resulting emptiness. Although the folds of the shroud imitate a pattern of the master, they are not born from a feeling for the material, but again they are applied from the exterior. The proportions of the limbs of Christ's body bear no inner correspondence; his legs are too short and lean in relation to his enormous dangling right arm. The stance of the Virgin remains unclear since there was no marble remaining for the execution of her right leg. The completely executed right hand of the Virgin below the armpit of Christ produces an effect alien to Michelangelo. The work seems, therefore, to be executed by a follower of Michelangelo, who used the master's composition of the Florentine Pietà in reverse and omitted one of the figures.

9. *History*: The work was originally in the funerary chapel of the Barberini, in the church of Santa Rosalia in Palestrina. This church was finished in 1677. The Barberini bought Palestrina from the Colonna in 1630.

The group is perhaps identical with that mentioned by G. D. Ottonelli and P. Berrettini, *Trattato della pittura, e scultura . . . composto da un theologo e da un pittore*, Florence, 1652, p. 210: ". . . fù trovato [the Pietà group] seppellito in una stanza a terreno, e hora si vede publicamente in una Officina di Roma." Toesca interprets the word "seppellito" to mean that, because of its unstable balance, the work had fallen forward. According to him it was Pietro da Cortona who advised the Barberini to buy the group. (Robinson, p. 337, however, connects this sentence with the Pietà Rondanini.)

In the funerary chapel of the Barberini, the group was set up in a niche above an altar and framed by a stucco curtain: the group stood isolated from the background. As mentioned above, the block did not come from a marble quarry but was a fragment of a late antique architectural ruin, probably an architrave or cornice, as can be seen on the lower left corner of the back. There are egg-and-dart ornaments and leaves, all worked with a drill.

10. *Subject*: This is not a Pietà, properly speaking, but an Entombment. It seems to be developed from Michelangelo's Pietà in Florence as shown in the text.

11. *Analogies*: The composition reverts to motifs invented by Michelangelo and is a kind of paraphrase in reversed version of the Florentine Pietà. The body of Christ corresponds to the earliest version of the Pietà Rondanini, Oxford sheet (second sketch from the left).

12. *Chronology*: Grenier dated the group around 1550; Toesca placed it in the time of the Florentine Pietà, 1547-1555. A *terminus post quem* ca. 1552, is given by the Oxford sheet with the Pietà drawings, the motifs of which were used by the sculptor of this work.

PIETÀ RONDANINI

Milan, Castello Sforzesco.
Marble group in the round; unfinished.
H. 1.95 m.

13. *Condition and technique*: Remains of mutilated earlier versions exist. Later the front of the base was partly cut away and the toes of the right foot of Christ were destroyed; an inscription was engraved on the front of the base: "Pietà di Michelangelo Buonarota."

Michelangelo began cutting into the block diagonally from its edge as can be seen from the rear. Thanks to this approach, he obtained a wider area for his group in his first version. Originally the block seems to have been irregular, protruding forward both at top and bottom. The master made use of this unusual shape, as can be seen in the profile views where the group forms a noticeable crescent.

14. *History*: The group is first mentioned in Vasari's second edition, 1568, p. 220, who after having reported the reasons why Michelangelo mutilated the Florentine Pietà (before December 3, 1555, date of the death of Urbino) says: "E tornando a Michelangelo, fu necessario trovar qual cosa poi di marmo, perchè e' potessi ogni giorno passar tempo scarpellando, e fu messo un'altro pezzo di marmo dove era stato già abbozzato un'altra Pietà, varia da quella, molto minore." This Pietà "già abbozzata" in the block was probably made after 1552, since Condivi, who wrote his life of Michelangelo that year, did not yet know it (Baumgart). This block was taken up again by Michelangelo ca. 1555 after the mutilation of the Florentine Pietà, as reported by Vasari (1568, p. 220), but was not finished. The group seems to have remained in the workshop of Michelangelo. A document from August 21, 1561 (Steinmann-Wittkower, p. 426 and doc. XIII) mentions a Christ with a cross and a Pietà. This Pietà can only be the Pietà Rondanini. According to the document Michelangelo gives these two unfinished statues to his servant Antonio del Francese da Casteldurante. But we know from the Inventory that both statues stood in Michelangelo's studio at the time of his death. The document was drawn up, therefore, as a last will and testament, and the servant was to have it only after Michelangelo's death. Baumgart (p. 9) calls attention to the fact that around 1560 the first version still existed since the body of Christ in Taddeo Zucchero's Pietà (painting ca. 1560, Rome, Gallery Borghese) is related to the first version of the Pietà Rondanini.

Toward the end of his life, ca. 1563-1564, Michelangelo partly reworked the group, and Daniele da Volterra reports in a letter of June 11, 1564, to Lionardo Buonarroti

(Daelli, no. 34) that the master was still working on it on February 12, 1564, six days before his death: "io non mi ricordo se in tutto quello scritto io messi chome Michelagnolo lavoro tutto il sabbato della domenica di carnovale ellavoro in piedi studiando sopra quel corpo della pietà. . . ." The group is mentioned also in the inventories of Michelangelo's belongings on February 19, 1564 (Gotti II, p. 150 and Frey, *Handz.*, p. 214): "Un'altra statua principiata per un Cristo ed un'altra figura di sopra, attaccate insieme, sbozzate et non finite." It is mentioned by Daniele da Volterra in a letter to Vasari on March 17, 1564 (Gotti I, pp. 357f): "Una Pietà ch'egli haveva cominciata, della quale vi s'intende solo le attitudine delle figure, sì v'è poco finimento; basta, quello di Cristo è il meglio. . . ."

It is not known what happened then to the Pietà Rondanini. The passage reported in G. D. Ottonelli and P. Berrettini, *Trattato della pittura e scultura . . . composto da un theologo e da un pittore*, Florence, 1652, p. 210, concerning a second Pietà besides the Florentine one, which second group "fu trovato seppellito in una stanza a terreno, e hora si vede publicamente in una Officina di Roma" does not necessarily refer to the Pietà Rondanini, but could refer to the Pietà of Palestrina (see above).

The Palazzo Rondanini became the Russian embassy in the nineteenth century. The group stood in the entrance. When the palace was taken over by Conte Sanseverino-Vimercati in the 1920's the group was transferred to the library on the *piano nobile*. (Here were executed the new photographs, published by Tolnay, *Burl.Mag.*, 1934.) After the death of the Count the palace was sold and the group was moved to the villa of his son Ottaviano in the outskirts of Rome. Recently it was donated to the city of Milan, and located, on December 20, 1952, in the Castello Sforzesco.

15. *Chronology*: Concerning the dating of the Pietà Rondanini see especially Baumgart, *J.d.p.K.*, 1935, pp. 44ff and D. Frey, *H. Kauffmann Festschrift*, 1956, p. 208. According to Baumgart, the first version was made ca. 1552-1553, the second version ca. 1555-1556, and the third ca. 1563-1564. Concerning the chronology of the Oxford sketches see Tolnay, *Burl.Mag.*, 1934, p. 151. This chronology has been accepted by Baumgart, von Einem, D. Frey.

Earlier scholars, Robinson (p. 337) and Thode (*Kr.U.*, II, p. 280) dated the Oxford sketches and the first version ca. 1541-1542, on the supposition that the Pietà Rondanini was begun before the Florentine Pietà. More recently von Einem (*J.d.p.K.*, 1940, p. 88) returned to this hypothesis, interpreting the phrase of Vasari "già abbozzato" as meaning that the Rondanini group was hewn roughly before the Florentine Pietà. He dates the Oxford sheet and the first version before 1550. However Vasari mentions the Rondanini Pietà after the one in Florence, and consequently, it may be supposed that its first version was also later than the inception of the Florentine Pietà. Brinckmann (*Zeichnungen*, p. 80) dated the Oxford sketches in the 1560's, which is too late in view of what Vasari says. Tolnay (*Burl.Mag.*, 1934, pp. 146ff) dated the sketches in Oxford and the first version ca. 1550-1556 and the last version ca. 1563-1564.

16. *Subject*: The Oxford sketches reveal that the subject was originally an Entombment and only in the last version did Michelangelo make of it a Pietà. (Also von Einem, *J.d.p.K.*, 1940, p. 77, emphasizes that it was originally an Entombment.)

The Rondanini Pietà has always been described as a "Schmerzensgruppe." Robinson regarded it as a representation of the Mother as "Mater Dolorosa." Worringer (1909, pp. 355*ff*) speaks of the "Tragik dieser Pietà." He explains the group as an expressionistic work and is the first to recognize its similarity to Gothic art. Then follows the remarkable page of Simmel (1910, pp. 220*f*) for whom this is "das tragischste Werk Michelangelos." Dvořák (1918-1919) saw in the group a representation "des erschütternden Mutterschmerzes" and emphasized its importance as a source of inspiration for El Greco. On the other hand, Tolnay (*Burl.Mag.*, 1934, p. 157) emphasized that the sorrow seems conquered by the feeling of blessedness.

218 17. *Analogies*: The first version of the Pietà Rondanini (see the Oxford sketches) resembled a late mediaeval type of Entombment and of Holy Trinity in which the suffering Christ or the dead Christ is held vertically by Joseph of Arimathea or by God the Father. To this type belongs the Entombment of the Master of San Miniato,

362 published in *Swarzenski Festschrift*, 1951, p. 99, or the Holy Trinity by the Master of

365 Flémalle, Frankfurt am Main; other examples are a wood sculpture from the second half of the fifteenth century originally in the church at Baern, Holland, now in

366 Utrecht, Archiepiscopal Museum; a woodcut of ca. 1430, published by Lemoine, *Les Xylographies du 14ᵉ et du 15ᵉ siecles au Cabinet des Estampes*, Paris, 1930, II, pl. 63. Another similar type, where the body of Christ is held vertically by an angel, called "insinuationes divinae pietatis," is represented by a group of small sculptures assembled by G. Swarzenski, *Goldschmidt Festschrift*, 1923, pp. 65*ff*.

The last version resembles a type in which the Virgin is supporting and presenting the suffering Christ. An early example is in Florence, Casa Horne, published by Panofsky, *M. J. Friedländer Festschrift*, 1927, p. 263; another attributed to Ambrogio

367, 368 Lorenzetti is in the National Gallery, London; a fresco in San Miniato al Monte; a painting attributed to the Catalan School in Vercelli, Museo Borgogna, published in *Boll.d'Arte*, 1938, p. 120. Two northern examples are published by Panofsky, *M. J. Friedländer Festschrift*, 1927, p. 274.

The group faintly resembles in its earlier version, as von Einem (p. 97) observed, ancient representations of the Entombment, e.g. an Etruscan urn, Florence, Museo Archeologico. This is a significant parallel rather than a direct influence on Michelangelo.

18. *Reconstruction*: A reconstruction of the first version was given first by Tolnay, *Burl.Mag.*, 1934, pp. 151*ff*; then by Baumgart, *J.d.p.K.*, 1935, who arrived at similar conclusions, and published a plastic reconstruction by Arno Breker; finally by Dagobert Frey, *Kauffmann Festschrift*, 1956, pp. 208*ff*. The problem of which parts belong to the first, second, and third versions is not yet resolved. Our opinion on this point actually differs slightly from that of Baumgart and D. Frey.

Within the final version of Christ's head, D. Frey (*H. Kauffmann Festschrift*, 1956, pp. 208*ff*) distinguished two phases: the forehead hairline belongs to the first attempt at reworking, but the remainder of this face was subsequently removed and a new face was sketched. This change may be interpreted as a *pentimento*. Besides, D. Frey supposes that that which we consider the first version of the Virgin's head does not belong to the original version of the group, but corresponds to the first attempt at the final version of Christ's face. However the larger dimensions speak for the first version and also the fact that in the second Oxford sketch one can already see at the extreme right the motif of the Virgin's averted head, which position is a consequence of the strain of her burden.

Altogether there are two main versions and within each version, two variants.

19. *Copies*: Taddeo Zucchero, Pietà, Rome, Galleria Borghese (copy of the first version, ca. 1560. See Baumgart, *J.d.p.K.*, 1935).

A free paraphrase by Angelo Bronzino, Florence, Santa Croce.

92, 93

218

364

VII. CATALOGUE OF DRAWINGS

PREFACE

The present Catalogue includes, besides the drawings of Michelangelo made in the last thirty years of his life, a few of his earlier sheets, which anticipate motifs used by the master in his later works and which were not listed in earlier volumes of this study.

The opinions expressed here concerning authenticity and chronology are based on new and prolonged contact with the originals. It was this writer who, some thirty years ago (1927), first attempted to present the late drawings of Michelangelo as a coherent group in chronological order. These early opinions I have checked and corrected where it seemed necessary. Concerning the genuineness of the late drawings of Michelangelo, I found that my first judgments were in some cases too severe and I have therefore included some drawings which I had rejected earlier. This is especially true with reference to several studies for the Last Judgment. Nevertheless, I am still not inclined to accept all the opinions of certain expansionist scholars, the most outstanding modern representatives of whom are Thode and Wilde. Wilde returns radically to the old attributions and often rejects the conclusions of the critics of the last half century. I could not convince myself of the correctness of Wilde's opinions concerning the following drawings of the Brit. Mus.: Wilde, *Brit.Mus.Cat.*, 11r, 11v, 14, 15, 17, 29r, 29v, 32, 40, 42r, 42v (Wilde follows here exactly Thode's Cat. 344), 43, 44 (questionable), 46v, 48v, 57r, 58, 59, 61r, 61v, 64r, 67, 69.

I should correct here the statement of my friend A. E. Popham in the introduction to the Catalogue of the British Museum in which he places Berenson beside Wilde, contrasting both with the so-called "hyper-critical school" of Morelli to which he also assigns the present writer. But, first, Berenson is one of the representatives of the discriminating critics and indeed almost all his new conclusions concerning the attribution of drawings to Sebastiano del Piombo and to "Andrea di Michelangelo" were rejected by Wilde, who returned to the traditional attributions to Michelangelo. Secondly, this writer has never belonged to the Morellian School. And, thirdly, Popham overlooked the fact that Wilde's recent attitude connects him with the Thode-Knapp trend. Wilde had been until some years ago the champion of the discriminating school of scholars and has only recently changed his viewpoint. In Popham's brief survey of recent criticism of Michelangelo's drawings, that which should be separated is put together and that which should be put together is rent asunder.

The present writer has also to correct an erroneous statement of Professor Johannes Wilde in his article in the *Fritz Saxl Memorial Essays*, London, 1957, p. 271 n. 3. Speaking of the Leda sketch of Michelangelo in Cod. XIII of the Archivio Buonarroti, he states, "The drawing [of the Leda] was noticed by Dr. Tolnay and myself, when we studied the Codex together in January 1926. Subsequently Dr. Tolnay published it in his paper in the *Münchner Jahrbuch*, 1928, pp. 436*ff*, figure 46." Let it be mentioned

here that Wilde and I never saw and studied together the Archivio Buonarroti draw-ings of Michelangelo. I had, prior to Wilde, for the first time access to the drawings from September 27 to October 20, 1926, and it was during those weeks of work in the Archivio that I noticed (independently and prior to Wilde) the connection of the sketch in question with the Notte and the Leda, as I may prove by my notes of 1926 still in my possession. I subsequently published my observation in my article. (Wilde, in answering my letter of November 4, 1957, in which I reminded him of these facts acknowledged the lapse of his memory and informed me in a letter of November 23, 1957, that he too had not been in Florence during January 1926, but that he, for the first time, had access to the Codex XIII of the Archivio Buonarroti on Decem-ber 1, 1926 only for one day.)

As to the chronology of the late drawings of Michelangelo, it seems that the present writer in his first approach (1927) has grasped at least the great line of the master's development. This is attested by the succeeding studies on this subject by scholars such as Baumgart, Wilde, Wittkower, and Parker who agree with our essential conclusions and differ only in details. In the present catalogue we have tried to make the chronology more precise whenever this was possible. The great difficulty in arriving at an exact chronology is that there are from this later period, except those for the Last Judgment, only a few drawings by Michelangelo to which a more or less precise date can be assigned. Such is the highly incomplete scaffold which must serve the scholar for a chronology of the late drawings. It is obvious that many prob-lems must remain unsolved.

I am greatly indebted to the work of earlier students, in particular to the authors of the critical catalogues of the drawings like Berenson, Frey, and Thode and, more recently, Baumgart, Wilde, and Parker.

The method adopted follows the pattern of the earlier volumes. My main concern remains the problem of authenticity, subject, purpose, and chronology. I do not attempt to examine all details. The measurements of the sheets of Oxford, London, Vienna, and Windsor are taken from the respective critical catalogues; those of Bayonne, Florence (Casa Buonarroti and Uffizi), Haarlem, and Paris were taken by the author.

The drawings are arranged within their groups as far as possible in chronological order.

The following drawings are published here for the first time: Figs. 119, 157, 187, 193, 220, 228, 232, 233, 251, 254. The following drawings were first published by this author and have not been reproduced since: Figs. 134, 135, 136, 155, 156, 159, 170, 176, 189, 205, 234, 235, 237.

N.B. Drawings Nos. 1 through 35 are listed in the Catalogue of Vol. I, pp. 175*ff*; Nos. 36 through 47 (and Nos. 1 A through 28 A) are listed in the Catalogue of Vol. II, pp. 199*ff*; Nos. 48 through 122 are listed in the Catalogue of Vol. III, pp. 203*ff*; Nos. 123 through 137 (and Nos. 29 A through 52 A) are listed in the Catalogue of Vol. IV, pp. 137*ff*.

CATALOGUE

DRAWINGS OF THE EARLY AND MIDDLE PERIODS
ANTICIPATING MOTIFS OF LATE WORKS

Preliminary remarks: In this section we are listing drawings by Michelangelo or his pupils of the Virgin with the Child, which, in their composition, anticipate the late Windsor drawing of the Virgin with the Child (No. 237). They bear witness to the *102* fact that Michelangelo was constantly occupied since his youth with the type Madonna del Latte. They show how he tried to synthesize the maternal aspect with the sibylline aspect, this latter characteristic of another group of his early works. We included also in this group a hitherto unpublished early drawing of St. Jerome.

138. *Two Studies of the Virgin with the Child.* Paris, Louvre (Inv. no. 4112r). *96* Pen and ink on yellowed paper. H. 388 mm. W. 279 mm. Recto of the succeeding drawing.

Müntz, *G.d.B.A.*, 1896, I, p. 321; Frey, *Dicht.*, pp. 323*ff*; Berenson, *Drawings*, no. 1599; Justi, *Ma.N.B.*, p. 106; Thode, *Kr.U.*, III, no. 511d; *Société de Reproductions des Dessins de Maîtres*, 1909, fasc. 1; Demonts, *Dessins*, no. 6; Popp, *Z.f.b.K.*, 1925-1926, p. 145; Goldscheider, no. 48.

The drawing is in our opinion of ca. 1505. The crosshatching technique is the same as in the early drawings of 1501-1505. Müntz dates the drawing ca. 1508; Demonts, ca. 1510; Berenson, ca. 1514 (1st ed.) and 1520 (2nd ed.); Thode, the time of the Sistine Ceiling or earlier; Frey, 1518-1524; Goldscheider, 1513.

The Virgin with the Child at the top (turning the sheet upside down) is of noticeably higher quality. It is inspired by the tragic Virgins of Donatello, as for example, the Madonna of the Casa Pazzi, formerly Berlin. To the right of her there is a foreshortened male figure asleep (either St. Joseph or the little St. John?). The whole group probably influenced Raphael's Madonna della Casa Tempi, Munich, ca. 1505, and anticipates the lunettes of the Sistine Ceiling. The influence on Raphael's early Virgin speaks further for our early dating.

The bottom study of a Virgin with the Child and little St. John is in a dryer line work. Yet its conception is certainly also by Michelangelo. The motif of the Child between the legs of the Virgin is close to that of the Bruges Madonna, from which it has been developed.

Both sketches are probably studies for a relief (or a picture) composition as Thode assumes (see the framing lines of the bottom study) and are not for a marble group (as Berenson contends).

Berenson (*Drawings*, 2nd ed., I, p. 361) attributes both sketches to his "Andrea di Michelangelo."

There is a line of handwriting on the left margin, certainly not by Michelangelo, which was (not convincingly) ascribed by Frey to Antonio Mini.

Müntz and Berenson pointed out that this sketch seems to have inspired Raphael's large Holy Family for François I in the Louvre.

(Collections: Bernardo Buontalenti; Michelangelo Buonarroti il Giovane [1568-1647], grand nephew of Michelangelo who was also collector of the drawings of his great ancestor; Wicar; M. Simpson; Léon Bonnat.)

97 139. *Madonna della Misericordia (or Sibyl) Standing in a Niche.* Verso of the preceding drawing. Same specifications. Same literature except for Demonts, *Dessins*, now no. 6bis; Goldscheider, now no. 34 and Tolnay, Vol. IV, pp. 36, 96.

In our opinion, this drawing is of the same period as the recto, ca. 1505. Müntz, Berenson, Thode: ca. 1510-1514; Demonts and Goldscheider: ca. 1513; Frey: time of the Medici Tombs. The technique and the treatment of the forms correspond to the top sketch of the recto and to the group of the early drawings.

A much damaged sheet with considerable staining on the border, probably attributable to the center having been partly pasted over at one time.

Differences of opinion concerning the intent of the work: according to Berenson, a Virgin with the Child Reading; according to Müntz and Demonts, possibly a symbol of Charity protecting a child; for Goldscheider (p. 33) it is a Sibyl and a putto and, following a remark of K. Frey, he thinks that it is a sketch for the second project of the Tomb of Julius II (1513) and that the background indicates the pilaster of the monument instead of a niche, as Frey and Berenson have, in our opinion rightly, assumed. It is probably a Madonna della Misericordia, protecting the Child with her mantle, whose pose is like that of the female saint in the right niche of the third zone of the Tomb of Julius II (1513). At the bottom the head and upper torso of the Child are repeated by Michelangelo. The object which the Child is holding and which has been interpreted by Berenson as a prayer book can no longer be determined with certainty.

After the sketch had been done, Michelangelo wrote with three different inks, which also differ from the ink of the drawing, a draft for a poem, published in Frey, *Dicht.*, XXXVII, pp. 258*ff*. The handwriting possesses the character of the master's hand of ca. 1505-1506.

(Same collections as for the preceding drawing.)

99 140. *Sketches for a Virgin with the Child.* Paris, Louvre (no. 689). Pen and ink. H. 367 mm. W. 250 mm.

Berenson, *Drawings*, no. 1589r; Thode, *Kr.U.*, III, no. 478; Brinckmann, *Zeichnungen*, no. 15; Popp, *Z.f.b.K.*, 1925-1926, pp. 173*f*; Baumgart, *Marburger Jahrbuch*, 1937, p. 47; Wilde, *Brit.Mus.Cat.*, pp. 14, 25, 104; Goldscheider, no. 55.

The left sketch was drawn first, serving as a model for the right sketch. (The execution of the latter is somewhat weaker.) The sketches show the style and tech-

nique of the early period of ca. 1503-1505, see, for example, No. 16 which, however, is of noticeably higher quality.

Thode noticed the similarity of the motif with the Medici Virgin and the Albertina sketch, No. 141. He considered the drawing as a preparatory study for the Medici *98* Virgin. Berenson dated it "not later than 1514" and supposed that the sketches were made for one of the lunettes of the Sistine Ceiling. Brinckmann dated the drawing around 1504 and believed that there is a connection with the Bruges Madonna, via the sketches on the Uffizi sheet, Brinckmann, no. 8. Wilde dates the drawing ca. 1503-1504, and follows Brinckmann in the supposition that it is evolved from the Uffizi sheet and connects it with the Taddeo-Taddei Madonna in London, Royal Academy. Goldscheider dates it around 1524. According to Popp and Baumgart, the sketches are not genuine. The latter believes that they are imitations of lost studies of Michelangelo, made probably by the same draftsman who drew the nude studies in the Louvre (Baumgart, fig. 31) and the Albertina Virgin, No. 141.

On the verso of this sheet there is a study of a standing male nude, not by Michelangelo (see No. 41A in Vol. IV). *Vol. IV, 266*

141. *Virgin and Child*. Vienna, Albertina. Pen and ink. H. 388 mm. W. 195 mm. *98* Schönbrunner-Meder, 360. Berenson, *Drawings*, no. 1603. Thode, *Kr.U.*, III, no. 526. Brinckmann, *Zeichnungen*, no. 16. Popp, *Z.f.b.K.*, 1925-1926, pp. 173*f*. *Albertina Cat.*, III, 132r. Baumgart, *Marburger Jahrb.*, 1937, p. 48. Wilde, *Brit.Mus.Cat.*, pp. 14, 25, 104. Goldscheider, no. 54.

The motif of the seated Madonna and of the Child was in its first version almost identical with No. 140, but it was reworked and completed with the drapery and *99* with a new head for the Virgin, which was now turned downward. Although the motif anticipates the Medici Virgin, the technique of the drawing points to a date of ca. 1503-1505. A similar date is proposed by Thode and by Brinckmann who, however, connects the sketch with the Bruges Madonna. Berenson dates the drawing "not later than 1514"; Goldscheider dates it around 1524.

According to Popp and Baumgart, the drawing is not genuine. We share these doubts. Baumgart gives the drawing to the same hand as No. 140 (see Vol. III, p. 213).

142. *Virgin with the Child, in half-length*. Florence, Casa Buonarroti. Black and *100* red chalk, heightened with white; small areas are worked in pen and ink. Yellowed paper, partly restored. H. 542 mm. W. 397 mm.

Berenson, *Drawings*, no. 607; Thode, *Kr.U.*, III, no. 63; Brinckmann, *Zeichnungen*, no. 20; Popp, *Belvedere*, 1925, *Forum*, p. 74; Wilde, *Brit.Mus.Cat.*, pp. 64, 104.

Thode and Brinckmann consider this sheet an early work of Michelangelo ca. 1506. Wilde, who also holds it to be genuine, dates it once in 1522-1524 (p. 64) and another time 1520-1525 (p. 104). Brinckmann remarks that the outlines and the coloring are by a later hand. The authenticity of this sheet has been doubted by Berenson, who

assigned it to Giuliano Bugiardini, and by Popp, who credits it to an unknown follower of Michelangelo.

First the black chalk outlines of the Virgin and the Child were made; then in red chalk, the left contour of the Child; finally the body of the Child was reworked with red and white chalk. The black chalk outlines of the Virgin are hesitant; the forms of her hands are weak. Much better in quality are the black chalk outlines of the Child. The modeling of the Child seems to be made by a later hand.

Wilde supposes that the two sketches of the Virgin in half-length on the London sheet No. 88 (Vol. III, Fig. 128) may have served as preliminary studies for this cartoon, but there seems no direct connection in the motifs. The pose of the Child is rather connected with the Virgin drawings in the Louvre (No. 140), the Albertina (No. 141), London (No. 143), the late drawing in Windsor (No. 237) and with the Child of the Medici Virgin.

Wilde supposes that the two sketches in London and the Casa Buonarroti sheet may be connected with the following commissions: (1) a Virgin which Cardinal Niccolò de Fieschi wanted to have from Michelangelo in May, 1522 (Frey, *Briefe*, p. 192); (2) the "disegno finito" which Michelangelo's friend Leonardo the saddler asked for at the end of 1522 (*ibid.*, pp. 194f); (3) the "quadretto per uno studiolo" for Cardinal Grimani. However, there is no certain proof for these hypotheses.

101 143. *Holy Family and Little St. John.* London, British Museum. Black chalk, partly rubbed and stippled. A strip stuck on at the bottom. H. 317 mm. W. 191 mm.

Berenson, *Drawings*, no. 1493; Frey, *Handz.*, no. 270; Thode, *Kr.U.*, III, no. 341; Brinckmann, *Zeichnungen*, no. 17; Popp, *Belvedere*, 1925, pp. 13, 21, no. 19; Wilde, *Brit.Mus.Cat.*, no. 65; Goldscheider, no. 82.

This is a Holy Family with St. Joseph and the little St. John; these latter are lightly sketched at the right behind the Virgin. The motif of the Child is similar to the
99, 98 drawings in the Louvre (No. 140), in the Albertina (No. 141) in the Uffizi (Berenson,
100, 102 no. 1645), in the Casa Buonarroti (No. 142) and in Windsor (No. 237). The authenticity of the Louvre, Albertina, Uffizi and Casa Buonarroti drawings is still debated. The position of the legs of the Virgin is anticipated in the Moses and will recur in the Giuliano de' Medici. The Child anticipates the pose of the Child of the Medici Madonna. We understand from this drawing why Michelangelo gave the Virgin in the marble group crossed legs. He could thereby raise the Child to bring it closer to the bosom.

The drawing is to be dated according to Berenson, 1510-1520; according to Thode and Colvin, at the time of the Medici Madonna; according to Frey, Brinckmann and Wilde, ca. 1534-1535. Popp rejects the sheet, attributing it to Antonio Mini; she holds that it is a combination of the Giuliano de' Medici and the Child from the Medici Madonna. The high quality speaks for its genuineness and the proportions

of the long neck, small head, feet, and hands as well as the masterful chiaroscuro speak in favor of a date around 1530-1532.

(A comparison of this sheet of high quality with the "cotton-like" Virgin, Christ Child, and little St. John [Wilde, *Brit.Mus.Cat.*, no. 58] which Wilde considers to be an original, shows that the latter drawing is in all probability by a pupil, probably by Sebastiano del Piombo, as has been assumed by Berenson, no. 2482, and later scholars.)

144. *St. Jerome*. Paris, Louvre (inv. no. 705). Pen and two inks; the body of the 254 saint in brownish ink; the drapery and the background grotto in darker ink. H. 225 mm. W. 212 mm. Hitherto unpublished drawing.

Berenson, *Drawings*, no. 1590A; Delacre, p. 512.

The drawing has a backing of white paper which completes the corners; the edges are lacking in the sheet of the drawing. Badly damaged.

As said above, the drapery and the grotto are of a darker ink coloring; the face, the torso and the left arm are done in light brown ink, all by Michelangelo. The inscription at the top right, "ieronimo sãto," written twice, is in the lighter ink and in the handwriting of the young Michelangelo, ca. 1504-1506. Michelangelo then used the darker ink to rework the drawing. Indeed the darker hatchings partially laid over the lower inscription prove that the work done with the darker ink followed that of the light ink.

Berenson's doubts (about the authenticity of the inscriptions, the drapery and the rocks), seem to be not justified. He says that if the rest is an original it should be dated in the time of the Battle of Cascina.

The features of the saint anticipate those of the Moses of the Tomb of Julius II and of St. Bartholomew in the Last Judgment. The saint holds a lightly sketched crucifix in his right hand and a stone in his left. It is the type of the actively penitent St. Jerome which seems to be a creation of the early fifteenth century, the earliest known example being Fra Filippo Lippi's panel in Altenburg, Lindenau Museum (see: Oertel, *Mitteilungen d.kh. Instituts*, Florence, 1955, pp. 111*ff*). Other examples of this type before Michelangelo are Filippino Lippi's panel, Florence, Accademia; Antonio Pollaiuolo's drawing and panel, Florence, Uffizi; Leonardo's panel in the Pinacoteca Vaticana. The newly discovered painting by Pontormo in the Hannover Kestner Museum probably reflects Michelangelo's influence.

DIVINE HEADS (TESTE DIVINE) OF THE EARLY AND MIDDLE PERIODS

Preliminary Remarks: The point of departure for the ideal heads of Michelangelo, seems to have been the ancient *capitani* with their elaborate helmets. Since Verrocchio, it had become fashionable in Florence to represent the face of a young and handsome

captain in profile confronted with the profile of an elderly ferocious one. Alexander the Great and Darius, Scipio and Hannibal were represented in this manner. Verrocchio executed two reliefs which Lorenzo il Magnifico sent as a gift to Mattias Corvinus, King of Hungary (Vasari III, p. 361), one of Alexander the Great, the other of Darius, both in profile (Planiscig, *J.d.Kh.Slg. Wien*, Vienna, 1933, pp. 89ff and idem, *Verrocchio*, Vienna, 1941, plates 37 and 38). This type seems to have influenced Leonardo in his Scipio and Hannibal, which he executed ca. 1473-1474 (according to Möller, *Raccolta Vinciana*, XIV, 1930-1934, pp. 3ff). The Florentine engravers of

107 the 1470's and 1480's propagated this type of representation. Beside the solemn type there also appear in the engravings the grotesque type, a kind of parody of the warrior, as has been shown by A. Chastel, "Les capitans antiques affrontés . . ." in: *Volume du Cent Cinquantenaire. Société Antiquaires de France*, Paris, 1955, pp. 279ff.

Michelangelo reverts in his early drawings of ideal heads to these prototypes. One finds in his drawings again the fantastic bizarre helmets, but of a more monumental type. Michelangelo rejected, however, the grotesqueness of the helmets. He returned to the original significance of the fantastic armor, the purpose of which was to frighten

110 the enemy. The best example for this is the so-called Count of Canossa, whose face appears under the snout of a ferocious monster; his chest is protected by a gorgon-like satyr-mask, and his shoulder armor is decorated with the image of wrestlers, suggesting struggle and victory. The stern look of his face corresponds to the style of his armor. The whole figure expresses masculine vigor and ardor; he is, however, not confronted with another *capitano*, but with a beautiful young woman, the so-called

111 Marchesa di Pescara, the incarnation of composed classical beauty. This seems to be an innovation of Michelangelo.

There exist other sheets in which Michelangelo makes masculine the feminine

113 features and endows them with a warrior-like quality, as in the so-called Zenobia.

114, 115 Still another type is the representation of the female as a kind of Sibyl. Michelangelo developed this type from his Sibyls of the Sistine Ceiling. In some of these drawings the glowing eyes look into the distance, as if foreseeing future fate; in others the eyes are cast down in melancholy. Michelangelo transferred this latter expression in one

118 instance to a head which seems to belong to a young man. In the Cleopatra, the

108 Sibylline type receives an erotic touch: this drawing was, in fact, presented to Tommaso Cavalieri. It belongs to a group called by Vasari (VII, p. 271) "teste divine," which Michelangelo made for Cavalieri "perchè egli imparasse a disegnare."

Finally there are a few studies of heads which seem to be portraits after life without particular idealizing tendencies. To this group belong: a) the sketch of a "Sibylline

115 Half-length Female Figure," London, Brit. Mus. (our No. 90, Vol. III, pp. 213f); see now also Wilde, *Brit.Mus.Cat.*, no. 41r, who considers the drawing completely genuine. We no longer share Berenson's doubts as far as the pen drawing is concerned, but are still hesitant concerning the attribution of the red and black chalk lines to Michelangelo.

b) Also the black chalk drawing of a female half-length figure on the verso of this *116* sheet (Wilde, *Brit.Mus.Cat.*, no. 41v) is a genuine sketch belonging to this group.

c) The female half-length figure in red chalk on the verso of the Fall of Phaeton, No. 119, is interpreted by Wilde (Windsor, Cat. no. 430v) on account of the mirror *112* as Prudence or Leah. It is attributed by Berenson, no. 1617, to "Andrea di Michelangelo," by Popp, *Belvedere*, 1925, p. 20 to Antonio Mini. Wilde holds that it is a genuine drawing from ca. 1532-1533, perhaps a study for Leah of the Julius Tomb. In my opinion the weakness of the lines and of the chiaroscuro speak clearly for a work of a pupil.

145. *Head of a youth in profile, with fantastic helmet; and other sketches and* *104* *inscriptions.* Hamburg, Kunsthalle. Pen and brownish ink; at the right and left top, black chalk lines. H. 205 mm. W. 254 mm.

Only partly published by Delacre. Thode, *Kr.U.*, III, no. 252; Delacre, p. 394.

The drawing is displayed in the Kunsthalle in Hamburg as the work of an imitator of the master. (This was our opinion in the thirties.)

It is partly genuine, of ca. 1504, but the outlines of the profile head seem to have been reworked. (The drawing might have been partially drawn with the left hand [?].) The handwriting is also that of Michelangelo, ca. 1504-1506: "Antonio dolcie mie caro prego che natura mi to . . . amicho Signor Alessandro; non bisognia. . . ." At the left top: "Amore."

Thode saw in the drawing a study for the cartoon of Pisa and considered it as genuine without doubt.

146. *Head of a youth in profile with elaborate helmet, and sketch of a head.* Rotterdam, Boymans Museum. Pen and ink. H. 138 mm. W. 118 mm. *105*

F. Lees, *The Art of the Great Masters* . . . , London, 1913, Fig. 33; Berenson, *Drawings*, no. 1676B.

According to Berenson, this is a copy or imitation, perhaps by Bandinelli, after studies by Michelangelo. The linework, however, has no resemblance to that of Bandinelli and is far superior. The sketches are slightly more developed and of higher quality than those in Hamburg (No. 145). They are possibly originals of 1504-1505.

Berenson, no. 1597r and v, belong to the same group, but are of lesser quality and probably drawings of a pupil.

(Collections: Valori, Wauters, Franz Koenigs.)

147. *"Conte di Canossa."* London, British Museum. Black chalk. H. 410 mm. *110* W. 263 mm.

Berenson, *Drawings*, no. 1688. Thode, *Kr.U.*, III, no. 343. Popp, *Belvedere*, 1925, pp. 10, 13, 20, no. 15. Tolnay, Vol. III, p. 199. Wilde, *Brit.Mus.Cat.*, no. 87.

This copy was a companion of the original of our No. 148. Both were etched by

Antonio Tempesta in 1613; this one with the inscription "Conte di Canossa." Thode (text III, 2, p. 510) supposes that this idealized head may represent Mars. Wilde (p. 79) follows Thode. Thode dates the original in the period of the Night of the Medici Chapel; Wilde, ca. 1525-1528.

Scholars generally and rightly doubt its authenticity. This copy was ascribed by Loeser (*Archivio Storico dell'Arte*, 1897, p. 352) to Bacchiaca; Berenson attributed it to his "Andrea di Michelangelo"; Popp to Antonio Mini. Wilde does not propose the name of an artist, and dates it in the second half of the sixteenth century.

111 148. *"Marchesa di Pescara."* London, British Museum. Black chalk. H. 287 mm. W. 235 mm.

Berenson, *Drawings*, no. 1689. Frey, *Handz.*, no. 289. Thode, *Kr.U.*, III, no. 344. Popp, *Belvedere*, 1925, p. 20, no. 14. Berenson, *L'Arte*, 1935, pp. 243, 251, 262. Wilde, *Brit.Mus.Cat.*, no. 42.

There was once a companion piece of this drawing, the so-called "Count of Canossa," a copy of which is our No. 147. Both were etched by Antonio Tempesta in 1613; the present version with the inscription "Marchesa di Pescara." Thode and Wilde, however, suspect that it might represent Venus.

This elaborate drawing, although better in quality than No. 147 (a fact already observed by Thode) is, nevertheless, in my opinion, a copy made by a different hand. It is academic with unsure outlines, which do not reveal any characteristics of the master.

The lost original was probably made in the mid-1520's.

Earlier scholars have already doubted its authenticity: Loeser, *Archivio Storico dell'Arte*, 1897, p. 352, attributed it to Francesco Bacchiaca; Berenson to an unknown pupil of Michelangelo; Popp to Antonio Mini; however, Thode and Wilde consider it genuine.

On the verso (Wilde, pl. 59) there are red chalk studies of heads and figures. Thode (no. 344) and Wilde believe that three among them are genuine. We, however, doubt their authenticity.

113 149. *"Zenobia."* Florence, Uffizi (598 E). Black chalk. H. 360 mm. W. 250 mm.
Morelli, *Kunstchronik*, 1893, p. 88. Berenson, *Drawings*, no. 1626. Thode, *Kr.U.*, III, no. 206. Brinckmann, *Zeichnungen*, no. 87. Popp, *Belvedere*, 1925, p. 20, no. 17. Berenson, *L'Arte*, 1935, p. 253. Wilde, *Windsor Cat.*, no. 454. Goldscheider, no. 50.

Probably a copy of a lost drawing presumably presented by Michelangelo around 1522 to his friend Gherardo Perini.

Thode dates the sheet in the period of the Sistine Ceiling; Wilde ca. 1525-1528; Brinckmann (who considers it a copy) dates the lost original in the first half of the thirties.

Earlier scholars have also doubted that it can be attributed to Michelangelo. Morelli

ascribed it to Bacchiaca, Berenson to his "Andrea di Michelangelo," Popp to Antonio Mini; Thode and Wilde consider the drawing genuine.

According to Wilde, the traditional name of the subject is erroneous; the drawing represents instead Venus, Vulcan, and Cupid. Goldscheider follows Wilde's judgment, but interprets Vulcan as Mars because of his helmet. The woman could represent rather Pallas Athene: she is a masculine type, wearing a helmet. The other two figures were added later, but by the same hand.

A second copy, weaker than this one, by Don Giulio Clovio, is in Windsor, no. 454.

150. *"Damned Soul."* Florence, Uffizi. Black chalk. H. 295 mm. W. 205 mm. *109*
Berenson, *Drawings*, no. 1628. Thode, *Kr.U.*, III, *sub* no. 544. Wilde, *Windsor Cat.*, *sub* no. 453. Goldscheider, no. 49.

While Berenson and Thode consider another version in Windsor to be the original and the Uffizi drawing a copy, Wilde considers the latter to be the original. Goldscheider follows Wilde. In our opinion, both the Uffizi and the Windsor drawings are copies of a lost original.

At the top of the Uffizi sheet there is the inscription "Gherardus de Perinis"; at the lower right "Michelan. Bonaroti Faciebat." Below this there are three intersecting circles—the stonemason's mark used for the blocks excavated for Michelangelo (see Vol. IV, Figs. 124-185). Neither of these inscriptions is in the handwriting of Michelangelo. Wilde suspects that it is the handwriting of Perini.

The relationship of Michelangelo to Gherardo Perini is known through three letters of the latter from 1522 (Frey, *Dicht.*, pp. 504*f*) and through one letter of Michelangelo to Perini of February 1522 (Milanesi, p. 418). Moreover, Vasari (1550, p. 986; 1568, VII, pp. 276*f*) tells that Michelangelo presented three drawings to his young friend Perini. It is generally supposed that one of these three is the sheet in question.

The drawing has usually been dated in the mid-twenties (Wilde ca. 1525). Later, the master adapted this head for the head of the devil at the left behind Minos in the Last Judgment (Berenson). The type stems from Gorgon heads.

The drawing is interpreted either as a physiognomical study of terror (Wilde) or as a symbol of Michelangelo's mad love for Gherardo Perini (Goldscheider).

Other copies of inferior quality, in addition to the one in Windsor, are in Florence, and formerly in the collection Vaughan. There also exists an engraving by Salamanca.

151. *Cleopatra.* Florence, Casa Buonarroti. Black chalk. H. 225 mm. W. 170 mm. *108*
Pasted on paper-backing.
Berenson, *Drawings*, no. 1655. Thode, *Kr.U.*, III, no. 12 and *Ma.*, III, 2, pp. 501*f*; *Kr.U.*, II, pp. 340*f*. Berenson, *L'Arte*, 1935, p. 253. Wilde, *Brit.Mus.Cat.*, pp. 95, 125*f*.

Earlier scholars doubted the authenticity of this drawing. Berenson attributed it to his "Andrea di Michelangelo," considering it as a copy of a lost drawing by Michel-

angelo. Thode thought it to be a copy of ca. 1503-1504. Wilde sees it as genuine and of ca. 1533. This author, however, also believes that it is a copy.

We know from Vasari (v, pp. 73ff, *Vita di Properzia de' Rossi*) that Michelangelo offered the original to Cavalieri; the master had probably executed it for him ca. 1532-1533. Cavalieri presented the drawing in 1562 to Duke Cosimo, together with a drawing by Sophonisba Anguissola.

The drawing is, as Thode remarks, inspired by Piero di Cosimo's "Simonetta Vespucci," Chantilly, Musée Condé. The rich coiffure, the uncovered breasts and the snake twined around the shoulders are common to both works. The full profile position of the earlier head is transformed by Michelangelo into a three-quarter profile. This turning of the head is extended to a spiral by the snake and by the braided hair.

There exist other copies in the British Museum and in the Louvre; a painted copy is mentioned by Wilde, p. 126.

114 152. *Head of a young woman with turban-like headdress.* Oxford, Ashmolean Museum. Red chalk. H. 205 mm. W. 165 mm.

Robinson, no. 10; Berenson, *Drawings*, no. 1552; Frey, *Handz.*, no. 172b; Thode, *Kr.U.*, III, no. 394; *Vasari Society*, II, IV, no. 2; Brinckmann, *Zeichnungen*, no. 30; Colvin, I, 2, pl. 10; Popp, *Belvedere*, 1925, p. 21; Tolnay, Vol. II, p. 209; Goldscheider, no. 65; *1953 London Exhibition*, no. 34; Parker, no. 315.

Generally dated in the period of the Sistine Ceiling: Berenson (1st ed.), Steinmann, Frey, Thode, Brinckmann. Robinson places the drawing before 1500; Berenson (2nd ed.) about 1518-1520; Goldscheider, 1528-1530. Popp attributes the sheet to a garzone, Carlo, according to her the painter of the Deposition in the National Gallery, London. Tolnay (1945) gives it to Bacchiacca, whose types are similar. Nevertheless, today (1956) I would consider the drawing's high quality a proof of its genuineness and date it ca. 1520-1525. Such drawings by Michelangelo must have influenced Bacchiacca.

The head is covered by a turban-like headdress, which has an oriental air. Probably the figure represents a Biblical character, as for instance, an ancestor of Christ.

The drawing was celebrated in the sixteenth century, as is testified by the copies in the Uffizi and in Oxford.

(Collections: Casa Buonarroti; Wicar; Lawrence; Woodburn.)

117 153. *Study of a young man's head in right profile.* Oxford, Ashmolean Museum. Red chalk. H. 282 mm. W. 198 mm.

Robinson, no. 9; Berenson, *Drawings*, no. 1551; Thode, *Kr.U.*, III, no. 393; *1953 London Exhibition*, no. 28; Parker, no. 316.

Dated in the period of the Sistine Ceiling by Berenson (1st ed.) and Thode; in the 2nd ed., Berenson proposed a date contemporary with the Giuliano de' Medici statue; Wilde (*1953 Exh.*) dates the sheet in 1520-1521, a contention which Parker finds "not

entirely convincing." I would date it somewhat later, 1525-1530, in view of the masterly, soft chiaroscuro obtained with broad, parallel hatchings.

The face has disdainful, almost demonic, features, with its protruding forehead and lower lip and its curiously shaped nose. A beret droops down the left side of his head. The neck is as long as those of the Giuliano and the Virgin of the Medici Chapel. This portrait represents possibly one of Michelangelo's garzoni.

(On the verso: nude man carrying a hog or boar.)

154. *Head of a Youth (or of a Girl?)*. Windsor Castle. Black chalk. H. 212 mm. 118 W. 142 mm. Top corners diagonally cut.

Berenson, *Drawings*, no. 1608; Steinmann, *Sixt.Kap.*, II, p. 661, fig. 60; Thode, *Kr.U.*, III, no. 533; Panofsky, *Handz.*, no. 6; *Vasari Society*, 1924, no. 5; Popp, *Belvedere*, 1925, *Forum*, p. 74; K. Clark, *Burl.Mag.*, 1930, p. 181; Wilde, *Windsor Cat.*, no. 434r; Goldscheider, no. 84.

Thode and Wilde describe this head as that of a young woman; Berenson and Popp as that of a young man; Panofsky as either. The head-covering is that used by Michelangelo for his Virgins, and it has been observed, first by Thode, that the head appears as a half-length Virgin in a pupil's drawing, London, now Collection of Sir Kenneth Clark (Berenson, no. 1694). In my opinion the model seems to be rather a young man whom, according to his custom, Michelangelo used for a Virgin. Goldscheider suggests without proof that it represents a portrait of Cavalieri.

There is no general agreement as to the date of the drawing: Berenson in his first edition connected the sketch with one of the lunettes of the Sistine Ceiling and dated it "at the end of the Ceiling"; Panofsky, who describes the sketch as "red chalk," follows Berenson and dates it around 1510-1511, connecting it also with the lunettes of the Sistine Ceiling; Wilde proposed a date around 1540. The right date, "later period of the drawings for Cavalieri (ca. 1533)," was first proposed by Thode, who is followed by Goldscheider and Berenson in his second edition. The drawing was accepted as genuine by Berenson, Steinmann, Thode, Panofsky, Wilde, and Goldscheider; it was considered by Popp as a copy of a lost original, and attributed hypothetically to Bugiardini by Kenneth Clark.

It is possible that this sheet belonged also to those drawings "disegnate di lapis nero e rosso, di teste divine," which Michelangelo made for Cavalieri. Cavalieri mentions in a letter of January 1, 1533, his attempts at drawing and Michelangelo's praise of the product (Symonds, II, p. 400). Wilde, who quotes this passage of Vasari, thinks that the light sketch of a head on the verso of this sheet may be an exercise in drawing by Cavalieri, while Berenson attributes it hypothetically to Sogliani.

This is an unfinished study of high quality. The long neck, the proportions of the noble face and the sensual expression of the lowered eyelids are close to the Giuliano de' Medici statue.

Preliminary remark: These Crucifixion studies form the transition from Michelangelo's

Vol. I, 145, 146 early Crucifixion of 1492 in Santo Spirito (Tolnay, Vol. I, pp. 195*ff*) to that made for

164 Vittoria Colonna and to the late group of Crucifixion drawings.

160 155. *Sketch for a Crucifixion.* London, British Museum. Red chalk. H. 94 mm. W. 60 mm.

Frey, *Handz.*, no. 280a; Thode, *Kr.U.*, III, no. 294; Wilde, *Brit.Mus.Cat.*, no. 68r.

Frey, Thode, and Wilde date the sketch in "the early years of Michelangelo's Roman period," i.e. the time of the Last Judgment. In our opinion this small sketch was made more probably still in Florence around 1530 at the time when Michelangelo was working on the Medici Chapel. The proportions, the use of red chalk, and the technique all speak in favor of this date. It may be a plan for a small bronze Crucifixion for the altar of the Medici Chapel. This is not improbable, since the furnishings of the Chapel were also made according to his design. Wilde, on the

164 contrary, tentatively connects this small Crucifix with the Vittoria Colonna Crucifixion.

162 The Haarlem Crucifixion sketches, which resemble this work, were also made, as we will show, for a bronze Crucifix which is known through a copy (New York, Metro-

327, 328 politan Museum).

Wilde tries to connect this sketch and those in Haarlem with the Casa Buonarroti

170 marble-block specification drawing (Tolnay, *Arch.Buon.*, p. 462, no. 20) but, as has been shown in our text, the Archivio Buonarroti sheet was made for a composition,

171 known to us through an engraving which is related to the drawings for Vittoria Colonna.

161 156. *Sketch for the torso of the Bad Thief.* Florence, Casa Buonarroti (30 F). Pen and ink. H. 109 mm. W. 74 mm.

Berenson, *Drawings*, no. 1405; Frey, *Handz.*, no. 244c; Thode, *Kr.U.*, III, no. 30.

Below the small rapid sketch, there are six lines of writing in the hand of Michelangelo deciphered by Frey (*op.cit.*, p. 116).

Frey connects this sketch with the Haman fresco of the Sistine Ceiling; Thode sees in it a study for a Good Thief and proposes no date. In our opinion, this is a sketch

330, 331 for the bronze Golgotha group (best bronze copies in Berlin and Paris) from the mid-thirties. (A copy of the whole group—lesser in quality—is in the Metropolitan Museum, New York.) The sketch was probably made after a wax model, which would explain why the arms are lacking.

162 157. *Four Studies, two for a Christ on the Cross.* Haarlem, Teyler Museum. Black chalk (some later pen and ink lines at bottom). H. 332 mm. W. 227 mm. Recto of the succeeding drawing.

Marcuard, pl. xxii; Berenson, *Drawings*, no. 1675; Thode, *Kr.U.*, iii, no. 269; Frey-Knapp, *Handz.*, no. 332; Panofsky, *Rep.f.Kw.*, 1927, p. 57; Wilde, *Windsor Cat., sub* no. 460; Goldscheider, no. 112.

Berenson rejects the drawing as "too stringy and fumbling for Michelangelo." Knapp and Panofsky follow this judgment; on the other hand, Marcuard, Thode, and Wilde consider it to be an original, an opinion which we now share.

Wilde dates the sheet 1535-1540. In our opinion, its slender proportions should date it in ca. 1530-1534.

The sketches were possibly made after a wax model. Hitherto unnoticed, but significant is the fact that they bear a close resemblance to the small bronze Crucifix (copy in the Metropolitan Museum, New York), attributed to Michelangelo. The *327, 328* pose here is identical in reversed version and the tracing on the verso corresponds *163* exactly to the bronze statuette. (Concerning the Crucifix in the Metropolitan Museum in New York, see John G. Phillips, *The Bulletin of the Metropolitan Museum of Art*, 1937, pp. 210*ff.*) The Good and the Bad Thieves belonging to this Crucifix and forming with it a Golgotha are preserved in two other bronze copies of higher quality, one in the Louvre (Leg Gatteaux, 1881) and the other in Berlin, Kaiser Friedrich Museum. *331*

A hitherto unpublished sixteenth century drawing, a copy of the Bad Thief, is in Haarlem, Teyler Museum; cf. No. 158 A. *332*

Copies of the Haarlem drawing are in the Louvre (Thode, no. 495) and in Windsor Castle (Wilde, no. 460 and Delacre, Fig. 172).

158. *Tracing of the Crucified Christ from the recto, Three small sketches of a* *163* *figure seen from the back* (all in black chalk) *and profiles of cornices* (in red chalk). Verso of the preceding drawing. Same specifications and literature except for Marcuard, now pl. xxiii, and Frey-Knapp, *Handz.*, now no. 333.

The red chalk sketches of architectural profiles are probably from ca. 1530-1534, i.e. earlier than the small black chalk sketches of figures which seem to be in the style of the period ca. 1545. The tracing of the Christ seems not to be genuine: its outlines are Manneristic; possibly it was made by the pupil who executed the bronze cast.

158A. *The Bad Thief.* Haarlem, Teyler Museum. Pen and ink. H. 255 mm. W. *332* 115 mm. (Hitherto unpublished.)

Inscription: "il ladrone di Micel Agnolo Buonarroti." This is a copy after the small bronze sculpture of the Bad Thief belonging to a group of Golgotha of which there is a copy in the Metropolitan Museum. There are, moreover, two bronze copies of *327 to 330* the Bad Thief, the better one in Berlin and the other in Paris. See F. Goldschmidt, *331* *Die italienischen Bronzen der Renaissance und des Barock*, Berlin, 1914, no. 103, pl. 37. (The wax model was apparently prepared by Michelangelo.) The drawing

is important only as a proof that the Bad Thief was already attributed to Michelangelo in the second half of the sixteenth century, the date of this drawing.

Another drawing of the School of Rosso, which I have identified as a copy after the same statuette, is in the Fogg Museum of Art, Cambridge, Mass.; see Sachs-Mongan, *Catalogue*, no. 173, fig. 91.

DRAWINGS ANTICIPATING THE LAST JUDGMENT

Preliminary remarks: In this section are listed drawings which chronologically preceded the Last Judgment and the motifs of which anticipate motifs of the latter.

121 Among these the most important seems to be, besides the drawing of the Fulminating

124 to 130 Zeus, the series representing the *Risen Christ*.

The problem of authenticity is still much discussed. Revising my earlier opinion, I believe today to have been too exclusive in my judgment in 1928. On the other hand, I remain skeptical concerning the attribution to Michelangelo of a few sheets of this group, which I shall indicate in the catalogue which follows. Wilde's lists of this series (*Windsor Cat.*, p. 251, and *Brit.Mus.Cat.*, pp. 89, 91, 92) should be completed by the drawings of a soldier, Archivio Buonarroti (Tolnay, Vol. III, Fig. 147) and the much weaker one in the Casa Buonarroti (Tolnay, Vol. III, Fig. 148). Wilde

Vol. III, 290, 291 connects these drawings, I believe erroneously, with the *Noli me tangere* cartoon (*Windsor Cat.*, p. 249), whereas I believe that they are made as preparatory drawings for the Resurrection in London (Vol. III, Fig. 146). Both drawings represent an advancing figure stopping suddenly in surprise and fear like the corresponding figure in the Resurrection composition, London. The gesture of the left hand in the Casa Buonarroti sketch clearly expresses surprise, like two of the soldiers in the Resurrection compositions. On the other hand, the Christ in the *Noli me tangere* is drawing back from Mary Magdalene toward the right side and is holding a gardener's hoe in his left arm. Only the position of the head seems to be similar, but actually even this is not the same. In the drawings the figure is looking downward (supposedly to the empty sarcophagus) whereas in the *Noli me tangere* Christ is looking sidewards at Mary Magdalene.

Another drawing belonging to this group not listed by Wilde is the Risen Christ in the Archivio Buonarroti (Tolnay, Vol. III, fig. 158).

As to the dating of the group, Wilde believes that the whole series was made from 1532 to 1533, "more especially from Michelangelo's ten months' stay in Rome." We, on the contrary, believe that they were made over a longer period of time. The earliest was made around 1525 to 1530 (to this time belong two compositional drawings, Vol. III, Figs. 144, 145, and the above-mentioned Christ, III, 158). This was followed by the Risen Christ on the verso of the Tityos drawing, end of 1532, the drawing on the verso of the plan for the Reliquetribune (III, 159) of the first half of October, 1532, the sketch in the Archivio Buonarroti of ca. September 19, 1532

(III, 160), and the lost original of the composition known through the copy in Rotterdam. A third group, I would date in February-March 1534 and connect with the Resurrection fresco, which Michelangelo had to paint on the altar wall of the Sistine Chapel before he decided to make the Last Judgment, and which is mentioned in the report of Agnello, March 20, 1534 (Pastor IV, Pt. II, p. 567 n. 2). To this group belong the sketch on the verso of the Last Judgment in the Casa Buonarroti (III, 161), the drawings in the British Museum, Nos. 53, 54, and finally, the elaborate drawing in Windsor.

As to the purpose of the drawings, five theories have been proposed. Popp connected the three compositional drawings hypothetically with a fresco for the lunette over the tombs of the Magnifici in the Medici Chapel. Although this hypothesis is not very well documented (the letter of December 25, 1531, by Giovanni da Udine mentions only *storie grande da una banda*), it should be noted that the composition would fit into the shape of a lunette.

According to Gamba, the studies might have been connected with a fresco that was to replace Ghirlandaio's badly damaged fresco in the Sistine Chapel on the entrance wall (Vasari III, p. 259). This theory is not convincing just because this fresco had the shape of a long, narrow rectangle.

Wilde offers two hypotheses. He connects the drawings with Michelangelo's offer in the summer of 1531 to give a picture to Cardinal Giovanni Salviati, but nothing is known about the subject of this picture, and moreover, the datable sheets of the series are all after the fall of 1532. Secondly, Wilde contends that they may have been made for presentation but it should be said that they are not completely finished, as are the other presentation sheets of the master.

We advanced the hypothesis that the drawing on the back of the Reliquetribune, as well as the Archivio Buonarroti drawing and the drawing on the back of the Last Judgment sketch in the Casa Buonarroti, may have been intended for a fresco in San Lorenzo in the lunette above the Reliquetribune on the entrance wall. We emphasized the fact that there is no other documentary evidence than the fact that one of these drawings is on the back of the plan for the Reliquetribune.

Now we should like to advance two new hypotheses concerning the purpose of some of the sheets although we do not reject the hypothesis of Popp and the belief that at least one drawing may be in connection with the lunette of the entrance wall of San Lorenzo. The Risen Christ on the verso of the Tityos drawing may have autobiographical significance. Since the Tityos is a symbol of the tormented lover, the representation of a Risen Christ in almost the same attitude on the back of the same sheet may be meant as a symbol of the liberation and rebirth of the lover. And it is possible that some of the other sheets, which are closely connected with this version of the Risen Christ, might also have been made for Cavalieri. The second hypothesis, that some of the drawings were made for the Resurrection fresco planned

[175]

for the altar wall of the Sistine Chapel, is supported by the fact that one of the Risen Christ sketches is on the back of the first sketch for the Last Judgment.

The Gospels do not tell how Christ rose from the tomb, but since the eleventh century, artists have developed several traditions of representing this scene. Characteristically, Michelangelo did not follow the type where the Savior is standing on the lid or on the edge of the sarcophagus, holding in one hand the banner of victory and with the other, making the gesture of benediction. Michelangelo instead followed three other ways of representing the Risen Christ. One way shows the Christ standing in the sarcophagus, with one foot on the edge. This is an old tradition, known through the fresco of P. Lorenzetti (Assisi), and Piero della Francesca (Borgo San-sepolcro) among others. But Michelangelo dramatized this Christ, showing him looking upward with a yearning expression and indicating the wound with his right hand (as he does in the Last Judgment). This is no longer the victorious Savior, but the man of God seeking salvation, and therefore he becomes a prototype for the human soul. According to Christian dogma the Resurrected Christ is a guarantee of man's resurrection from the dead on the basis of the equation: *Christianus alter Christus* (see L. Réau, *Iconographie de l'art Chrétien*, II, 2, pp. 538*ff*).

A second type that can be found among Michelangelo's drawings is the one in which Christ is stepping out of the tomb ("Christus uno pede extra sepulcrum"). This type has been known since the thirteenth century (Schrade, *Die Auferstehung Christi*, 1932). In all earlier representations Christ is holding in one hand the banner of victory, blessing with the other. Again Michelangelo dramatizes the scene. Christ is as if bursting forth from the tomb, thrusting his arms upward, throwing himself heavenward. It becomes a symbol of liberation from the *carcer terreno* and Christ seems to be seized by the desire for union with God. In the figures of the soldiers around the tomb, on the contrary, we see man as prisoner of the flesh. To this type belong No. 108 and No. 109.

In a third type Christ is hovering above the open sarcophagus. This type is also well known in earlier representations, where Christ is represented in *contrapposto*, as if he were standing on a cloud above the tomb. To this type belong the reliefs of Ghiberti, Luca della Robbia, Vecchietta, the painting by Perugino, etc. Among Michelangelo's drawings there are three variants of this type. In one, Christ is ascending in a diagonal direction, instead of the traditional vertical one, and his body is already transfigured to pure spirit (Vol. III, Fig. 146, obviously developed from Fig. 145). This diagonal ascension of Christ is anticipated in the panel of the school of Leonardo in Berlin, and it will be followed in the Resurrection of Tintoretto in the Scuola di San Rocco.

In the second variant of this type the body of Christ is rising vertically and pushing back the lid of the sarcophagus with one leg. The Resurrected is looking downward and the position of the legs is that of ancient river gods (explainable by the fact that

they come from the Tityos). To this belong the verso of the Tityos, the verso of the *Vol.* III, *159* Reliquetribune, and the two drawings in London, Nos. 53 and 54. *126, 129*

Finally, in a third variant Michelangelo changed the position of the legs and turned the head upward. To this type belong the composition known only through the copies in Rotterdam and the Uffizi, the drawing in the Archivio Buonarroti, where the *128* upward movement describes a spiral around the body, the sketch on the verso of the *Vol.* III, *160, 161* Last Judgment drawing of the Casa Buonarroti, and finally, the elaborate drawing in Windsor, which is a combination of the second and third variants. *130*

Among these drawings the two in the British Museum and that in Windsor, as well as the verso of the Casa Buonarroti drawing, seem to have been made in connection with the projected fresco on the altar wall of the Sistine Chapel.

The many-figured drawings in Windsor and London are combined into a new composition by Marcello Venusti (Fogg Museum, Cambridge, Mass. See Tolnay, *Art* *Vol.* III, *149* *in America*, 1940, pp. 169*ff*). Vasari used the motif of the Resurrected Christ on the verso of the Last Judgment drawing in the Casa Buonarroti in one of his altars in Santa Maria Novella, Florence, and Marco da Siena was inspired by the gesture and the upward glance of the head of the Windsor drawing in his painting in the Galleria Borghese, Rome. But all these borrowings are superficial. These artists did not understand that for Michelangelo the Resurrected Christ is a symbol of the *rinascita* of the soul.

(We intend to treat the problem of the Resurrection drawings of Michelangelo in a separate article.)

159. *Sketch of a figure with right arm raised to strike, probably a Fulminating* *121* *Zeus.* Florence, Casa Buonarroti (4F). Red chalk. H. 114 mm. W. 71 mm.

Berenson, *Drawings*, no. 1401 A; Frey, *Handz.*, no. 155 b; Thode, *Kr.U.*, III, no. 14.

Frey connects the figure with Samson slaying the Philistine or with Christ expelling the Money Changers. Berenson, who accepts Frey's hypothesis concerning the subject, nevertheless recognizes "that the contours and strokes seem earlier." Thode connects the sketch with an angel casting down a Damned in the Last Judgment. In Wilde's opinion: this is probably a preliminary sketch for a Fulminating Zeus in the Fall of Phaeton. See the presentation sheet with this subject in Venice (No. 118; Vol. III, Fig. 152). The motif is an important anticipation of the Christ of the Last Judgment sketch of the Casa Buonarroti (No. 171). See Wilde, *Brit.Mus.Cat.*, p. 93.

160. *Unfinished study of a seated nude torso.* Florence, Uffizi. Hard black chalk. *122* H. 420 mm. W. 265 mm.

Berenson, *Drawings*, no. 1399 D; Jacobsen-Ferri, p. 78, pl. VII; Steinmann, *Sixt.Kap.*, II, p. 610, ill. 8; Thode, *Kr.U.*, III, no. 220.

Watermark: a siren with a forked tail.

Berenson, Steinmann, and Thode date this sheet in the period of the Sistine Ceiling

and see a connection in the pose with the *Ignudo* above the Prophet Isaiah, but the figure seems rather to be seated on a cloud and in its pose reminds one of the Zeus in the master's Phaeton sheets and also, to a lesser degree, of the Christ-Judge in the Casa Buonarroti drawing of the Last Judgment (the latter connection was pointed out by Jacobsen).

A study of high quality, the authenticity of which, however, is not completely established (the eyes are drawn in the form of empty circles, recalling the method of Mannerists such as Pontormo). The drawing seems to be from the period 1530-1534.

161. *Study of a slender seated nude.* London, British Museum. Black chalk, partly rubbed. H. 342 mm. W. 263 mm.

Berenson, *Drawings*, no. 1513; Frey, *Handz.*, no. 229; Thode, *Kr.U.*, III, no. 298; Wilde, *Brit.Mus.Cat.*, no. 62r.

Frey connected this figure with the Christ of the Last Judgment; Wilde sees in it studies intended for the St. Bartholomew in the Last Judgment. His chief argument is that there is a knife in the right hand, the attribute of this saint. Rather, it seems to me, the figure is to be connected with the works of the Medici Chapel, especially with Giuliano de' Medici and the object in his hand is perhaps a commander's baton which Michelangelo did not draw in completely in order not to hide the anatomy of the abdomen.

The drawing seems to be still from the Florentine period about 1530-1534 because of its slender proportions and the intricate twisting and flexing of the body.

162. *Study of a male torso and a head.* Verso of the preceding drawing. Same specifications and literature except for Frey, *Handz.*, now no. 230.

It has been supposed that it may be an earlier idea for the figure on the recto (Wilde). Only the outlines are drawn, seemingly, by a weaker hand.

163. *Rapid sketches for a Risen Christ.* Florence, Casa Buonarroti. Black chalk. H. 380 mm. W. 252 mm. This sketch is on the verso of Brinckmann, *Zeichnungen*, no. 61.

Berenson, *Drawings*, no. 1665 A; Wilde, *J.d.Kh.Slg. Wien*, Vienna, 1928, p. 201; *idem, Windsor Cat.*, p. 251, *sub* no. 428; *idem, Brit.Mus.Cat.*, pp. 89f, 92; Goldscheider, no. 75 (here published for the first time).

This sketch forms a group with Brinckmann, nos. 61 and 62. Berenson doubts its authenticity. Brinckmann, speaking of the sketch on the recto, considers it as representing the Christ-Judge of the Last Judgment. Wilde, in 1928, also questioned the originality of the drawing on the recto, but changed his opinion in the *Windsor Cat.* and *Brit. Mus. Cat.* and now believes it to be an original. Goldscheider has adopted Wilde's later opinion.

This rapid sketch in my opinion, is presumably connected with the projected Resurrection fresco for the altar wall of the Sistine Chapel, February-March 1534. The

pose anticipates that of the Christ-Judge of the Last Judgment. On the back of the Last Judgment sketch of the Casa Buonarroti there is also a Risen Christ (Vol. III, Fig. 161), which confirms my hypothesis. Of doubtful authenticity.

Wilde, who sharply criticizes all the earlier scholars for doubting the authenticity of these three drawings, on page 252 of his *Windsor Cat.* says, "I can find no argument to justify these verdicts" (namely that these Resurrection drawings are not by the master); but he failed to quote his own earlier article (*J.d.Kh.Slg. Wien*, Vienna, 1928, p. 201) in which he himself rejected Brinckmann, 61.

164. *The Risen Christ*. Rotterdam, Boymans Museum. Black chalk. H. 354 mm. *128* W. 172 mm. Hitherto unpublished. (See also Vol. III, No. 114.)

Berenson, *Drawings*, no. 1676 A; Wilde, *Windsor Cat.*, p. 251; *idem, Brit.Mus.Cat.*, p. 89.

According to Berenson, this is a school copy. The lost original was probably made ca. September 1532, about the same time as the Risen Christ of the Archivio Buonarroti (Vol. III, Fig. 160) which is datable in this year. The raised head anticipates one of the floating nude Elect in the Last Judgment to the left.

Wilde hypothetically attributes this copy to Giulio Clovio. There exists another, but weaker, copy in the Uffizi, Santarelli Collection, no. 1450, attributed to Alessandro Allori, but it seems to be a drawing of the mid sixteenth century.

(Collections: Lawrence [Cat. 1836, no. 56]; Koenigs.)

165. *The Risen Christ*. London, British Museum. Black chalk. H. 406 mm. W. 271 *126* mm.

Berenson, *Drawings*, no. 1507 A; Frey, *Handz.*, no. 110; Thode, *Kr.U.*, III, no. 338; Popp, *Medici Kap.*, p. 163; Brinckmann, *Zeichnungen*, no. 51; Popp, *Z.f.b.K.*, 1925-1926, pp. 172f; Tolnay, *Arch.Buon.* (1928), p. 445 n. 60; *idem*, Vol. III, p. 188; Wilde, *Brit.Mus.Cat.*, no. 53.

Popp and this author (1928) considered this drawing as not genuine, especially because of the Manneristic, wavy form of the banner and shroud, the weak outlines of the soldiers at the left, and the dry design of the sarcophagus. However, after a new examination (1956) I hold it probable that at least the body of Christ was completed by Michelangelo himself. The motif of the Resurrected is almost identical in reversed version with that on the verso of the Tityos (No. 115). The motif of the legs was used later by Michelangelo in one of the ascending souls at the left of the Last Judgment. The drawing is in my opinion, probably connected with the projected Resurrection fresco of the altar wall of the Sistine Chapel, February-March, 1534.

166. *The Risen Christ*. London, British Museum. Black chalk, partly stippled. *129* H. 414 mm. W. 274 mm. Cut at the top.

Berenson, *Drawings*, no. 1523; Frey, *Handz.*, no. 288; Thode, *Kr.U.*, III, no. 350

(and no. 365); Popp, *Medici Kap.*, pp. 162*f*; Brinckmann, *Zeichnungen*, no. 50; Popp, *Z.f.b.K.*, 1925-1926, p. 172 and 1927-1928, p. 10; Tolnay, *Arch.Buon.*, p. 445 n. 60; *idem*, Vol. III, p. 188; Wilde, *Brit.Mus.Cat.*, no. 54r; Goldscheider, no. 81.

125 Similar torso, arms, and legs can be found in the rapid sketch (partly a tracing) on the verso of the Tityos drawing, and this seems to be copied in the rapid sketch in the Casa Buonarroti (Brinckmann, 62), of doubtful authenticity.

Because of the dry drawing of the shroud and of the sarcophagus, we have previously doubted the genuineness of this sheet; but now (1956) it seems to .us that as far as the body of Christ is concerned, the drawing was done by Michelangelo in connection with the Resurrection project for the altar wall of the Sistine Chapel. The figure anticipates in mirror image the movement of the Christ in the Last Judgment. The drawing, usually dated 1532-1533 and, according to Wilde, perhaps a presentation sheet, should be dated ca. February-March 1534, date of the Resurrection project.

A copy is in the Städel Institut, Frankfurt am Main, no. 3976.

Verso: The grotesque monster on the back is, according to Wilde, connected with the fabulous creature, carved on the tomb of Lorenzo de' Medici, but it seems somewhat more developed and through its muscular forearm close to the style of the Last Judgment. The nude man at the bottom is, in my opinion, not genuine. Wilde considers it by the hand of the master.

130 167. *The Risen Christ*. Windsor Castle. Black chalk. H. 373 mm. W. 221 mm. Slightly cut on left at top and bottom. Pasted on backing sheet.

Berenson, *Drawings*, no. 1616; Frey, *Handz.*, no. 8; Thode, *Kr.U.*, III, no. 541; Popp, *Medici Kap.*, pp. 162*f*; Brinckmann, *Zeichnungen*, no. 49; Popp, *Belvedere*, 1925, *Forum*, p. 75; Tolnay, *Arch.Buon.*, p. 445 n. 60; Wilde, *Windsor Cat.*, no. 428.

This study is developed from the Risen Christ sketches in the Archivio Buonarroti and the Casa Buonarroti (No. 113). The drawing was probably made around February-March 1534, date of the Resurrection project for the altar wall of the Sistine Chapel. It anticipates the upward floating Elect at the left in the Last Judgment.

Berenson, Frey, Brinckmann, and Wilde consider the drawing as genuine; Popp and Tolnay (1928) doubted it. We now (1956) believe that the drawing is by the master, but that the outlines have been worked over by a pupil. The dry hatching of the sarcophagus and of the shroud are also probably by the pupil; but the chiaroscuro modeling of the body has the mastery of Michelangelo.

120 168. *Study for a Pietà used by Sebastiano del Piombo in his Pietà in Ubeda*. Paris, Louvre (Inv. no. 716). Black chalk. H. 254 mm. W. 318 mm.

Berenson, *Drawings*, no. 1586; Justi, *Miscellaneen*, II, p. 156; Frey, *Handz.*, no. 21; Thode, *Kr.U.*, III, no. 475; d'Achiardi, *Seb. del Piombo*, p. 280; Demonts, *Dessins*, no. 8; Brinckmann, *Zeichnungen*, no. 23; Panofsky, *Handz.*, no. 16; *idem*, *Schlosser Festschrift*, 1927, pp. 150*ff*; Popp, *Belvedere*, 1925, pp. 72*ff*; *idem*, *Z.f.b.K.*, 1927,

pp. 54*ff*; Dussler, *Seb. del Piombo*, no. 169; Pallucchini, *Sebastianos Viniziano*, p. 179; Goldscheider, no. 43; Wilde, *Brit.Mus.Cat.*, p. 95, 104.

The drawing was used by Sebastiano del Piombo for the Body of Christ of the Pietà in Ubeda, Spain, Iglesia del Salvador. This painting was commissioned by Don Ferrante Gonzaga, ca. 1533, and was sent to Spain in 1537. The connection between the drawing and the Pietà of Ubeda was first pointed out by Carl Justi to d'Achiardi. The painting was first published in photograph by Panofsky, 1927, p. 152.

The authorship and the dating of the drawing are much debated. It is attributed to Michelangelo by Berenson, Frey, Thode, Demonts, Panofsky (1922), and Brinckmann. On the other hand it has been attributed to Sebastiano del Piombo by d'Achiardi, Panofsky (1927), Dussler, and Pallucchini. Popp gives the drawing to an imitator of Michelangelo.

This is a more finished version of a study in the Casa Buonarroti: Berenson, no. 1416; Frey, no. 15, which is also of high quality.

We now (1956) believe that the masterful chiaroscuro modeling, the finesse of which is equal to the quality of the sheets made for Cavalieri, belongs to Michelangelo. On the other hand, the form of the hands recalls Sebastiano, as well as the noticeably weaker sketch of an arm at the left bottom. (In Vol. III, p. 21, attributed to Sebastiano).

Several scholars (Frey, Brinckmann) date the drawing in 1508-1509 and connect it with the dead young man held by his father in the Deluge of the Sistine Ceiling. Justi dated the drawing in the thirties, a view which Thode, Panofsky (ca. 1533), and Dussler agreed with. Berenson dated the drawing in his first edition as being of the period just preceding the Sistine Ceiling, and in his second edition "10 or 15 years later."

(Collections: Buonarroti; Wicar; Lawrence; King William II of the Netherlands.)

169. *The Dream*. London, Count Antoine Seilern Collection. Black chalk. H. 396 *131* mm. W. 278 mm.

Berenson, *Drawings*, no. 1748 B; Justi, *Ma.N.B.*, p. 347; Thode, *Kr.U.*, III, no. 520; Frey, *Handz., sub* no. 157; Brinckmann, *Zeichnungen*, no. 59; Popp, *Belvedere*, 1925, *Forum*, p. 74; Pigler, *Art Bulletin*, 1939, p. 233; Panofsky, *Art Bulletin*, 1939, p. 402; *idem, Studies in Iconology*, New York, 1939, pp. 223*ff*; Goldscheider, no. 93; Marabottini, in *Onoranze L. Venturi*, 1956, pp. 349*ff*; Wilde, *Brit.Mus.Cat.*, p. 95.

This presentation sheet, called by Vasari "Il Sogno," seems to be similar, yet perhaps slightly more developed than the drawings made for Cavalieri (Phaeton, Ganymede, Tityos). It is not known whether this sheet was actually presented to Cavalieri.

According to Berenson, this is "a painstaking and exact copy of a design by Michelangelo." Frey and Popp are of the same opinion. Thode and Joh. Wilde consider the drawing as genuine; Brinckmann leaves the question of authenticity open.

The drawing has been partly reworked in the scenes at the upper left, where there was originally a large hand holding a phallus, as can be seen in the engraving by *306*

[181]

Beatrizet. A detailed description of this drawing can be found in Thode, *Kr.U.*, II, pp. 375*ff.* The scenes represented starting from the bottom left are: Gula, Luxuria, Avaritia, Ira, Invidia, and Accedia.

Concerning the subject and the Neoplatonic thoughts expressed in this composition, see Hieronymus Tetius, *Aedes Barberinae ad Quirinalem*, Rome, 1642, p. 158, a passage to which Panofsky called attention in *Art Bulletin*, 1939, p. 402, where he also refutes Pigler's interpretation, *ibid.*, p. 233. Pigler supposes that Michelangelo illustrated Ovid's *Metamorphoses*, XI, 589*ff*, where "Hypnos is aroused by Iris, the messenger of Juno, so that he might send veracious dreams to Halcyone." Actually it is the representation of the struggle between the intellect and the passions (Panofsky) or the exaltation of the purifying force of love (Marabottini).

183 Thode noticed that the figure of Ira has a gesture similar to Samson in the Samson and Philistine drawings in Oxford. The main figure is in the pose of a river god. The angel which is descending and seen in foreshortening is anticipated by a figure in Pordenone's Simon Magus, Cremona (1526). The circular disposition of the dream visions around the main figure point to the compositional pattern of the Last Judgment.

Among the copies, the most important are the drawing by Marcello Venusti, Morgan Library and the above-mentioned engraving by Beatrizet (Passavant, 112) published by Lafreri. The engraving by Michele Lucchesi (Passavant, 15) is made from Beatrizet. Various painted copies are listed by Thode, *Kr.U.*, II, pp. 375*f*, and by Marabottini, e.g. London by Battista Franco, Vienna, Uffizi (attributed to Allori), Casa Buonarroti, etc. Battista Franco inserted the main figure of the drawing in his painting, Battle of Montemurlo (1537), Florence, Palazzo Pitti.

(Collection: Grand Duke of Weimar.)

307 In the collection of J. Q. van Regteren—Altena, Amsterdam, there is a drawing representing a Woman Dreaming, which I would attribute to Raffaello da Montelupo. (Compare with his drawings, Berenson, nos. 1640 and 1716.) The composition and the subject of this drawing are inspired by Michelangelo's Dream, but here it is a woman who is surrounded by the images of her dream (infant bacchanals) again in a size smaller than the dreamer. The forms of the female nude are inspired by Michelangelo's Aurora and the dream visions are a paraphrase of Michelangelo's Bacchanal of Children, Windsor.

SKETCHES AND STUDIES FOR THE LAST JUDGMENT

Preliminary remarks: We have changed our earlier opinion about the authenticity of several drawings belonging to this group (*Art Quarterly*, 1940, p. 127, and *Michel-Ange*, p. 75). The following list reflects our latest opinion on this question.

132 170. *Sketch for the Christ, Apostles, and Elect in the Last Judgment.* Bayonne, Musée Bonnat. Black chalk. H. 345 mm. W. 291 mm. (Watermark: a circle enclosing an anchor.)

Steinmann, *Sixt.Kap.*, II, p. 665, fig. 64 (published here for the first time); Thode, *Kr.U.*, III, no. 512 a; *Le Musée de Bayonne, Collection Bonnat*, Paris, 1925, pl. 3; Berenson, *Drawings*, no. 1395 B; Goldscheider, no. 99; Wilde, *Brit.Mus.Cat.*, p. 28.

What seem to be circular lines at top and bottom are in reality creases in the paper itself. There are *pentimenti* in the legs of Christ. Directly to the right of Christ there are faint outlines of a figure, perhaps the first version of Christ.

Müntz, Thode, and Goldscheider accepted the drawing without reservation; Berenson (p. 229 note) accepted it with hesitation and remarked that the drawing is "gentler in types . . . almost Raphaelesque." The drawing shows weak parts and seems to have been worked over later, particularly the eyes and the mouths. The attribution to Michelangelo is not sure although certain graphic abbreviations, e.g. the drawing of the feet and the heads in the background, are close to his style. The *concetto* seems to be that of Michelangelo. It must precede the Casa Buonarroti sketch: Christ is *133* represented seated in the center in a pose which reverts to tradition (Traini, Fra Bartolommeo); however, here he is naked. A circle of naked figures is formed about him; in the foreground, there are six figures to each side of him, which are more nearly completed than those in the background, undoubtedly meant to represent the Twelve Apostles. The kneeling figure at the left of Christ, with arms raised in supplication, is probably the interceding Virgin. Behind to the right and left are lightly sketched figures. At the right the motif of embracing, which will also appear in the fresco, is present. The artist follows the tradition when he represents all the Apostles seated, but he transforms the Heavenly Tribunal into a kind of *consilium deorum*, where the fate of humankind is debated.

171. *Sketch for the composition of the Last Judgment*. Florence, Casa Buonarroti *133* (65F). Black chalk, a few outlines strengthened with pen and ink, probably by another hand. H. 420 mm. W. 300 mm. Recto of the succeeding drawing. (Watermark: coat of arms in the form of a *tête de cheval* with a ladder within it and a star at the top.)

Berenson, *Drawings*, no. 1413; Steinmann, *Sixt.Kap.*, II, p. 605, no. 65; Frey, *Handz.*, no. 20; Thode, *Kr.U.*, III, no. 57; Panofsky, *Handz.*, no. 15; Brinckmann, *Zeichnungen*, no. 60; Tolnay, *Cod.Vat.*, p. 176; Wilde, *Die graphischen Künste*, 1936, pp. 7ff; Tolnay, *Jugement*, p. 126; Goldscheider, no. 100; von Einem, *Kunstchronik*, 1955, pp. 89ff.

This is the earliest preserved sketch for the entire composition of the Last Judgment. (The Bayonne sketch [No. 170], which probably preceded this, gives only the upper section.)

Frey supposed that the sketch was probably made under Clement VII after the meeting between this Pope and the artist in San Miniato al Tedesco, September 1533. Wilde agrees with this dating and says Fall 1533 to Spring 1534. Brinckmann and Goldscheider choose 1534; Panofsky, mid-thirties. I believe that the sketch was made probably shortly after February-March 1534, date of the Resurrection project for the altar wall.

Frey observed that the grouping at the top forms a half-circle and concludes that Michelangelo still intended to preserve his older frescoes in the two lunettes. Wilde suggested that the lacuna in the lower center indicates that at this stage the artist wanted to preserve Perugino's altarpiece. Thode observed the gap in the right center of the composition and that Minos and Charon's boat are both still lacking. According to Panofsky, any suggestion of the spatial surroundings and of the limits of the painting is lacking: "es handelt sich im Grunde nur um die Fixierung einzelner Gruppen und Bewegungsmotive." He does not see dynamic unity in the composition.

Traditional iconographical motifs are that: Christ is seated upon a bank of clouds; Mary as Intercessor approaches him; St. John the Baptist is on the opposite side of the Judge; four trumpeting angels are below Christ. But the idea of the upward movement of the group of the Elect and the downward movement of the Damned is unconventional.

Several motifs of the drawing will find definite form in the fresco (see Brinckmann), though they will sometimes be transposed to the opposite side in the final work.

Vol. III, 161 172. *A male nude for a Resurrected Christ.* Verso of the preceding drawing. Same specifications.

Tolnay, *Arch.Buon.*, pp. 446f (here published for the first time); *idem*, Vol. III, Fig. 161; Berenson, *Drawings*, no. 1413v; Wilde, *Brit.Mus.Cat.*, pp. 89ff; Goldscheider, no. 76.

Vol. III, 160 Another almost identical sketch of higher quality is in the Archivio Buonarroti, VI, fol. 24v; on the recto there is a letter from Bartolomeo Angiolini, dated September 19, 1532, which gives a *terminus post quem* for the sketch of the verso. The ascending figure at the left border of the second zone of the Last Judgment is developed from the sketch of the Archivio.

The present sketch, considered by Berenson and Wilde as genuine, we would now consider (1956) to be a copy made by the master himself ca. February-March 1534. The purpose of the sketch was probably to prepare for the fresco of the Resurrection on the altar wall of the Sistine Chapel.

137 173. *Sketch for the Christ-Judge and the group of the Martyrs of the Last Judgment.* Florence, Uffizi (Santarelli Collection, 170). Black chalk; red-chalk stain, probably resulting from contact with red-chalk drawing. H. 193 mm. W. 285 mm.

Berenson, *Drawings*, no. 1399 K; Steinmann, *Sixt.Kap.*, II, p. 667, ill. 66; Frey, *Handz.*, no. 100; Thode, *Kr.U.*, III, no. 235; Jacobsen-Ferri, pl. 24; Brinckmann, *Zeichnungen*, no. 63; Popp, *Belvedere*, 1925, p. 73.

133 I now consider this drawing to be genuine and probably made after the Casa Buonarroti compositional sketch (No. 171) and before the British Museum sheet *139* for the Martyrs (No. 178). The movement of Christ and the Virgin is more dramatic than in the Casa Buonarroti sketch and the disposition of the Martyrs is not as close

to the final version as is the British Museum drawing. Only two Martyrs can be identified on the basis of their attributes: St. Lawrence, with his grill, and St. Philip, with his cross. Christ is here still bearded, his left hand pointing to his wound. At the right above the Martyrs, Michelangelo drew two couples embracing, a motif which recurs in the Bayonne sketch and in the final version. *132*

174. *Sketch for the Martyrs or Elect to the left of the Virgin in the Last Judg-* *138*
ment, and architectural profiles of cornices. Bayonne, Musée Bonnat. Black chalk. H. 179 mm. W. 239 mm. (Watermark: a six-pointed star, enclosed in a circle with a cross above.)

Steinmann, *Sixt.Kap.*, II, p. 668, no. 67; Thode, *Kr.U.*, III, no. 512 b; Berenson, *Drawings*, no. 1395 A; Goldscheider, no. 98.

The sketch is generally accepted as genuine (Steinmann, Thode, Berenson, Gold-scheider). The architectural profiles of the cornices, however, are drawn less forcefully than is usual with Michelangelo. The main figure seen from the back was used almost exactly by the artist in his fresco, whereas the other figures do not recur in the group to the left of Christ. The motif of the creeping figure was used by the master but moved to the right and lower into the group of Martyrs in the final form of the work.

On the verso there is an unpublished architectural drawing, which will be pub-lished in Vol. VI.

175. *Sketch for one of the floating Elect of the Last Judgment.* Codex Vaticanus, *135*
3211, folio 88v. Black chalk.

Tolnay, *Cod.Vat.*, p. 173 (who published it for the first time).

This is perhaps the first sketch in which the Elect no longer storm Heaven, as in the Casa Buonarroti drawing, but try to save themselves from Earth, as depicted in the final version. The naked figure is seen obliquely from below; the right leg is bent, the left hanging down; the right arm is bent while the left hand tries to reach upward. This sketch has been deciphered by Wilde (1927). The figure seems to be developed from that at the bottom of the group of the Elect in the Casa Buonarroti drawing. In the fresco, the main figure of the group (the nude seen from the back, kneeling on his left leg upon the cloud just attained while the right leg hangs down as if paralyzed) seems to be developed from this sketch. The figure in the fresco also strains upward to reach the hand of his helper, but his strength is insufficient to the task.

176. *Sketch for a struggling Damned Soul of the Last Judgment.* Codex Vaticanus *136*
3211, folio 93r. Black chalk.

Frey, *Dicht.*, p. 455; Tolnay, *Cod.Vat.*, p. 175 (who published it for the first time). Much in the sketch remains unclear; clearly visible is the figure of a fighting person

who grasps his opponent fiercely. The motif reminds one of Michelangelo's Hercules and Anteus group; however, it is more probable that this represents a Damned Soul clutching his opponent. It is perhaps the first appearance of the motif of rebellion and struggle against fate, in contrast to the first version where the Damned were still passive. Frey describes, "Einige unverständliche Blei- und Tintenstriche."

134 177. *Sketch for a Martyr, probably St. Lawrence, of the Last Judgment.* Codex Vaticanus 3211, folio 88v. Black chalk.

Tolnay, *Cod.Vat.*, pp. 175f (who published it for the first time).

The figure is holding with both hands a grill, the attribute of St. Lawrence, and is walking bent forward, with heavy tread. On the verso of the London sheet there *141* occurs a similar figure. On the other hand, the St. Lawrence of the final version in a seated position was developed by Michelangelo from the *Ignudi* and the Prophet Jonas of the Sistine Ceiling and not from this sketch.

139 178. *Sketches and studies for the Martyrs and the struggling Damned of the Last Judgment.* London, British Museum. Varying black chalks. H. 385 mm. W. 253 mm.

Berenson, *Drawings*, no. 1536; Steinmann, *Sixt.Kap.*, II, p. 606; Frey, *Handz.*, no. 79; Thode, *Kr.U.*, III, no. 364; Brinckmann, *Zeichnungen*, no. 64; Popp, *Belvedere*, VIII, 1925, *Forum*, p. 75; Tolnay, *Thieme-Becker*, p. 522; *idem, Jugement*, 1940, p. 127; *idem, Michel-Ange*, p. 75; Wilde, *Brit.Mus.Cat.*, no. 60r; Goldscheider, no. 101.

All scholars consider all the sketches of the sheet to be genuine except for Popp and Tolnay, who consider the sketches beneath the main study for the Last Judgment to have been made by a garzone. The lines of these first drawings are not of the same quality as those of Michelangelo, who might have used a sheet on which there was already work by a pupil.

The sheet is generally dated in the period of the initial work for the Last Judgment, 1534 (Berenson) or 1535 (Brinckmann), but probably somewhat later because of its closeness to the final version.

The sequence of the several layers of the sketches was described by Berenson, Frey, Thode, Brinckmann, and most exhaustively by Wilde. The latter concludes that within the main groups of Martyrs and Damned (his Group C) the sequence was C_3, C_2, C_1 because "the lowest group partly overlaps the middle group and this in its turn partly overlaps the upper one." However, the middle and the lower groups are separated by a cloud and there are also no overlappings between the middle and the upper group. The sequence was most probably that Michelangelo drew the Martyrs (C_2), then the Damned (C_3) and, finally, in softer chalk, the group (C_1) of advancing figures immediately above the Martyrs. Group C_1 is not a first version of the group to the right of Christ in the fresco, the figures of which are not advancing but are oriented in the direction of Christ; rather it seems to be a second group of Martyrs,

[186]

which was not used by Michelangelo in the final version of his Last Judgment. Only about ten years later there returns the *concetto* of this group in the top right of the Crucifixion of St. Peter.

59

Before these drawings, there were three sketches on this sheet, drawn in softer black chalk: one at the top left below the nude half-figure; one at the bottom center, a nude in the pose of the *Ignudo* above and at the right of the Delphic Sibyl; and, finally, one nude figure in the center right, seen upside down.

After the main sketches for the Martyrs and Damned, the chest and the arms at the top left were probably made and then a left arm with clenched fist in the right center, both in harder chalk.

In the first layer, the usual vigor of Michelangelo's lines is lacking and in the final layer, there is a calligraphic play in the wavy outlines. We prefer not to make a commitment concerning the genuineness of the final layer.

As has been said in the text, Michelangelo's sketches on this sheet in the silhouette of a cluster of grapes were probably conceived as a complement to the cluster of the Elect in the earliest extant project of the whole composition in the Casa Buonarroti. *133*

Several motifs will recur in the fresco, however always transformed: the fleeting quality of the sketches will solidify into the stiffer idiom of the fresco. One can identify among the Martyrs: St. Sebastian with the arrows, close to the final version; St. Catherine with the broken wheel, the figure farthest to the right and still quite different from the final version; St. Philip, holding the Cross; St. Simon with his saw, again quite close to the final version. The Damned, seen from the back in the center of the group, the man seen falling head first to the right of this figure, and the damned soul at the right top of the sheet (Wilde's S) are all motifs which will recur in the fresco. The small sketches scattered about the border were probably made immediately after the main group since in them are repeated motifs from it.

179. *Studies for the Last Judgment*: Verso of the preceding drawing. Same speci- *141* fications, except for single red-chalk sketch (center top) and same literature except Frey, *Handz.*, now no. 80.

Seven small figures for the Last Judgment, the two at the top right traced from the recto, the second in red chalk; the center top figure is a variant of the Saint Lawrence sketch in *Cod.Vat.* 3211 (Tolnay, *Cod.Vat.*, p. 176). Turning the drawing to the left, *134* two male heads, drawn from the same model and used, perhaps, for a head in the Last Judgment (De Campos, pl. 30).

Wilde sees the "same sureness of hand" in these sketches as in the recto; however, the lines are hesitant. We prefer not to make a commitment concerning their authenticity, although probably they are by Michelangelo.

180. *Sketches and studies for the Resurrection of the Dead of the Last Judgment.* *140* Windsor Castle. Black chalk, partly rubbed. H. 277 mm. W. 419 mm. A strip of paper has been pasted onto the lower right edge.

Berenson, *Drawings*, no. 1620; Steinmann, *Sixt.Kap.*, II, Fig. 83, p. 682; Frey, *Handz.*, no. 188; Thode, *Kr.U.*, III, no. 545; Tolnay, *Thieme-Becker*, 1930, p. 522; *idem, Jugement*, 1940, p. 127; Wilde, *Windsor Cat.*, no. 432.

At top left there is a torso more lightly sketched than the rest, perhaps the first thing drawn on this sheet, and of somewhat weaker quality than the others. All of the other sketches are for the lower left section of the Last Judgment. Several figures are close to the final version, but there are still lacking here the two standing figures, St. Stephen the Archdeacon at the left and the female figure in the center.

Wilde says that the sketches are only "in the nature of single figures or groups of figures." However, they show rather a compositional idea still differing from the final version but not without its own beauty. The scene is here conceived as a whole in itself and not with regard to the zone above containing the upward floating figures as it will be in the final version. Here Michelangelo shows a deserted field from which the Resurrected creep forth in the center and in the periphery, forming a circular pattern. Here there is still a suggestion of the depth of space; in the fresco, he compresses the figures in relief-like planes. The figures and groups move more freely here whereas in the fresco they are somewhat stiffened.

The three groups in the lower right of the circular composition most nearly approximate the form which he used in the fresco. (For the resurrected inverted figure being raised by two angels and pulled down by a demon, Michelangelo sketched eight versions at the right side of the sheet.) Other motifs of the fresco are anticipated in this sheet but not in the same arrangement: the kneeling figure at the left in the drawing will be transferred in reversed version to the center in the fresco; the figure in the center of the second plane, crawling forward, reappears in the fresco in the center of the first plane; the seated nude in the center of the drawing will be transposed to the left of the first plane in the fresco. Other motifs will be transformed in the fresco as, for example, the figure in the middle of the second plane, crawling forth and looking upward, which becomes the standing woman in the center of the first plane of the fresco. Berenson and Wilde date the drawing 1534. Probably somewhat later because of its closeness to the final version.

142 181. *Sketches and studies, mostly for the Resurrected of the Last Judgment.* Windsor Castle. Verso of the preceding drawing. Same specifications and literature except for Frey, *Handz.*, now no. 189, and Tolnay, *Art Bulletin*, 1940, p. 128 n. 4.

We now (1956) consider all the studies of this sheet to be originals. They are all save one for the Last Judgment: there are three detailed studies for the group with the resurrected soul, whose body is supported under the armpits by two angel-genii while it is being pulled back by a demon; the small study of a walking man (Wilde's "R") is, however, drawn with a softer chalk and, in our opinion, probably later than the rest. It already has the style of the Pauline frescoes. Wilde connects the two sketches of standing figures with the two standing figures in this section of the fresco; the connection is, however, tenuous.

Chronology of the sketches: first Michelangelo drew the study of the two arms and the hand; then he lightly sketched the standing figure at the center of the sheet; after this there followed the detailed study of the legs at the left; finally, he drew the small sketch of the walking man.

182. *Studies for the Last Judgment.* Florence, Casa Buonarroti (69 F). Black chalk. *143*
H. 430 mm. W. 288 mm. Verso of Berenson, no. 1416.

Berenson, *Drawings*, no. 1416v; Frey, *Handz.*, 15; Thode, no. 61. Panofsky, *Schlosser Festschrift*, 1927, pp. 158*ff* (who published it for the first time); Popp., *Z.f.b.K.*, 1928/9, p. 54*f.*

Berenson attempts to connect the figures on the verso with the Flood and dates the sheet in the period of the Sistine Ceiling. Panofsky rightly identifies three studies as being for the Last Judgment and dates the sheet around 1535.

At the left top are a right arm and the outline of the breast for an "Apostle" at the right of and on the level of Christ's head. Alongside this study, there is the turning torso of a seated male figure, a study for the "Prophet" just above St. Blaise: this study is probably made after a wax model (without arm). The study of a head at the lower center is for the figure directly above the "Apostle" whose outstretched arm was already studied on this sheet.

Other sketches cannot be traced to the Last Judgment: the right arm at the top of the sheet, weaker in execution, probably not by the master and drawn later as indicated by the overlapping; two rapid sketches of left knees; and—the most important—a small running nude seen from the back. This latter figure is drawn with a softer chalk and seems to have been made by Michelangelo somewhat later than the other studies; it anticipates the running figure seen from the back at the far left of the Conversion of Saul, as Panofsky has observed: ". . . wirklich vollentsprechende *58* Analogien zu dieser unkontrapostischen Gestalt sind erst in den Paolina Fresken . . . anzutreffen." Concerning the recto, See: Dussler, *Seb.delPiombo*, p. 188, no. 203.

183. *Study for the body and the head of St. Lawrence in the Last Judgment.* Haar- *145* lem, Teyler Museum. Black chalk, partly rubbed, on yellowed paper. H. 241 mm. W. 181 mm. Recto of the succeeding drawing.

Marcuard, pl. XIII; Berenson, *Drawings*, no. 1468; Steinmann, *Sixt.Kap.*, II, no. 71, Fig. 671; Thode, *Kr.U.*, III, no. 261; Frey-Knapp, *Handz.*, no. 322; Brinckmann, *Zeichnungen*, no. 83; Panofsky, *Rep.f.Kw.*, 1927, pp. 41*f*; Goldscheider, no. 102.

Marcuard, Berenson, Steinmann, Thode, and Wilde consider the drawing genuine. It is hesitatingly rejected by Brinckmann and by Panofsky.

The lighting of the body is slightly different from that in the fresco and its modeling is richer in details; the forms are slightly narrower in the horizontal dimensions than in the fresco. The head study at left bottom seems to be truer to the individual features

of the model than in the case of the final version. The high quality of the draughts-manship together with all the preceding characteristics speak in favor of a genuine drawing and not for a copy made after the fresco.

144 184. *Torso and legs of a standing male figure seen from the rear.* Verso of the preceding drawing. Same specifications and literature except for Marcuard, now pl. XIV; Frey-Knapp, *Handz.*, now no. 323; Steinmann, *Sixt.Kap.*, II, now no. 71B, Fig. 672; Panofsky, *Rep.f.Kw.*, 1927, now p. 43.

150 In technique and style close to the verso of the Lamentation and, somewhat different from the usual studies of Michelangelo, which difference may perhaps be explained by the use of a softer black chalk.

Marcuard and Berenson connect the figure with the Last Judgment and the latter thinks that it is a study for the figure above "Isaiah" (our St. Stephen). Panofsky connects this sketch, which he does not accept as genuine, with the figure at the left of St. Peter in the Crucifixion of St. Peter, a connection which Berenson (2nd ed.) does not accept. The motif of the drawing was not used in the Last Judgment.

146 185. *Study for one of the Resurrected of the Last Judgment.* London, British Museum. Black chalk. H. 293 mm. W. 233 mm.

Berenson, *Drawings*, no. 1683; Steinmann, *Sixt.Kap.*, II, p. 683, Fig. 84; Jacobsen, *Rep.f.Kw.*, 1907, p. 499; Frey, *Handz.*, no. 299; Thode, *Kr.U.*, III, no. 333; Wilde, *Brit.Mus.Cat.*, no. 63r.

A study for one of the resurrected bodies in the lower left corner of the Last Judgment. Richer in detail and different in lighting from the corresponding figure in the fresco. In the sketch, the light is more diffused and falls from above and slightly from the left; in the fresco, the right arm is lighted and the left is in shadow. This drawing was made in preparation for the full-sized cartoon and, since the figure is at the bottom of the composition, the drawing must belong to the last stage of the preparation of the fresco.

The drawing is considered genuine by Steinmann, Thode, and Wilde, whose opinion we now share. Berenson sees in this work a copy made after the fresco, a view which is contradicted by the differences between drawing and fresco and the high quality of the study. Frey thinks that it is a copy after a lost drawing by Michelangelo.

147 186. *Studies for the Last Judgment: a torso of one of the Resurrected, a right hand, and a left arm.* Verso of the preceding drawing. Same specifications and literature, except for Frey, *Handz.*, now no. 300.

Studies for two figures at the lower left of the Last Judgment: for the hands of the figure of St. Stephen the Deacon and the body of the resurrected soul beneath him. The latter seems to have been drawn from a corpse. (See the head and the right hand dangling down lifelessly.) In the fresco the figure is resting upon this hand.

187. *Study for one of the Resurrected of the Last Judgment*. Oxford, Ashmolean *148*
Museum. Black chalk. H. 216 mm. W. 266 mm. The recto of the succeeding drawing.

Robinson, no. 58; Berenson, *Drawings*, no. 1568A; Frey, *Handz.*, no. 148; Thode,
Kr.U., III, no. 435; *1953 London Exhibition*, no. 70; Parker, no. 330r.

Preparatory study for one of the Resurrected on the extreme lower left of the Last
Judgment (De Campos, pl. 101). First Michelangelo made a light sketch of the whole *39*
figure and then he began to model carefully the shoulders and the right arm. The rest
remains sketchy.

Considered as an original by Robinson, Thode, Wilde (*Brit.Mus.Cat.*, pp. 102f).
Berenson (1st ed.) rejected the drawing as a copy by a pupil, perhaps Cungi; in the
2nd ed. he admits that the work is probably genuine. Frey expresses doubt. In view
of the differences between the drawing and the fresco both in form and in lighting,
we now (1956) would admit it as genuine. The outline of the back is simplified in
the fresco; the face is different; the right shoulder and upper arm are lighted in the
drawing but in shadow in the fresco—all speak in favor of genuineness.

188. *Study of the legs of a recumbent male figure*. Oxford, Ashmolean Museum. *149*
Black chalk. Verso of the preceding drawing. Same specifications and literature as in
the preceding except for Frey, *Handz.*, now no. 149.

Generally connected with the Last Judgment, like the recto, but Parker rightly
emphasized the analogies with the Last Judgment are insufficient for justifying more
than the general assumption. A. E. Popp (*Die Medici Kapelle*, pp. 144-145) drew
attention to the fact that the drawing is not from life but from one of the models
of the River Gods of the Medici Chapel (1524). She observes the resemblance (in
reverse) of the legs of the River God in one of the Phaeton drawings (No. 117). She
emphasizes that there is a noticeable difference between recto and verso and rejects
the present drawing. Parker, nevertheless, accepts the verso as well as the recto. But
there are curious calligraphic lines in the knees and there is a difference in quality
from the recto.

189. *A kneeling man digging a hole*. London, British Museum. Black chalk. H. 140 *152*
mm. W. 180 mm.

Berenson, *Drawings*, no. 1525; Jacobsen, *Rep.f.Kw.*, 1907, p. 496; Frey, *Handz.*, no.
159 b; Thode, *Kr.U.*, III, no. 351, Baumgart, *Goldschmidt Festschrift*, 1933, p. 131
note; Baumgart-Biagetti, *Cappella Paolina*, pp. 33f; Wilde, *Brit.Mus.Cat.*, no. 70r.

The position of the left arm has been changed in a *pentimento*. The first version
seems to be a preparation for the kneeling figure bent forward at the left in the
second zone of the Last Judgment as Frey assumed. Also in its style the first version
of the sketch fits this period well.

The drawing has been transformed by means of stronger outlines into a figure
resembling in reverse the figure digging the hole for the Cross, in the Crucifixion

of St. Peter in the Cappella Paolina. That this latter version is also by Michelangelo may be questioned. There is a marked difference in quality between the two versions.

Baumgart attributes the drawing to Daniele da Volterra. Wilde does not see any difference in quality between the two versions, and assumes that both are for the Pauline fresco.

On the verso of this sheet there is a genuine architectural sketch in the pale black chalk of the first version of the recto and pen-and-ink inscriptions by the hand of the master (See Vol. VI).

151 190. *Two figures from the Last Judgment.* Florence, Casa Buonarroti. Black chalk. H. 175 mm. W. 215 mm.

Berenson, *Drawings*, no. 1660 A; Steinmann, *Sixt.Kap.*, II, p. 669, Fig. 69; Thode, *Kr.U.*, III, no. 28a.

Berenson, in our opinion quite rightly, sees in these sketches a copy by a pupil, while Steinmann and Thode consider them to be genuine.

154 191. *Studies for a flying angel-genius in the right lunette and for other figures of the Last Judgment.* London, British Museum. Black chalk, partly rubbed. H. 407 mm. W. 272 mm. (Watermark: Robinson 13.)

Berenson, *Drawings*, no. 1684; Jacobsen, *Rep.f.Kw.*, 1907, pp. 494*ff*; Frey, *Handz.*, no. 278; Thode, *Kr.U.*, III, no. 327; Brinckmann, *Zeichnungen*, no. 68; Popp, *Belvedere*, VIII, 1925, *Forum*, pp. 73, 75; Wilde, *Brit.Mus.Cat.*, no. 61r.

According to Berenson "either copies of original sketches or enlargements of slight indications by the master"; Frey and Popp, consider them as copies after lost drawings by Michelangelo. Steinmann, Jacobsen, Thode, Brinckmann, and Wilde assume they are genuine studies for the Last Judgment.

Wilde's argument in favor of their authenticity is the sequence of the studies on recto and verso; but since these are not copies after the fresco but supposedly after lost drawings, this argument is not conclusive. The small, sometimes calligraphic, broken curves of the outlines and the lifeless parallel strokes of the hatchings betray a different hand.

The male torso, top left, is similar to that on the sheet of the Libyan Sibyl (Vol. II, Fig. 80) as Wilde pointed out (p. 101).

The bottom right figure is "an elaboration of a motif which occurs in the group C_3, on [Wilde, *Brit.Mus.Cat.*] no. 6or, but it does not occur in the fresco" (Wilde).

153 192. *Studies for a flying angel-genius and other figures.* Verso of the preceding drawing. Same specifications and literature except for Frey, *Handz.*, now no. 277.

Concerning the figure for the lunette on the right (here holding the crown of thorns), Wilde observed, "In the fresco, this instrument of the Passion is given to another angel, in the left hand lunette, who is, however, a reversed version of the same figure."

The bent legs remind Wilde (p. 101) of the legs of Christ in the Pietà for V. Colonna, *159* but the relation is only superficial.

The ductus of the lines is broken, nervous, mannered as with Battista Franco, but somewhat more powerful.

193. *Study of a left leg*. Codex Vaticanus 3211, folio 93v. Black chalk. *155*
Frey, *Dicht.*, p. 455; Tolnay, *Cod.Vat.*, pp. 178*ff* (who published it for the first time).
Frey describes "verwischte Bleistiftzeichnung eines Schenkels von demselben Stil wie bei A, I" (i.e. fol. 88r, the right knee.) Frey dates the study ca. 1538-1544. Probably the study belongs, however, to the beginning of the period of the Last Judgment, around 1534-1536, and was used by the master for the left leg of the Christ-Judge in that fresco.

The frontal view of the standing leg and foot is peculiar to Michelangelo; it emphasizes the firmness of the stance. In the upper section of the Last Judgment, this motif occurs five times; in the works of earlier artists, the feet are somewhat turned outward even when the view of the leg is frontal, thus producing an effect which is light and tenuous.

An analysis concerning the theoretical importance of this study was given by Tolnay, *loc.cit.*

194. *Study of a right knee*. Codex Vaticanus 3211, folio 88r. Black chalk. *156*
Frey, *Dicht.*, p. 454; Tolnay, *Cod.Vat.*, pp. 188*ff* (who published it for the first time).
Frey describes: "prachtvoll leider stark verwischte Bleistiftzeichnung eines Schenkels (oder Schulterblattes?)," but it is actually a right knee in the position of that of the Prophet Jonah in the Sistine Ceiling and that of St. Lawrence in the Last Judgment *18* (which is in the same position as the former). In the richness of the modeling, the sketch is closer to the knee of Jonah, but its outlines do not have its rhythm; nevertheless, the drawing is chronologically nearer to the knee of St. Lawrence, executed, ca. 1537-1538.

195. *Lower part of a left leg*. Florence, Casa Buonarroti (13 F). Black chalk. H. 260 *157* mm. W. 130 mm.
(Not included in Berenson); Thode, *Kr.U.*, III, no. 21. (Hitherto unpublished.)
A vigorous study of a left leg with indication of the bones and muscles; it is probably from the period of the Last Judgment.

DRAWINGS MADE FOR VITTORIA COLONNA

Preliminary remarks: Included in this section is, besides the drawings certainly made for Vittoria Colonna, the Madonna del Silenzio, a presentation sheet probably made for her, although there is no documentary evidence of this.

196. *Madonna del Silenzio*. Collection Duke of Portland. Red chalk. H. 322 mm. *158* W. 285 mm. *Exhibition of works by Holbein and other masters, Royal Academy,*

London, 1950-1951, no. 276; C. Gould, *Burl.Mag.*, 1951, pp. 279*f* (who published it for the first time).

This is the carefully executed original drawing of the Madonna del Silenzio of which numerous copies are known.

The condition of the drawing is described in detail by Gould, p. 280. There are slight *pentimenti* in the Madonna's neck, in the Child's legs, and in the outline of the back of St. Joseph. Above the Virgin's and Joseph's heads there were outlines of additional figures, subsequently shaded over. One can still recognize the outlines of two figures, probably two angels, embracing each other and reading (Gould). There are other lines at the left of the Virgin's head, but their significance can no longer be recognized. Therefore, the originally planned composition contained more than four figures; the reduction was made by the master himself. "It has been suggested that the Madonna's head was originally conceived more or less in profile and inclined downwards" (Gould). This is a presentation sheet.

On the basis of its style it should be dated around 1538-1540. The Madonna's head-dress has a form like that of the Aurora of the Medici Chapel.

Among the numerous copies, the most important ones are the engraving by *309* Bonasone of 1561; the painted copy by Marcello Venusti of 1563, Leipzig, Museum; the *310* copies in the London National Gallery, and in the Dresden Gallery.

We are indebted to His Grace the Duke of Portland for permission to publish the drawing and to Mr. Cecil Gould of the London National Gallery for having furnished the photograph.

(Collection: Casa Buonarroti; Wicar; Sir Thomas Lawrence; Woodburn; William II, King of Holland. Further collections, through which the drawing passed, are listed in Gould.)

159 197. *Pietà for Vittoria Colonna*. Boston, Isabella Stewart Gardner Museum. Black chalk. H. 295 mm. W. 195 mm.

Berenson, *Drawings*, no. 1623 C (Fig. 736); Tolnay, *Record of the Art Museum, Princeton University*, 1953, pp. 44*ff*.

Badly damaged. Paper yellowed with water spots. Cut at top and bottom. Mounted.

Originally, the whole cross was probably visible at the top, as described by Condivi, p. 202. (Watermark: a ladder inside a circle.) Sir Charles Robinson, who acquired the drawing in 1886 and in whose collection it was until 1902, wrote on the back: "It is unquestionably an authentic drawing of Michelangelo's later time. The watermark in the paper, a ladder within a circle, will be found in my *Oxford Account of the Michelangelo and Raphael drawings*." It is no. 19 of the facsimile marks.

The drawing is frayed around the edges and three toes of Christ's left foot are patched. There is a *pentimento* on the left foot of the left angel.

This is a presentation sheet made by Michelangelo for Vittoria Colonna, and is probably mentioned in an undated letter of Vittoria Colonna to Michelangelo (Fer-

rero-Müller, *Vittoria Colonna, Carteggio*, Torino, 1892, p. 209; Frey, *Dicht.*, p. 534). The drawing mentioned in this letter could, however, refer instead to the Crucifixion which he made for her, since in this drawing there is also one angel on either side of Christ.

Berenson lists the drawing as a copy. In the museum the drawing is exhibited as being by "a follower of Michelangelo, probably Roman ca. 1530." According to Sir Charles Robinson it is an original, and we agree. Concerning the provenance, see Tolnay, *Record*, p. 35 n. 3, no. 1. Concerning copies, see p. 132.

(Published by courtesy of the Gardner Museum, Boston.)

198. *Crucifixion for Vittoria Colonna*. London, British Museum. Black chalk, *164* stippled and partly rubbed. H. 370 mm. W. 270 mm.

Berenson, *Drawings*, I, pp. 232f, and note to no. 1724 A; Frey, *Handz.*, no. 287; Thode, *Kr.U.*, III, no. 353; Tolnay, *Cod.Vat.*, pp. 198ff; *idem, Michel-Ange*, p. 144; Wilde, *Brit.Mus.Cat.*, no. 67; Goldscheider, no. 113.

According to Thode, Wilde, and Goldscheider, the whole drawing is genuine; Berenson, Frey, Tolnay (1927) consider it to be a copy.

This drawing is mentioned several times in the correspondence between Michelangelo and Vittoria Colonna: in a draft letter by Michelangelo, from which we learn that Vittoria Colonna returned the sheet to the master by Cavalieri, probably making suggestions with regard to its completion (*J.d.p.K.*, 1883, p. 46); in an undated letter by Vittoria Colonna to Michelangelo, in which she asks the master to return to her the Crucifixion sheet for a short time, even if it is not finished, "se ben non è fornito" (Frey, *Dicht.*, p. 533, doc. 108). This remark probably means that the Virgin and St. John the Evangelist were still lacking. The remaining allusion is found in a letter from Vittoria Colonna to Michelangelo in which she highly praises the finished execution of the Crucifixion drawing: "Ho hauta la vostra et visto il crucifixo il qual certamente ha crucifixe nella memoria mia quante altre picture viddi mai; non se po vedere piu ben fatta, piu viva et piu finita imagine et certo io non potrei mai explicar quanto sottilmente et mirabilmente è facta . . . io l'ho ben visto al lume et col vetro et col specchio, et non viddi mai la piu finita cosa" (Steinmann-Wittkower, pl. XIV). The sequence of these letters cannot be established with certainty. It is generally assumed that they date between 1538 and 1541.

While the angels and the parallel horizontal hatchings of the background seem to be weaker and by another hand, the body of Christ, rich in soft nuances of modeling, may be considered genuine. In favor of this judgment is the *pentimento* on the left hip of Christ; against it, however, is the uncertainty of the outlines, of the hair treatment, and of the hands. The angels seem to have been drawn shortly afterwards, since the horizontal hatchings of the sky can be seen beneath them. Also the hilltop of the Golgotha seems to have been made by the same weaker hand. The pupil who seems

[195]

to have executed the angels after projects by the master did not add the Virgin and
St. John the Evangelist, whom Michelangelo thought belonged to this composition
165-172 as testified by an engraving and by several paintings.

337 The drawing was already celebrated in the sixteenth century as can be seen by
the several copies: Oxford; Louvre (Inv. no. 752, attributed to Giulio Clovio by
Philip Pouncey); Mond Collection, London; and in the British Museum, by Barto-
lomeo Aretino (Wilde, no. 93).

168 199. *Study for a Virgin under the Cross.* Paris, Louvre (Inv. no. 720). Black chalk
on greyish paper. H. 230 mm. W. 100 mm. Right upper corner bears later addition.
Berenson, *Drawings,* no. 1595; Thode, *Kr.U.,* III, no. 488; Delacre, Fig. 140; Wilde,
Brit.Mus.Cat., p. 120; Goldscheider, no. 115.

This sketch of doubtful authenticity is intended for the elaborate versions of the
171, 172 Crucifixion for Vittoria Colonna with two figures below the cross, ca. 1538-1541.
Marcello Venusti made a painted copy of this composition, which is also known
through old engravings.

Considered as a genuine drawing by Berenson, Thode, Wilde, Goldscheider. How-
ever, it is weaker in execution than the originals for Vittoria Colonna and may be a
copy of a lost drawing by the master. The companion piece representing St. John the
Evangelist is also in the Louvre.

169 The Louvre (Inv. no. 765) has a second copy of this drawing, probably by Giulio
Clovio.

167 200. *Sketch of a nude male figure in the pose of the Virgin on the recto.* Paris,
Louvre. Verso of the preceding drawing: same specifications and literature as for the
recto, except for Delacre, now no. 141, and Goldscheider, now no. 120.

This is a rapid sketch of a male figure in the same pose as the Virgin on the recto
and served as a preparatory sketch for the latter. Although it is close in technique to
the late drawings of Michelangelo, it does not have the quality of his line work and
may be an imitation of a lost sketch by the master (note the drawing of the legs and
the right arm). The sketch is accepted as being genuine by Berenson, Thode, Delacre,
Wilde, and Goldscheider.

165 201. *Study of a St. John the Evangelist under the Cross.* Paris, Louvre (Inv. no. 698).
Black chalk on grey paper; heightened in the background with white chalk. Pasted
on paper backing which completes the missing corner. H. 250 mm. W. 83 mm.
Berenson, *Drawings,* no. 1582; Thode, *Kr.U.,* III, no. 469; Delacre, Fig. 166; Wilde,
Brit.Mus.Cat., p. 120; Goldscheider, no. 116.

Intended for the elaborate version of the Crucifixion for Vittoria Colonna with
172 two figures beneath the Cross, of which Marcello Venusti made painted copies. Com-
panion piece to the above-mentioned Virgin.

According to Berenson, Thode, Wilde, and Goldscheider a genuine drawing. In our opinion, however, of lesser quality and possibly a copy of a lost original drawing by the master. The grey paper is also alien to Michelangelo.

There is a second, weaker copy of this drawing in the Louvre (Inv. no. 801). *166*

SKETCHES USED IN THE FRESCOES OF THE PAULINE CHAPEL; CARTOON FOR THE CRUCIFIXION OF ST. PETER, PAULINE CHAPEL; STUDIES FROM CA. 1542-1550

Preliminary remarks: There are only a few sketches in existence which can be related to the frescoes of the Pauline Chapel. To these belong, at least indirectly, the group of advancing figures in the London sheet of Martyrs and Damned of the Last Judg- *139* ment, a group which Michelangelo seems to have used in the Crucifixion of St. Peter; the running figure seen from the back on a sheet of studies for the Last Judgment *143, 174* in the Casa Buonarroti; a figure on the verso of the sheet with the sketches for the tomb of Cecchino Bracci. The last corresponds to one of the figures in the Conver- *Vol. III, 125* sion of Saul.

Baumgart (in *A. Goldschmidt, Zu seinem Siebenzigsten Geburtstag, 1933*, Berlin, 1935, pp. 134*ff* and in Baumgart-Biagetti, pp. 29*ff*) tries to connect one of the figures on the recto of the Haarlem drawing (Frey-Knapp, nos. 326, 327) with the youthful *198, 200* leader of the upper right group in the Crucifixion of St. Peter. On the verso of this *201* sheet Baumgart thought he recognized three versions of the soldier at the right of the captain in the Crucifixion of St. Peter. In my opinion these figures are probably related to the inside decoration planned for the dome of St. Peter's.

202. *Horseman seen from rear.* (Red chalk) *and sketches presumably of fortica-* *173* *tions* (ink). Florence, Uffizi (14412 F). H. 243 mm. W. 275 mm.

Berenson, *Drawings*, no. 1399 A; Thode, *Kr.U.*, III, no. 217; Frey, *Handz.*, no. 99; Jacobsen-Ferri, pl. 2; Brinckmann, *Zeichnungen*, no. 6; Tolnay, Vol. I, p. 214.

The fortification sketches can hardly have been made in connection with work on the fortifications of Florence in 1529; they were, rather, done in connection with the plan of the fortification of the Borgo, i.e. around 1545. On February 26, 1545, Michelangelo was consulted concerning the fortifications of the Borgo, and the artist offered his services as architect (Gotti I, pp. 295*ff* and II, p. 126).

Berenson, in his first edition, dated the sketches as from 1530; in his second edition he believes them to be "considerably later" than the head on the recto, which he dates in the time of the Sistine Ceiling. Thode connects them with the fortifications of Florence in 1529; Brinckmann with the Cascina period, 1504; Frey sees in the Horseman a sketch for the Conversion of Saul of the Pauline Chapel, 1542-1545. The latter's opinion seems to be the most likely: the horse, seen in foreshortening, seems to have a connection with the horse of the Conversion of Saul.

On the recto there is a fragment of a poem in Michelangelo's handwriting, according to Frey from ca. 1534-1538; a red-chalk study of a head and two sketches for heads. There are also, in ink, drawings of halberts and fortifications.

203. *Fragment of the Cartoon for the Crucifixion of St. Peter of the Pauline Chapel.* Naples, Galleria Nazionale di Capodimonte. Black chalk. Outlines pricked for transfer. H. 263 mm. W. 156 mm. The cartoon is drawn on nineteen pieces of paper (*Fogli Reali Bolognesi*) pasted onto a canvas.

Steinmann, "Cartoni di Michelangelo," in *Bollettino d'Arte*, 1925, pp. 11f (who published it for the first time); Baumgart-Biagetti, *Cappella Paolina*, p. 23; Berenson, *Drawings*, no. 1544 A; Goldscheider, no. 117; Neumeyer, *Z.f.b.K.*, 1929/30, p. 182.

This is the full-size cartoon for the figures in the left bottom corner of the fresco of the Crucifixion of St. Peter, which Michelangelo began 1545-1546 (and not 1542 as Goldscheider states). Since the outlines are pricked, it is obvious that this is the cartoon used by the master for the transfer to the wall.

The cartoon is much damaged. At the right center a hole has been patched with other paper; the right leg of the figure at the right has been supplied by a later hand. The paper is stained.

According to Steinmann, Baumgart, and Goldscheider the cartoon is genuine; Berenson sees "a disturbing sleekness about these figures" and assumes that they have been worked over by another hand, perhaps that of Daniele da Volterra. But that which Berenson calls "sleekness" is the soft style of the late Michelangelo, whose hand can be recognized in all the lines except the later completion of the leg, mentioned above. The delicate chiaroscuro is attained partly by hatchings, partly by rubbing and is also characteristic of the late Michelangelo.

The cartoon is mentioned in the inventory of Fulvio Orsini, in 1600: "Quadro grande corniciato di noce, nel quale è un pezzo della storia di San Pietro della Cappella Paolina di mano di Michelangelo" (see P. de Nolhac, *G.d.B.A.*, 1884, p. 433 n. 59). From the Orsini collection it came into the property of the Farnese family, from where in 1759 it was transferred to the Museo di Capodimonte (cf. Vasari, ed. Bottari, *Vita di Michelangelo*, Rome, 1760, p. 75 n. 2). From there it came to the Museo Nazionale in Naples and finally to the Galleria Nazionale, Capodimonte.

204. *Studies of a man's legs and an arm.* Oxford, Ashmolean Museum. Black chalk on bluish-grey paper. H. 239 mm. W. 144 mm.

Robinson, no. 67; Berenson, *Drawings*, no. 1570; Thode, *Kr.U.*, III, no. 440; Frey, *Handz.*, no. 195; Brinckmann, *Zeichnungen*, no. 27; *1953 London Exhibition*, no. 122; Parker, no. 329; Tolnay, Vol. II, no. 10 A.

The authenticity of this sheet has not been established. If original, it should probably be dated in the period of the Paolina frescoes. Robinson, Frey, Thode, Parker assume the date of the Last Judgment. Berenson connects the sheet with a Resur-

rected Christ in London of about 1535, i.e. the same period. On the other hand, Brinckmann assumes the early date of 1509-1510 and sees a connection with the separation of light and darkness in the Sistine Ceiling. Wilde (*1953 London Exhibition*) proposes the date of 1545-1550 (not illustrated in this volume). Tolnay (Vol. II, p. 208. No. 10 A): "by a *garzone*."

205. *Sketch of a left leg*. San Marino, Cal., Huntington Library. Black chalk. *176*
Tolnay, *Art Bulletin*, 1940, pp. 127*ff* (who published it for the first time); Creighton E. Gilbert, *Art Bulletin*, 1944, pp. 48*f*; Wilde, *Windsor Cat.*, p. 256, *sub* no. 432.
Michelangelo seems first to have drawn this sketch on the top of the sheet and to have written later in pen and ink the drafts of two poems, the first two lines being separated from the remainder. We connected the sketch (1940) with the left leg of the resurrected man in the lowest zone, near the mouth of Hell, in the Last Judg- *36* ment. The motif is similar but not identical. Following our publication, C. E. Gilbert has noted that the final version of the madrigal draft on this sheet was published in Frey, *Dicht.*, cix, 63, and that it should be dated according to Frey about 1546. (Gilbert does not speak about the sketch.) Probably the sketch however should be dated earlier: in the period of the Last Judgment.

206. *A bent right arm*. London, British Museum. Soft black chalk. H. 113 mm. W. 156 mm.
Berenson, *Drawings*, no. 1512; Steinmann, *Sixt.Kap.*, ii, no. 72; Frey, *Handz.*, no. 200 b; Thode, *Kr.U.*, iii, no. 283; Wilde, *Brit.Mus.Cat.*, no. 80.
Generally this sketch was dated in the period of the Last Judgment, but Wilde pointed out rightly that it is a later drawing of ca. 1545-1555 (here not illustrated).

SMALL COMPOSITIONAL SKETCHES OF CA. 1542-1550
USED BY DANIELE DA VOLTERRA

Preliminary remarks: In this section I am listing sketches for four compositions, among which three were used by Daniele da Volterra for the corresponding paintings still in existence today. Although the sketches of Samson slaying the Philistine are not certainly done as models for Daniele da Volterra, they are included in this section because they are compositionally closely related to the David and Goliath sketches, which were certainly made for Daniele da Volterra.

207. *David slaying Goliath* (four small sketches). New York, Pierpont Morgan *179-182* Library. Black chalk, edges cut.
Fairfax Murray, *Selection from the Drawing of Old Masters*, London, 1904, nos. 32 a-d; Frey, *Handz.*, no. 76 a-d; Thode, *Kr.U.*, iii, no. 367 a; Berenson, *Drawings*, no. 1544 E; Goldscheider, nos. 106-107.
Pasted on backing sheets.

Fairfax Murray connects the sketches with the David and Goliath fresco on the Sistine Ceiling. Frey assumes that the drawings represent the battle of Samson and a Philistine and dates them end of the twenties—beginning of the thirties; according to him, the Oxford sketches of Samson and a Philistine are a further development. Thode rightly rejects Frey's assumptions concerning the subject and agrees with Murray that it is David slaying Goliath, but considers them late and made for Daniele da Volterra's painting in the Louvre. Goldscheider supposes that the sketches are directly developed out of the Oxford sketches, whereas they obviously precede them.

184, 185

The sequence of the drawings, which may originally have been on a single sheet which was later cut, seems to me different than that proposed by Murray, Frey and Thode. Using their designation, I would present the sequence, I (b), II (a), III (d) and IV (c).

179 I. H. 51 mm. W. 84 mm. This sketch is done only in outline.

180 II. H. 70 mm. W. 111 mm. Goliath is repeated at the right. The drawing is badly preserved and has been torn at the bottom.

181 III. H. 71 mm. W. 87 mm. This drawing is developed from No. II. The movement of the figures is almost identical; the modeling further elaborated.

182 IV. H. 49 mm. W. 66 mm. In this composition David is no longer seen from the back, as in I, II and III, but rather frontally. The two figures form a more compact mass, enclosed in a triangular silhouette. These features anticipate the Samson and a Philistine sketches in Oxford. While in the first three sketches the athletic figure of David still has the rhythmic outlines of the figures in the Last Judgment and the Conversion of Saul, the fourth sketch recalls the massive bodies of the Crucifixion of St. Peter. The sketches may therefore be dated around 1542-1545.

(Collections: Sir Joshua Reynolds; Breadalbane; Leighton; Fairfax Murray.)

186 208. *Two sketches for a St. John the Baptist in the Desert.* Oxford, Ashmolean Museum. Black chalk. H. 115 mm. W. 110 mm.

Robinson, no. 70 (3); Frey, *Handz.,* no. 280 b; Berenson, *Drawings,* no. 1572 B; Thode, *Kr.U.,* III, no. 444; *1953 London Exhibition,* no. 129; Parker, no. 338.

H. Voss, *J.d.p.K.,* 1913, pp. 301*ff,* and idem, *Die Spätrenaissance,* I, p. 131, has shown that the two sketches are for the seated St. John the Baptist, reaching down to fill a cup of water, which motif was used by Daniele da Volterra for a painting made for Giovanni della Casa (Vasari). This painting by Daniele exists in two versions,

190, 191 one in the Capitoline Gallery, Rome, and the other at the Bayerische Nationalgalerie, Munich.

There are two further sketches for the same figure on the recto and verso of a

188, 189 sheet in the Casa Buonarroti, along with sketches for the Tomb of Cecchino Bracci (Nos. 69, 70; Vol. III, Figs. 124, 125).

189 The earliest among these sketches seems to be that on the verso of the Casa Buonarroti sheet because of the position of the head, which is not yet inclined as in the

final version; then followed the recto sketch on the same sheet and finally the two *188*
Oxford sketches, in which the technique is freer. The year of Bracci's death, 1544, *186*
gives us the date of the Casa Buonarroti sketches. The Oxford sketches may have
been done shortly thereafter. Wilde assumes for them, however, the date 1550-1552
(*1953 London Exhibition*).

Recently the sheet of paper pasted on the back was removed at the initiative of *187*
Parker and two sketches (published here for the first time) for the legs of the same
figure came to light.

(Collections: Ottley; Lawrence; Woodburn.)

209. *Mercury bidding Aeneas leave the couch of Dido*. Haarlem, Teyler Museum. *192*
Black chalk. H. 135 mm. W. 180 mm. (On the verso. No. 215).

Marcuard, no. XVIII B; Berenson, *Drawings*, no. 1470; Thode, *Kr.U.*, III, no. 265;
Frey-Knapp, *Handz.*, no. 329; Wilde, *Belvedere*, 1927, pp. 142*ff*; idem, *Brit.Mus.Cat.*,
p. 114; Panofsky, *Rep.f.Kw.*, 1927, p. 49; Goldscheider, no. 185.

First was drawn on this sheet a system of frames probably for a wooden ceiling and
two profiles of cornices; then at the left an outstretched figure in the pose of a River
God or of a sarcophagal figure.

Wilde (1927) attributed the drawing to Daniele da Volterra, and recognized it as a
study for a picture by this artist, now in a Swedish private collection, mentioned by
Vasari, and representing Aeneas and Mercury. Berenson observed rightly that the
Haarlem drawing cannot be by Daniele "as it has all the dynamic ponderousness
of the aged Michelangelo." This is consequently a sketch made by Michelangelo
for his pupil Daniele. Wilde recently revised his opinion, now considering the draw-
ing as also being by Michelangelo.

According to Berenson, the sketch is about 1550. In our opinion, perhaps it is some-
what earlier, about 1545 (the time of the finishing of the first Pauline fresco). The
nude figure of Aeneas is stylistically close to the left soldier in the Conversion of Saul *58*
(legs are identical and the torso a reversed version of this figure).

The British Museum acquired recently a preparatory drawing by Daniele da Vol-
terra for his painting mentioned above in a Swedish private collection.

210. *Mercury bidding Aeneas leave the couch of Dido*. London, Collection of V. *193*
Bloch. Black chalk, rubbed. H. 100 mm. W. 75 mm. *1953 London Exhr.*, no. 130.

This is another version for the same composition as the preceding drawing. It was
probably made a little later than that in Haarlem since the putto was here originally
seen from behind (i.e. the pose of the Haarlem drawing) but was later transformed.

211. *Samson slaying the Philistine and Sketches for the Christ in the Cleansing* *183,241*
of the Temple. Oxford, Ashmolean Museum. Black chalk. H. 210 mm. W. 245 mm.
Robinson, no. 69; Berenson, *Drawings*, no. 1571; Frey, *Handz.*, no. 157; Colvin, I,

2, pl. 39; Thode, *Kr.U.*, III, no. 441; Brinckmann, *Zeichnungen*, no. 44; Tolnay, *Thieme-Becker*, p. 524; Baumgart, *Goldschmidt Festschrift*, 1933, pp. 134ff; Gold-scheider, no. 105; *1953 London Exhibition*, no. 102; Parker, no. 328.

241 The four light sketches for the Christ of the Cleansing of the Temple are on a separate sheet later pasted on to the L-shaped larger companion sheet. The connection with the composition of the Cleansing was first observed by Robinson. Christ is already shown here in frontal view but both of his legs are visible; this is probably

245, 246 an earlier stage than the frontal Christ in the British Museum drawings.

The Battle Group is found in seven versions and probably represents Samson slaying the Philistine. Michelangelo seems to have begun at top right, then drawn the sketch at top left, worked downwards with the two sketches in the center and, finally, made the two sketches at the bottom, the most developed and the most unified. They show a completely compact group enclosed in a triangle. The stocky proportions and the technique of the soft black chalk speak in favor of a date between 1550-1556. The date given to these sketches varied: 1525 (Brinckmann); late thirties (Robinson, Berenson, Parker, Frey, Thode); ca. 1556-1557 (Tolnay, 1927; the late date proposed here for the first time was accepted with small reservations by Baumgart, 1543-1544, and by Wilde [*1953 Exhibition*], 1550-1552.) We would now (1956) say that they

59 were made between 1550-1556, i.e. after the Crucifixion of St. Peter and before the

208 Oxford Annunciation.

The group has also been called Hercules and Cacus or Cain Killing Abel. Panofsky, *J.f.Kg.*, I, 1921-1922, *Buchbesprechung*, p. 6, observed a resemblance with a group of the Devil and Damned in the Hell of Signorelli in Orvieto and Goldscheider, p. 52, contends that there is a similarity with a woodcut by H. S. Beham representing Cain killing Abel. However, since the development from the earlier versions on the same sheet, which have no resemblance with Signorelli or Beham, can clearly be followed, there seems to be no direct connection with either. The figure of the victor is antici-

131 pated in the Ira group at the top right in the *Dream of Human Life*, London, Count A. Seilern Collection, as Thode has observed.

On the verso (Frey, no. 158), there is a man's left leg and an inscription, neither by Michelangelo. The verso was rejected also by Thode, Frey, and Parker; the latter attributes the leg hypothetically to Montelupo.

(Collections: Casa Buonarroti; Wicar; Lawrence; Woodburn.)

SKETCHES MADE PROBABLY FOR THE INTERIOR DECORATION
OF THE DOME OF ST. PETER'S, FROM CA. 1546

200, 198 212. *Cross-section for the dome and lantern of St. Peter's and sketches for figures.* Haarlem, Teyler Museum. Black chalk. H. 397 mm. W. 232 mm.

Marcuard, pl. XVI; Berenson, *Drawings*, no. 1469; Thode, *Kr.U.*, III, no. 264; Frey-Knapp, *Handz.*, no. 326; Panofsky, *Rep.f.Kw.*, 1927, pp. 45ff; Tolnay, *J.d.p.K.*, 1930,

pp. 8ff; and 1932, pp. 235ff; Körte, *J.d.p.K.*, 1932, pp. 90ff; Baumgart, *Goldschmidt Festschrift*, 1933, p. 131; Wittkower, *Z.f.Kg.*, 1933, pp. 348ff.

We are here concerned only with the figural sketches (the architectural sketches on this sheet will be treated in Vol. vi).

Formerly there was pasted onto the top right of this sheet a small sketch, probably for the Porta Pia, which was recently removed and there was brought to light a small rapid sketch of a nude seen from the back (only the legs and the lower section of the back are visible).

The sketches for the dome of St. Peter's have been dated by Körte and Wittkower ca. 1546, in the first phase of Michelangelo's work on this project, or ca. 1557, by Tolnay, i.e. in the final phase of this work. I am now (1956) inclined to accept the arguments for the earlier date (i.e. after M.'s letter of July 30, 1547).

First Michelangelo drew the figures on the verso and then he transferred two of them—the niche figure at left and the figure at bottom center—onto the recto. *201*

This latter, overlaid by the lantern sketch on the recto, is according to Baumgart (p. 31), a preparatory sketch for the youthful leader in the top right group in the Crucifixion of St. Peter; however, the pose is by no means identical. The figure sketch at the left of it is probably an Apostle. The figure overlaid by the right outline of the dome is, according to Baumgart (p. 32), perhaps a sketch for the youth at top center in the Crucifixion of St. Peter, but actually it is a reversed version of the Apostle at the left on the verso. *198* *200*

Although from the same period as the Crucifixion of St. Peter, the direct connection with the Pauline frescoes remains problematic and it seems that Marcuard's and Thode's suggestions that they are connected with the decoration of the interior of the dome at St. Peter's seem more probable. These would also fit with the program of the decoration of the dome as later executed by Zuccari.

213. *Plan for the lantern volutes of St. Peter's, seen from above, and six figure studies, several in niches.* Verso of the preceding drawing. Same specifications and literature except for Marcuard, now no. xvii, and Frey-Knapp, *Handz.*, now no. 327. *201*

The standing niche figures seem to represent Apostles, while the seated figure probably represents a Prophet. This latter recalls in its pose the Jeremiah of the Sistine Ceiling, but here the silhouette is more closed and the effect more monumental. The standing nude figures at the bottom left and right are in a pose which Michelangelo developed from his Christ in Santa Maria sopra Minerva. The object in his hand is perhaps an allusion to the Cross. The pose is further developed in the niche figure in the left center.

These seem to be, as Marcuard and Thode suggested, projects for two series of painted niche figures for the decoration of the interior of the dome of St. Peter's: a series consisting of Christ and the Apostles and a series of Prophets. The figure at bottom center seems to represent St. John the Evangelist. Baumgart holds that the

figure at the bottom left and right, which we associate with Christ, is connected with
59 the soldier beside the horse of the Captain at the top left of the fresco of the Cruci-
fixion of St. Peter, but again the resemblance is a rather casual one.

Beneath the seated Prophet there is the ground plan of the Tribune of St. Peter's.

199 214. *Sketch for a standing nude figure, probably an Apostle.* London, British
Museum. Black chalk. H. 170 mm. W. 55 mm.

Berenson, *Drawings*, no. 1532; Frey, *Handz.*, no. 291 a; Thode, *Kr.U.*, III, no. 360;
Wilde, *Brit.Mus.Cat.*, no. 74.

Michelangelo here probably used a motif of one of his early Apostles for the
Cathedral of Florence, which series of Apostles was commissioned in 1503 and from
which only the St. Matthew was hewn in the rough. (See Vol. I, pp. 168*ff*.)

Thode and Frey date the sketch in the period of the Last Judgment; Wilde dates
it around "the middle of the century." In my opinion, this sketch may be a project
for one of the painted Apostles for the decoration of the interior of the dome of St.
Peter's and is related to the Haarlem Apostle drawings, ca. 1547.

202 215. *Sketches for Apostles, probably for the decoration of the interior of the dome
of St. Peter's.* Haarlem, Teyler Museum. Black chalk. H. 180 mm. W. 138 mm. Verso
of No. 209.

Marcuard, no. XVIII A; Berenson, *Drawings*, no. 1470; Thode, *Kr.U.*, III, no. 265;
Frey-Knapp, *Handz.*, no. 328; Panofsky, *Rep.f.Kw.*, 1927, p. 49; Stechow, *J.d.p.K.*,
1928, p. 83 n. 3; Wilke, *Belvedere*, 1927, pp. 142*ff*; *idem, Brit.Mus.Cat.*, p. 114; Gold-
scheider, no. 123.

According to Wilde (1953), probably made by Michelangelo for Daniele da Vol-
terra's sculptures in San Pietro in Montorio (Venturi, *Storia*, x, Part 2, Fig. 158).
In 1927 (*Belvedere*, p. 144) Wilde attributed the drawing to Daniele da Volterra.
According to Panofsky and Stechow, by Daniele for the central Apostle figure in his
Assumption of the Virgin in Santissima Trinità dei Monti.

The upper section of the figure is repeated at the left when turning the sheet to
the left. An architectural sketch and the torso of a seated nude are beneath the main
sketch.

It seems probable that this drawing is a project of one of the painted niche figures
of the interior of the dome at St. Peter's and thus belongs with the sketches on the
201 verso of the drawing in Haarlem for the dome of St. Peter's. Marcuard and later
Thode were the first to suggest the purpose of the drawing in connection with St.
Peter's; however, Berenson calls it a Prophet.

Berenson dates the sheet ca. 1550; Wilde (1953), ca. 1556. I would suppose 1547,
the period of his sketches for the decoration of the dome of St. Peter's.

216. *Two sketches of male figures; slight architectural scribbles.* Oxford, Ashmolean Museum. Black chalk. H. 202 mm. W. 120 mm. *194*

Robinson, no. 60 (3); Berenson, *Drawings*, no. 1569 (3); Thode, *Kr.U.*, III, no. 438; Wilde, *Brit.Mus. Cat.*, p. 114; *1953 London Exhibition*, no. 127 c; Parker, no. 336.

The poses of both sketches are, except for the positions of the head, similar to the so-called Evangelist of the Malcolm Epiphany, as pointed out by Berenson. The *248* position of the legs of the Evangelist are repeated from the left sketch, and the position of the upper part of the body is repeated from the right sketch. There are slight architectural sketches in the center and at the bottom right.

In my opinion, this drawing precedes the Oxford sketch, No. 218, and does not *196* succeed it as commonly supposed. These sketches and two others in Oxford and one *195* in the Gathorn-Hardy Collection seem to belong to a group of preparatory sketches *197* for the same project, as has been assumed since Robinson.

(Collections: Casa Buonarroti; Wicar; Lawrence; Woodburn.)

217. *Sketch for a walking male figure, in the same pose as in No. 216.* Oxford, *195* Ashmolean Museum. Black chalk. H. 205 mm. W. 125 mm.

Robinson, no. 60 (1); Berenson, *Drawings*, no. 1569 (1); Thode, *Kr.U.*, III, no. 436; Wilde, *Brit.Mus.Cat.*, p. 114; Goldscheider, no. 121; *1953 London Exhibition*, no. 127 A; Parker, no. 334.

In my opinion, this drawing was made following the left sketch on the Oxford *194* sheet (No. 216) and not before it, as has been generally assumed.

This sketch and two others in Oxford and one in the Gathorn-Hardy Collection seem to belong to a group of preparatory sketches for one and the same project, as has been assumed since Robinson. Among the different suggestions of Berenson relating the drawing with the Pauline frescoes, the Christ Expelling the Money-Changers, the Entombment, etc., that of the so-called Malcolm Epiphany seems to be the most *248* likely. This opinion is also shared by Wilde although it remains not completely convincing. Perhaps they are rather connected with the project of decorating the inside of the dome of St. Peter's with frescoes or mosaics showing the standing Apostles; the same project seems to be found on the verso of the Haarlem drawing for the dome of St. Peter's, ca. 1547.

The date suggested by Berenson and accepted also by Wilde is ca. 1550, just after the Pauline frescoes.

(Collections: Casa Buonarroti; Wicar; Lawrence; Woodburn.)

218. *Sketch of an advancing male nude.* Oxford, Ashmolean Museum, Black chalk. *196* H. 181 mm. W. 87 mm.

Robinson, no. 60 (2); Berenson, *Drawings*, no. 1569 (2); Thode, *Kr.U.*, III, no. 437; *1953 London Exhibition*, no. 127 B; Parker, no. 335.

The pose resembles that of the large figure in No. 216. The weakness of the outline *194*

194　does not permit one to accept the drawing without reservations. If orginal, it would be a preparatory sketch for No. 216.

(Collections: Casa Buonarroti; Wicar; Lawrence; Woodburn.)

197　219. *Advancing nude.* Newbury, Collection G. M. Gathorn-Hardy, Esq. Black chalk. H. 230 mm. W. 100 mm.

Berenson, *Drawings*, no. 1544 B; *1953 London Exhibition*, no. 128.

194, 195　The motif is, as Berenson observed, close to two Oxford sheets, Nos. 218, 219. This drawing is, however, of less quality. Since the figure here is nude while those in the Oxford sheets are clothed, we must presume that the present sheet is somewhat earlier. These three sketches are, perhaps, preparatory drawings for the project of decorating the inside of the dome of St. Peter's, ca. 1547. Berenson tentatively connects them with *58*　the nude of the right upper corner of the Conversion of Saul.

DRAWINGS FOR THE LATE ANNUNCIATIONS AND FOR A CHRIST
TAKING LEAVE OF HIS MOTHER

203　220. *Virgin for the Annunciation.* London, British Museum. Black chalk, partly rubbed. H. 348 mm. W. 224 mm.

Berenson, *Drawings*, no. 1519; d'Achiardi, *Sebastiano del Piombo*, p. 319; Frey, *Handz.*, no. 190; Thode, *Kr.U.*, III, no. 340; *Vasari Society*, I, II, 5; Panofsky, *Handz.*, no. 19; Brinckmann, *Zeichnungen*, no. 78; Tolnay, *Thieme-Becker*, p. 524; Baumgart, *Bolletino d'Arte*, 1934-1935, p. 346; idem, *Goldschmidt Festschrift*, 1933, p. 136; Dussler, *Sebastiano del Piombo*, Basel, 1942, p. 191, no. 216; Wilde, *Brit.Mus.Cat.*, no. 71r; Goldscheider, no. 122.

The sheet is cut along the right border and Thode has observed that the few lines at the right center may be the hand of the Angel just above the hand of the Virgin. Originally, the reading stand was lower and the Virgin's right arm rested on a book upon it; the whole figure of the Virgin was originally drawn further to the left, as can be seen in the outline of her right leg; also her head was drawn twice.

The authenticity of this sheet is doubted by Frey; d'Achiardi attributed it to Sebastiano del Piombo. All other scholars accept the drawing as genuine, dating it ca. 1547-1550.

The purpose of the drawing is unknown. Berenson and Brinckmann connect it with the Annunciation painted after Michelangelo's sketch by Marcello Venusti for San *314 to 316*　Giovanni in Laterano. Wilde relates it either to the Annunciation of the Cesi Chapel or the Annunciation of San Giovanni in Laterano (see Vasari, ed. Milanesi, VII, p. 272 *312, 313*　and, also, p. 575). But for the Cesi Chapel the composition seems to have followed another pattern with a floating angel descending from Heaven. The San Giovanni in Laterano copy by Venusti (still in existence) shows a composition which seems to reach back to an earlier *concetto* of Michelangelo, perhaps of the mid-thirties, i.e. about ten *315*　years before this drawing was made. (In the Uffizi there is preserved Marcello Venusti's

cartoon for his small copies, made after Michelangelo's lost sketches [Berenson, no 1644, Fig. 737].) It is not known who extended the commission to make the altar piece in San Giovanni in Laterano, nor do we know its date. But we may suppose that Marcello Venusti used an earlier sketch by Michelangelo and that the master returned to the subject later, making the London sketch perhaps without direct relation to the Lateran panel.

The hovering angel on the verso (Wilde, no. 72v) which according to Brinckmann *206* and Wilde was originally a part of the composition of No. 220, is of weaker execution and in different scale than the Virgin. Frey already doubted its authenticity. Baumgart, *Bollettino d'Arte*, 1934-1935, p. 346, ascribed it to Daniele da Volterra. Wilde considers it to be genuine.

A replica by Venusti of this or of the Cesi composition was in the possession of Michelangelo's garzone Francesco Urbino (Gotti I, pp. 334f).

221. *The Annunciation (cf. Cappella Cesi)*. London, British Museum. Black chalk. *204* H. 283 mm. W. 196 mm.

Berenson, *Drawings*, no. 1534; Frey, *Handz.*, no. 259; Thode, *Kr.U.*, III, no. 362; Brinckmann, *Zeichnungen*, no. 77; Panofsky, *Rep.f.Kw.*, 1927, p. 44; Baumgart, *Bollettino d'Arte*, 1934-1935, p. 346; Wilde, *Brit.Mus.Cat.*, no. 72r; Goldscheider, no. 126.

This study had been connected with the altarpiece of the Cappella Cesi in Santa Maria della Pace. Vasari (ed. Milanesi, VII, p. 272) describes this composition. The Cappella Cesi was built ca. 1524 for Agnolo Cesi by Ant. da Sangallo the younger. Around the middle of the century, Agnolo's brother, Cardinal Federigo Cesi, ordered erected in the Chapel the tombs of his Mother and brother Agnolo. He was a friend of Cavalieri, who asked Michelangelo to make a drawing for the altarpiece which was painted by Marcello Venusti (no longer in existence). There exist a small replica of this altar, also by Venusti, in the Galleria Corsini in Rome, and a large black-chalk *313* drawing (H. 382 W. 296 mm.) by the same artist, now in the Morgan Library in New *312* York. Berenson, no. 1696. This sheet has been attributed to Daniele da Volterra by Panofsky.

The quality of this sheet is somewhat inferior to the other Annunciation drawing No. 220. Its authenticity is questioned: according to Frey, doubtful; according to *203* Baumgart, by D. da Volterra, ca. 1560.

The left arm of the Virgin was originally raised higher; this was changed by Michelangelo in a *pentimento* and he then showed it holding her head veil.

The motif of the floating angel is influenced by Giovanni Pisano's Sibyls in the Pistoia pulpit, as Wilde (*Mitteilungen des Kunsthistorischen Instituts*, Florence, 1932, p. 61) pointed out.

On fol. 74r of the Cod. Vat. 3211 (Tolnay, *Cod.Vat.*, p. 204) there is the pen and *205* ink sketch of a right hand, holding a small book and, as Wilde (p. 112) pointed out,

the right hand of the Virgin of the Cesi Annunciation was painted from this study. On the basis of a draft of a letter on the verso of this same sheet, this sketch may be dated between April and July, 1547. Cf. No. 222.

205
222. *Sketch of a right hand holding a book.* Codex Vaticanus 3211, fol. 74r.
Frey, *Dicht.*, pp. 473*f*; Tolnay, *Cod.Vat.*, p. 204 (who published it for the first time); Wilde, *Brit.Mus.Cat.*, p. 112.

312, 313
Frey describes "flüchtige Federskizze, die schwer zu deuten ist: Hand (?) mit einem Buch." After we published this sketch (1927), Wilde noted that this is a preparatory sketch for the right hand of the Virgin in the Cesi Annunciation (see copy by Marcello Venusti in the Galleria Corsini, Rome). The sketch was probably made between April and July of 1547, the date of the draft of a letter on the verso.

207
223. *Sketch for an ascending figure.* London, British Museum. Black chalk, rubbed; tinged by pink offset. H. 102 mm. W. 60 mm.
Berenson, *Drawings*, no. 1510; Frey, *Handz.*, no. 279 b; Thode, *Kr.U.*, III, no. 331; Wilde, *Brit.Mus.Cat.*, no. 73.

The position of the arms was originally lower and was transformed in a *pentimento*. The first lightly sketched pose is reminiscent of that of the angel in the Lateran

314 to 316
Annunciation and may be, as Wilde assumes, a fragment of a sketch of an Annunciation made in connection with either the Lateran or the Cesi composition. Therefore it may be dated around 1547. The second version—the ascending figure with upraised arms—has been connected with the Last Judgment by Frey and Thode. But the drawing is probably from the time of the Pauline frescoes, and its purpose remains

58
unknown. Perhaps a project for one of the angel-genii in the sky of the Conversion of Saul.

210
224. *Christ taking leave of his Mother.* Cambridge, Fitzwilliam Museum. Black chalk. H. 270 mm. W. 160 mm.
Berenson, *Drawings*, no. 1396 A; Frey, *Handz.*, no. 77; Thode, *Kr.U.*, III, no. 367; *Vasari Society*, II, 12, no. 7; Tolnay, Vol. III, p. 198; Goldscheider, no. 119.

The left top corner has been completed with a piece of paper.

Berenson, followed by Frey, thought that this was a sketch for the *Noli me tangere* panel for the Marchese Davalos, of 1531. But the style of the drawing points to the late period, as rightly observed by Thode, who was also the first to give the appropriate title to these sketches.

These sketches were probably made for the large cartoon of Christ Taking Leave of His Mother ("Cristo che si parte dalla Madre," Gotti I, p. 357) which Michelangelo gave during his lifetime to Cavalieri (cf. Gotti II, pp. 155*f*; Thode, *Kr.U.*, II, p. 502). The cartoon is also mentioned with the above-quoted title in a letter by Daniele da Volterra to Vasari of March 17, 1564 (Gotti I, p. 357).

There are also two sketches of a left hand on this sheet, of which the upper is identical with the left hand of the Virgin under the Cross in the Crucifixion for Vittoria Colonna. A copy of this Virgin is in the Louvre. Although this would point *168, 172* to a date around 1540, it must be admitted that the style of the drawing fits better with the second half of the forties. It is possible that Michelangelo, according to his custom, used the same motif later.

225. *Sketches of two nude figures and studies for a left hand; the profile of a cornice.* *209*
Verso of the preceding drawing. Same specifications and literature except for Frey, *Handz.*, now no. 78.

Probably first projects for the composition on the recto of this sheet. The movements are still different. Thode, followed by Goldscheider, sees a relationship to the left figure in the "Epiphany" in London, but this connection remains problematic. *248*

SMALL COMPOSITIONAL SKETCHES OF CA. 1550-1555
USED BY MARCELLO VENUSTI: CHRIST IN GETHSEMANE
AND CHRIST CLEANSING THE TEMPLE

226. *Two sketches for Apostles for a Gethsemane composition.* Codex Vaticanus *235, 236*
3211, fols. 81v and 82v. Black chalk.

Frey, *Dicht.*, pp. 490*f*; Tolnay, *Cod.Vat.*, pp. 176*ff* (who published it for the first time).

Frey could not decipher the figures and thus overlooked their connection with the Gethsemane composition. It was Wilde who called my attention to this relationship in 1927. Frey describes fol. 81v, "Rohe Bleistifskizzen eines Fusses und einer nicht recht deutbaren Figur." Fol. 82v, "Einige unverständliche Bleistiftstriche."

These two sketches seem to precede the sketches of the Apostles in the Oxford sheet *237*
No. 227, because they are still connected with traditional poses of the Apostles in *320*
Gethsemane compositions. The outstretched figure has the motif of the river gods as
it appears, for example, in the latest Phaeton drawing of Michelangelo. The huddled *Vol. III, 153*
figure seen in frontal view, his head fallen forward on his folded hands, supported by
his knee, is a pose known in Gethsemane compositions since the late Middle Ages. *321*
This sketch anticipates the central figure of the Apostle in the Oxford sheet. *237*

227. *Sketches of sleeping Apostles for Christ in Gethsemane.* Oxford, Ashmolean *237*
Museum. Black chalk. H. 107 mm. W. 325 mm.

Robinson, no. 70 (2); Berenson, *Drawings*, no. 1572 A; Thode, *Kr.U.*, III, no. 443; Frey, *Handz.*, no. 240; *Vasari Society*, Second Series, IV, no. 5; Tolnay, *Cod.Vat.*, p. 177; Baumgart, *Goldschmidt Festschrift*, 1933, pp. 134*ff*; *1953 London Exhibition*, no. 81 B; Parker, no. 340.

There is a vertical scar in the paper, somewhat right of center. Inscription at

lower right margin by unknown hand. Nine figures of sleeping apostles and two figures rising (one seen from back) which are probably studies for the figure of Christ. At bottom, second from left is a kneeling figure in outline, which could also have been intended for the Christ.

 323 There is general agreement that all these sketches are for Christ in the Gethsemane composition, which was painted by Marcello Venusti (Rome, Galleria Doria; cf.
 322 Thode, *Kr.U.*, p. 462). The cartoon for this painting is in the Uffizi (230 F).

Berenson assumes the approximate date 1545; Tolnay, *Cod.Vat.*, ca. 1556; Baumgart, 1550-1554; Wilde, 1556-1560. We would now (1956) assign the date of the draw-
 218 ing for the Pietà Rondanini, Oxford ca. 1552 (No. 247).
 235, 236 Other similar sketches are in the Cod.Vat. 3211 (cf. Tolnay, *Cod.Vat.*, pp. 177*f*)
 238 and the British Museum (cf. Wilde, no. 79).

(Collections: Ottley; Lawrence, Woodburn.)

 238 228. *Two sketches probably for a sleeping Apostle.* London, British Museum. Black chalk. H. 66 mm. W. 101 mm.

Berenson, *Drawings*, no. 1511; Frey, *Handz.*, no. 279 a; Thode, *Kr.U.*, III, no. 332; Wilde, *Brit.Mus.Cat.*, no. 79.

Two sketches of a sleeping Apostle, seen from different angles, for a composition
 323 of Christ in Gethsemane, which was eventually painted by Marcello Venusti (Rome
 322 Galleria Doria). The cartoon for this painting is preserved in the Uffizi, no. 230 F. This drawing was connected by Berenson, Frey, and Thode with the Last Judgment, and Wilde related it more convincingly with the Gethsemane composition.
 235 Other similar sketches for a Gethsemane composition can be found in the Cod.Vat.
 236, 237 2311 (No. 226) and on a sheet in Oxford (No. 227). Finally, there is one sheet in the Albertina, Vienna, No. 229, dated by a later hand 1560, which also has been related to this group.

I proposed (*Cod.Vat.*, pp. 176*ff*) the date ca. 1556 for the later Gethsemane composition, a date which is accepted by Wilde, who assumes that these sketches were made between 1555-1560, 1555 being the approximate date of the autographs on the verso of the Vatican sketches.

For three of the Apostles in the Venusti painting no sketches by Michelangelo have survived.

 239 229. *Sketches for a seated sleeping figure, seen from the back.* Vienna, Albertina. Black chalk. H. 173 mm. W. 198 mm.

Berenson, *Drawings*, no. 1606; Thode, *Kr.U.*, III, no. 531; Brinckmann, *Zeichnungen*, no. 67; Stix, *Albertina Cat.*, III, no. 133; Wilde, *Brit.Mus.Cat.*, p. 118; Goldscheider, no. 83.

Berenson dates this sheet in the time of the Cavalieri drawings; Brinckmann and Stix associate it with the Last Judgment; Wilde holds that the sketches are for

Apostles of the late Gethsemane composition. Berenson finds that the top left sketch is the most "exquisite"; Stix considers all the sketches to be original except that at the top left; Wilde holds that only the sketches at the far left and at the far right are by the master. In our opinion, only the sketch at the extreme left representing a male nude (and which Berenson finds "scarcely Michelangelo's own") is genuine; all *240* the others seem to be copies by a pupil who transformed the male figure into a woman. Below the original sketch there is the following inscription, probably by the original owner of this sheet: "Micaelis Angeli manu Anno aetatis suae lxxxvij Roma' 1560, xxvij Martij." (Michelangelo was at that time actually eighty-five years old.) The position of the inscription indicates which sketch had in the sixteenth century been considered as the original. Another inscription in black chalk, also not by the master, in the left bottom corner was deciphered by Stix, *sub* no. 133.

Christ cleansing the Temple. London, British Museum. Three sheets, recto and *242-247* verso, all in black chalk.

230. (I) H. 148 mm. W. 276 mm.

Berenson, *Drawings*, no. 1515; Frey, *Handz.*, no. 254; Thode, *Kr.U.*, III, no. 323; *242* Tolnay, *Cod.Vat.*, p. 178 n. 1; Tolnay, *Thieme-Becker* (1930), p. 524; Baumgart, *Goldschmidt Festschrift*, 1933, pp. 134f; Wilde, *Brit.Mus.Cat.*, no. 76v.

In the sketch at the bottom, Christ is seen in side view, his back to the spectator. The two arches in the background signify the architecture of the Temple and are reminiscent of Quattrocento reliefs, e.g. those of Donatello in Padua, Santo. The fragmentary sketch in the upper left corner may have been drawn by Michelangelo somewhat later, since he used these figures at the left of the group in the final version. *246*

231. (II) Recto of I. Same specifications and same literature, except for Frey, *Handz.*, *245* now no. 253; Goldscheider, now no. 109.

There are two versions, one beside the other, of which Michelangelo probably made first the left sketch, where the idea of the revolving movement appears for the first time, and then he drew the right sketch, which is only a fragment.

232. (III) H. 139 mm. W. 167 mm. *243*

Berenson, *Drawings*, no. 1516; Frey, *Handz.*, no. 252 b; Thode, *Kr.U.*, III, no. 324; Tolnay, *Cod.Vat.*, p. 178 n. 1; Baumgart, *Goldschmidt Festschrift*, 1933, pp. 134f; Wilde, *Brit.Mus.Cat.*, no. 77v.

Sketches for the figure of Christ, partly in side view and partly in frontal view.

233. (IV) Recto of III. Much rubbed and badly preserved. Same specifications and *244* literature except for Frey, *Handz.*, now no. 252 a; Wilde, *Brit.Mus.Cat.*, no. 77r; Goldscheider, no. 108.

This sketch was probably made after II, since it is closer to the final version, cf. at

[211]

the left the kneeling figure with the cauldron, and also the crouched figure at the right. The outlines of the table are not drawn through the figure seen from the back, which also speaks for a slightly later execution than II. The simplified outlines in this sketch also seem to speak in favor of this chronology.

234. (v) H. 178 mm. W. 373 mm.

247 Berenson, *Drawings*, no. 1517v; Frey, *Handz.*, no. 256; Thode, *Kr.U.*, III, no. 322v; Tolnay, *Thieme-Becker*, p. 524; Wilde, *Mitteilungen des Kunsthistorischen Instituts*, Florence, 1932, p. 50; Tolnay, *Michel-Ange*, p. 93; Wilde, *Brit.Mus.Cat.*, no. 78v.

242 In the left top corner, there is a fragment of the composition of which another fragment is at the right top of I; in the center, two versions of the figure of Christ; at the top right edge, a seated figure of high quality, probably of an Apostle for a Gethsemane composition. (This latter figure has not so far been related to the Gethsemane composition.)

246 235. (VI) Recto of v. Final version. Same specifications and literature except for Frey, *Handz.*, now no. 255, and Goldscheider, no. 110.

Drawn on five pieces of paper and a strip along the bottom, pasted together.

It seems that Michelangelo first drew the central group and then he completed this nucleus with four figures at the right and two at the left, these latter lightly sketched. The whole composition opens fanlike and has the silhouette of a segment of the arc of a circle; therefore I proposed in the text that it was intended to decorate a lunette, perhaps on the entrance wall of the Pauline Chapel. Before Michelangelo began the main sketch, he had already drawn rapidly a Christ on the sheet at the right.

The approximate order of execution of this series is, in our opinion, the following:

242, 243 first, Michelangelo made the sketches with Christ seen in side view, our I bottom, III, v
247 center. Within this group there are also two versions: either Christ's back, or his chest is visible.

242, 241 Christ in frontal view appears, probably for the first time in I, lower center. The whole composition, with the revolving movement and with Christ in frontal view

245, 244 in the center first appears in II. Then Michelangelo introduced, in IV, the crouching woman at the right and the kneeling figure with the cauldron at the left. Both motifs will be used by the artist in the final version. The woman to the left of Christ with

242 the fruit basket on her head appears in the top sketch of I, a fragment, and the
247 crouching woman at the right in the other fragment of this composition, on v. Both
246 motifs are incorporated into the final version.

244 In the final version, the central group is developed from IV; yet this is completed
242, 245 at the left with figures from I top sketch, and II left side (two figures at a small table)
244 and completed at the right with a figure carrying a sack, from IV, and with a kneeling figure holding a kind of water pot, which does not occur in any earlier version.

This series of drawings should probably be dated around or after Michelangelo's

Crucifixion of St. Peter in the Pauline Chapel, i.e. ca. 1550ff. The massive proportions of the figures and the composition itself are still close to the Pauline frescoes.

Frey assumes a date between the late thirties and the early forties; Berenson around 1545; Baumgart dates the group between 1543-1549 and sees a development from the principles of the Conversion of Saul to the Crucifixion of St. Peter. His order differs also somewhat from ours: Oxford drawing, then I, V, IV, II, VI.

Michelangelo follows rather closely Matt. 21: 12-13; see also Mark 11: 15 and John 2: 14-16.

The composition was eventually painted by Marcello Venusti in a small panel, in *317* London, National Gallery (Davies, *Nat.Gal.Cat., Italian School*, no. 1194). The final version served directly as a model for the figures of Venusti who, however, clothed them, following the prescriptions of the Council of Trent. He added an architectural background of which Wilde (p. 118) states that "we do not know the source." Yet the columns are inspired by the so-called Colonna Santa or Column of Solomon in St. Peter's and the upper section by the pendentifs of the vault in St. Peter's. So the Jewish Temple is identified with St. Peter's and this may be an allusion to the cleansing or inner reform of the Church. This observation would support Thode's hypothesis that the master's use of this subject can be traced to Michelangelo's conversations with Vittoria Colonna concerning the need for the inner reform of the Church. The fragment in Oxford (Berenson, *Drawings*, no. 1571; Frey, *Handz.*, no. *241* 157) also belongs to this group.

There exists a paraphrase of this composition by Francesco Bassano, Dresden, Gemäldegalerie (repr. Venturi, *Storia*, IX, part 4, p. 1289). The free paraphrases by *318, 319* Greco and Rembrandt are mentioned in the text.

DRAWINGS WITH LARGE FIGURES FROM THE FIFTIES: EPIFANIA, VIRGIN AND CHILD (WINDSOR), ST. JEROME

236. *Cartoon of an "Epiphany."* London, British Museum. Black chalk and char- *248-250* coal on yellowed paper, mounted on wood. The cartoon is made up of 25 folio sheets. H. 2327 mm. W. 1655 mm. Badly damaged; cut on both sides and on the top (see the copy by Condivi in the Casa Buonarroti). *333*

Berenson, *Drawings*, no. 1537; Thode, *Kr.U.*, III, no. 552; *Vasari Society*, X, 1915, no. 4, note by S. Colvin (who published it for the first time); Steinmann, *Bollettino d'Arte*, 1925, pp. 4ff; Tolnay, *Michel-Ange*, pp. 148f; Wilde, *Brit.Mus.Cat.*, no. 75; Goldscheider, no. 118.

The authenticity of this cartoon is proven by three early references immediately after the death of Michelangelo: first, in the inventory of Michelangelo's belongings, February 19, 1564—"un altro cartone grando, dove sono designate et schizzate tre figure grande et dui putti" (Gotti II, p. 151); secondly, in a letter by Daniele da Volterra to Leonardo Buonarroti, March 17, 1564—"l'altro [cartone] quello che dipigneva

Ascanio, se ve ne ricorda" (Gotti I, p. 357); lastly, in the postscript (atto di consegna) to the above-mentioned inventory of April 21, 1564—". . . altero magno [*scil.* cartoon] in quo sunt designate tres figure magne et duo pueri, nuncupato Epifania . . ." (Gotti II, p. 156).

The first to identify the cartoon with these documents and with a reference of Vasari, who also mentions a copy made by Ascanio Condivi (1568, ed. Milanesi, VII, pp. 274f), was Jean Paul Richter, *Art Journal*, 1897, p. 152.

According to Wilde, the cartoon was "not worked over by any later hand." But it may be noted that the two bearded heads in the upper right corner and the two youthful heads in the upper left are of inferior quality. There seem to be also slight retouchings in the outlines of the main figures and in the fur cloak of the little St. John. The oval outline for another head, immediately to the left of the Virgin is recognizable. The above-quoted inventory of Michelangelo's belongings describes this cartoon as consisting of three large figures and two putti. In the postscript to this inventory, again only three large and two small figures (". . . tres figure magne et duo pueri . . .") are mentioned. The oldest documents thus describe only the five foreground figures. The main argument of Wilde, p. 116, that the other heads also are by Michelangelo is that Condivi left Rome for good probably in 1554. But since Condivi lived until 1574, it is possible that he added the heads in the background after 1564, date of the inventories.

There are *pentimenti* by Michelangelo in the Virgin's head, right arm, left foot, and in St. John's head and right arm.

The composition is called in the above-mentioned postscript to the inventory an "Epifania." Wilde calls it "some kind of a Sacra Conversazione." The most detailed discussion of the subject matter can be found in Thode, *Michelangelo*, III, 1912, pp. 702ff; and *idem, Kr.U.*, II, pp. 439ff. The figure of the young man at the left is, according to the inventory of the belongings of Fulvio Orsini made in 1600, "San Giuliano" (see P. de Nolhac, *G.d.B.A.*, 1884, p. 433, no. 58). Thode (*Kr.U.*, II, 439ff) calls this figure the Prophet Isaiah who announces the coming of the Savior. According to Berenson, who is followed by Goldscheider, it is St. John the Evangelist.

The stylistic connection of this cartoon with the Pauline frescoes has been generally recognized, but whereas Goldscheider dates it about 1542, Berenson and Wilde place it more correctly around 1550. Wilde maintains that it was only in the years 1550-1553 that Vasari could have followed Ascanio Condivi in copying Michelangelo's cartoon because it was only in these years that Vasari was in Rome. Although these arguments are not decisive because of Vasari's stay in Rome from 1542 to 1546 (with a few interruptions), nevertheless on stylistic grounds we consider the date ca. 1550 the more likely.

333 The unfinished copy by Ascanio Condivi, a panel, is preserved in the Casa Buonarroti, Florence. It contains also the five heads which seem to have been added to the cartoon and it shows on the sides and the top the proportions of the original. Wilde

supposes Michelangelo's cooperation in the changing of the position of the arm of the little St. John in Condivi's panel; however, the execution of this arm is weak and so close to that of the rest of the panel that it can hardly be attributed to the master.

Berenson connects five sketches in Oxford with the so-called Isaiah. A further sketch  in the Gathorn-Hardy collection also belongs to this group. However, we connect these sketches with the decoration of the interior of the dome for St. Peter's. Wilde supposes that the sketch of a nude in the center of the Casa Buonarroti sheet, published in Tolnay (Vol. III, Fig. 125), should also be connected with the "Isaiah," and he dates this drawing in 1551 because of the sketches of staircases, which he connects with the staircases of the Vatican Belvedere (Wilde, p. 109). The form of the staircases also recalls, however, that of the Capitol, Palazzo dei Senatori (1546) and since there are also, on the same sheet, Michelangelo's projects for the tomb of Cecchino Bracci, who died in 1544, it is more likely that the sheet should be dated between 1544-1546 and not in 1551.

(Collections: Fulvio Orsini; Farnese; Cardinal Silvio Valenti [Vasari-Bottari, p. 168]; Luciano Bonaparte; Lawrence; Woodburn; Malcolm.)

237. *Virgin and Child*. Windsor Castle. Black chalk, partly over a preliminary  sketch in red chalk, rubbed in places. The background was gilded at a later date and, still later, this background was washed off. H. 225 mm. W. 194 mm.

Berenson, *Drawings*, no. 2505; Frey, *Handz.*, nos. 34, 35 b; Thode, *Kr.U.*, III, no. 550; d'Achiardi, *Seb.del Piombo*, p. 323; Tolnay, *Thieme-Becker*, p. 524; Baumgart, *Goldschmidt Festschrift*, 1933, p. 134; Dussler, *Seb.del Piombo*, 1942, p. 199; Pallucchini, *Seb.Viniziano*, 1944, pp. 83, 193; Wilde, *Windsor Cat.*, no. 435r.

If we turn the sheet to the right, there are some lines in Michelangelo's handwriting, the rough draft of a poem which has been deciphered by Frey, *Handz.*, p. 34, and Wilde, p. 259. The motif of the Child astride the Virgin's right knee, turning back to kiss his Mother reverts to an earlier type of Michelangelo which can be seen in several drawings (Albertina, Louvre, British Museum) and also in the Medici Virgin. 98, 99, 101

Berenson and d'Achiardi attributed the drawing to Sebastiano del Piombo, and the former proposed the date 1514-1515. Frey and Thode recognized this work as genuine and connected it with the Medici Virgin, dating it 1520-1530. Finally, the drawing was judged by Tolnay (1930) to be a late drawing by Michelangelo, ca. 1556-1560; this dating has been accepted by Dussler ("Alterswerk"), by Baumgart (who placed the drawing somewhat earlier, ca. 1548-1549) and by Wilde, who placed the work around 1545. Because of the stocky proportions and block-like closed silhouette, we would like to date the drawing in the fifties.

A copy by Venusti (whereabouts unknown) is reproduced by Duppa, *Life of Michelangelo*, London, 1807, p. 331, pointed out by Wilde (p. 259). In this copy the Virgin was placed in a room.

On the verso of this sheet there are twenty-eight lines of an unfinished poem by

the master, a transcription of which was given in Frey, *Dicht.*, xxxv, and corrected in Wilde, p. 259.

251 238. *St. Jerome.* Rotterdam, Boymans Museum. Black chalk. H. 258 mm. W. 190 mm.

Not yet mentioned in the literature; hitherto unpublished.

The drawing is in fragmentary state: there are tears at the right center margin and the upper left corner which have been mended by later additions. The sack at the right bottom of the drawing seems to have been done by another hand.

Marcello Venusti executed, in addition to the Annunciation, a second altarpiece for Santa Maria della Pace following Michelangelo's design. It represented a St. Jerome meditating and was formerly in the Mignanelli Chapel (cf. Baglione, *Le Vite*, Naples 1733, p. 19 and Steinmann, *P. Clemen Festschrift*, Bonn, 1926, pp. 420f). No doubt, it was for this composition that this drawing was made, the attribution of which to Michelangelo remains problematic. Rather it is probably a *modello* by Marcello Venusti, after a lost sketch by Michelangelo. The soft chiaroscuro corresponds to that of the
252 presentation sheets by the master for Vittoria Colonna.

The composition was engraved by Sebastiano da Reggio, dated 1557 (Nagler, *Monogrammisten*, iv, no. 4056); on this engraving Michelangelo is mentioned as inventor and Marcello Venusti as painter. There exist two other engravings after the same composition; one by Cherubino Alberti (1575) with landscape and another by an
253 anonymous Flemish master who also added a landscape. Rubens was inspired by this composition in his "St. Jerome," formerly in Sanssouci.

(Collection: Boguslao Jolles.)

211 239. *The Lamentation or Deposition.* Vienna, Albertina. Red chalk. H. 320 mm. W. 250 mm.

Berenson, *Drawings*, no. 2502; Thode, *Kr.U.*, iii, no. 521; Stix, *Albertina Cat.*, iii, no. 135; Dussler, *S. del Piombo*, p. 199, no. 251; Pallucchini, pp. 82, 180.

Berenson attributes the drawing to Sebastiano del Piombo. Thode sees in it a genuine drawing. The *Albertina Catalogue* (Stix) calls it a genuine sketch for the Pietà in the Cathedral in Florence. The attribution to Michelangelo is doubtful. The interlacing of the figures and their sinuous outlines are in the style of the Florentine Mannerists of ca. 1525-1535. However, the delicate *sfumato* is close to Michelangelo's drawings of ca. 1525-1530.

The inventory of Michelangelo's belongings mentions a cartoon of a Pietà with nine figures which is lost today. One may well ask whether the present composition is not connected with this lost cartoon.

It may also be mentioned that the manner in which the body of Christ is supported and presented to the beholder reminds us of the Pietà of Palestrina.

[216]

240. *Entombment of Christ*. Paris, Louvre. (Inv. no. 704v). Red chalk. H. 290 mm. 213
W. 180 mm.

Berenson, *Drawings*, no. 1584; Thode, *Kr.U.*, III, no. 473; Brinckmann, *Zeichnungen*, no. 65; Popp, *Belvedere*, 1925, p. 75; Panofsky, *Rep.f.Kw.*, 1927, p. 35.

According to Berenson and Brinckmann this sheet is genuine. According to Thode it is a study for the Deluge of the Sistine Ceiling which was not used by the artist. Brinckmann considers it to be from the period of the Last Judgment, and probably for the Fall of the Rebellious Angels. Popp attributed the drawing, more convincingly to Rosso and sees in it a sketch for one of the frescoes in Fontainebleau.

241. *Descent from the Cross*. Haarlem, Teyler Museum (A25). Red chalk. H. 261 214
mm. W. 185 mm.

Marcuard, pl. XIX; Berenson, *Drawings*, no. 2480; Thode, *Kr.U.*, III, no. 266; Frey-Knapp, *Handz.*, no. 330; Brinckmann, *Zeichnungen*, no. 89; Panofsky, *Rep.f.Kw.*, 1927, pp. 49*ff*; Stechow, *J.d.p.K.*, 1928, p. 92; Goldscheider, no. 89.

Preparatory sketch for a wax relief, a copy of which is in the Casa Buonarroti. This 215
sketch is, judging by its style, from ca. 1536-1540; it might have been made by Michelangelo for his pupil Daniele da Volterra when the latter was commissioned to execute the Descent from the Cross in Santa Trinità dei Monti (1541). The wax relief in the Casa Buonarroti is not completely identical with this sketch; the group of the Virgin, for example, differs. This wax model seems to be a copy. It is attributed by Panofsky, Wilde, and Stechow to Daniele da Volterra.

Berenson attributes this sheet to Sebastiano del Piombo; Dussler does not accept it as Sebastiano; Pallucchini attributes it to Michelangelo; Panofsky, Wilde 1927, and Stechow, to Daniele da Volterra, ca. 1540; Goldscheider to Michelangelo ca. 1533. The latter considers this drawing as a companion sheet to the "Three Crosses," London, British Museum (Goldscheider, no. 90), although the measurements are different. See also Wilde, *Brit.Mus.Cat.*, p. 65.

The numerous copies in different media are listed in Thode, *Kr.U.*, II, p. 284, and Morey, *Gli Oggetti di Avorio . . . del . . . Vaticano*, Princeton, 1937, pp. 43*f*.

On the verso in red chalk are copies of heads after Giotto's fresco in the Cappella Bardi in Santa Croce (identified by Wilde) and a woman bending forward. The verso is published by Marcuard, pl. XX; Wilde, *Belvedere*, 1927, p. 145 and Frey-Knapp, *Handz.*, no. 331. The copy after Giotto is certainly not by Michelangelo, the study of the woman is considered by Panofsky to be by Daniele da Volterra.

242. *The Descent from the Cross*. Oxford, Ashmolean Museum. Red chalk on pale 212
buff paper. H. 375 mm. W. 280 mm.

Robinson, no. 37; Berenson, *Drawings*, no. 2491; Colvin, I, 2, pl. 38; Frey, *Handz.*, no. 150; Thode, *Kr.U.*, III, no. 420; Brinckmann, *Zeichnungen*, no. 76; Goldscheider, no. 88; Dussler, *S. del Piombo*, p. 194; *1953 London Exhibition*, no. 95; Parker, no. 342.

This composition composed of eight or nine figures is according to Thode, *Kr.U.*, II, p. 499, a preparatory drawing for the cartoon of a Pietà with nine figures mentioned in the inventory of Michelangelo's belongings: "Un cartone grande, dove è designata una Pietà con nove figure non finite. . . ." Mentioned also in a letter of March 17, 1564, from Daniele da Volterra to Vasari (Gotti I, p. 357).

Parker observes that the drawing has been extensively reworked in red chalk and he believes that this fact accounts for its uneven and strange quality, also observed by other authors. However, the strange character can be detected also in the figures behind the Corpse, which were not reworked.

The drawing was accepted as genuine by Robinson, Thode, Brinckmann, Goldscheider, Wilde, and Parker. On the other hand, Wickhoff, *J.d.p.K.*, 1899, p. 202, and later Berenson attributed it to Sebastiano del Piombo, an attribution which also is not completely convincing. There is a kinship with the drawings of Rosso, but we prefer to leave the question open.

The date of the drawing has been differently assigned to various decades of the sixteenth century: Robinson and Berenson (2nd ed.), the second; Frey, the fourth; Thode, the fifth; Wilde (*1953 Exh.*), the sixth (or ca. 1555). Parker accepts with some reservations the last date.

Parker observes the close relationship of this sheet to the drawing of a Pietà or
211 Lamentation with eight figures in the Vienna Albertina, No. 240, which seems to be, however, earlier (about 1525-1530).

(Collections: Vivant-Denon; Lawrence; Woodburn.)

216 243. *Pietà*. Vienna, Albertina. Red and black chalk. H. 410 mm. W. 240 mm.
Berenson, *Drawings*, no. 2503; Thode, *Kr.U.*, III, no. 522; D'Achiardi, p. 327; Brinckmann, *Zeichnungen*, no. 70; Stix, *Albertina Cat.*, III, no. 134; Dussler, *Sebastiano del Piombo*, p. 198, no. 250; Pallucchini, *Sebastian Viniziano*, p. 180.

The drawing was first doubted by Morelli; nevertheless, Thode, Brinckmann, and Stix considered it genuine from the period of the Pietà Rondanini. Berenson, d'Achiardi, and Pallucchini attributed this sheet to Sebastiano del Piombo. Dussler rejected both of these attributions.

Only the motif is connected with Michelangelo's Pietà Rondanini; the proportions of the body, the forms of the face, hands, and the drapery, the soft modeling and the dull drawing of the lines seem not to be from the hand of Michelangelo. We agree with Dussler that also the attribution to Sebastiano is by no means certain.

DRAWINGS FOR A LAMENTATION (CA. 1547) AND FOR
AN ENTOMBMENT (THE PIETÀ RONDANINI) (CA. 1552)

217 244. *Lamentation of Christ*. Haarlem, Teyler Museum. Black chalk. H. app. 166 mm. (max. h. of the upper portion); W. app. 306 mm.
Recto of the succeeding drawing.

Berenson, *Drawings*, no. 1674; Frey-Knapp, *Handz.*, text to nos. 324-325; Panofsky, *Rep.f.Kw.*, 1927, pp. 43f (who published it for the first time).

Pasted together from two larger pieces of paper on the initiative of Panofsky (1927) and recently augmented by one more small fragment at the lower right. In this new fragment part of the posteriors of a kneeling figure, probably Mary Magdalene and a left leg can be seen.

The figure supporting Christ with the left arm is probably the Virgin. Speaking in favor of this interpretation is the following fact: the right arm of Christ is drawn twice, first close to his body and then raised and supported by the hand of the figure just mentioned, which should be the Virgin since it is she who traditionally holds his arm (cf. Giovanni da Milano, Lamentation, Florence, Uffizi). Nevertheless, Panofsky considers it probable that this figure is the young St. John citing as an analogy a fresco fragment from the sixteenth century in the Vicolo degli Alberighi, Florence. In my opinion, St. John would rather be the figure at the right of Christ and the two figures at the left would be the two Marys. *370*

This drawing, which I believe is genuine, was first described by Knapp (in Frey-Knapp) and first published by Panofsky, who dates the composition ca. 1547 because of analogies with the Christ Expelling the Money Changers and with the Annunciations. He says that this drawing anticipates the Pietà Rondanini sheet in Oxford (No. 247). Berenson rejects the drawing because he thinks its "touch is too wooly to be Michelangelo's own." Executed probably after 1550. *218*

245. *Three fragments of a sheet with studies of a nude youth.* Haarlem, Teyler *150* Museum. Soft black chalk. Verso of the preceding drawing, although fragments now bear no necessary relationship to one another. Same specifications and literature as for the recto except now Marcuard, pl. xv A; Steinmann, *Sixt.Kap.*, II, no. 76, Fig. 607; Thode, *Kr.U.*, III, no. 262; Frey-Knapp, *Handz.*, no. 324.

Berenson and Panofsky doubted the authenticity of the verso; Marcuard, Steinmann, Thode, and Knapp consider it to be original.

According to Marcuard (p. 17), this is a preparatory study for the Last Judgment; according to Steinmann, who is followed by Thode, it is a study made after Signorelli's "Anima dannata," which Michelangelo used at the right bottom of his Last Judgment. Panofsky supposes rather that the drawing comes from the period of the Pauline frescoes and not from that of the Last Judgment.

The drawing is somewhat different from the usual studies and is close in style to the study of the figure seen from the back in Haarlem. It probably should be dated *144* somewhat earlier than the Lamentation on the recto.

246. *Sketches for an Entombment and for the Pietà Rondanini.* Oxford, Ashmolean *218* Museum. Black chalk. H. 108 mm. W. 281 mm.

Robinson, no. 70 (1); Berenson, *Drawings*, no. 1572; Frey, *Handz.*, no. 239; Thode,

Kr.U., III, no. 442; *Vasari Society*, Second Series, IV, no. 4; Brinckmann, *Zeichnungen*, no. 80; Tolnay, *Burl.Mag.*, 1934, pp. 150*f*; Baumgart, *Goldschmidt Festschrift*, 1933, pp. 134*ff*; idem, *J.d.p.K.*, 1935, pp. 44*ff*; Goldscheider, no. 111; *1953 London Exhibition*, no. 81 A; Parker, no. 339; von Einem, *J.d.p.K.*, 1940, p. 77; D. Frey, *H. Kauffmann Festschrift*, 1956, pp. 208*ff*.

237 Vertical scar in paper, somewhat right of center. Parker assumes rightly, that the drawing originally formed part of the same sheet as the Gethsemane apostles. At far left, Michelangelo drew with few lines the head and one shoulder of the Virgin; near the left group, only in outline and in smaller size, the group is repeated.

The probable succession of the sketches has been established by Tolnay, *Burl.Mag.*, 1934, pp. 150*f*: first, Michelangelo drew in the center of the sheet the composition of an Entombment with three figures, which he repeated alongside it, somewhat larger. Then he drew the second sketch from the left, an Entombment with two figures, where the head and knees of Christ are in *contrapposto*; then followed the sketch at the far right where the head and the knees are bent in the same direction and where the head of the Virgin is drawn twice. Finally, the sketch at the extreme left where he held fast to the second version of the head of the Virgin and of the body of Christ. This succession has been accepted by von Einem and Dagobert Frey.

88 Three of the sketches are rightly connected, since Robinson, with the first version of the Rondanini marble Pietà, Milan, Castello Sforzesco. Only Karl Frey and Berenson refuse to admit this obvious connection.

The sketches have been dated by Robinson and Goldscheider as about 1541-1542; Brinckmann places it in the sixties; Tolnay (1934) assumed 1550-1556; Baumgart places the drawings in 1552-1553; Dagobert Frey proposes also the date of 1552.

219 247. *Sketch for the Nude Christ seen in profile; studies of a tabernacle and a staircase.* Lille, Palais des Beaux-Arts. Black chalk. H. 259 mm. W. 255 mm.

Von Geymüller, *Michelangelo B. als Architekt*, Munich, 1904, p. 39; Frey, *Handz.*, no. 170 b; Thode, *Kr.U.*, III, no. 274; Wittkower, *Z.f.Kg.*, 1933, p. 357.

(On the recto of this sheet there is the project for the dome of St. Peter's, which will be published in Vol. VI.)

Except for Frey who expresses slight doubt, this drawing is regarded, rightly we believe, as genuine.

The inscription in Michelangelo's hand in pen reads: "pasuino se [i] coppie di cacio e quaranta pere." Pasuino is obviously Pasquino, the muleteer who was messenger from 1556 to 1561 between Michelangelo in Rome and Cornelia, widow of Urbino, in Casteldurante. It is probably from 1555-1556 that the drawings were made. The date can also be determined from the sketch of the staircase which is, in our opinion, for the Ricetto of the Laurenziana, a project that concerned Michelangelo again at the end of 1555 (cf. his letter of September 28, 1555, in the Vatican Library).

In our opinion, the drawing of the figure was made after that of the tabernacle. Thode, on the contrary, thinks there was first the figure and then the tabernacle; but the overlapping of the lines speaks in favor of our sequence.

The purpose of the tabernacle with segment pediment, drawn with a ruler, is uncertain: according to Frey, perhaps a project for the tambour windows of St. Peter's. The small sketch of the staircase, as we said above, was certainly for the *Ricetto* and may be compared with the two small sketches which Michelangelo drew on the margin of his letter of September 28, 1555 (Panofsky, *Mh.f.Kw.*, 1922, pp. 262ff). The nude male figure seen in profile reminds one of the crucified Christ particularly in the position of the feet although his left arm is missing and the right one is bent behind his head. Thode suggests that perhaps this sketch might be a study for the Pietà Rondanini. The slender proportions would fit well those of the Christ of the Pietà Rondanini and at the same time this sketch would show that, after resuming work on this project, Michelangelo still let Christ's head hang down in profile and that it was only in the last phase that he transformed his head to the frontal position. This sketch seems to have been made after a wax model.

LATE CRUCIFIXION DRAWINGS

248. *Crucifixion.* Paris, Louvre (Inv. no. 842r). Black chalk. H. 241 mm. W. 132 mm. Fragment of a larger sheet.

Berenson, *Drawings*, no. 1598 A; Thode, *Kr.U.*, III, no. 503; Delacre, Fig. 168; Wilde, *Windsor Cat.*, p. 260, and *Brit.Mus.Cat.*, p. 120.

The drawing is classed in the Louvre as being from the school of Michelangelo but it is considered as a genuine drawing by all scholars who have discussed it recently. There are differences of opinion concerning the dating: Berenson assumes a date "earlier than any other [Crucifixion] done for . . . Vittoria Colonna," i.e. before 1540; Wilde dates this sheet ca. 1552-1557. In our opinion it is slightly earlier and of somewhat inferior quality to that of the Count Antoine Seilern Collection, London.

Many *pentimenti* in the outlines of the arms, of the body and of the Cross, drawn with a ruler.

The verso is a hitherto unpublished architectural design, perhaps a barrel vault seen in perspective, published here for the first time.

249. *Crucifixion with the Virgin and St. John.* Paris, Louvre (Inv. no. 700). Black chalk with white chalk corrections. H. 432 mm. W. 289 mm. White paper backing. Badly damaged.

Berenson, *Drawings*, no. 1583; Thode, *Kr.U.*, III, no. 471; Brinckmann, *Zeichnungen*, no. 74; Tolnay, *Cod.Vat.*, p. 199; idem, *Thieme-Becker*, p. 524; Baumgart, *Goldschmidt Festschrift*, 1933, pp. 134ff; Wittkower, *Burl.Mag.*, 1941, pp. 159f; Goldscheider, p. 58, Fig. 13; Wilde, *Brit.Mus.Cat.*, p. 125.

Several *pentimenti*, especially in the arms and hands of Christ, in the Cross drawn with a ruler as in the other sheets of this group, and in both figures beneath the Cross. Both Mary and St. John are looking down, slightly bent. It is an expression of humility in the face of the inevitable. The bowed head of St. John is foreshortened. An angel, holding a chalice to the height of the chest wound, is lightly sketched.

Besides the white chalk used by Michelangelo probably for the purpose of correction, there is also a thick white coloring on the garment of the Virgin and on the body of Christ which may be a later addition. The figures have suffered from water damage.

The ground is indicated by a few hatchings near the Virgin.

The drawing is generally accepted as belonging to the late group of Crucifixions (Berenson, Thode, Brinckmann, Tolnay, Baumgart, Wittkower, Goldscheider).

For the date of this work, see No. 256.

226 250. *Crucifixion with the Virgin and St. John*. Windsor Castle. Black chalk. H. 382 mm. W. 210 mm.

Berenson, *Drawings*, no. 1622; Frey, *Handz.*, no. 130; Thode, *Kr.U.*, III, no. 548; Tolnay, *Cod.Vat.*, pp. 201f; Baumgart, *Goldschmidt Festschrift*, 1933, pp. 134f; Wittkower, *Burl.Mag.*, 1941, pp. 159f; Wilde, *Windsor Cat.*, no. 436; Goldscheider, p. 58.

Margin cut at bottom (see the foot of St. John); paper backing.

Many *pentimenti* in Christ; beneath the final version, several earlier ones can be recognized: Christ's right arm was drawn in four or five different positions, higher each time, so that finally the arms of Christ no longer fit the crossarm, which is also drawn several times with a ruler. The two figures below the Cross are more finished than the Christ: Mary, with her arms crossed and her hand over her mouth, expresses muteness in grief; St. John's hands and facial expression seem that of a deaf man who, however, senses the roar of the storm about him.

For the date of this work, see No. 256.

225 251. *Crucifixion with the Virgin and St. John*. London, British Museum. Black chalk on yellowish paper. H. 410 mm. W. 285 mm.

Berenson, *Drawings*, no. 1529; Frey, *Handz.*, no. 127; Thode, *Kr.U.*, III, no. 356; Tolnay, *Cod.Vat.*, pp. 201f; Baumgart, *Goldschmidt Festschrift*, 1933, p. 135; Wittkower, *Burl.Mag.*, 1941, pp. 159f; Wilde, *Brit.Mus.Cat.*, no. 81.

The artist used white to cover the lines of the drawing which he wanted to alter; this white is partly oxidized.

Pentimenti in the bodies of all three figures. Christ's head bent forward, is seen foreshortened. His right hand is open, showing the palm, his left hand is closed. The right arm of the Virgin was originally at her side with her hand open and was then altered to cross her breast; the head was also drawn twice. The head and the upper part of the body of the St. John was also altered. Originally his head was placed higher

and turned more to the left. The cross was drawn with a ruler. There are diagonal hatchings in the background on both sides and horizontal hatchings above the cross. The ground is indicated as a hill.

For the date and purpose, see No. 256.

252. *Crucifixion with the Virgin and St. John.* Windsor Castle. Black chalk. H. 405 mm. W. 218 mm. 227

Berenson, *Drawings*, no. 1621; Frey, *Handz.*, no. 129; Thode, *Kr.U.*, III, no. 547; Brinckmann, *Zeichnungen*, no. 72r; Baumgart, *Goldschmidt Festschrift*, 1933, pp. 134f; Wittkower, *Burl.Mag.*, 1941, pp. 159f; Wilde, *Windsor Cat.*, no. 437r; Goldscheider, no. 128.

The margins of the drawing are cut.

Michelangelo seems to have drawn first the Christ and then only lightly sketched the Virgin and St. John, which figures he left unfinished. A third kneeling figure at the foot of the Cross, also barely sketched, is, according to Wilde, Mary Magdalene. Several versions of Christ, one on top of the other. The form of the Cross is that of the Croce dei Bianchi in Santa Croce, as seen in the Pietà for Vittoria Colonna. 340 The motif of the arms crossed over the breast here seem to have been transferred by Michelangelo from the Virgin to St. John; it occurs indeed earlier in the Virgin 225 of the Last Judgment. 4

For the date of this drawing, see No. 256.

253. *Outline of a marble block and a left leg.* Verso of the preceding drawing. 228 Same specifications and literature except for Frey, *Handz.*, now no. 220.

The block drawing so far has been ignored by scholars. The shape of it exactly fits the silhouette of Christ on the recto and was drawn against the light by Michelangelo. It is probably the shape of the marble block from which he intended to make this Crucifix. This observation explains the whole series of Crucifixion Drawings as projects for a marble group.

The left leg, seen in frontal view, is probably a study for the left leg of Christ and not as Wilde supposes (p. 260) for that of the St. John in the Louvre (Berenson, 224 *Drawings*, no. 1583), since the foot is not in a standing position as it would have to be for St. John.

254. *Crucifixion with two figures below the Cross.* Oxford, Ashmolean Museum. 229 Black chalk; some corrections in white chalk. H. 278 mm. W. 234 mm.

Robinson, no. 72; Berenson, *Drawings*, no. 1574; Thode, *Kr.U.*, III, no. 446; Frey, *Handz.*, no. 180; Tolnay, *Cod.Vat.*, p. 199; Baumgart, *Goldschmidt Festschrift*, 1933, pp. 134ff; Wittkower, *Burl.Mag.*, 1941, p. 159; Goldscheider, no. 125; *1953 London Exhibition*, no. 99; Parker, no. 343r.

(Watermark: two arrows crossed.)

The Cross was drawn twice with a ruler, the first version being lower than the final version. Several *pentimenti* in the figure of Christ, whose head was orginally turned further to the right; there are also *pentimenti* in his legs. In the two soldiers, Michelangelo used hatchings.

According to Robinson, Berenson, and Frey, the figure to the right would be the Virgin; to the left, St. John the Evangelist. Such a placing of the figures would be contrary to tradition which dictates that the Virgin shall stand to the right of Christ in a Crucifixion. On the other hand, Thode considers the figure on the right to be St. John and that on the left the Virgin, rendered in masculine form. According to Goldscheider, the figure on the left would represent St. Peter denying Christ and the figure on the right St. John. In our opinion, the figure on the right which has a long mantle corresponding to the garments of the soldiers in the Crucifixion of St. Peter could be Stephaton the centurion, and the figure on the left would be Longinus. If this hypothesis is right, Michelangelo would have followed the tradition of the Middle Ages when such a representation of the two soldiers below the Cross recurs often.

Robinson, Frey, Panofsky (*Handz.*, 1922, p. 12) related the group of Crucifixion drawings to the Crucifixion made by Michelangelo for Vittoria Colonna about 1540, but the Colonna Crucifixion is considerably earlier and differs in *concetto* from this group. It does not show the dead, but the living Christ (Condivi). Berenson and Tolnay (*Cod.Vat.*, p. 199) assume the date of 1545-1557; Wittkower agreed with this later date and tried from stylistic grounds and from Michelangelo's poems treating the same subject to fix the group as being from the year 1554.

In my opinion, all these late Crucifixions are for a projected second, marble group. Proof for this is the outline of a block (overlooked in the Windsor Catalogue) which 228 occurs on the verso of the Crucifix of the Windsor Sheet, our No. 253.

(Collections: Casa Buonarroti; Wicar; Lawrence; Woodburn.)

230 255. *Crucifixion.* Verso of the preceding drawing. Oxford, Ashmolean Museum. Black chalk. H. 278 mm. W. 234 mm.

Parker, no. 343v (who published it for the first time).

The drawing was uncovered in 1953 after the removal of the backing. It was, however, known in the mid nineteenth century as testified by a small sketch by Fisher in the margin of one copy of the Robinson Catalogue in the Ashmolean Museum, Oxford.

The sketch is almost identical with the Christ on the recto except for the position of the feet. In my opinion, it is not a preparatory study, but a fair copy made by Michelangelo himself shortly after the recto, since it shows no *pentimenti* and corrects the position of the legs. There are light horizontal construction lines on the chest.

231 256. *Crucifixion with the Virgin and St. John.* London, British Museum. Black chalk. H. 412 mm. W. 279 mm.

Berenson, *Drawings*, no. 1530; Frey, *Handz.*, no. 128; Thode, *Kr.U.*, III, no. 357; Panofsky, *Handz.*, no. 17; Brinckmann, *Zeichnungen*, no. 75; Tolnay, *Cod.Vat.*, pp. 201ff; Wittkower, *Burl.Mag.*, 1941, pp. 159f; Tolnay, *Michel-Ange*, p. 154; Wilde, *Brit.Mus.Cat.*, no. 82; Goldscheider, no. 129.

The paper in the left lower corner is a later addition. Michelangelo used white to cover those lines that he wanted to alter; this white is now partly oxidized.

The Cross is drawn twice with a ruler; originally the master planned to place it somewhat to the right and slightly lower. There are *pentimenti* in the head of Christ (originally higher and more to the right), in his right shoulder and arm and torso; the Virgin's body was narrowed down in a *pentimento*. The ground is indicated by a simple horizontal line, drawn with a ruler. The body of Christ is somewhat more completely executed than those of the two other figures. The right arm of St. John reaches round the back of the Cross and, as Wilde (p. 120) observes, his fingers are visible above the head of the Virgin.

This is probably the last in this series of seven drawings, as has been supposed by Berenson and this writer (1927). The drawings were made, as has been said above, with a view to a plastic execution in marble (cf. the Windsor sheet, Nos. 252-253). They probably are not, as Wilde (p. 121) assumes, mere presentation sheets.

The dates assigned to this group by different scholars vary considerably, between 1538 and 1557. The most likely date for this group would be ca. 1550 to 1556.

A copy of this drawing by Giulio Clovio is preserved in the Uffizi; he completed the composition with additional figures.

257. *Crucifixion*. London, Count Antoine Seilern Collection. Black chalk. H. 300 mm. W. 190 mm. *223*

Wittkower, *Burl.Mag.*, 1941, pp. 159f (who published it for the first time); Wilde, *Brit.Mus.Cat.*, p. 120.

This sheet belongs to the late group of Crucifixions.

Originally probably both arms (certainly the right) were drawn in a lower horizontal position and the crossbar—done with a ruler—was also lower. Other *pentimenti* are in the head, along the outlines of the body, and the legs of Christ. The left leg was originally turned slightly outwards. The whole figure was originally larger and Michelangelo reduced its mass to obtain more elongated proportions. The wonderful softness of the modeling is in this drawing well preserved.

The movement of the body of the Christ on the Cross as it can be found in other Crucifixions of the master—in *contrapposto* (early Crucifixion in Santo Spirito, Florence), the movement of a spiral ascending (Crucifixion for Vittoria Colonna), the movement of a spiral descending (Windsor sheet), the Gothic zigzag bending (Oxford sheet)—is replaced here by an axial mass, hanging heavily on the diagonal arms. The head falls directly forward. This immobile and passive type is prepared in the drawings in the Louvre and in the two British Museum sheets. Perhaps the Seilern

Vol. 1, 145
164
226, 229

224, 225, 231

Crucifixion is the latest of the group, as Wittkower assumes, and probably made around 1556.

A copy, possibly of an earlier version of this same composition is in the Louvre (Delacre, Fig. 167); a copy of the Seilern sheet is in Frankfurt am Main (Thode, *Kr.U.*, III, no. 250; Delacre, Fig. 170).

234 258. *Crucified Christ.* Codex Vaticanus 3211, fol. 100r. Black chalk.
Frey, *Dicht.*, p. 456; Tolnay, *Cod.Vat.*, pp. 198ff (who published it for the first time). Drawn with trembling hand.

Frey describes "flüchtige Bleistiftskizze des Gekreuzigten, von dem der Brief handelt (i.e. the letter on fol. 99v, published by Frey, *Dicht.*, Reg. 107). Auf dem Verso dieses Blattes, Brief Michelangelos an Cornelia, Witwe seines Dieners Urbino, 28 März 1557." Frey's conclusion that the drawing is related to the letter of ca. 1540 on the leaf (fol. 99v) that accidentally precedes it is erroneous. Rather the date of the letter on the back of this sheet (fol. 100) is the one which is important. In any event, March 28, 1557, provides a *terminus post quem* for the sketch, but Michelangelo could have made the scribbles a few years later since the letter remained a draft and was never posted. This sketch seems to be the latest surviving Crucifixion drawing by the master.

The Cross has the form of the *Croce dei Bianchi* in Santa Croce with its diagonally raised arms (cf. Condivi, p. 202); Christ's head falls onto his chest. The borrowing from Duecento painting suggests a possible source of the late style of Michelangelo.
324 Indeed, the forms here remind one of Berlinghieri's Crucifixion, Florence, now in the Uffizi.

233 259. *A rapid sketch for a Crucifixion.* Codex Vaticanus 3211, fol. 96v. Black chalk. Tolnay, *Cod.Vat.*, pp. 158ff. Hitherto unpublished.

A head inclined to the right, the upper chest and the upper parts of a crucified Christ, done in the same style as the preceding. Poem: Frey, *Dicht.*, CXIX. 232.

232 260. *A rapid sketch for a Crucifixion.* Codex Vaticanus 3211, fol. 95v. Black chalk. Frey, *Dicht.*, p. 486; Tolnay, *Cod.Vat.*, p. 158. Hitherto unpublished.

Frey describes, "Einige undeutbare Bleistiftstriche." In my opinion, the sketch represents the bent head of Christ on the Cross in the same scrawling style as the Crucifixion of fol. 100. Poem: Frey, *Dicht.*, CXLVI, of ca. 1552-1554.

175 261. *Studies of the chest and left arm of a male figure and of a left knee.* Oxford, Ashmolean Museum. Black chalk on bluish-gray paper. H. 252 mm. W. 161 mm. On the recto of the following drawing.
Robinson, no. 5; Berenson, *Drawings*, no. 1547; Frey, *Handz.*, no. 203; Thode, *Kr.U.*, III, no. 389; *1953 London Exhibition*, no. 120; Parker, no. 341v.

Inscription in Michelangelo's hand. There is a wide divergence of opinion concerning the date of this work: Robinson sees a connection of the recto studies and the knee of the verso to the marble David of 1501; Frey dates the drawing 1503-1506; Wilde (*1953 Exh.*) assumes a date between 1555-1560; also in our opinion this is a late drawing. Panofsky, *Z.f.b.K.*, 1927-1928, p. 243 n. 38, suggested hypothetically that the drawing might be by Mini and the inscription might have been copied by this artist.

(Collections: Casa Buonarroti; Wicar; Lawrence; Woodburn.)

262. *Studies for a Crucified Christ: Part of the chest and left shoulder and a right* 221
knee. Verso of the preceding drawing. Same specifications and literature except for Frey, *Handz.*, now no. 201 b.

Two studies, one above the other, for a Christ crucified and a study of a right knee. The latter is of higher quality than the remainder.

Robinson and Berenson connect the sketches hypothetically with the marble David. Frey dates the knee 1503-1506; the two other studies, inferior in quality, he does not accept as genuine. This is a late drawing, after 1550. According to Wilde (*1953 London Exhibition*), the sketches were made between 1555 and 1560.

LATEST PRESERVED DRAWINGS MADE AFTER 1556

263. *Portrait of a Child, possibly a son of Francesco Urbino.* Haarlem, Teyler *119*
Museum. Black chalk on greyish paper. H. 235 mm. W. 159 mm.

Not yet mentioned in the literature and reproduced here for the first time.

The upper corners completed with two pieces of paper.

The drawing was recently attributed to Michelangelo by J. Q. van Regteren-Altena, Amsterdam, who kindly drew my attention to it. The attribution is by no means certain. The drawing is, however, close to the late style of Michelangelo in the plastic treatment of the soft garment and head covering as well as in the quality of the chiaroscuro. We do not wish to commit ourselves concerning the attribution because of lack of comparative material.

Van Regteren-Altena supposes that this is the portrait of one of the sons of Francesco Urbino, Michelangelo's garzone, who was the father of two boys. We know that Michelangelo painted portraits of both, which were then acquired by Guidobaldo, Duke of Urbino. The portraits were painted after 1556, which year would be the approximate date of this drawing.

The story of these portraits is told in Thode, *Kr.U.*, II, p. 309f. Concerning Francesco Urbino, see Frey, *J.d.p.K.*, 1909, Bh., p. 144 note. Francesco Urbino is mentioned in connection with the Last Judgment as a *pittore*; in the last phase of the Tomb for Julius II, he is called in the documents *scultore*. In the Fabbrica di San Pietro, he is mentioned in the documents as *coadjutore architectorum*. He died December 3, 1555.

On the verso of this sheet there are three weak red chalk sketches of legs.

208 264. *Annunciation*. Oxford, Ashmolean Museum. Black chalk. H. 221 mm. W. 199 mm.

Robinson, no. 74; Berenson, *Drawings*, no. 1575; Colvin, I, 2, pl. 40 (b); Frey, *Handz.*, no. 140; Thode, *Kr.U.*, III, no. 448; Brinckmann, *Zeichnungen*, no. 79; Baumgart, *Goldschmidt Festschrift*, pp. 134ff; Goldscheider, no. 127; *1953 London Exhibition*, no. 108; Parker, no. 345.

Pasted on a sheet of backing paper. There is a fragment of a *ricordo* at top left, deciphered by Frey, *Handz.*, p. 67: "Dieci V [Scudi] al pictore per dio andro a pasquino per mandare a Chasteldurante legnie." In this *ricordo*, the muleteer Pasquino and the place Casteldurante are both mentioned. Cornelia, the widow of Michelangelo's servant Urbino, had been living at Casteldurante since 1556, and Pasquino was charged with carrying messages to and from Michelangelo. Therefore the *ricordo* is to be dated, as Frey assumes, between 1556 and 1561, when the messages ceased. This seems to be as well the date of the drawing. Parker assumes as the most probable date 1559-1560.

Both figures show many *pentimenti*. The Virgin was at first larger: the first version of her head was further to the left; her right leg was bent; her coiffure, a kind of diadem, still recalls the *teste divine*. The angel was walking in the first version; the left leg, with the foot on the ground, is lightly sketched. Michelangelo changed both legs into the position which suggests a movement of floating downward; he was prob-
311 ably inspired in this by the late Trecento Annunciations or Lorenzo Monaco's panel in the Accademia in Florence. See: Tolnay, *Michel-Ange*, p. 154f.

(Collections: Casa Buonarroti; Wicar; Lawrence; Woodburn.)

256 265. *Project for an Equestrian Monument of Henry II*. Amsterdam, Rijksmuseum. Black chalk; the lower part of the attica heightened with white chalk. H. 128 mm. descending to 124 mm. at the right. W. 120 mm. (Watermark: a clover.)

J. Q. van Regteren-Altena in *Vereeniging Rembrandt, Verslag over de Jaren, 1952-1953* (who published it for the first time).

After the death of Henry II in July, 1559, his widow, Catherine de' Medici directed Roberto Strozzi to have a bronze equestrian monument made by Michelangelo to honor her departed husband. She herself wrote to the master on November 14, 1559, concerning her wish (Gotti I, pp. 349ff). Michelangelo declined because of his age and suggested that the contract be delivered to Daniele da Volterra, whom the master would help with advice (Vasari, ed. Milanesi, VII, p. 66). For the history of this project, see also Gotti II, pp. 144ff, and Thode, *Kr.U.*, II, pp. 299ff. The connection of this drawing to the equestrian monument of Henry II was proposed by Wilde and van Regteren-Altena.

The drawing was certainly made after November 14, 1559 (first letter of Catherine de' Medici), but more probably after October 30, 1560, her second letter (Gotti, II, p. 146).

The pediment of the monument is partly done with ruler. Michelangelo developed its articulation into three fields with lateral niches and framed by Herma-pilasters from his first project of the lowest zone of the Tomb of Julius II. Furthermore, the *Vol.* IV, *95* horse is a variation of the antique type of walking horse in the statue of Marcus Aurelius, but more dynamic. Seated figures are at the short ends of Attic.

Daniele da Volterra died in 1566, after the horse for this monument had been cast in bronze (September 8, 1565). Daniele's heirs made an offer to the French ambassador to finish the horse and to execute the horseman, but it seems that nothing was done until 1586 when Henry III made a gift of the horse to Orazio Rucellai, who had it set up in his palace on the Corso in Rome. In 1639 this horse was used for the statue of Louis XIII erected by Cardinal Richelieu on the Place Royale in Paris. The statue was destroyed in 1793 (cf. Vasari, ed. Milanesi, VII, p. 68 note). The plaster cast of the horse by Daniele da Volterra was erected in the Chateau de Fontainebleau in the *Cour du Cheval Blanc*, named after this horse. The identification of the Cheval Blanc as the plaster horse by Daniele da Volterra was made by Adhémar, *G.d.B.A.*, 1949, pp. 297*ff.*

There exists an engraving by Antonio Tempesta of this monument, to which he 255 added a rider.

It may be mentioned here that Francis I had already shown eagerness to have an equestrian statue executed by the sculptor Rustici, who, however, died before finishing the great bronze statue.

Henry II had the same idea and a statue of this king "on horseback, armed, and victorious" was exhibited in 1559 in the courtyard of the Chateau of Oiron. It is also known that in 1558 Jodelle had painted this king on horseback at the Hôtel de Ville and a drawing in Chantilly, Musée Condé, representing Henry II on horseback, is supposed to be the preparatory drawing for this painting (Adhémar). The horse is here like that of the Marcus Aurelius at the Capitol but with elaborate trappings. The whole conception is, however, rather conventional. (Published in Adhémar, *French Drawing of the Sixteenth Century*, Lausanne, 1955, Plate 54.)

The drawing of Michelangelo, which was made after the death of the king for his widow, Catherine de' Medici, shows a quite different and original conception.

Ronsard wrote of the King's passion for horses and of his skillful horsemanship in his *Hymne de Henri II* (1555).

After the death of Henry II his successor, Charles IX, seems also to have been eager to have himself represented on horseback and a drawing by Caron, Chantilly (Adhémar, *op.cit.*, Plate 70), is supposed by Adhémar to be the project for a painting intended to replace the portrait of Henry II in the Cabinet des Empereurs.

This whole problem of equestrian statues of the French kings of the sixteenth century is surveyed in the book by Adhémar, mentioned above, pp. 128 and 132.

266. *Standing Virgin with the Child.* London, British Museum. Black chalk; some red-chalk stains, probably resulting from contact with a red-chalk drawing. H. 266 mm. W. 117 mm. Small strip of paper at top right corner and another at bottom right corner are later additions.

Berenson, *Drawings*, no. 1518; Frey, *Handz.*, no. 257; Thode, *Kr.U.*, III, no. 305; Brinckmann, *Zeichnungen*, no. 81; Tolnay, *Thieme-Becker*, p. 524; Baumgart, *Gold-schmidt Festschrift*, p. 135; Tolnay, *Michel-Ange*, p. 155; Wilde, *Brit.Mus.Cat.*, no. 83; Goldscheider, no. 130.

This is perhaps the latest of Michelangelo's preserved compositional drawings (see Tolnay, *Thieme-Becker*; Wilde agrees with this dating), done with the trembling hand of the aged master. The forms are no longer defined by closed, continuous out-lines and by precise modeling, but they are only generally suggested by short repeated lines and diagonal hatchings, which do not follow the roundings of the forms. By this approximate suggestion of the forms, the master evoked the lighted aura which seems to envelop the vision. At first Michelangelo drew the figure more in profile and somewhat more bent as can be seen in the lines at the left. The first version of the head is at the right and slightly above the final version. Then he narrowed down the outlines and drew the figure in a somewhat more frontal and seemingly more upright position. (This process of narrowing down was first described by Robinson in his Oxford catalogue.) There is a kind of belt about the waist of the Virgin, perhaps as a sling to support the Child's legs. Around her body there seems to float a trans-parent tunic. The technique of this sheet seems to be even freer and thus later than that of the late Crucifixion series. Instead of soft, parallel crosshatching, Michelangelo uses narrow zigzag lines which no longer always respect the outlines of the plastic forms; for instance, they overflow the contours of the left leg. The drawing is of highest quality in rendering the effect of the massive and yet spiritualized forms and of the inner light glowing through the half shadows. This effect of phosphorescence is achieved by leaving transitions so that areas in total light and areas in half shadow stand next to one another. In spite of the heaviness of the proportions of the body of the Virgin and of the athletic form of the Child, the ensemble is light and phantom-like as though it were empty within.

223-231

BIBLIOGRAPHICAL ABBREVIATIONS

Bartsch A. Bartsch, *Le Peintre Graveur*, Leipzig, 1870.

Baumgart-Biagetti. F. Baumgart and B. Biagetti, *Gli affreschi di Michelangelo e L. Sabbatini e F. Zuccari nella Cappella Paolina in Vaticano*, Vatican City, 1934.

Baumgart, *Goldschmidt Festschrift* F. Baumgart, "Eine Entwurfszeichnung Michelangelos zur Cappella Paolina," *Festschrift Adolph Goldschmidt 1933*, Berlin, 1935, pp. 131*ff*.

Baumgart, *J.d.p.K. 1935* F. Baumgart, "Die Pietà Rondanini," *J.d.p.K.*, 1935, pp. 44*ff*.

Baumgart, *Marburger Jahrb. 1937* F. Baumgart, "Die Jugendzeichnungen Michelangelos bis 1506," *Marburger Jahrbuch f. Kunstwissenschaft*, 1937, pp. 1*ff*.

Berenson, *Drawings* B. Berenson, *The Drawings of the Florentine Painters*, 2nd ed., Chicago, 1938.

Biagetti B. Biagetti, "Tecnica di esecuzione, stato di conservazione e restauri," in De Campos, 1944, pp. 75*ff*.

Brinckmann, *Zeichnungen* A. E. Brinckmann, *Michelangelo-Zeichnungen*, Munich, 1925.

Burl.Mag. Burlington Magazine.

Chapon L. Chapon, *Le Jugement dernier de Michel-Ange*, Paris, 1892.

V. Colonna Vittoria Colonna, *Rime e lettere*, Florence (Barbèra), 1860.

Colvin S. Colvin, *Drawings of the Old Masters in the University Galleries and in the Library of Christ Church, Oxford*, Oxford, 1907.

Condivi A. Condivi, *Vita di Michelagnolo Buonarroti*, Rome, 1553. Quoted from the edition: *Le vite di Michelangelo Buonarroti scritte da Giorgio Vasari e da Ascanio Condivi*, ed. K. Frey, Berlin, 1887.

Daelli G. Daelli, *Carte Michelangiolesche inedite*, Milan, 1865.

De Campos, 1944 D. Redig De Campos e B. Biagetti, *Il Giudizio universale di Michelangelo*, Vatican City, 1944.

De Campos, 1950 D. Redig De Campos, *Michelangelo. Affreschi della Cappella Paolina in Vaticano*, Milano [1950].

Delacre M. Delacre, *Le dessin de Michel-Ange*, Brussels, 1938.

Demonts, *Dessins* L. Demonts, *Musée du Louvre. Les dessins de Michel-Ange*, Paris [1922].

Dörken E. Dörken, *Geschichte des französischen Michelangelobildes*, Bochum [1936].

Dorez, *La Cour* Léon Dorez, *La Cour du Pape Paul III, d'après les Registres de la Trésorerie secrète*, Paris, 1932.

Dorez L. Dorez, "L'Achèvement de la Chapelle Sixtine," *Revue des Deux Mondes*, Paris, 1932, pp. 915*ff*.

Dvořák Max Dvořák, *Geschichte der Italienischen Kunst*, Munich, 1928.

v. Einem, *J.d.p.K.*, 1940 H. v. Einem, "Bemerkungen zur Florentiner Pietà Michelangelos," *J.d.p.K.*, 1940, pp. 77*ff*.

v. Einem, *Kunstchronik* H. v. Einem, "Michelangelos Jüngstes Gericht und die Bildtradition," *Kunstchronik*, 1955, pp. 89*ff.*

Esequie *Esequie del divin Michelagnolo Buonarroti*, Florence (Giunti), 1564.

Feldhusen R. Feldhusen, *Ikonologische Studien zu Michelangelos Jüngstem Gericht.* Hamburg, 1953 (unpublished thesis).

D. Frey D. Frey, "Die Pietà Rondanini und Rembrandts Drei Kreuze," *Kunstgeschichtliche Studien für Hans Kauffmann*, Berlin [1955], pp. 208*ff.*

Frey, *Briefe* K. Frey, *Sammlung ausgewählter Briefe an Michelagniolo Buonarroti*, Berlin, 1899.

Frey, *Dicht.* K. Frey, *Die Dichtungen des Michelagniolo Buonarroti*, Berlin, 1897.

Frey, *Handz.* K. Frey, *Die Handzeichnungen Michelagniolos Buonarroti*, 3 vols., Berlin, 1909-1911.

Frey-Knapp, *Handz.* F. Knapp, *Die Handzeichnungen Michelagniolos Buonarroti. Nachtrag*, Berlin, 1925.

Frey, *Q.u.F.* K. Frey, *Michelagniolo Buonarroti, Quellen und Forschungen*, Berlin, 1907.

Frey, *Studien 1909* K. Frey, "Studien zu M. B. und zur Kunst seiner Zeit," *J.d.p.K.*, 1909, *Beiheft*, pp. 137*ff.*

Friedländer W. Friedländer, *Caravaggio Studies*, Princeton, 1955, pp. 3*ff.*

G.d.B.A. *Gazette des Beaux-Arts.*

Gaye G. Gaye, *Carteggio inedito d'artisti dei secoli xiv, xv, xvi*, 3 vols., Florence, 1839-1840.

Gilio da Fabriano G. A. Gilio da Fabriano, *Due Dialogi di M. Giovanni Andrea Gilio da Fabriano*, Camerino, 1564.

Goldscheider L. Goldscheider, *Michelangelo Drawings*, London, 1951.

Gotti A. Gotti, *Vita di Michelangelo Buonarroti*, 2 vols., Florence, 1875.

Grünwald A. Grünwald, *Florentiner Studien, Prague, 1914.* Dresden, n.d.

Haendke B. Haendke, "Bemerkungen zu Michelangelos Jüngstem Gericht," *Kunstchronik*, N. F. xiv, 1902-1903, col. 57*ff.*

Hollanda, Francisco de Francisco de Hollanda, *Vier Gespräche über die Malerei*, ed. J. de Vasconcellos, Vienna, 1899.

Jacobsen-Ferri E. Jacobsen und P. N. Ferri, *Neuentdeckte Michelangelo-Zeichnungen in den Uffizien zu Florenz*, Leipzig, 1905.

J.d.A.K. *Jahrbuch der kunsthistorischen Sammlungen des Allerhöchsten Kaiserhauses*, Vienna.

J.d.Kh.Slg.Wien *Jahrbuch der Kunsthistorischen Sammlungen in Wien*, N.F.

J.d.p.K. *Jahrbuch der preussischen Kunstsammlungen*, Berlin.

Justi, *Ma.N.B.* C. Justi, *Michelangelo. Neue Beiträge*, Berlin, 1909.

Kallab Wolfgang Kallab, "Die Deutung von Michelangelos Jüngstem Gericht," *Beiträge zur Kunstgeschichte, Franz Wickoff gewidmet*, Vienna, 1903, pp. 138*ff.*

Kleiner G. Kleiner, *Die Begegnungen Michelangelos mit der Antike*, Berlin, 1950.

Lanckorónska, *Dawna Sztuka*, 1939 Carla Lanckorónska, "La Descente de Croix de Michel-Ange," *Dawna Sztuka*, 1939, pp. 111*ff*.

Lanckorónska, *Annales* Carla Lanckorónska, "Appunti sulla interpretazione del Giudizio Universale di Michelangelo," *Annales Institutorum*, 1932-1933, pp. 122*ff*.

Lomazzo, *Idea* P. Lomazzo, *Idea del tempio della pittura*, Milan, 1590.

Lomazzo, *Trattato* P. Lomazzo, *Trattato dell'arte de la pittura*, Milan, 1584. Quoted from the edition: Rome, 1844.

1953 London Exhibition Summary Catalogue of an Exhibition of Drawings by Michelangelo, Brit. Museum, 15 April to 28 June 1953 (A. E. Popham).

Magi F. Magi, "Nuovi aspetti Michelangioleschi della Paolina," *Ecclesia*, 1953, pp. 584*ff*.

Mâle E. Mâle, *L'Art Religieux après le Concile de Trente*, Paris, 1932.

Marcuard F. v. Marcuard, *Die Zeichnungen Michelangelos im Museum Teyler zu Haarlem*, Munich, 1901.

Mariani V. Mariani, *Gli affreschi di Michelangelo nella Cappella Paolina*, Rome, 1932.

Mercati Angelo Mercati, "I documenti Pontifici relativi al Giudizio di Michelangelo," in De Campos, 1944, pp. 167*ff*.

Mh.f.Kw. Monatshefte für Kunstwissenschaft.

Milanesi G. Milanesi, *Le lettere di Michelangelo Buonarroti*, Florence, 1875.

Milanesi, *Corr.* G. Milanesi, *Les Correspondants de Michel-Ange*, Paris, 1890.

Panofsky, *Bemerkungen* E. Panofsky, "Bemerkungen zu der Neuherausgabe der Haarlemer Michelangelo-Zeichnungen durch F. Knapp," *Rep.f.Kw.*, XLVIII, 1927, pp. 25*ff*.

Panofsky, *Bemerkungen zu D. Frey's Michelangelostudien* E. Panofsky, in *Wasmuths Monatshefte f. Baukunst*, 1920-1921, *Archiv*.

Panofsky, *Nachleben der Antike* E. Panofsky, note no. 858 on the book of Mariani, *op.cit.*, published in *Kulturwissenschaftliche Bibliographie zum Nachleben der Antike*, Leipzig, 1934.

Panofsky, *Pietà von Ubeda* E. Panofsky, in *Festschrift f. Julius von Schlosser*, Vienna, 1927, pp. 160*ff*.

Panofsky, *Handz.* E. Panofsky, *Die Handzeichnungen Michelangelos*, Leipzig, 1922.

Parker K. T. Parker, *Catalogue of the Collection of Drawings in the Ashmolean Museum*, Oxford, 1956.

Pastor L. von Pastor, *Geschichte der Päpste im Zeitalter der Renaissance*, vols. V, VI, VII, Freiburg i. B., 1909*ff*.

Pog. H. Pogatscher, *Dokumente zur Sixtinischen Kapelle*, Munich, 1905; published in Steinmann, II, pp. 687*ff*.

Rep.f.Kw. Repertorium für Kunstwissenschaft.

Robinson J. C. Robinson, *A Critical Account of the Drawings by Michel Angelo and Raffaello in the University Galleries, Oxford,* Oxford, 1870.

Sauer Fr. X. Kraus and H. Sauer, *Geschichte der Christlichen Kunst,* Freiburg, 1908, II, part 2, pp. 535*ff.*

Simmel E. Simmel, "Michelangelo" in *Logos, Internationale Zeitschrift f. Philosophie der Kultur,* II, 1910, pp. 207*ff.* Reprinted in *Philosophische Kultur,* Leipzig, 1911, pp. 157*ff.*

Steinmann-Wittkower E. Steinmann und R. Wittkower, *Michelangelo Bibliographie, 1510-1926,* Leipzig, 1927.

Steinmann, *Cartoni* E. Steinmann, "Cartoni di Michelangelo," *Bollettino d'Arte,* 1925, pp. 3*ff.*

Steinmann, *Portraitdarstellungen* E. Steinmann, *Die Portraitdarstellungen des Michelangelo,* Leipzig, 1913.

Steinmann, *Sixt.Kap.* E. Steinmann, *Die Sixtinische Kapelle,* 2 vols., Munich, 1901-1905.

Symonds J. A. Symonds, *The Life of Michelangelo Buonarroti* . . . , 2 vols., London, 1893. Quoted here from the third edition, London, 1901.

Thode, *Ma.* H. Thode, *Michelangelo und das Ende der Renaissance,* 3 vols., Berlin, 1902-1913.

Thode, *Kr.U.* H. Thode, *Michelangelo, Kritische Untersuchungen über seine Werke,* 3 vols., Berlin, 1908-1913.

Tolnay, *Arch.Buon.* C. de Tolnay, "Die Handzeichnungen Michelangelos im Archivio Buonarroti," *Münchner Jahrbuch für bildende Kunst,* v, 1928, pp. 450*ff.*

Tolnay, *Cod.Vat.* C. de Tolnay, "Die Handzeichnungen Michelangelos im Codex Vaticanus," *Rep.f.Kw.,* XLVIII, 1927, pp. 157*ff.*

Tolnay, *Thieme-Becker* Thieme-Becker, *Allgemeines Künstlerlexikon,* sub *Michelangelo,* 1930.

Tolnay, *Jugendwerke* C. de Tolnay, "Michelangelo Studien: Die Jugendwerke," *J.d.p.K.,* 1933, pp. 95*ff.*

Tolnay, *Burl.Mag.* 1934 C. de Tolnay, "The Rondanini Pietà," *Burlington Magazine,* 1934, pp. 146*ff.*

Tolnay, *Ill.Vat.* C. de Tolnay, "I disegni di A. da Sangallo per la Cappella Paolina," *Illustrazione Vaticana,* 1934, pp. 285*ff.*

Tolnay, *Jugement,* 1940 C. de Tolnay, "Le Jugement dernier de Michel-Ange," *Art Quarterly,* 1940, pp. 125*ff.*

Tolnay, *Werk u. Weltbild* C. de Tolnay, *Werk und Weltbild des Michelangelo,* Zurich, 1949.

Tolnay, *Michel-Ange* C. de Tolnay, *Michel-Ange,* Paris, 1951.

Vasari, *1550 and 1568* *Le Vite di Michelangelo Buonarroti scritte da Giorgio Vasari e da Ascanio Condivi,* ed. K. Frey, Berlin, 1887.

Vasari VII *Le opere di Giorgio Vasari,* ed. G. Milanesi, 9 vols., Florence, 1878.

Vasari, *Carteggio* *Il Carteggio di Giorgio Vasari*, ed. K. Frey, 3 vols., Munich, 1923*ff*.

Venturi, *Storia* A. Venturi, *Storia dell'arte italiana*, IX, part I; X, part II, Milan, 1925, 1936.

Venturi L. Venturi, "La critique d'art en Italie, II. Michel-Ange." *G.d.B.A.*, 1923, pp. 43*ff*.

Weise G. Weise, *Renaissance und Antike*, Tübingen, 1953.

Wilde, *Brit.Mus.Cat.* J. Wilde, *Italian Drawings in the Department of Prints and Drawings in the British Museum: Michelangelo and his Studio*, London, 1953.

Wilde, *Eine Studie* J. Wilde, "Eine Studie Michelangelos nach der Antike," *Mitteilungen des Kunsthistorischen Institutes in Florenz*, IV, 1932, pp. 41*ff*.

Wilde, *Graph.Künste*, 1936 J. Wilde, "Der ursprüngliche Plan Michelangelos zum Jüngsten Gericht," *Die graphischen Künste*, N.F., I, 1936, pp. 7*ff*.

Wilde, *Windsor Cat.* A. E. Popham and J. Wilde, *The Italian Drawings of the 15th and 16th centuries in the Collections of His Majesty the King at Windsor Castle*, London, [1949].

Wilde, *Zwei Modelle* J. Wilde, "Zwei Modelle M.'s für das Juliusgrabmal," in *J.d.Kh.Slg.Wien*, Vienna, 1928, pp. 199*ff*.

Wittkower R. Wittkower, "Newly Discovered Drawing by Michelangelo," *Burl.Mag.*, LXXVIII, 1, 1941, pp. 159*f*.

Worringer W. Worringer, "Die Pietà Rondanini," in *Kunst und Künstler*, VII, 1909, pp. 355*ff*.

Z.d.d.V.f.Kw. Zeitschrift des deutschen Vereins für Kunstwissenschaft.

Z.f.b.K. Zeitschrift für bildende Kunst.

Z.f.Kg. Zeitschrift für Kunstgeschichte.

ADDENDA

The following books and articles appeared after the present book had been paged and it was, therefore, no longer possible to refer to them:

André Chastel, *Art et Humanisme à Florence au temps de Laurent le Magnifique*, Paris, 1959.

Luitpold Dussler, *Die Zeichnungen des Michelangelo. Kritischer Katalog*, Berlin, 1959.

Herbert von Einem, *Michelangelo* (Urban Bücher), Stuttgart, 1959.

René Huyghe, "Formes, vie at pensée de la Renaissance," *La Table Ronde*, 1959, pp. 71*ff*.

Percy Ernst Schramm, *Sphaira, Globus, Reichsapfel*, Stuttgart, 1958.

Georg Weise, *Die Plastik der Renaissance und des Frühbarock im Nördlichen Spanien*, II (Die Romanisten), Tübingen, 1959.

Johannes Wilde, " 'Cartonetti' by Michelangelo," *Burl. Mag.*, 1959, pp. 369*ff*.

INDEX

INDEX

d'Achiardi, 180, 206, 215, 218

Ackerman, J., 128

Adhémar, J., 229

Agnello, 19, 20, 99 n. 5, 100 n. 6, 175

Agostino Veneto engraving after Andrea del Sarto, 63, 86, 132, 133 n. 25, 151 n. 5, Fig. 360

Alberti, L. B., 12, 16

Allori, Alessandro, 128 n. 82 (4), 179

Altenburg, Lindenau Museum, Fra Filippo Lippi panel, 165

Amatore, Francisco (called Urbino), 13, 21, 88, 97 n. 5, 99 n. 3, 103 n. 13, 119 n. 64, 136 n. 2, 143 n. 17, 149 n. 2, 207, 227

Ambrosio, Friar, 56

Ammannati, Bartolommeo, 9, 17

Amsterdam, Collection van Regteren-Altena, 182, Fig. 307

Amsterdam, Rijksmuseum, Sebastiano del Piombo drawing, 100 n. 7; Michelangelo drawing Equestrian monument, 228, Fig. 256; Conversion of Saul (attributed), Fig. 305

Anderson, Domenico, 119 n. 68

Andrea del Sarto, 63, 151 n. 5, Fig. 360

Fra Angelico, 27, 86, 183; Annunciation, 82; ceiling Cappella Brizio, 35; Entombment, 89; Last Judgment, 23, 24, 34, 109 n. 32b, 113 n. 38, Figs. 268, 275

Angiolini, Bartolomeo, 184

Anguissola Sophonisba, 170

Aretino, Bartolomeo, copy after Michelangelo drawing Crucifixion for V. Colonna, 198

Aretino, Pietro, 46, 114 n. 44, 119 n. 65, 67, 146 n. 24; letters to Michelangelo, 21, 45, 68, 123 n. 81

Arezzo, Casa Vasari, Copy (master anonymous) after Michelangelo Pietà for V. Colonna, 63, Fig. 351

Aristotle, 12, 36

d'Avalos, Francesco, 51

Avignon, Bibliothèque Municipale, copy after Michelangelo Christ on the Cross, 60, Fig. 338

Azara, 124 n. 81

Bacchiaca, 168, 169; Michelangelo influence on, 170

Baern, formerly Church of, Holy Trinity (now Utrecht, Archiepiscopal Museum), 90, 156 n. 17, Fig. 366

Baglione, 127 n. 82 (2), 216

Baltrusaïtis, 106 n. 29, 121 n. 74

Bandinelli, 167

Bandini, Francesco, 14, 17, 150 n. 2

Bari, 130 n. 9, 131 n. 10

Barocci, 77

Baron, 97 n. 2

Fra Bartolommeo, 109 n. 32b; The Last Judgment, fresco transferred to canvas, 23, 24, 113 n. 38, Fig. 269

Bartolommeo di Giovanni, drawing, Conversion of Saul, 71, 139-40 n. 9 passim, Fig. 297

Bartsch, A., 63, 74, 78, 86, 133 n. 25, 27, 138 n. 7, 142 n. 15

Baruzi, Jean, 57

Basel, Collection of Dr. J. Schmid-Paganini, Venusti (attributed) copy after Michelangelo Pietà for V. Colonna, 63, Fig. 348

Bassano, Francesco, paraphrase Christ Cleansing the Temple, 213

Bastianino, Last Judgment, 128, Fig. 289

Bataillon, M., 54

Baumgart, F., 89, 135-36 passim, 137 n. 46, 138 n. 7, 140 n. 10, 142 n. 15, 143 nn. 16, 17, 145 nn. 21, 23, 149 n. 2, 154 n. 14, 155 n. 15, 156 n. 18, 159, 162-63 passim, 191, 197-98 passim, 203, 206-7 passim, 209-11 passim, 213, 215, 220-23 passim, 228, 230

Bayonne, Musée Bonnat, Michelangelo drawings, No. 170, 24, 106, 182, 183, Fig. 132; No. 174, 27, 106 n. 27, 185, Fig. 138

Beatrizet, N., 61, 119 n. 62, 138 n. 7; engravings after Michelangelo, Annunciation, Fig. 316; Christ and the Samaritan Woman, 64, 133 n. 27, Fig. 335; Conversion of Saul, 74, 138, 142 n. 15, Fig. 300; Crucifixion of St. Peter, 145 n. 23; The Dream, 181f; Pietà for V. Colonna, 63, Fig. 341

Beccafumi, 77

Beham, H. S., 202

Belcari, Feo, 110 n. 32b

Bellini, Giovanni, 62

Bellini, Jacopo, 139 n. 9

Belloni, Francesco, 99 n. 3

Benesch, 122 n. 79

Berenson, B., 116 n. 52, 133 n. 34, 158-59 passim, 161-69 passim, 171, 173, 179-80 passim, 183-86 passim, 188-92 passim, 194-98 passim, 200-2 passim, 204-13 passim, 215-19 passim, 221-25 passim, 227-28 passim, 230

Berrettini, P., 153 n. 9, 155 n. 14

Bergamo, Accademia Carrara, Lorenzo Lotto, 65

Berlin, Kaiser Friedrich Museum, Masaccio predella, 74, 144 n. 18; Michelangelo copies, Bad Thief, 173; Pietà (silver pax) 63, Fig. 357; Cosimo Rosselli panel, 86; Rubens, Conversion of Saul, 139 n. 9, 142 n. 11

Berliner, R., 117 n. 57, 148

Berlinghieri Crucifixion, 226

Bernardy, A. A., 129 n. 1

Bernini, Gian Lorenzo, 150 n. 2, 152 n. 8

Bertini-Calosso, A., 112 n. 37, 114 n. 44, 120 n. 69

Bertoldo di Giovanni, 23, 113 n. 38; medallion Last Judgment, 25, 104 n. 20, 106 n. 27, 113, Fig. 276

Berulle, 122 n. 80

Beyer, H. W., 129 n. 1

Biagetti, B., 98 nn. 1, 2, 3, 103 n. 12, 128 n. 82 (2), 135 n. 2, 136 n. 2, 137 nn. 4, 6, 128 nn. 7, 8, 140 n. 10, 142 n. 15, 143 n. 16, 17, 145 nn. 21, 23, 191, 197, 198

Biagio da Cesena, 21, 46

Bigio, Nanni di Baccio, 8, 68; attacks against Michelangelo, 14

Bloch, V., Collection of, Michelangelo drawing No. 210, 201

Bode, 25, 104 n. 20, 106 n. 27, 113 n. 38

Boll, F., 120 n. 71

Bologna, Pinacoteca, Carracci, Conversion of Saul, 139 n. 9

da Bologna, Vitale, 104 n. 18

Bonasone, 60; copies after Michelangelo, Madonna del Silenzio, No. 196, 194, Fig. 309; Pietà for V. Colonna, 63, Fig. 340; Last Judgment, Fig. 260b

Borghini, Vincenzo, 16, 17, 97 n. 9

Borinski, 108 n. 32

Bosch, H., 116 n. 54

Boston, Isabella Stewart Gardner Museum, Michelangelo drawing Pietà for V. Colonna, No. 197, 61-63 passim, 132 n. 22, 193, 194, 223, Fig. 159

Botticelli, 36

Bramante, 3

WORKS (*continued*)
39, 41, 115, 116, 124, Fig. 9;
Resurrection of the Flesh, 36,
109, 116, 120 n. 70, Fig. 14;
"Choir of the Sibyls," 39, 115,
Fig. 8
historical place, 23, 24, 99 ff
"illuminating images," 111
interpretations, as eschatological
drama, 36 ff, 109 ff; as per-
sonal tragedy, 44 ff, 118 f;
as cosmologic religious vision,
46 ff, 120 ff
lighting, 31 f, 107 n. 30, 123 n.
81
literary sources, 107; Dante, 34,
36, 37, 41, 42, 44, 46, 47, 117
n. 54, 55, 121 n. 72, 123, 125
n. 81; Feo Belcari, *Rappre-
sentazione del di del Giudizio*,
110; *Dies Irae*, 108, 122; Bible,
33 f, 108-9 n. 32b, 116 n. 53,
117 n. 57, 118 n. 58, 120 nn. 70,
71, 138 n. 9
liturgy in relation to, 101
medallions, influence of, 25
mythical conception, *see* Mi-
chelangelo and classical an-
tiquity
overpaintings, later, 99
perspective, 30 f, 106 n. 29
poetry in connection with, 110 f
Rebellious Angels, *see* Rome,
Sistine Chapel
related works, Andrea Andreani,
woodcut, 121, Fig. 280; Fra
Bartolommeo, 23, 24, 113 n.
38, Fig. 269; Bastianino, 128,
Fig. 289; Bertoldo di Gio-
vanni, 25, 104, 106, 113, Fig.
276; Byzantine Last Judg-
ment, 19, 42, Fig. 260a; "Dal-
matica" of Charlemagne, 40,
41, 48, 115, Fig. 272; Dutch
Master, woodcut, Course of
Life, 121, Fig. 282; Sum-
moning of the Elect (16 Cent.
triptych), 40, 41, 115, Fig.
273; Florentine woodcut, 48,
116, Fig. 274; fresco (12
Cent.), 23, 109, Fig. 264; Ger-
man Master, book illumina-
tion, Wheel of Fortune, 48,
121, Fig. 279; Giotto, 23, 24,
42, 104 n. 18, 108, 117 n. 55,
Fig. 266; Giovanni Battista de'
Cavalieri, engraving, 127, Fig.
258; Giovanni di Paolo, 23,
27, 113 n. 38, Figs. 270-71;
Mantovano engraving (copy),
41, 117, Fig. 261, 98, Fig. 262;
Martinus Rota, engraving,
127, Fig. 259; Mosaic (12

Cent.), 23, 109, Fig. 264; Pe-
rino del Vaga, 128, Fig. 290;
Reverdino, Cesare, 25, Fig.
277; Roman panel (13 Cent.),
37, 48, 111, 120, Fig. 265; Si-
gnorelli, Charon, 42, 106, 117,
Figs. 285b, 286; Traini, 23,
104 n. 18, 111, 113 n. 38, Fig.
267; Tuscan Master, book il-
lumination, Wheel of For-
tune, 121, Fig. 278; Van-
quished Giants (antique mo-
saic), 118, Fig. 285a; Venus,
ancient statue, 38, 113, Fig.
283; Venusti (copy), 98, 127,
Fig. 257; woodcut (16 Cent.),
48, Fig. 282
style, 30 f, 105 n. 26, 125 n. 81
symbolism, *see* individual fig-
ures and groups
unveiling, 22, 112 n. 36, 135 n.
2
Wheel of Fortune, Wheel of
Life, 48 f, 121
window, Pope's chamber, 29,
Fig. 3

"Marchesa di Pescara," No. *148*,
see Michelangelo works, "Di-
vine Heads"
Medallions, Leone Leoni, Michel-
angelo medallion 12, Fig. 376;
three depicting Vittoria Colon-
na, 53, Fig. 374
Mercury and Aeneas, Nos. *209, 210*,
see Daniele da Volterra, paint-
ings from Michelangelo sketches
Pauline Chapel, 7, 9, 15;
appreciation of the frescoes, 145f
architecture and interior, San-
gallo (the younger) 70, 136
nn. 3, 4, 5, 137, Figs. 291-94
chronology, 70, 137
history of the frescoes, 135ff
program, choice of, 70, 135
Crucifixion of St. Peter, 26, 70,
74ff, 135-37, 187, 191f, Fig. 59;
analogies, 144-45 n. 21; car-
toon No. *236*, 16, 65-67 *passim*,
213, Figs. 248-50; colors, 76,
144 n. 20, 146 n. 24; composi-
tion, 75; condition, 143 n. 16;
copies, 145 n. 23; Giovanni
Battista de' Cavalieri, 143, 145,
Fig. 303; Michele Lucchese,
145, Fig. 302; Masters (anony-
mous), 144, 145, Figs. 301, 304;
details, group above the Cross,
75, 144, Fig. 70; group of
women, 75, 143, Fig. 74; head
of mounted soldier (possibly
self-portrait), 144, Fig. 75; old
man, 75, 144, Fig. 72; St. Peter,

76, 145, Fig. 68; drawings No.
70 (Vol. III), 145 n 22; No.
203, 143, 145 n. 22, 198, Fig.
178; history, 143 n. 17; style,
76; subject, 74f, 144 n. 18
Conversion of Saul, 71ff, 135,
137, 138, 189, Fig. 58; analo-
gies, 71, 141f n. 11; Angel-
genii, 138, Fig. 64; Biblical
source, 71, 138 n. 9; Christ, 71;
colors, 72, 138 n. 8, 140f n. 10;
composition, 71f; condition,
74, 138 n. 7; copies, 74, 142 n.
15, Figs. 299, 300; Michel-
angelo (attributed), drawing,
142, Fig. 305; head of horse
(first version), 73, 142, Fig. 66;
second version, 73, 142, Fig.
67; Saul, 73, 74, 138, 139, Fig.
61; subject, 71, 138-40 n. 9;
technique 138 n. 8
Pietàs, *see also* Entombment, De-
scent from the Cross, and La-
mentation
Florence Cathedral, 10, 86ff, 92,
106, 149, 151, 153, Figs. 77-83;
analogies, 151 n. 5; condition,
149 n. 1; copies, 151 n. 6, Fig.
373; history, 419 n. 2; subject,
150 n. 3; technique, 151 n. 4
Palestrina (attributed), 88, 106,
152, 153, 216, Figs. 84-87;
analogies, 153 n. 11, chro-
nology, 154 n. 12; condition,
152 n. 7; history, 153 n. 9;
subject, 153 n. 10
Rondanini, 8, 10, 15, 16, 65, 89-
92, 106, 154-57, 210, 219, 220,
Figs. 88-95; analogies, 156 n. 17;
condition and technique, 154
n. 13; copies, 157 n. 19; chro-
nology, 155 n. 15; *drawings*:
No. *243*, 218, Fig. 216; No.
244, 87, 218, Fig. 217; No.
246, 89ff, 152, 153, 155, 156,
159, 219f, Fig. 218; No. *247*,
220, Fig. 219
Ricetto of Laurenziana, 220
Risen Christ, Nos. *163-67*, *see*
Michelangelo works anticipating
Last Judgment
Rome, St. Peter's, dome projects
for interior decoration, No. *212*,
202 n. 47, Figs. 198, 200; No. *213*,
203, Fig. 201; No. *214*, 204, Fig.
199, No. *215*, Fig. 202
Samson slaying the Philistine, No.
211, *see* small compositional
sketches used by Daniele da
Volterra
Tityos, 145, 147, 175, 177, 179 (*see*
Vol. III)
Tomb of Julius II, 6, 8, 30, 162,

ILLUSTRATIONS

LIST OF ILLUSTRATIONS

THE LAST FRESCO OF THE CAPPELLA SISTINA

Folded Sheet. Full view of Michelangelo's Last Judgment.

THE LAST JUDGMENT: DETAILS

THE LAST JUDGMENT: DETAILS OF SINGLE FIGURES

68. Head of St. Peter.
69. Group of soldiers at the left back.
70. Group of figures at the center rear.
71. Group of soldiers at the lower left.
72. Upper body of the bearded old man at the lower right.
73. Group of figures at the right rear.
74. Group of women in right foreground.
75. Head of a mounted soldier in left rear. (Possibly a self-portrait of Michelangelo as a young man.)
76. View of Damascus in right background.

THE LAST SCULPTURES

THE PIETÀ OF THE FLORENCE CATHEDRAL

77. Frontal view.
78. Rear view.
79. Seen from right side.
80. Seen from left side.
81. Head of Joseph of Arimathea, in profile.
82. Head of Joseph of Arimathea, front view.
83. Heads of Christ and the Virgin.

THE PIETÀ OF PALESTRINA, FLORENCE, ACCADEMIA DELLE BELLE ARTI (attributed to Michelangelo)

84. Frontal view.
85. Seen from left side.
86. Heads of the Virgin and Christ.
87. The legs of Christ.

PIETÀ RONDANINI, MILAN, CASTELLO SFORZESCO

88. Frontal view.
89. Three-quarter view from the left.
90. Seen from left side.
91. Seen from the right side.
92. Heads of the Virgin and Christ, in frontal view.
93. Heads of the Virgin and Christ, seen in three-quarter view.
94. Head of Christ, seen in profile.
95. First version of the right hand of Christ.

EARLY DRAWINGS ANTICIPATING MOTIFS OF LATE WORKS

96. Two studies of the Virgin with the Child. Paris, Louvre (No. 138).
97. Madonna della Misericordia in a niche. Paris, Louvre (No. 139).
98. Virgin and Child. Vienna, Albertina (No. 141).
99. Sketches for a Virgin, with the Child. Paris, Louvre (No. 140).
100. Virgin with Child, in half-length. Florence, Casa Buonarroti (No. 142).
101. Holy Family and little St. John. London, British Museum (No. 143).
102. Virgin and Child. Windsor Castle, Royal Library (No. 237).
103. Standing Virgin with the Child. London, British Museum (No. 266).

"TESTE DIVINE" AND PORTRAITS OF THE EARLY AND MIDDLE
PERIODS, CA. 1506-1533

104. Head of a youth in profile, with fantastic helmet, and other sketches and in-scriptions. Hamburg, Kunsthalle (No. 145).
105. Head of a youth in profile, with elaborate helmet; and sketch of a head. Rotter-dam, Boymans Museum (No. 146).
106. Studies of heads with fantastic helmets. Paris, Louvre.
107. Florentine engraving of ca. 1480, heads with fantastic helmets. London, British Museum (After Hind).
108. Cleopatra. Florence, Casa Buonarroti (No. 151).
109. "Damned Soul." Florence, Uffizi (attributed to Michelangelo) (No. 150).
110. "Conte di Canossa." London, British Museum (No. 147).
111. "Marchesa di Pescara." London, British Museum (No. 148).
112. Half-length figure of a sibylline woman. Windsor Castle, Royal Library.
113. "Zenobia." Florence, Uffizi (No. 149).
114. Head of a young woman with turban-like headdress. Oxford, Ashmolean Museum (No. 152).
115. Half-length figure of a sibylline woman. London, British Museum.
116. Half-length figure of a young woman. London, British Museum.
117. Study of a young man's head in right profile. Oxford, Ashmolean Museum (No. 153).
118. Head of a youth (or of a girl?). Windsor Castle, Royal Library (No. 154).
119. Portrait of a child, possibly a son of Francesco Urbino. Haarlem, Teyler Museum (No. 263).

DRAWINGS ANTICIPATING THE LAST JUDGMENT

120. Study for a Pietà used by Sebastiano del Piombo in his Pietà in Ubeda. Paris, Louvre (No. 168).
121. Sketch of a figure with right arm raised to strike, probably a Fulminating Zeus. Florence, Casa Buonarroti (No. 159).
122. Unfinished study of a seated nude torso. Florence, Uffizi (No. 160).

123. Study of a slender, seated nude. London, British Museum (No. 161).
124. The Risen Christ. Florence, Casa Buonarroti (No. 163).
125. The Risen Christ. Florence, Casa Buonarroti (sub No. 163).
126. The Risen Christ. London, British Museum (No. 165).
127. The Risen Christ. Florence, Casa Buonarroti (sub No. 163).
128. The Risen Christ. Rotterdam, Boymans Museum (No. 164).
129. The Risen Christ. London, British Museum (No. 166).
130. The Risen Christ. Windsor Castle, Royal Library (No. 167).
131. The Dream. London, Count Antoine Seilern Collection (No. 169).

SKETCHES AND STUDIES FOR THE LAST JUDGMENT

132. Sketch for the Christ, Apostles, and Elect in the Last Judgment. Bayonne, Musée Bonnat (No. 170).
133. Sketch for the composition of the Last Judgment. Florence, Casa Buonarroti (No. 171).
134. Sketch for a Martyr, probably St. Lawrence, of the Last Judgment. Codex Vaticanus 3211, folio 88v (No. 177).
135. Sketch for one of the floating Elect of the Last Judgment. Codex Vaticanus 3211, folio 88v (No. 175).
136. Sketch for a struggling Damned Soul of the Last Judgment. Codex Vaticanus 3211, folio 93r (No. 176).
137. Sketch for the Christ-Judge and the group of Martyrs of the Last Judgment. Florence, Uffizi (No. 173).
138. Sketch for the Martyrs or Elect to the left of the Virgin in the Last Judgment. Bayonne, Musée Bonnat (No. 174).
139. Sketches and studies for the Martyrs and struggling Damned of the Last Judgment. London, British Museum (No. 178).
140. Sketches and studies for the Resurrection of the Dead of the Last Judgment. Windsor Castle, Royal Library (No. 180).
141. Studies for the Last Judgment (verso of Fig. 139) (No. 179).
142. Sketches and studies, mostly for the Resurrected of the Last Judgment (verso of Fig. 140). Windsor Castle, Royal Library (No. 181).
143. Studies for the Last Judgment (verso of Frey, *Handz.*, no. 15). Florence, Casa Buonarroti (No. 182).
144. Torso and legs of a standing male figure, seen from the rear (verso of Fig. 145). Haarlem. Teyler Museum (No. 184).
145. Study for the body and head of St. Lawrence in the Last Judgment (recto of Fig. 144). Haarlem, Teyler Museum (No. 183).
146. Study for one of the Resurrected of the Last Judgment. London, British Museum (No. 185).
147. Studies for the Last Judgment; a torso of one of the Resurrected, a right hand and a left arm (verso of Fig. 146). London, British Museum (No. 186).

148. Study for one of the Resurrected of the Last Judgment. Oxford, Ashmolean Museum (No. 187).

149. Study of the legs of a recumbent male figure (verso of Fig. 148). Oxford, Ashmolean Museum (No. 188).

150. Three fragments of a sheet with studies of a nude youth. Haarlem, Teyler Museum (No. 245).

151. Two figures from the Last Judgment, made by a pupil. Florence, Casa Buonarroti (No. 190).

152. A kneeling man digging a hole. London, British Museum (No. 189).

153. Studies for a flying Angel-genius and other figures (verso of Fig. 154). London, British Museum (No. 192).

154. Studies for a flying Angel-genius in the right lunette and for other figures of the Last Judgment (recto of Fig. 153). London, British Museum (No. 191).

155. Study of a left leg. Codex Vaticanus 3211, folio 93v (No. 193).

156. Study of a right knee. Codex Vaticanus 3211, folio 88r (No. 194).

157. Lower part of a left leg. Florence, Casa Buonarroti (No. 195).

DRAWINGS MADE FOR VITTORIA COLONNA AND RELATED DRAWINGS

158. Madonna del Silenzio. Collection of the Duke of Portland (No. 196).

159. Pietà for Vittoria Colonna. Boston, Isabella Stewart Gardner Museum (No. 197).

160. Sketch for a Crucifixion. London, British Museum (No. 155).

161. Sketch for the Torso of the Bad Thief. Florence, Casa Buonarroti (No. 156).

162. Four studies, two for a Christ on the Cross. Haarlem, Teyler Museum (No. 157).

163. Tracing of the Crucified Christ on the recto (Fig. 162), and profiles of cornices. Haarlem, Teyler Museum (No. 158).

164. Crucifixion for Vittoria Colonna. London, British Museum (No. 198).

165. Study of St. John the Evangelist under the Cross. Paris, Louvre (No. 201).

166. A Copy after the Study of St. John the Evangelist under the Cross. Paris, Louvre.

167. Sketch of a nude male figure in the pose of the Virgin of Fig. 168. Paris, Louvre (No. 200).

168. Study for a Virgin under the Cross (recto of Fig. 167). Paris, Louvre (No. 199).

169. Copy of the Virgin under the Cross of Fig. 168, probably done by Giulio Clovio. Paris, Louvre.

170. Block sketches for a Crucifixion with the Virgin and St. John. Florence, Archivio Buonarroti (cf. vol. IV, Fig. 174).

171. Engraving after a lost Golgotha composition of Michelangelo by Lafréry (dated 1568). Paris, Bibliothèque Nationale.

172. Marcello Venusti's copy after a lost Golgotha composition by Michelangelo. Rome, Galleria Doria.

173. Horseman seen from rear; Fortifications of Borgo. Florence, Uffizi (No. 202).
174. Sketch of a running nude figure, seen from the rear. (Detail from Fig. 143.) Florence, Casa Buonarroti.
175. Studies of the chest and left arm of a male figure and of a left knee. Oxford, Ashmolean Museum (No. 261).
176. Sketch of a left leg. San Marino, California, Huntington Library (No. 205).
177. Detail of the fresco of the Crucifixion of St. Peter in the Cappella Paolina.
178. Fragment of the cartoon for the Crucifixion of St. Peter of the Cappella Paolina. Naples, Galleria Nazionale di Capodimonte (No. 203).

SMALL COMPOSITIONAL SKETCHES OF CA. 1542-1550 USED BY
DANIELE DA VOLTERRA

179. David slaying Goliath. New York, Pierpont Morgan Library (No. 207, I).
180. David slaying Goliath. *ibidem* (No. 207, II).
181. David slaying Goliath. *ibidem* (No. 207, III).
182. David slaying Goliath. *ibidem* (No. 207, IV).
183. Samson slaying the Philistine and sketches for the Christ in the Cleansing of the Temple. Oxford, Ashmolean Museum (No. 211).
184. David and Goliath by Daniele da Volterra. Paris, Louvre.
185. David and Goliath by Daniele da Volterra. Paris, Louvre (the verso of the preceding panel).
186. Two sketches for a St. John the Baptist in the Desert. Oxford, Ashmolean Museum (No. 208).
187. Sketches for the legs of St. John the Baptist on the verso of Fig. 186. Oxford, Ashmolean Museum (*sub* No. 208).
188. Sketch for St. John the Baptist. Detail of No. 69, cf. Vol. III, Fig. 124. Florence, Casa Buonarroti.
189. Sketch for St. John the Baptist in the Desert. Detail of No. 70, cf. Vol. III, Fig. 125. Florence, Casa Buonarroti.
190. Daniele da Volterra, St. John the Baptist in the Desert, after Michelangelo. Rome, Musei Capitolini. (By courtesy of Prof. Emilio Lavagnino, Soprintendente alle Gallerie del Lazio.)
191. Daniele da Volterra, St. John the Baptist in the Desert, after Michelangelo. Munich, Bayerische Staatsgemäldesammlungen. (By courtesy of the Direction of these galleries.)
192. Mercury bidding Aeneas leave the couch of Dido. Haarlem, Teyler Museum (No. 209).
193. Mercury bidding Aeneas leave the couch of Dido. London, Collection Dr. V. Bloch (No. 210).
194. Two sketches of a male figure. Oxford, Ashmolean Museum (No. 216).

195. Sketch for a walking male figure. Oxford, Ashmolean Museum (No. 217).
196. Attributed to Michelangelo, Sketches of an advancing male nude. Oxford, Ashmolean Museum (No. 218).
197. Attributed to Michelangelo, Advancing male nude. England, Gathorne-Hardy Collection (No. 219).

SKETCHES PROBABLY MADE FOR THE INTERIOR DECORATION OF THE DOME OF ST. PETER'S

198. Cross-section for the dome and lantern of St. Peter's and sketches for figures. Haarlem, Teyler Museum (No. 212).
199. Sketch for a figure, probably an Apostle. London, British Museum (No. 214).
200. Cross-section for the dome and lantern of St. Peter's and sketches for figures, detail. Haarlem, Teyler Museum (No. 212).
201. Plan for the lantern volutes of St. Peter's, seen from above, and six figure studies, several in niches. Haarlem, Teyler Museum (No. 213).
202. Sketches for Apostles, probably for the decoration of the interior of the dome of St. Peter's. Haarlem, Teyler Museum (No. 215).

SKETCHES FOR THE LATE ANNUNCIATION COMPOSITIONS

203. The Virgin of the Annunciation. London, British Museum (No. 220).
204. The Annunciation. London, British Museum (No. 221).
205. Sketch of a right hand holding a book. Codex Vaticanus 3211, folio 74r (No. 222).
206. Sketches for an Angel of the Annunciation. London, British Museum (sub No. 220).
207. Sketch for an ascending figure. London, British Museum (No. 223).
208. Annunciation (ca. 1556-1557). Oxford, Ashmolean Museum (No. 264).
209. Christ taking leave of his Mother, preparatory sketches. Cambridge, Fitz-William Museum (No. 224).
210. Christ taking leave of his Mother (recto of Fig. 209). Cambridge, Fitz-William Museum (No. 224).

SKETCHES FOR AN ENTOMBMENT OF CHRIST

211. Attributed to Michelangelo and to Sebastiano del Piombo, Lamentation or Deposition. Vienna, Albertina (No. 239).
212. Attributed to Michelangelo, The Descent from the Cross. Oxford, Ashmolean Museum (No. 242).
213. Attributed to Michelangelo, Entombment of Christ. Paris, Louvre (No. 240).
214. The Descent from the Cross. Haarlem, Teyler Museum (No. 241).
215. The Descent from the Cross. Stucco Relief, Florence, Casa Buonarroti.

216. Attributed to Michelangelo, Pietà. Vienna, Albertina (No. 243).
217. Lamentation of Christ. Haarlem, Teyler Museum (No. 244).
218. Sketches for an Entombment and for the Pietà Rondanini. Oxford, Ashmolean Museum (No. 246).
219. Sketch for the Nude Christ seen in profile; studies of a tabernacle and a staircase. Lille, Palais des Beaux-Arts (No. 247).
220. Architectural study, probably for a barrel vault, in foreshortening (on the verso of Fig. 222). Paris, Louvre (*sub* No. 248).

LATE CRUCIFIXION DRAWINGS

221. Sketches from life for a Crucified Christ. Oxford, Ashmolean Museum (No. 262).
222. Crucifixion. Paris, Louvre (No. 248).
223. Crucifixion. London, Count Antoine Seilern Collection (No. 257).
224. Crucifixion with the Virgin and St. John. Paris, Louvre (No. 249).
225. Crucifixion with the Virgin and St. John. London, British Museum (No. 251).
226. Crucifixion with the Virgin and St. John. Windsor Castle (No. 250). (By gracious permission of H.R.M. the Queen of England.)
227. Crucifixion with the Virgin and St. John. Windsor Castle (No. 252). (By gracious permission of H.R.M. the Queen of England.)
228. Outline of a marble block and a left leg (on the verso of Fig. 227). Windsor Castle. (By gracious permission of H.R.M. the Queen of England.)
229. Crucifixion with two figures below the Cross. Oxford, Ashmolean Museum (No. 254).
230. Crucifixion (on the verso of Fig. 229). Oxford, Ashmolean Museum (No. 255).
231. Crucifixion with the Virgin and St. John. London, British Museum (No. 256).
232. A rapid sketch for a Crucifixion. Codex Vaticanus 3211, folio 95v (No. 260).
233. A rapid sketch for a Crucifixion. Codex Vaticanus 3211, folio 96v (No. 259).
234. Crucified Christ. Codex Vaticanus 3211, folio 100r (No. 258).

SKETCHES FOR CHRIST ON THE MOUNT OF OLIVES

235. Two sketches for Apostles for a Gethsemane Composition. Codex Vaticanus 3211, folio 82v (No. 226).
236. Sketch for a sleeping Apostle. Codex Vaticanus 3211, folio 81v (No. 226).
237. Sketches of sleeping Apostles for Christ in Gethsemane. Oxford, Ashmolean Museum (No. 227).
238. Two sketches probably for sleeping Apostles. London, British Museum (No. 228).
239. Sketches for seated sleeping figures, seen from the back. Vienna, Albertina (No. 229).
240. Sketch of a sleeping male figure seen from the back (detail of Fig. 239). Vienna, Albertina (No. 229).

241. Sketches for Christ cleansing the Temple. Oxford, Ashmolean Museum (No. 211).
242. Sketches for a composition of Christ cleansing the Temple. London, British Museum (No. 230).
243. Sketches for Christ cleansing the Temple. London, British Museum (No. 232).
244. Christ cleansing the Temple. London, British Museum (No. 233).
245. Christ cleansing the Temple. London, British Museum (No. 231).
246. Christ cleansing the Temple. London, British Museum (No. 235).
247. Sketches for Christ cleansing the Temple (verso of Fig. 256). London, British Museum (No. 234).
248. Cartoon of an "Epiphany." London, British Museum (No. 236).
249. Detail from the Cartoon of the "Epiphany": The Head of the Christ Child. London, British Museum (No. 236).
250. Detail from the Cartoon of the "Epiphany": The Head of the Infant St. John. London, British Museum (No. 236).

ST. JEROME COMPOSITIONS

251. Marcello Venusti, after Michelangelo, St. Jerome in the Desert. Rotterdam, Boymans Museum (No. 238).
252. Engraving, after Michelangelo's St. Jerome, by Sebastiano da Reggio (1557). Paris, Bibliothèque Nationale.
253. Anonymous engraving, after Michelangelo's St. Jerome. Paris, Bibliothèque Nationale.
254. St. Jerome. Paris, Louvre (No. 144).

THE EQUESTRIAN MONUMENT OF HENRY II OF FRANCE

255. Nicolaus van Aelst, Engraving after the project of the equestrian statue of Henry II. Paris, Bibliothèque Nationale.
256. Sketch for the equestrian monument of Henry II (1159-1160). Amsterdam, Rijks-Museum (No. 265).

RELATED WORKS

WORKS RELATED TO THE LAST JUDGMENT

257. Marcello Venusti, Copy of the Last Judgment of Michelangelo. Naples, Galleria Nazionale di Capodimonte.
258. Giovanni Baptista de' Cavalieri, Engraving after the Last Judgment of Michelangelo (1567). London, British Museum. (Heinecke, I, p. 399.)
259. Martinus Rota, Engraving after the Last Judgment of Michelangelo (1569). Paris, Bibliothèque Nationale.

260a. Byzantine Last Judgment. Paris, Bibl. Nat. MS gr. 74, folio 51v.

260b. Giulio Bonasone, Engraving after the Last Judgment of Michelangelo. Paris, Bibliothèque Nationale.

261. Giulio Mantovano, Detail from the Engraving after the Last Judgment of Michelangelo. Paris, Bibliothèque Nationale.

262. Giulio Mantovano, Detail from the Engraving after the Last Judgment of Michelangelo. Paris, Bibliothèque Nationale.

263. The Last Judgment. Mosaic from the twelfth century. Torcello, Duomo.

264. The Last Judgment. Fresco from the twelfth century. Sant' Angelo in Formis.

265. Roman Last Judgment. Panel from the mid thirteenth century. Vatican, Pinacoteca.

266. Giotto, The Last Judgment. Padua, Scrovegni Chapel.

267. Francesco Traini, The Last Judgment. Pisa, Campo Santo.

268. Fra Angelico, The Christ-Judge. Detail from the ceiling fresco. Orvieto, Cappella Brizio.

269. Fra Bartolommeo, The Last Judgment. Fresco transferred to canvas. Florence, Uffizi.

270 and 271. Giovanni di Paolo, Last Judgment. Siena, Pinacoteca.

272. The so-called Dalmatic of Charlemagne. The Summoning of the Elect. Vatican.

273. The Summoning of the Elect. From a sixteenth century Triptych of Mt. Sinai. Vatican, Pinacoteca.

274. Florentine woodcut from the end of the fifteenth century depicting the Last Judgment with the Zodiac. New York, Metropolitan Museum of Art.

275. Fra Angelico, Detail from the Last Judgment: the Christ-Judge in Glory with Interceding Virgin and St. John. Florence, Accademia.

276. Bertoldo di Giovanni, The Last Judgment. Reverse of a Medallion for Filippo de' Medici. Paris, Bibliothèque Nationale.

277. Cesare Reverdino, Engraving of a Last Judgment (ca. 1530). London, British Museum.

278. Tuscan Master of the late fourteenth century, book illumination representing the Wheel of Fortune. Florence, Biblioteca Nazionale.

279. German Master of ca. 1430, book illumination representing the Wheel of Fortune. Rome, Bibliotheca Casanatensis (Cod. 1404).

280. Andrea Andreani, Woodcut representing the Triumph of Death, after Giovanni Fortuna Fortunio (1588). Paris, Bibliothèque Nationale.

281. Dutch Master of the sixteenth century, Woodcut representing the Wheel of Life (1558), from the Book "Nedrl. Houtsneden, 1500-1550," pl. 291.

282. Dutch Master of the sixteenth century, Woodcut representing the Course of Life with Last Judgment (1558), from the Book "Nedrl. Houtsneden, 1500-1550," pl. 292.

283. Ancient statue of Venus and Amor from the Farnese Collection. Naples, Museo Nazionale.
284. Michelangelo, Detail from the Last Judgment: the Virgin.
285a. Vanquished Giants. Antique mosaic in a Roman villa. Piazza Armerina.
285b. Signorelli, Charon in his boat meeting the Damned. Orvieto, Cathedral, Cappella Brizio.
286. Signorelli, Detail from the fresco of the Damned: a flying Demon abducting a Damned Soul. Orvieto, Cathedral, Cappella Brizio.
287. Michelangelo, Detail from the Last Judgment: a flying Demon abducting a Damned Soul.
288. Michelangelo, Detail from the Last Judgment: a flying Demon abducting a Damned Soul.
289. Bastianino, Last Judgment. Ferrara, Cathedral, apse fresco (ca. 1580-1583).
290. Perino del Vaga, Project for the Decoration of the Base of the Last Judgment of Michelangelo. (The executed canvas is today in Rome in the Palazzo Spada). Florence, Uffizi (no. F 726r).

WORKS RELATED TO THE PAULINE CHAPEL

291. Antonio da Sangallo the Younger, Project for the architecture of the Pauline Chapel. Florence, Uffizi (no. A 1091).
292. Antonio da Sangallo the Younger, Project for the architecture of the Pauline Chapel. Florence, Uffizi (no. A 1125).
293. Antonio da Sangallo the Younger, Project for the windows and ceiling decoration of the Pauline Chapel. Florence, Uffizi (no. A 1234).
294. Antonio da Sangallo the Younger, Sketches for the cornice and the decoration of the Pauline Chapel. Florence, Uffizi (no. A 1258).
295. Benozzo Gozzoli, The Conversion of Saul. New York, Metropolitan Museum of Art. (By courtesy of the Metropolitan Museum of Art.)
296. Florentine Engraving of ca. 1460-1470. The Conversion of Saul. (After Hind, AII.10.)
297. Bartolommeo di Giovanni, The Conversion of Saul. Florence, Uffizi.
298. Francesco Salviati, The Conversion of Saul. Rome, Galleria Doria.
299. Unknown master, Copy after the Conversion of Saul by Michelangelo, with indications of the loincloths. Drawing, pen and ink and wash. Paris, Bibliothèque Nationale, Cabinet des Estampes.
300. Nicolas Beatrizet, Engraving after Michelangelo's Conversion of Saul. London, British Museum.
301. Giovanni dal Ponte, The Crucifixion of St. Peter. Florence, Uffizi.
302. Michele Lucchese, Etching after Michelangelo's Crucifixion of St. Peter. Paris, Bibliothèque Nationale.

303. Giovanni Batista de' Cavalieri, Engraving after Michelangelo's Crucifixion of St. Peter. Paris, Bibliothèque Nationale.

304. Unknown master, probably Giulio Clovio, Copy after one of the Soldiers from Michelangelo's Crucifixion of St. Peter. Princeton University, The Art Museum.

305. Attributed to Michelangelo, Study for one of the soldiers of the Conversion of Saul. Amsterdam, Rijksmuseum.

WORKS RELATED TO LATE DRAWINGS OF MICHELANGELO

306. Engraving by Beatrizet after Michelangelo's drawing, The Dream. London, British Museum.

307. Raffaello da Montelupo, The Dream. Amsterdam, Collection J. Q. van Regteren-Altena.

308. Sebastiano del Piombo, the Madonna with the Veil. Naples, Galleria Nazionale di Capodimonte.

309. Giulio Bonasone, Engraving after Michelangelo's Il Silenzio (1566).

310. Marcello Venusti, Copy after Michelangelo's Il Silenzio. London, National Gallery.

311. Lorenzo Monaco, The Annunciation. Florence, Accademia.

312. Marcello Venusti, Drawing after Michelangelo's Annunciation for the Cesi Chapel in Santa Maria della Pace. New York, Morgan Library.

313. Marcello Venusti, Annunciation after Michelangelo's Annunciation for the Cesi Chapel in Santa Maria della Pace. Rome, Galleria Nazionale Barberini.

314. Marcello Venusti, Annunciation after Michelangelo. Rome, San Giovanni in Laterano.

315. Marcello Venusti, Preparatory drawing for the Annunciation after Michelangelo. Florence, Uffizi. (Berenson, no. 1644.)

316. Nicolas Beatrizet, Engraving after Michelangelo's Annunciation. (Bartsch, no. 12.)

317. Marcello Venusti, The cleansing of the Temple, after Michelangelo. London, National Gallery.

318. El Greco, The cleansing of the Temple. London, National Gallery.

319. Rembrandt, Etching representing The cleansing of the Temple (1635). (Bartsch, no. 69). New York, Metropolitan Museum of Art. (By courtesy of the Metropolitan Museum of Art.)

320. Duccio di Buoninsegna, Christ on the Mount of Olives. Siena, Museo dell' Opera del Duomo.

321. Giovanni di Paolo, Christ on the Mount of Olives. Vatican, Pinacoteca.

322. Marcello Venusti, Christ on the Mount of Olives. Drawing after Michelangelo. Florence, Uffizi (no. F 230).

323. Marcello Venusti, Christ on the Mount of Olives. Rome, Galleria Doria.

324. B. Berlinghieri, The Crucifixion of Christ and scenes of his Passion. Florence, Uffizi.

325. Attributed to Michelangelo, Christ on the Cross, Drawing (Thode, no. 495). Paris, Louvre (Inv. no. 739).

326. Attributed to Michelangelo, Christ on the Cross, Drawing. Paris, Louvre (Inv. no. 841).

327. Copy after Michelangelo, Christ on the Cross, Bronze Statuette. New York, Metropolitan Museum of Art. (By courtesy of the Metropolitan Museum of Art.)

328. Copy after Michelangelo, Christ on the Cross of Fig. 327 seen in Side View. (By courtesy of the Metropolitan Museum of Art.)

329. Copy after Michelangelo, The Good Thief. Bronze Statuette (belonging to a Golgotha Group containing Figs. 327-330). New York, Metropolitan Museum. (By courtesy of the Metropolitan Museum of Art.)

330. Copy after Michelangelo, The Bad Thief, Bronze Statuette (belonging to a Golgotha Group containing Figs. 327-330). New York, Metropolitan Museum. (By courtesy of the Metropolitan Museum of Art.)

331. Attributed to Michelangelo, The Bad Thief, Fragment of a Bronze Statuette from a Golgotha Group. Paris, Louvre (Leg Gatteaux).

332. Unknown Artist of the sixteenth century, Copy after Michelangelo's Bad Thief, Drawing. Haarlem, Teyler Museum.

333. Ascanio Condivi, Copy after Michelangelo's so-called Epiphany, Painting on panel. Florence, Casa Buonarroti.

334. Copy after Michelangelo, Christ and the Samaritan Woman, Drawing. Whereabouts unknown (Reproduction from a Photograph in the Collection of Sir Robert Witt, London, Courtauld Institute).

335. Nicolas Beatrizet, Christ and the Samaritan Woman, after a Composition by Michelangelo, Engraving (Bartsch, no. 17). Paris, Bibliothèque Nationale.

336. Drawing after Michelangelo's Christ and the Samaritan Woman. Paris, Louvre (Inv. no. 766).

337. Drawing after Michelangelo's Crucifixion for Vittoria Colonna (probably by Giulio Clovio). Paris, Louvre (Inv. no. 732).

338. Copy after a lost version by Michelangelo of a Christ on the Cross, Miniature in the Roman Missal for Cardinal d'Armagnac. Avignon, Bibliothèque Municipale, MS 172, folio 10. (From Leroquais, *Les Sacramantaires*, pl. 124.)

339. Copy after a lost Crucifixion drawing of Michelangelo (Delacre, no. 169). Paris, Louvre (Inv. no. 843).

340. Giulio Bonasone, Michelangelo's Pietà for Vittoria Colonna, Engraving of 1546 (Bartsch, no. 64). Florence, Uffizi.

341. Nicolas Beatrizet, Michelangelo's Pietà for Vittoria Colonna, Engraving of 1547 (Bartsch, no. 25). Vienna, Albertina.

342. G. B. de Cavalieri, Michelangelo's Pietà for Vittoria Colonna, Engraving (Le Blanc, *Manuel*, I, p. 660, no. 16). Paris, Bibliothèque Nationale.

343. Undescribed copy after Nicolas Beatrizet's Engraving of Michelangelo's Pietà for Vittoria Colonna. London, Victoria and Albert Museum.

344. First undescribed version of Agostino Caracci's Engraving after Michelangelo's Pietà for Vittoria Colonna. Paris, Bibliothèque Nationale.

345. Agostino Caracci, Second version (1579) of engraving after Michelangelo's Pietà for Vittoria Colonna (Bartsch, no. 103). Paris, Bibliothèque Nationale.

346. Marcello Venusti, Copy of Michelangelo's Pietà for Vittoria Colonna. Rome, Galleria Borghese.

347. Unknown master of the sixteenth century, Copy of Michelangelo's Pietà for Vittoria Colonna. Munich, Bayrische Staatsgemäldesammlungen. (By courtesy of the Direction of the Bayrische Staatsgemäldesammlungen.)

348. Attributed to Marcello Venusti, Copy after Michelangelo's Pietà for Vittoria Colonna. Basel, Collection of the late Dr. J. Schmid-Paganini.

349. Unknown master of the mid sixteenth century, Copy after Michelangelo's Pietà for Vittoria Colonna. Florence, Casa Buonarroti.

350. Unknown master of the mid sixteenth century, Copy after Michelangelo's Pietà for Vittoria Colonna. Florence, Uffizi Store Rooms. (By courtesy of Prof. Ugo Procacci.)

351. Unknown master from the end of the sixteenth century, Copy after Michelangelo's Pietà for Vittoria Colonna. Arezzo, Casa Vasari.

352. Unknown Flemish master of the late sixteenth century, Copy after Michelangelo's Pietà for Vittoria Colonna. Formerly Gotha, Herzogliche Gemäldegalerie.

353. El Greco, Pietà, Free copy after Michelangelo's Pietà for Vittoria Colonna and that for the Duomo of Florence. New York, The Hispanic Society of America. (By courtesy of the Hispanic Society of America.)

354. Copy after Michelangelo's Pietà for Vittoria Colonna, Marble Relief. Vatican, Museo Profano.

355. Unknown sculptor of the sixteenth century, Copy after Michelangelo's Pietà for Vittoria Colonna. Rome, Santo Spirito in Sassia.

356. Silver *pax*, with copy of Michelangelo's Pietà for Vittoria Colonna. Princeton, The Art Museum of Princeton University.

357. Silver *pax*, with copy of Michelangelo's Pietà for Vittoria Colonna. Berlin, Kaiser Friedrich Museum. (From Bange, *Catalogue of the K. Fr. Museum*, no. 945.)

358. Gilt bronze *pax*. London, Victoria and Albert Museum. (By courtesy of Mr. John Pope-Hennessy of the Victoria and Albert Museum.)

WORKS RELATED TO THE LATE PIETÀS

359. Albrecht Dürer, The Holy Trinity, Woodcut from 1511. Paris, Bibliothèque Nationale.

360. Andrea del Sarto, Pietà, Engraving by Agostino Veneto, from 1516 (Bartsch, no. 40). (From Knapp, *Andrea del Sarto*, ill. 27.)

361. Angelo Bronzino, The Holy Trinity, 1571. Florence, SS. Annunziata.

362. Master of San Miniato, Descent from the Cross, detail.

363. Palma Giovane (attributed to Tintoretto), Pietà. Venice, Palazzo Ducale.

364. Taddeo Zuccari, Pietà. Rome, Galleria Borghese.

365. Master of Flémalle, The Holy Trinity. Frankfurt am Main, Städel'sches Kunstinstitut. (By courtesy of the Städel'sches Kunstinstitut.)

366. Unknown North Netherlandish master of the second half of the fifteenth century, Holy Trinity from the Church of Baern. Utrecht, Archiepiscopal Museum (Inv. no. 266).

367. P. and A. Lorenzetti, The Virgin with the Man of Sorrows. London, National Gallery.

368. Unknown master of the late Trecento, The Virgin with the Man of Sorrows. Florence, San Miniato al Monte.

369. Master of the Imhoff Altar, The Virgin with the Man of Sorrows. Nüremberg, Germanisches Museum.

370. Giovanni da Milano, Lamentation of Christ. Florence, Uffizi.

371. Giovanni di Pietro da Napoli, Lamentation of Christ. New Haven, Gallery of Fine Arts of Yale University. (By courtesy of the Gallery of Fine Arts of Yale University.)

372. Attributed to Fra Filippo Lippi, Entombment of Christ. Cherbourg, Musée.

373. Engraving from the period 1572-1585 after the Deposition by Michelangelo in the Duomo at Florence (Bartsch, XVII, p. 58, no. 23). Paris, Bibliothèque Nationale.

MEDALLIONS

374. Three Medallions depicting Vittoria Colonna. Paris, Bibliothèque Nationale, Cabinet des Médailles.

375. The reverse sides of the medallions of Fig. 374.

376. Leone Leoni, Medallion depicting Michelangelo as a blind man (probably after a drawing by Michelangelo). Paris, Bibliothèque Nationale, Cabinet des Médailles.

PHOTOGRAPHIC SOURCES

THE following photographs were taken for the author of this work:

Ashmolean Museum: no. 187 (by courtesy of Dr. K. T. Parker).

Bibliothèque Nationale, Paris: nos. 171, 252, 253, 258, 260, 261, 262, 276, 280, 299, 302, 303, 309, 316, 335, 342, 344, 345, 373, 374, 375, 376.

Brogi, Florence: no. 189.

British Museum, London, Photo Macbeth: no. 300; Photo Freeman: nos. 209, 210, 277, 306.

Carboni, Rome: nos. 177, 355.

Ciacchi, Florence: no. 170.

Courtauld Institute, London: no. 334.

Faraglia, Rome: no. 92.

Fototeca Italiana, Rome: nos. 291, 292, 293.

Frankenstein, Vienna: nos. 240, 341.

Frequin, Den Haag: no. 251.

Gabinetto Fotografico, Soprintendenza alle Gallerie, Florence: nos. 78-81, 121, 124, 127, 151, 157, 161, 294.

Isabel Stewart Gardner Museum, Boston: no. 159.

Huntington Library, San Marino, California: no. 176.

Formerly Koenigs Collection (now Rotterdam, Boymans Museum): nos. 105, 128.

Lagache, Lille: no. 219.

by courtesy of Prof. Lavagnino, Rome: no. 190.

Louvre, Cabinet des Dessins, Paris: nos. 97, 99, 166-169, 220, 224, 325, 326, 336, 337, 339.

Metropolitan Museum of Art, New York: no. 274.

by courtesy of Dr. Pope-Hennessy, Victoria and Albert Museum, London: no. 358.

by courtesy of Dr. Procacci, Florence: no. 350.

by courtesy of Prof. van Regteren-Altena, Amsterdam: no. 307.

Sansaini, Vatican: nos. 8, 9, 10, 11, 13, 14, 15, 134, 135, 136, 155, 156, 205, 232-236.

by courtesy of the Soprintendenza, Photo Sella, Milan: nos. 89, 90, 91, 94.

Giusti, Florence: no. 311.

Herzgl. Gemäldegalerie, Gotha: no. 352.

Hispanic Society of America, New York: no. 353.

Formerly Koenigs Collection (now Rotterdam, Boymans Museum): nos. 105, 128.

Kunsthalle, Hamburg; Photo Kleinhempel: no. 104.

Index of Christian Art, Princeton, N.J.: no. 301.

Mather Collection, Princeton, N.J.: no. 304.

Metropolitan Museum, New York: nos. 295, 319, 327-330.

Pierpont Morgan Library, New York: nos. 179-182, 312.

National Gallery, London: nos. 310, 317, 318, 367.

National Gallery, London; by courtesy of the Duke of Portland: no. 158.

Princeton Museum of Art: no. 356.

Rijskmuseum, Amsterdam: nos. 256, 305.

Sansaini, Vatican: no. 265.

by courtesy of Dr. Schmid-Paganini, Basle: no. 348.

by courtesy of Count Antoine Seilern, London: nos. 131, 223.

Soprintendenza alle Antichità della Sicilia Orientale: no. 285 a.

Städel'sches Kunstinstitut, Frankfurt a. M.: no. 365.

Teyler Museum, Haarlem: nos. 119 (by courtesy of Prof. van Regteren-Altena), 144, 145, 150, 162, 163, 192, 198, 200, 201, 202, 214, 217.

Utrecht, Archiepiscopal Museum: no. 366.

Warburg Library, London: no. 279.

Windsor Castle; by permission of Her Majesty the Queen of England: nos. 102, 112, 118, 130, 140, 142, 226, 227, 228.

Yale University Art Gallery: no. 371.

by courtesy of the Teyler Museum, Haarlem: no. 332.

Vecchi, Ferrara: no. 289.

Victoria and Albert Museum, London: no. 343.

For the following photographs thanks are due to:

Alinari, Florence: nos. 57, 82, 83, 85, 86, 113, 125, 257, 263, 270, 298, 313, 320, 324, 346, 368, 370.

Anderson, Rome: Folded photograph of the Last Judgment and nos. 1, 2, 4-7, 12, 58-65, 68-77, 84, 87, 88, 93, 95, 139, 172, 178, 244, 264, 266, 267, 275, 284, 285 b, 287, 288, 308, 314, 321, 323, 354, 364 (by courtesy of Dr. D. Redig de Campos).

Archives Photographiques, Paris: nos. 106, 132, 138, 165, 184, 185, 213, 222, 254, 372.

Archivio Fotografico Gallerie e Musei Vaticani: through the courtesy of Dr. R. de Campos: nos. 3, 16-41, 43-56, through the courtesy of Dr. F. Magi: nos. 66, 67.

Ashmolean Museum, Oxford: nos. 114, 117, 148, 149, 175, 183, 186, 194, 195, 196, 208, 212, 218, 221, 229, 230, 237, 241.

Bayerische Staatsgemälde Sammlg., Munich: nos. 191, 347.

Bibliothèque Nationale, Paris: nos. 255, 259, 260 a, 359.

Bildarchiv d. Oest. Nationalbibliothek, Vienna: nos. 98, 211, 216, 239.

by courtesy of Dr. Victor Bloch, London: no. 193.

British Museum, London; Photo Freeman: nos. 101, 103, 110, 111, 115, 116, 123, 126, 129, 141, 146, 147, 152, 153, 154, 160, 164, 199, 203, 204, 206, 207, 209, 210, 225, 231, 238, 242, 243, 245-250.

Brogi, Florence: nos. 133, 143, 174, 188, 215, 278, 283, 333.

Fototeca Italiana, Florence: no. 290.

Gabinetto Fotografico, Soprintendenza alle Gallerie, Florence: nos. 100, 108, 109, 122, 137, 173, 297, 315, 322, 340, 349, 351, 361.

Cipriani, Florence: no. 269.

by courtesy of Gathorne-Hardy Collection, Newbury, England: no. 197.

Germanisches National-Museum, Nürnberg: no. 369.

Giraudon, Paris: nos. 96, 120, 331.

The following illustrations are from publications:

E. I. Bange, *Die italienischen Bronzen d. Renaissance und d. Barock*, 1922, no. 945: no. 357.

B. Berenson, in *Essays in honor of G. Swarzenski*, Chicago, 1951, p. 99: no. 362.

A. M. Hind, *Early Italian Engravings*, London, 1938, A.11.10: nos. 107, 296.

Knapp, *Andrea del Sarto*, Künstler Monographien: no. 360.

V. Leroquais, *Les Sacramentaires et les Missels manuscrits des Bibliothèques de France*, Paris, 1924, pl. 124: no. 338.

G. Millet, *Broderies Religieuses de style Byzantin*, Paris, 1939, Vol. II, pl. 136: no. 272.

A. Muñoz, *I Quadri bizantini della Pinacoteca Vaticana*, Rome, 1928, no. 16: no. 273.

Nederlandsch Houtsneden 1500-1550, pls. 291, 292: nos. 281, 282.

PLATES

1

2

3

4

5

11

13

17

16

18

19

21

20

23

22

27

26

29

28

33

32

35

34

36

37

38

39

41

40

43

42

45

44

47

46

49

48

18

19

23

22

25

24

27

26

29

28

33

32

35

34

36

37

38

39

41

40

43

42

45

44

47

46

49

48

51

50

52

53

54

56

55

59

60

61

65

64

66

67

68

72

71

73

74

75

78

80

79

83

85

84

MICHELANGELO BUONAROTI

88

90

91

92

93

94

97

97

98

102

101

100

103

104

105

106

107

111

110

113

112

114

115

116

119

118

117

120

121

122

123

124

125

126

127

128

129

130

131

132

133

134

135

136

137

138

139

141

142

143

145

144

147

146

148

149

150

151

152

154

153

157

156

155

158

159

160

161

162

163

164

165

166

167

168

169

170

171

172

174

173

175

176

178

177

180

182

179

181

184

185

186

187

188

189

190

191

192

193

194

195

196

197

198

199

200

204

203

205

206

207

208

211

212

213

215

216

214

219

217

218

220

221

223

222

224

225

226

228

227

229

230

231

232

233

234

236

235

237

238

239

240

241

242 243

244

245

246

247

248

250

249

251

253

252

256

255

VISITVR · ROMÆ · IN · PALATIO · EX · FAMILIA · RVCELLAIA

257

258

259

260a

260b

261

262

263

264

265

266

268

269

267

270

274

277

273

276

272

275

278

279

280

281

282

284

283

285a

285b

286

287

288

289

290

291

292

293

294

295

296

297

298

299

300

301

302

303

305

304

MICHAEL·ANGELVS·IN·VEN·

308

309

310

311

312

313

314

315

316

318

319

317

321

320

323

322

324

325

326

327

328

329

330

331

332

333

334

335

336

339

338

337

342

345

341

344

340

343

346

347

348

349

350

351

352

353

354

355

356

357

358

361

360

359

364

363

362

369

373

368

372

367

371

366

365

370

374

375

376